Bob,

Wishing you many happy hours of carving!

Best regards,

Rosalyn Leach Daisey

SHOREBIRD CARVING

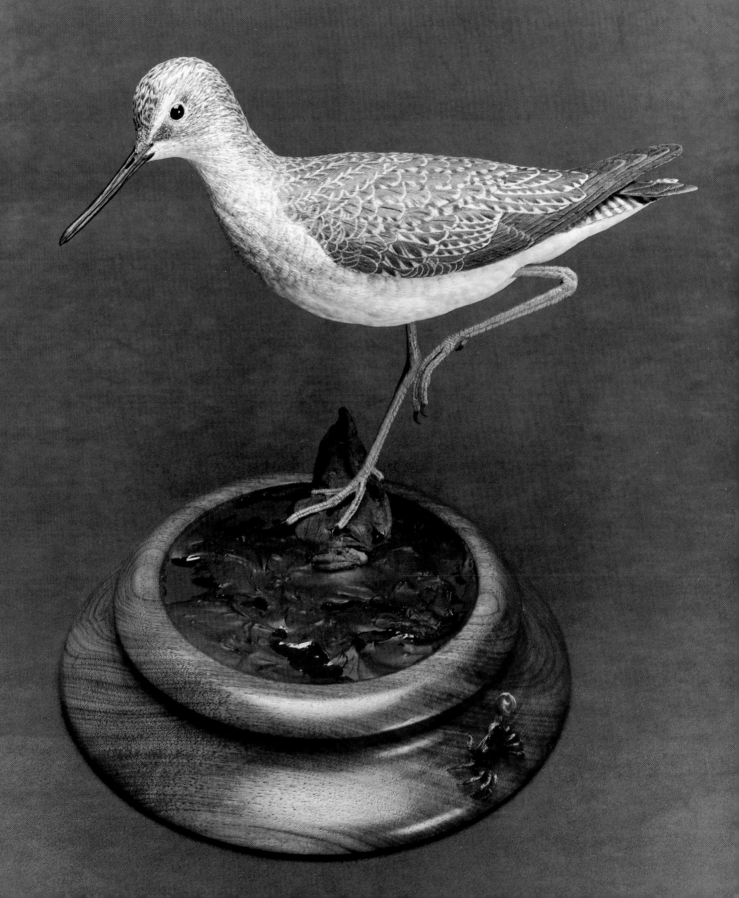

Other books by Rosalyn Leach Daisey

Songbird Carving

Songbird Carving II

Future book:

Upland Game Bird Carving

Published by Schiffer Publishing, Ltd.
1469 Morstein Road
West Chester, Pennsylania 19380
Please write for a free catalog
This book may be purchased from the publisher.
Please include $2.00 postage.
Try your bookstore first.

Copyright © 1990 by Rosalyn Leach Daisey.
Library of Congress Catalog Number: 89-63675.

Printed in the United States of America.
ISBN: 0-88740-219-4

This work is dedicated to my sister, Dale, and my brothers, Bud, Coston, and Kent, who taught me to share, work, play, laugh, and love, all with enthusiasm!

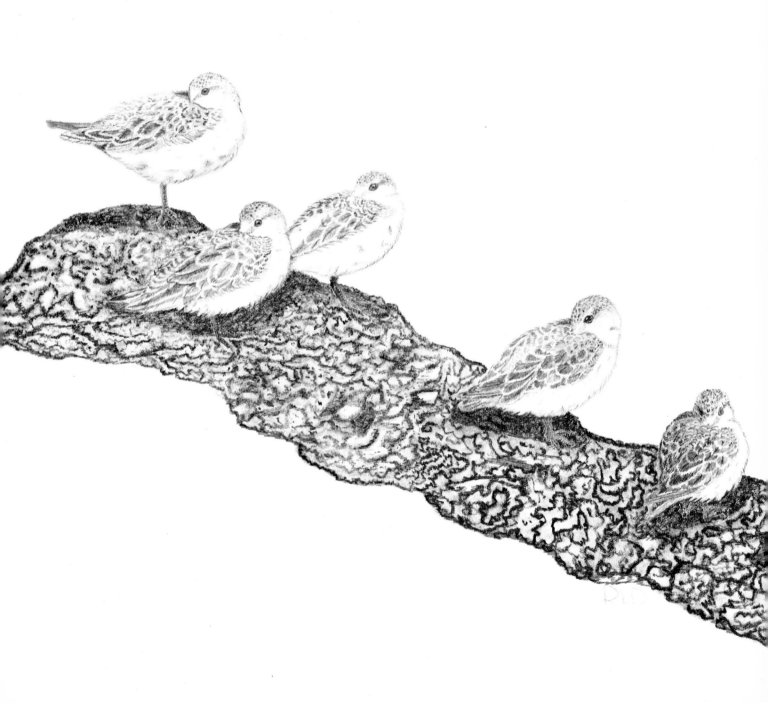

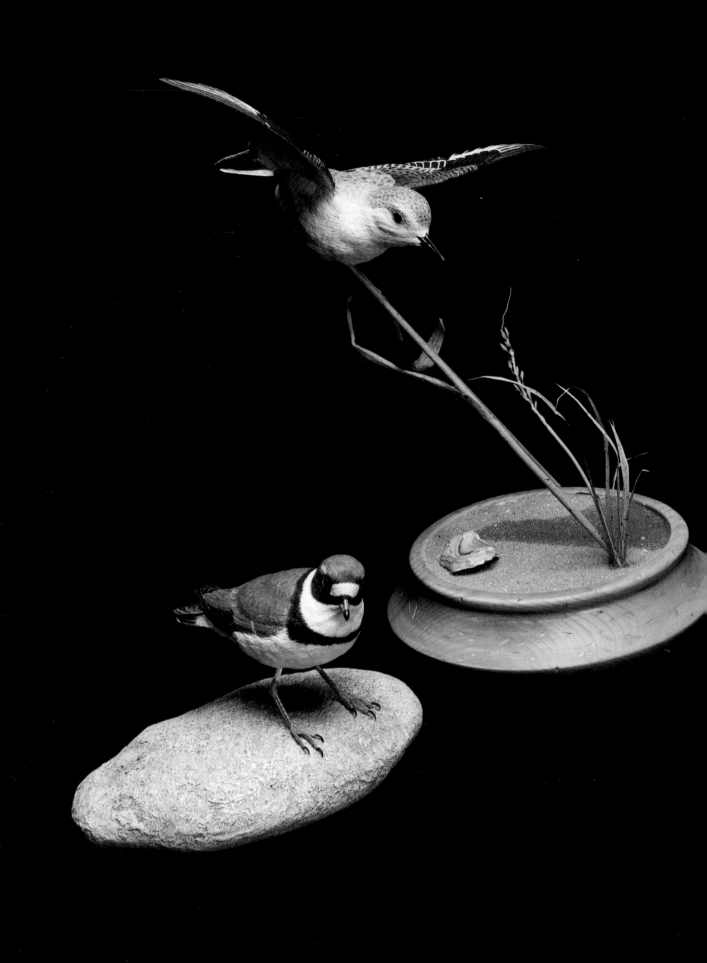

SHOREBIRD CARVING

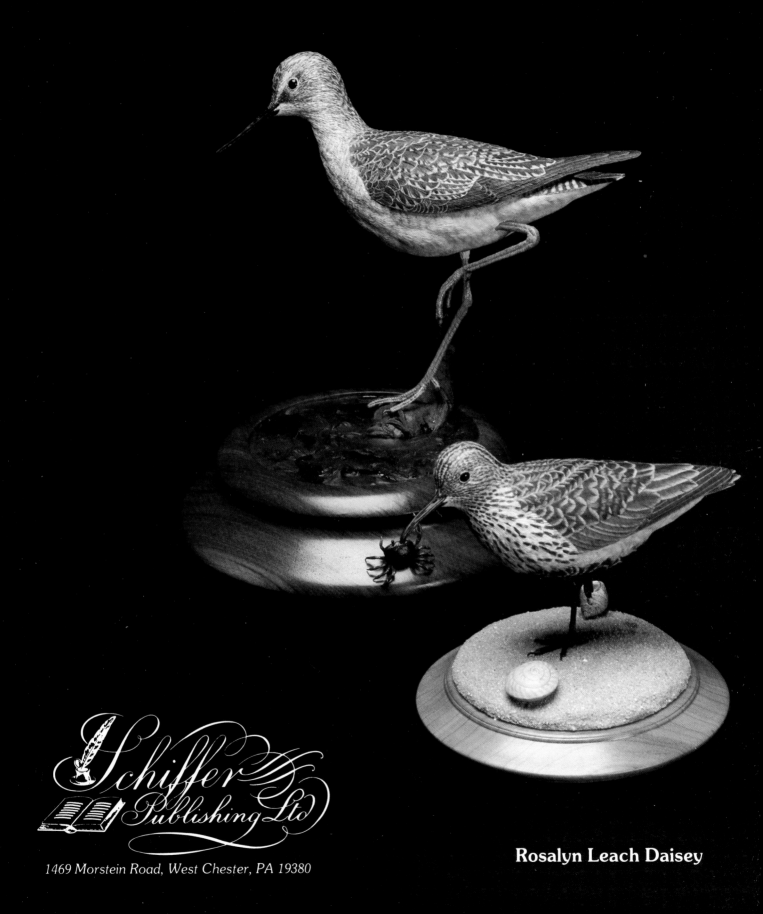

Schiffer Publishing Ltd

1469 Morstein Road, West Chester, PA 19380

Rosalyn Leach Daisey

Acknowledgements

My sincerest thanks to all the students who have attended my seminars. I appreciate your encouragement and suggestions.

I wish to thank Gene Hess of the Delaware Museum of Natural History for his helpful assistance. Thank you, Gene.

My warmest thanks to Pat and Betsy Cameron for their trek through the marsh to find the fiddler crabs for me. Only true friends would have tolerated the bugs, wet feet, and inconvenience of a distant plea for a fiddler crab! I am so proud to call them both my friends. Thank you, Pat and Betsey.

I am very grateful to George Cowan for showing me the best shorebird niches of the New Jersey side of the Delaware Bay. Thank you, George.

My sincerest thanks to Ellen Taylor, Tim Scott, and Douglas Congdon-Martin of Schiffer Publishing for their expert assistance and warm working environment. Thank you, all.

I wish to thank Jonathan Dewees of Dewees Business Equipment for his much needed help when my computer was sick! His assistance went beyond the call of duty. Thank you, Jon.

My warmest thanks to my friend, Pat Kurman, for her encouragement and suggestions throughout this project. Thank you, Pat.

I am most grateful to my children, Jason and Jenna, who witness first hand the number of hours and problems involved in a project of this scope. Their enthusiasm and standing ovations for whatever I do are unending. I get their letters in the mail, notes left on my computer, and bouquets of flowers that seem to come when my spirits and energy are the lowest. Both of these young people are the very best! All whose lives they touch are genuinely enriched. Thank you, Jason and Jenna.

Contents

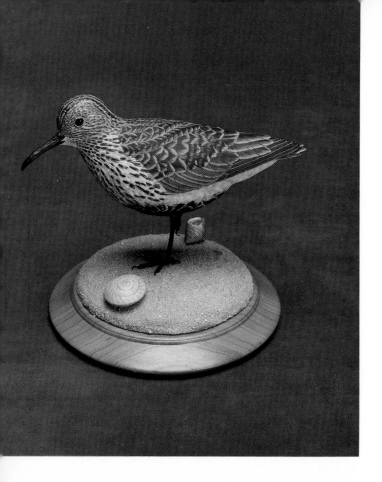

Introduction

Living within thirty minutes of the headwaters of the Chesapeake Bay and the Delaware River (which becomes the Delaware Bay within a short distance), affords me the opportunity to view millions of shorebirds yearly. Every year in the spring and fall, shorebirds stopover nearby, on their journey north to their nesting grounds or south to their wintering grounds, to replenish their depleted energy supply. On any day at the end of May, one can observe many shorebirds poking in the sand or mud for edibles. Some of the birds will still have their winter plumage while others have begun to change to their brighter breeding plumage. It is a feast for the eyes of any bird lover to view thousands of birds at a glance!

Observation of birds is the starting point for every carver. Learning to see shape and form, and then learning to see color, shadow and highlight are very important. All carvers need to learn to use their eyes in such a way as to distinguish a rounded form from a depressed one, an upward slant from a downward one and all of the other attributes of shape and form. If you are interested in carving natural finished (with no paint for coloring) birds, your area study may be limited to shape and form. But if you want to paint the carving, you will need to learn to see colors, shades, tints and highlights. All of these are learned skills! Yes, there is hope for us all, because we can learn! All of us start at zero and where the learning leads and how it is used is up to each individual. May your journey be filled with joy and a real sense of accomplishment as mine has been!

This teaching text, as with *Songbird Carving* and *Songbird Carving II*, is a photographic, illustrative and step-by-step composition of four carving projects and

their habitats. The instructions will lead you through the carving, texturing and painting of each of the four shorebirds, and then demonstrate the construction of a typical habitat for that bird. There are two shorebird projects with the birds in their breeding plumage, the dunlin and semi-palmated plover, and two projects with the birds in non-breeding plumage, the greater yellowlegs and sanderling. The sanderling project is particularly challenging since the bird has fully extended wings.

I find writing a book an easy task if I can sustain the energy for its completion. Having taught so many seminars, I look at a photograph or drawing and imagine myself in a seminar situation. The explanation comes to mind immediately. I have been asked so many questions by students that I recognize and anticipate the problem areas. In the books, as well as in class, I spend extra time and effort on these problem areas to provide an explanation that is easily understood.

The carving and painting photographs, instructions and explanations for the four projects and the chapter on habitat construction and painting are intended to provide five seminars at your fingertips. The only two elements that I cannot provide are desire and time. Desire is almost the whole ballgame! It is the one ingredient that is basic for all learning. I am firmly convinced that anyone able to peel a potato or shave his face or her legs can carve a bird if he/she desires and has good instruction! Time is an easily supplied ingredient for, if one really desires to do something, the time will be made available.

The photographs, illustrations and instructional text are all enthusiastically supplied. Bring your desire and time, and join me on a tremendously satisfying journey!!

Chapter 1.

Shorebird Anatomy

TOPOGRAPHY

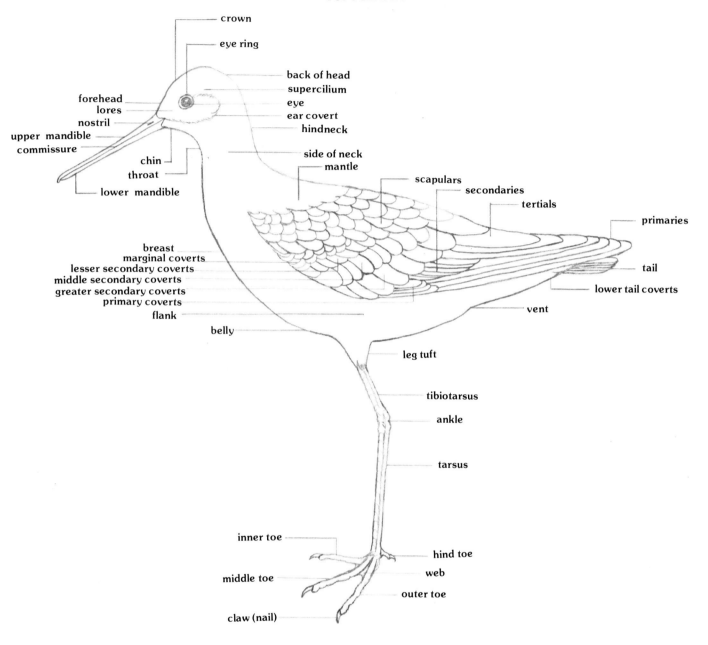

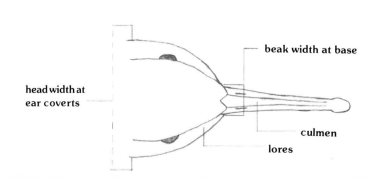

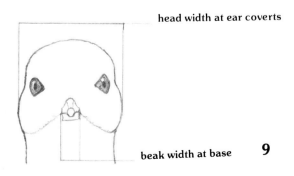

WING FEATHER GROUPS

alula

marginal coverts

lesser primary coverts

middle primary coverts

greater primary coverts

lesser secondary coverts

middle secondary coverts

greater secondary coverts

leading edge

trailing edge

scapulars

primaries

secondaries

Upper Surface of the Right Wing

tertials

greater underwing coverts

lesser underwing coverts

marginal underwing coverts

lesser under primary coverts

middle under primary coverts

greater under primary coverts

middle underwing coverts

axillaries

primaries

Under Surface of the Left Wing

Secondaries

tertials

WHAT IS HAPPENING UNDER THE COVERTS?

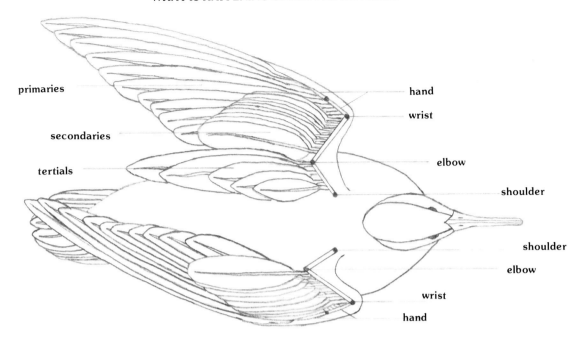

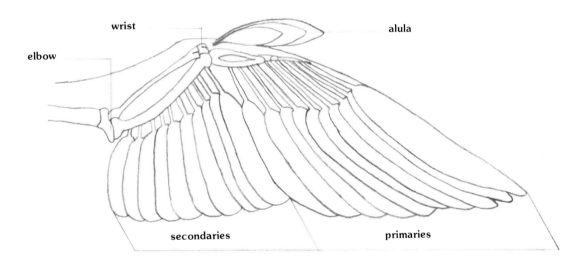

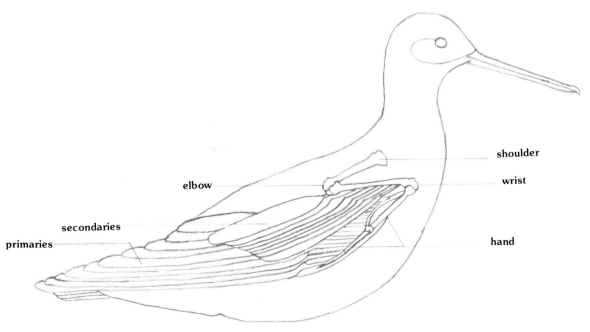

TOP PLAN VIEW

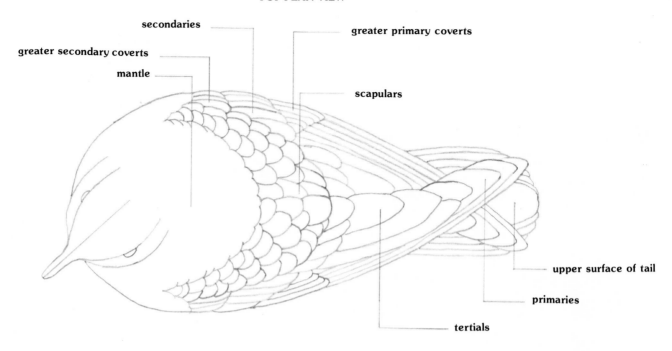

secondaries

greater primary coverts

greater secondary coverts

mantle

scapulars

upper surface of tail

primaries

tertials

UNDER PLAN VIEW

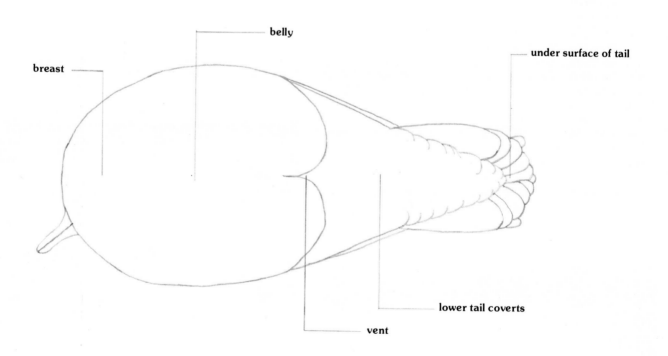

belly

under surface of tail

breast

lower tail coverts

vent

Chapter 2.
Basic Techniques

Feather Contouring and Stoning

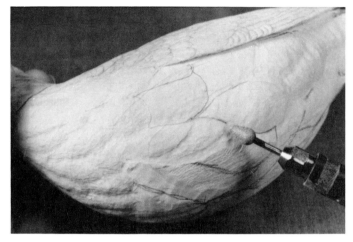

Figure 1. Here you see the dunlin's dark belly patch. You can see the contouring of the puffs of feathers and their flow. Feather contouring is also called "lumps and bumps" and feather fluffing or landscaping. Close observation of live birds reveals this contouring. Notice that every single feather has curvature, not only from base to tip but also from side to side (leading edge to trailing edge).

There is no right way to layout this contouring. When a live bird fluffs its feathers, they will be arranged differently almost every time. The wind will also do amazing tricks with feathers. When sketching the feather contouring, think in terms of graceful curves with high points falling down to low areas. Let your imagination ramble to execute a creative pattern and let every bird you do be different. A variety of size, shape and contour is very important. Most people tend to want each side of the bird to be balanced or the same. Force yourself to make each side of the bird contoured differently.

Figure 2. On the yellowlegs' breast and belly, you see the feather contouring sketched in. Divide the areas into large groups with large sweeping curves and no straight lines! The main idea is to create areas of interest that enhance the fluidity and naturalness of the composition.

Figure 3. Channel along the contour lines. Round over the high points, flowing the wood down to the surrounding channels. Progressing from the head of the bird to its tail, each feather group emerges from below the one above. On each area of the bird, there should be a variety of high and low points. All of the high areas should not be the same height or the lows the same depth.

Lighting is important when viewing contours. Flat overhead lighting will not enable you to see contours or shadows. An adjustable light such as an architect's or gooseneck light is so valuable in viewing contours, because it can be adjusted to a low trajectory. When the light source shoots across a subject, it allows shadows to fall in place and contouring to be highly evident.

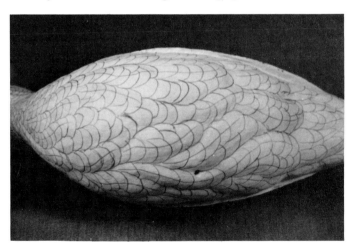

Figure 4. On the yellowlegs' belly, you see the feather layout sketched over the contouring. The lines on top of the feathers are flow lines. When drawing in feather patterns, varying the amount of exposed feather and the tip's shape will enhance the motion and add interest to the area.

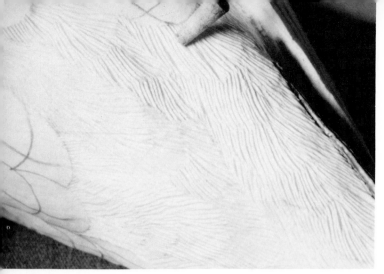

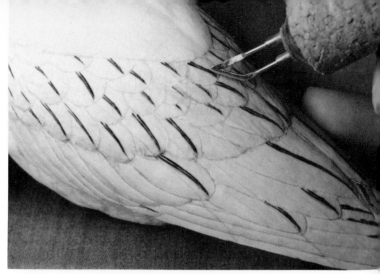

Figure 5. Holding the stone at an angle allows the corner to grind away wood in an angular shape. Stones of various degrees at the edge will create grooves with different angled sides. Most people find that some stones give more life-like texturing on the end grain of wood and other stones do a better job on flat grain. Experimentation is the key here. What works for you may not work for me. People handle tools differently. Play around with different stones in all areas and determine what works best for you.

Begin stoning at the tip of whatever group you are working on. This allows the texturing of the feather above to cover the bases of the strokes executed on the feather below for a more realistic look. All of the stoned strokes should not be the same depth. A variety enhances a fluffy appearance to the feathering. Every stoning stroke should be located as closely as possible to the one next to it so that there are no flat (unstoned) spaces of wood. On larger feathers, curving each stroke will create a fluid motion to each feather. On small feathers, it may be difficult to curve the short strokes. Varying the direction of the feather flow will add interest.

Burning

Burning in the barbs on feathers helps to create realism. The rheostat type of burning pen has a sharply beveled tip that will burn small grooves in the wood when heated. Grooves on the surface, I am convinced, enhance the soft quality of any carving because of the light reflection. One side of the v-groove will reflect the light while the other will not. Viewing the carving from many angles will cause different light reflective values. Burning too deep will cause less light reflection and a very difficult painting job.

As with stoning, burned strokes should be kept as close as possible with no flat unburned spaces in between. Each time you texture a bird, strive to tighten up the burning a little more so that eventually there are no microscopic flat spaces between the lines.

Figure 6. After drawing in the quills, burn a stroke on one side of the pencil line from the base of the feather to the tip. Burn the second stroke again starting at the base but leave a small strip of wood in between the two strokes. This strip will actually be the raised quill since the burning will depress the wood on each side. The two strokes should get closer as they near the tip and finally merge into a point approximately one-eighth of an inch from end on a medium sized feather.

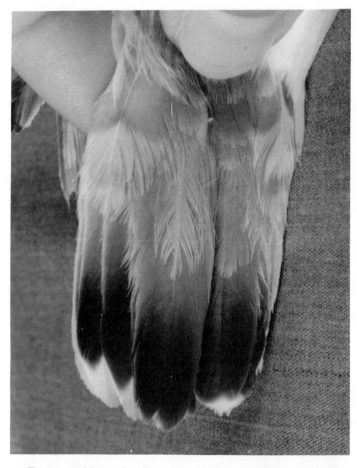

Figure 7. Note the direction that the barbs come off the quill on the plover's tail feathers. The sharp angle is important in burning. Burn in the barbs at this sharp angle and begin to curve down as the stroke nears the feather edge, just as on a real feather.

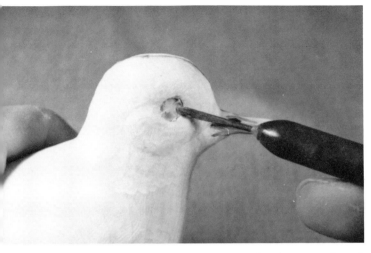

Figure 8. When the bird is completely carved and textured, the eyes can be set. Fill both eye holes with any oily, non-hardening clay.

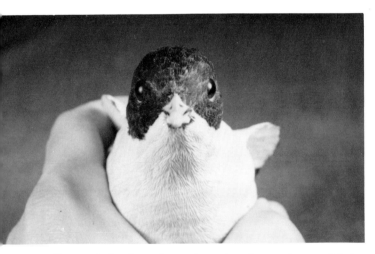

Figure 9. Push each eye into the clay and press it into place with the wooden handle of an awl or some other tool. The eyes should not be pushed in too far causing you to have to look down into the hole to make eye contact. Neither should they be left out too much so that the bird looks bug-eyed. Note the depth of the eyes from the head-on view of the sanderling.

Figure 10. Using the pointed end of a dissecting needle or clay tool, clean out any clay that can be reached. The ribbon putty will not adhere to any surface with clay on it.

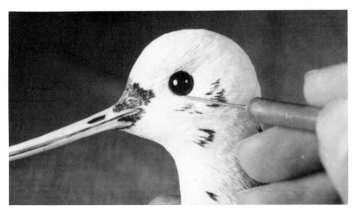

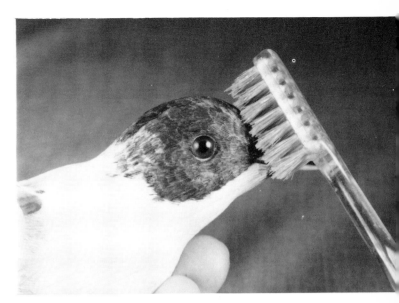

Figure 11. A toothbrush is helpful in cleaning clay out of the texturing around the eye.

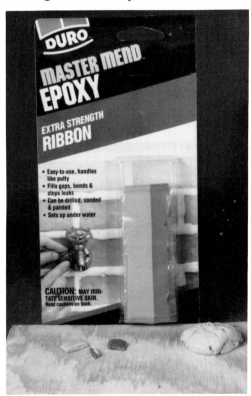

Figure 12. The ribbon putty comes in a blue and yellow strip. Cut off a small piece. Always remove and discard the middle piece where the two colors join. This area has already chemically reacted and hardened and will leave hard bits of material in your mix. Knead a piece of blue and a piece of yellow thoroughly in your fingers until the mix is consistently green throughout. The little mound of clay that you see is necessary when working with the ribbon putty. The putty will stick to tools, fingers, etc. unless you put on a coating of oil from the clay. When pushing the putty around, you will feel it stick to the tool. By pressing the tool into the clay, you may go back to the putty without it sticking.

15

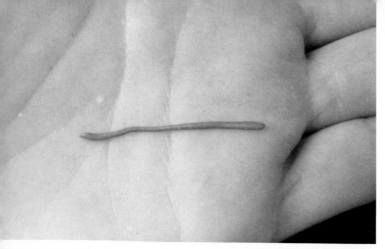

Figure 13. After the ribbon putty is mixed, take a small amount and roll it into a worm in the palm of your hand.

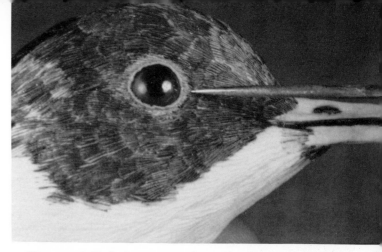

Figure 16. Pull the putty edge into the surrounding texturing.

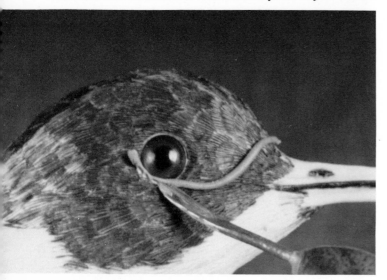

Figure 14. Press the worm down into the crevice around the *eye.* Cut off any excess. As you press the putty down into the crease, you can easily form the very small ridge around the *eye* called the *eye ring.*

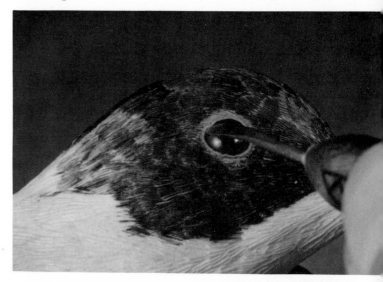

Figure 17. If the eye ring starts creeping down onto the eye or hugging the eye too tightly, just push it back into place.

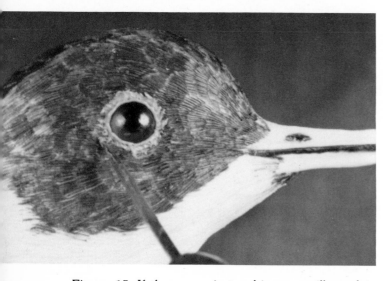

Figure 15. If the worm is too big, you will need to remove the excess. You want to only cover the crevice, not the entire side of the head. A small amount is all that is needed.

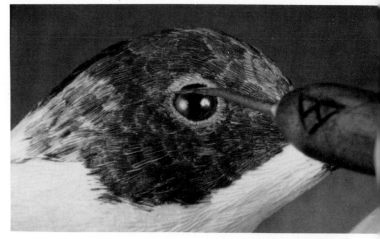

Figure 18. When the shape and size of eye ring are satisfactory, texture the ridge itself. Using the end of a dental tool or a small knife blade, score the eye ring by pressing in small lines radiating around its circumference. Proceed in setting the other eye without damaging the first one! Allow several hours for the putty to harden before painting or handling.

Constructing Feet

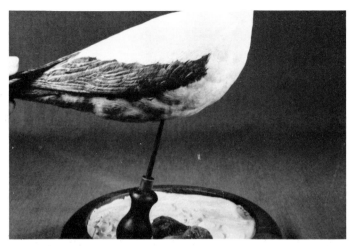

Figure 19. Determine the placement for the leg exit from the belly feathers. Shorebirds' legs typically are more centrally located on the belly than other birds. Hold the bird in the desired position and mark the placement with an awl. Here you see the placement for the "down" foot of the yellowlegs.

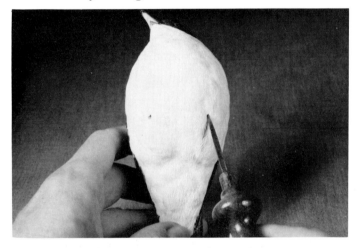

Figure 20. Notice the mid-belly placement for the semi-palmated plover's feet.

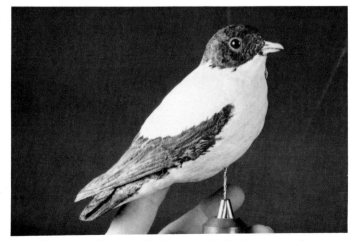

Figure 21. Drill the hole in the belly the same diameter as that for whatever size wire needed for the leg.

Figure 22. Measurements listed here are for the yellowlegs and the particular way in which I mounted him. Using a permanent ink marker, mark the measurements on the wire for the length needed into the body, length from the body to the ankle (1.4 inches), length from the ankle to the main toe joint (tarsus length 2.4 inches) and the length needed for insertion into the driftwood (1.3 inches). Having the yellowlegs raised up on his toes meant that the length of 3/32" brazing rod needed an additional length of the base joint of the middle toe (.6 of an inch).

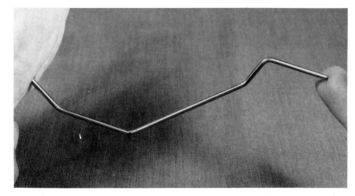

Figure 23. Make the appropriate bends for the ankle, main toe joint, middle toe joint and the angle needed for insertion into the driftwood (or mount).

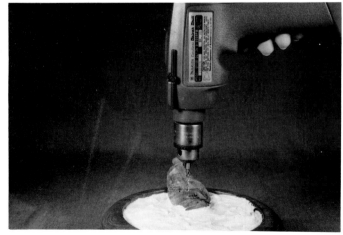

Figure 24. Drill a slightly oversized hole into the driftwood.

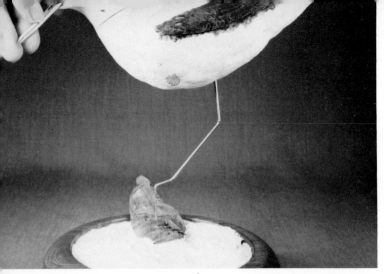

Figure 25. Adjust the bends on the leg for the desired position.

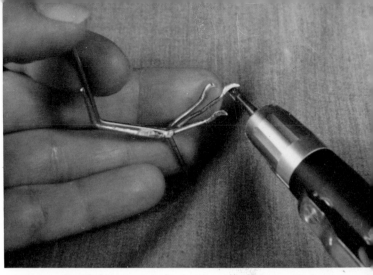

Figure 28. Refine the hook shape of the flattened claw with a carbide bit.

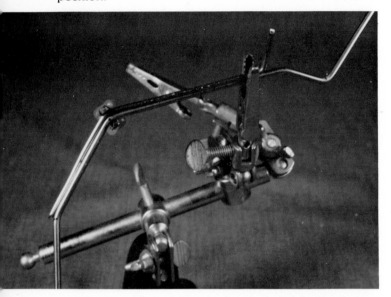

Figure 26. Cut and shape a hind tendon from 16 gauge copper wire allowing .4 of an inch for the hind toe and claw. The hind toe for the yellowlegs is .25 of an inch above the main toe joint. A small pair of needle-nose pliers will easily bend a small hook at the end of the hind toe which will be its claw.

Figure 29. Now that the yellowlegs' hind tendon, toe and claw are shaped, position it on the back of the leg and hold in place with helping hands (a mechanical devise with pairs of alligator clips to hold parts together while soldering or gluing) and extra alligator clips. Apply flux and solder in place. Allow it to cool before disturbing.

Figure 30. Cut the remaining toes from 16 gauge copper. The piece for the remainder of the middle toe should measure 1.1 inches. Cut a piece of wire for the combined inner (1.35 inches) and outer (1.4 inches) and bend into a "v". Hammer to flatten the claws and further refine with a carbide bit. Sand the claws smooth with a cartridge roll sander.

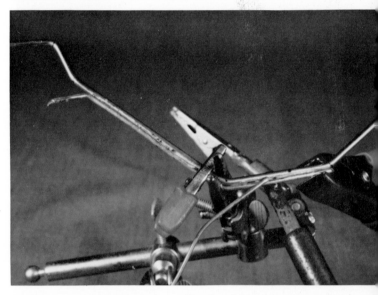

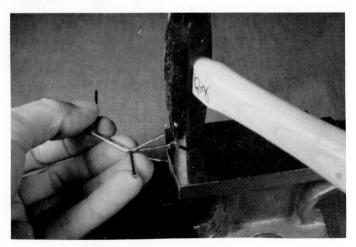

Figure 27. To flatten a claw, hammer it on a small anvil or the flat anvil part of a machinist's vise.

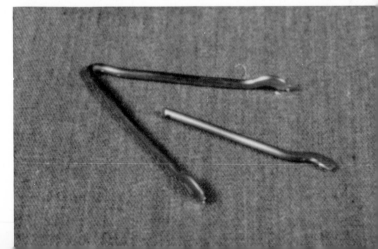

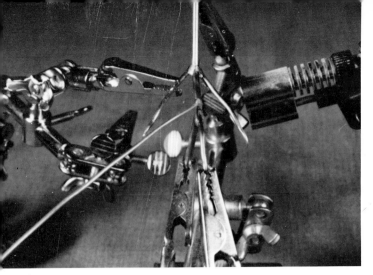

Figure 31. Clamp and silver solder the inner/outer toe piece at the main toe joint. Clamp and silver solder the remainder of the middle toe in place. It took two sets of helping hands to hold everything in place and twenty minutes for proper alignment.

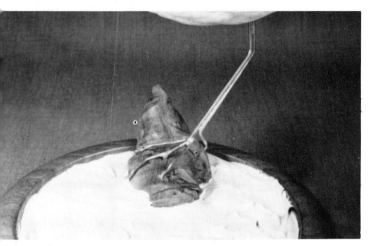

Figure 32. Check the entire foot and leg for proper alignment.

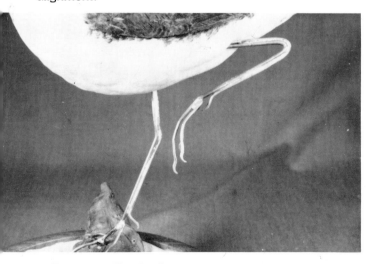

Figure 33. The "up" leg for the yellowlegs was a similar procedure with the exception that no extra length was needed to go into the driftwood. The middle toe was one piece of 16 gauge copper wire. The droopy toes were bent to shape before soldering to the tarsus.

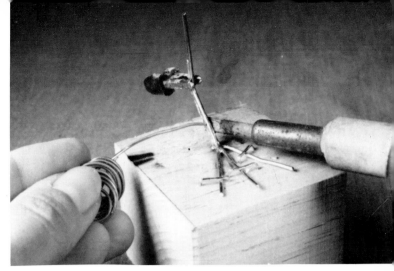

Figure 34. For smaller birds with a less complicated position, a scrap block of wood, staples and an extra alligator clip will hold the tarsus, hind tendon and toes in place for soldering.

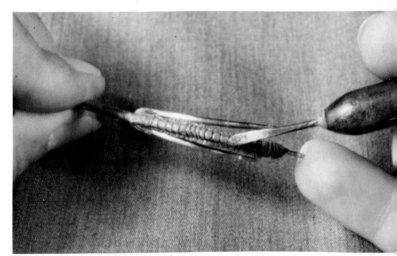

Figure 35. Mix a moderate amount (a one-half inch strip) of the ribbon putty. Beginning with the toes, cover the wire and shape the underneath pads. Press in the scales on the top and sides of each toe.

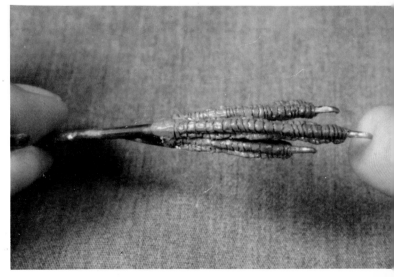

Figure 36. Work the putty on each toe separately.

19

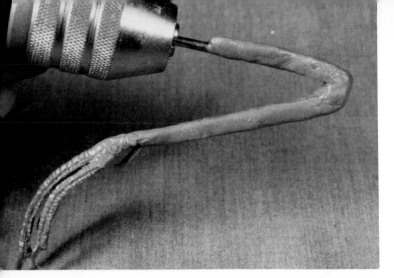

Figure 37. Apply and shape the putty on the tarsus, ankle and the exposed tibiotarsus.

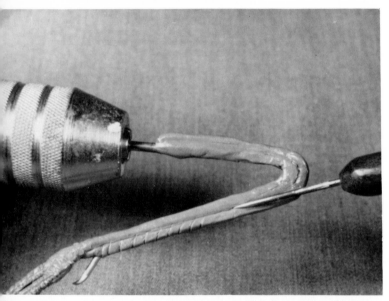

Figure 38. Press in the indentation for the hind tendon and then press in its scaled markings.

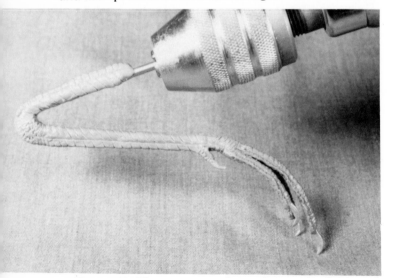

Figure 39. Then press in the scales on the front and sides of the tarsus, ankle and tibiotarsus. Cover and texture the hind toe. Set aside to harden.

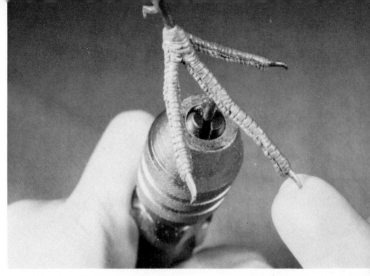

Figure 40. Apply the putty to the toes of the "down" leg and texture.

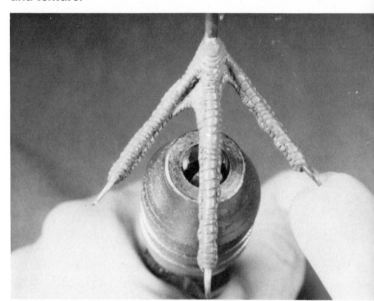

Figure 41. Because the toes were pulled together on the "up" foot, the webs between them are not evident. However, on the spread toes of the "down" foot, the webs will be visible. After the toes are completely textured, apply a small amount of putty to the space between the outer and middle toes and shape into the web, holding it in place with a finger underneath. Shape the smaller web between the inner and middle toes. Both webs have a texture similar to wrinkly skin.

Figure 42. Apply and texture the putty on the tarsus, ankle and tibiotarsus. Set aside to harden.

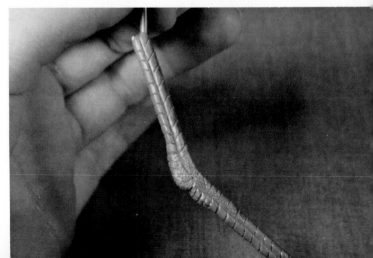

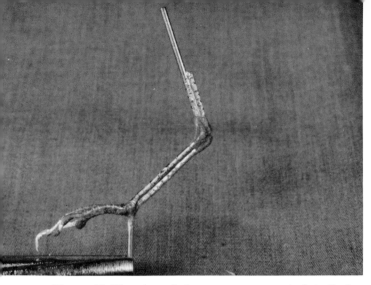

Figure 43. The plover's foot was constructed similarly, with the exception that the wire for the tarsus and hind tendon were scored with a small triangular file for the scale markings.

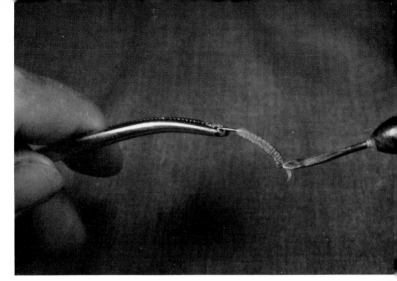

Figure 46. The dangling toes were done with longer wires than the actual toes to have a handle to hold onto. After the claw was shaped, hammered and refined, putty was applied and textured.

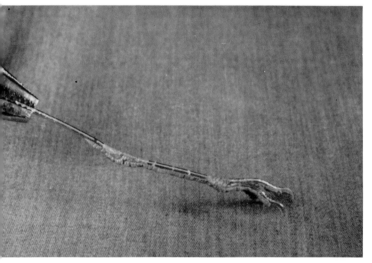

Figure 44. The wire for the sanderling's tarsus and the three toes were scored on their top and side surfaces with a file for the scale markings. The hind tendon, ankle, main toe joint and toe pads were executed with putty.

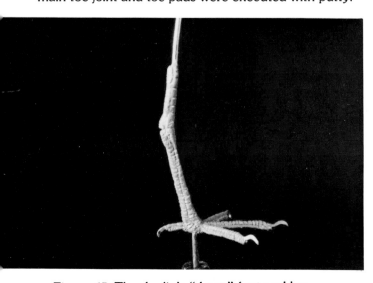

Figure 45. The dunlin's "down" foot and leg.

Figure 47. When the putty on all three toes is hard, super-glue them together.

Careful study of color and its application is as important as the study of form. To render a realistic bird, the unpainted bird needs to be characteristic of whatever species it is. To put color on the bird should further that characteristic look. All of us perceive color differently. What may appear to you as a greenish grey may look grey-blue to me. And some people are partially or completely color-blind.

Learning to see color is something all of us can use and enjoy. Many of us look but do we really see? Observation of color is very important. If you cannot see the color, then you cannot paint it. When observing a color, I find myself asking what color is it close to or what could I use to mix it. It is a problem solving situation. Playing with different color mixtures on a palette will eventually lead to the right color.

Even though carved birds are three-dimensional, it is helpful to use two-dimensional techniques in rendering realism. Using darker values for shadows and lighter ones for highlights will certainly bring the carved bird to life. If you paint a bird a solid color like you would paint a wall, it will look flat. Just as a one-directional light will enable you to see contours more easily, darks, lights, and values in between will enhance the contours and not hide them.
The painting of these birds is done with acrylics.

Base Coats

Base coats are the first coats applied to a given area. Usually they are the medium value of the area. It will take several coats to cover the area. Keep the paint thin so the texturing does not get filled up and finally obliterated.

Wash

A wash is a very thin mixture of a small amount of pigment in a large amount of water. Washes are used to slightly alter or enhance the base coat color. It is always advisable to add more water than you think is necessary, since a thick wash may totally obscure the colors underneath. It is much safer to apply two very thin washes than one thicker one. If the wash contains too much pigment and not enough water, it may totally cover the details underneath. Because water seeks the lowest level, a wash deposits a small amount of pigment in the bottom of the texture grooves. When you make a wash, always touch your wet brush to a paper towel to remove some of the wash. A drippy brush will have the wash traveling all over the bird to places you do not need that particular color.

Glaze

A glaze is similar to a wash in that a small amount of pigment is mixed in a liquid, only in a glaze the liquid is one of the mediums (matte or gloss). When adding small amounts of color to a beak, it is useful to use a glaze and gradually build up the color's intensity.

Dry-brush

To obtain a dry-brush effect, mix the color, load the brush and wipe most of the paint in the brush on a paper towel. Only a small amount of the paint will remain in the brush. Only this small amount of pigment will be transferred to the bird. Because this pigment is dry, it will be deposited on the high points of the texture grooves.

Blending

On a bird there will be dark patches of feathers next to light ones and even on a single feather a dark area next to a light one. These contrasting colors will need to be blended for a natural, soft appearance. Three blending techniques are stippling, dry-brush and wet-blend.

Stippling is a technique in which the two contrasting colors are dabbed into each other with the point or end of the brush. Dab the light one into the dark, let dry, and then dab the dark one into the light. It will take several applications to get a soft blend.

Dry-brushing a blend line is accomplished by loading the light color on a soft, sable brush, wiping most of the pigment on a paper towel and flicking the ends of the brush into the dark color. At the end of each flicking stroke, pull the brush up and away from the surface. Then load the dark color, wipe the brush on the paper towel and flick the dark color into the edge of the light one. It will take several applications to obtain a soft blend line.

To obtain a soft, natural transition between light and dark with wet-blending, both colors will need to be wet. You can use two brushes (one loaded with each color) or one brush wiped in between dabbing each color. Again, you pull the dark color into the edge of the light one and light into the dark one. Pulling each color into the other several times will provide a softly blended line.

Chapter 3.

Semi-palmated Plover

(Charadrius semipalmatus)

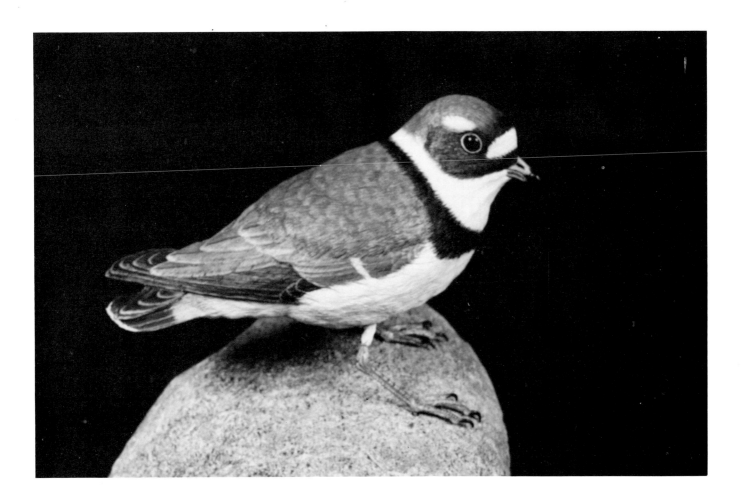

One of the most common species of plover, this little round bird inhabits beaches, marshes and mud flats of the seacoasts, river and lakes. The semi-palmated plover often flocks with sandpipers and feeds similarly, moving along the beach or marsh using their beaks to probe for small crustaceans, insects and worms. Plovers sometimes stamp their feet on the sand or mud to roust out edibles. Both sexes are similar in shape, size and coloring with the female having a slightly more brownish neck band. In the fall, the characteristic black neck band dulls to a grayish brown, the orange-yellow feet become dullish and the orange beak with black tip becomes completely dull black. In all plumages the semi-palmated plover has a narrow yellow orbital ring. There is distinctive webbing between the toes, with the middle-outer toe web larger than the middle-inner toe web. There is no hind toe.

In nesting, the semi-palmated plover scoops a depression out of the sand or mud above the high-water mark and lines it loosely with moss and grass. There are usually four eggs laying with their points to the center of the nest. After approximately three weeks of incubation by both parents, the chicks arrive and shortly leave the nest, toddling along after the parents.

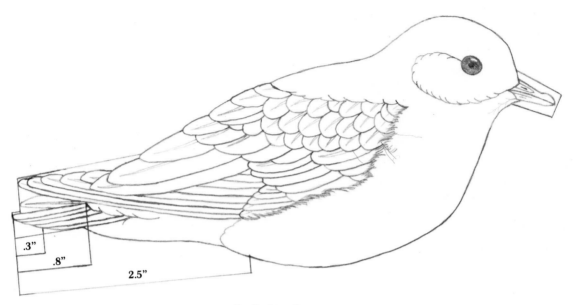

.3"

.8"

2.5"

Profile Line Drawing

*Crossed primaries may cause measurement distortions. Check the dimensions chart.

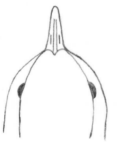

Top plan view of head

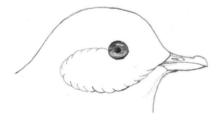

Profile view of head

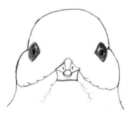

Head-on view

SEMI-PALMATED PLOVER

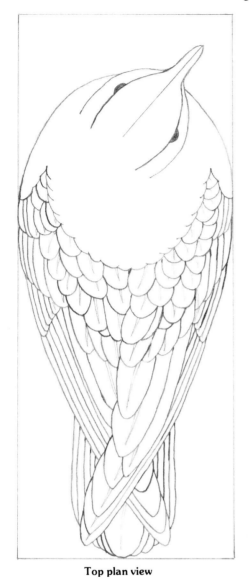

Top plan view

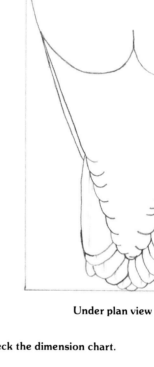

Under plan view

*Foreshortening may cause measurement distortions in both plan views. Check the dimension chart.

Mid-body cross section

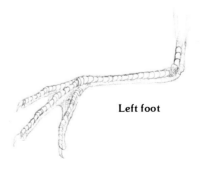

Left foot

25

Top surface right wing

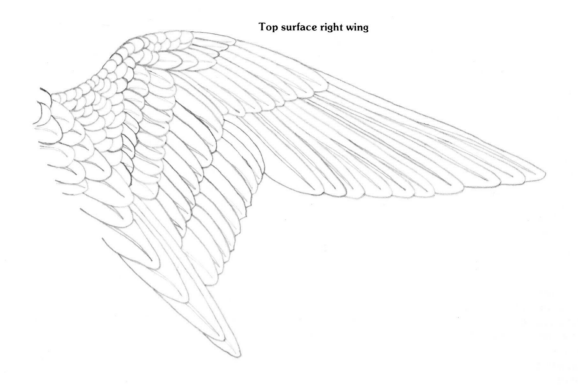

Under surface right wing

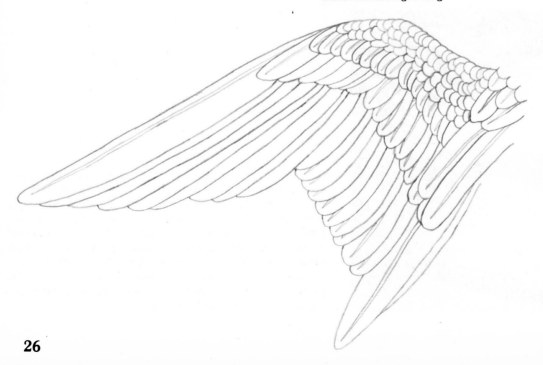

DIMENSION CHART

1. End of tail to end of primaries .2 of an inch
2. Length of wing 4.7 inches
3. End of primaries to alula 3.7 inches
4. End of primaries to top of 1st wing bar 3.0 inches
5. End of primaries to bottom of 1st wing bar 3.3 inches
6. End of primaries to mantle 3.0 inches
7. End of primaries to end of secondaries 2.6 inches
8. End of primaries to end of tertials .7 of an inch
9. End of primaries to end of primary coverts 2.5 inches
10. End of tail to front of wing 4.9 inches
11. Tail length overall 2.5 inches
12. End of tail to upper tail coverts .8 of an inch
13. End of tail to lower tail coverts .3 of an inch
14. End of tail to vent 2.5 inches
15. Head width at ear coverts 1.1 inches
16. Head width above eyes .8 of an inch
17. End of beak to back of head 1.8 inches
18. Beak length
 Top .52 of an inch
 Center .55 of an inch
 Bottom .35 of an inch
19. Beak height at base .22 of an inch
20. End of beak to center of eye (6 mm. brown) .9-1.0 inches
21. Beak width at base .24 of an inch
22. Tarsus length .9 of an inch
23. Toe length
 Inner .64 of an inch
 Middle .83 of an inch
 Outer .73 of an inch
24. Overall body width 2.3 inches
25. Overall body length 5.7 inches

TOOLS AND MATERIALS

Bandsaw (or coping saw)
Flexible shaft machine
Carbide bits
Ruby carvers and/or diamond bits
Variety of mounted stones
Pointed clay tool or dissecting needle
Compass
Calipers measuring in tenths of an inch
Rheostat burning machine
Ruler measuring in tenths of an inch
Awl
400 grit sandpaper
Drill
Laboratory bristle brush
Drill bits
Needle-nose pliers
Toothbrush
Wire cutters
Safety glasses and dustmask
Super-glue
Krylon Crystal Clear
Duro ribbon epoxy putty
 (blue and yellow variety)
Tupelo or basswood block 2.9" x 2.3" x 5.7"
Pair of 6 mm. brown eyes
Pair of cast feet for a semi-palmated plover (to use in bird or as a model for feet construction)
For making feet:
 16 gauge galvanized wire
 18 gauge copper wire
 solder, flux and soldering pen or gun
 (or silver solder, flux and butane torch)
permanent ink marker
hammer and small anvil
small alligator clips
cartridge roll sander on a mandrel
small block of scrap wood and staples for holding jig (or several pairs of helping hands holding jigs)

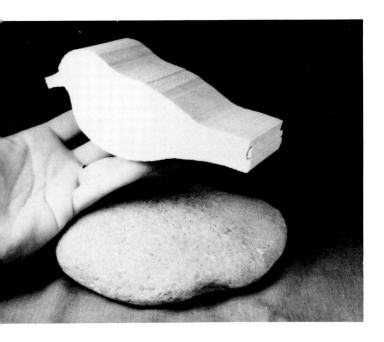

Figure 1. Wanting a peaceful bird on a rock composition, I first found a real rock to use as a model. It had a fairly smooth texture, an incline for interest and coloring that complemented the plover's. Fortunately, my sister, Dale, was constructing a rock garden around a new pond in her yard, so my choices were extensive. (I must remember to return her rock!) The rock's construction is covered in the chapter on habitat. After drawing the pattern, I cut the profile out of a piece of tupelo, although basswood could have been used.

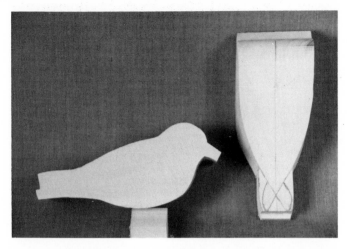

Figure 2. After drawing the profile pattern on the wood and cutting it out with a bandsaw or coping saw, draw the plan view on the topside using the plan view drawing or the Dimension Chart. Cut off the excess wood around the wings and tail.

Figure 3. A flexible ruler makes it easy to put a centerline on the underside contour. A centerline is very important throughout the carving procedure, since it allows you to check for balance and symmetry more easily. If it is ever necessary to cut away a centerline, be sure to put it back as soon as possible. It is not necessary to put the centerline around the head at this point since the head of the bird will be turned in the wood and have its own independent centerline.

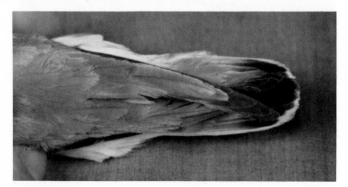

Figure 4. Note the shape of the crossed wings from a plan view.

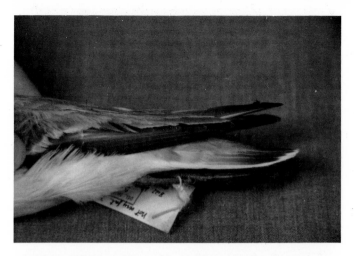

Figure 5. Note the angle of the crossed primaries.

Figure 6. On the sides of the tail, draw in the height of the top surface of the tail. The lines will extend from the bottom of the notch on the blank towards the bird's head. Check the profile drawing for reference. Using a small ruby carver, remove the excess wood from the sides and between the crossed tips of the primaries, keeping the sides vertical. Do not undercut at this point.

Figure 7. Draw in the curvature of the top surface of the tail.

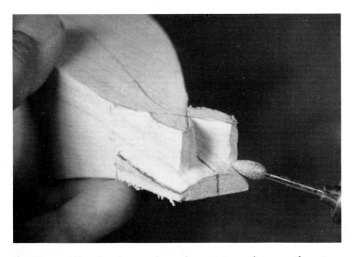

Figure 8. Again not undercutting, lower the top surface of the tail to the curvature lines.

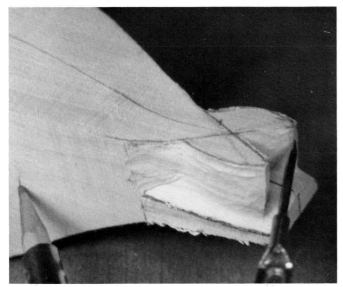

Figure 9. A compass is a useful tool for transferring measurements from drawings.

Figure 10. Draw in the edges of the flank feathers that will be covering the forward portion of the lower wing edge and the remainder of the exposed lower wing edge on both sides of the bird.

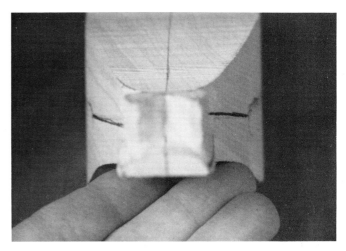

Figure 11. Note that the lower wing edge on the right is higher than the one on the left since the right primaries will be crossed over the left ones.

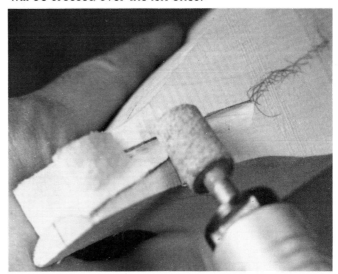

Figure 12. Using a square-edged carbide cutter, relieve a small amount of wood from under each lower wing edge. Be careful not to accidentally cut away any of the tail. It is very helpful to remember that every bit or cutter has a backside; that is, if you concentrate solely on what the tip of the tool is doing, the back edge of the tool can do irreparable damage on an adjacent area.

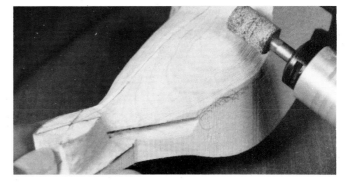

Figure 13. Round over the wings and upper back from the base of the neck to the point where the primaries begin to cross. Leave the crossed primaries the full thickness at this roughing) out stage.

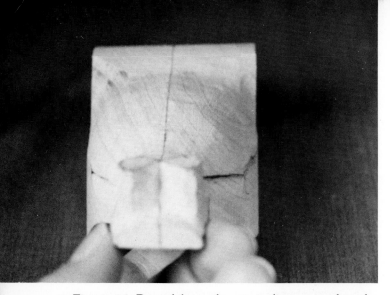

Figure 14. Round from the centerline around to the lower wing edge line on both sides.

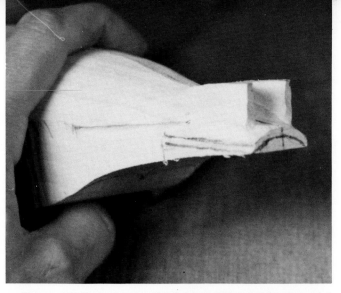

Figure 17. Draw in the thickness of the tail feathers (.1 of an inch) on both sides and the end of the tail section.

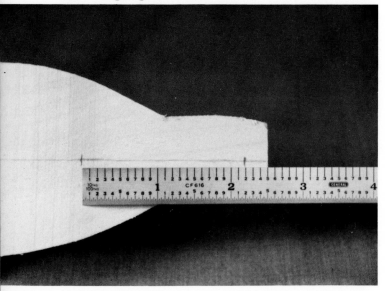

Figure 15. On the underside centerline, mark in the vent measurement (2.5 inches) and the lower tail covert measurement (.3 of an inch) from the end of the tail.

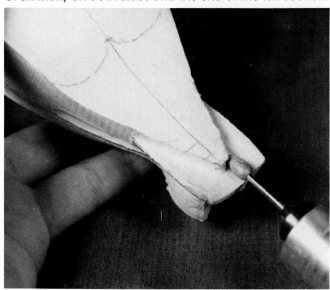

Figure 18. With a medium diameter ruby carver, cut away the excess wood from the underside of the tail up to the line around the lower tail coverts. The tail should be .1 of an inch thick throughout.

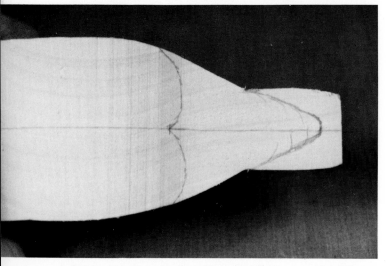

Figure 16. Draw in the shapes of the vent and the lower tail coverts at their respective marks.

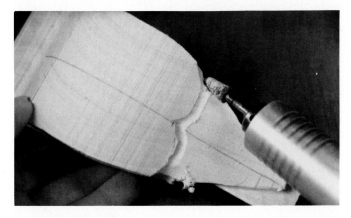

Figure 19. Using a small tapered carbide cutter, channel around the vent lines. The channel should extend around the flanks to the lower wing edges. Be careful not to nick the edges of the wings.

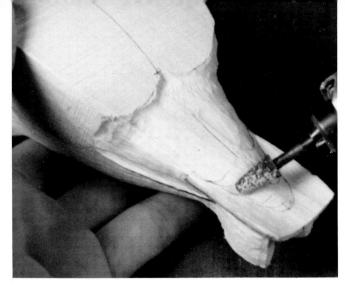

Figure 20. Round over the lower tail covert section from the flanks to the centerline. Flow the tips of the coverts down to the base of the tail. Redraw any centerline that is cut away.

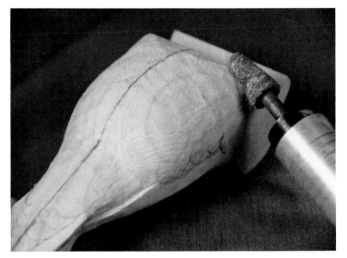

Figure 21. A larger carbide cutter can be used to round over the belly and lower breast. At this time, do not cut away any wood on the throat or head.

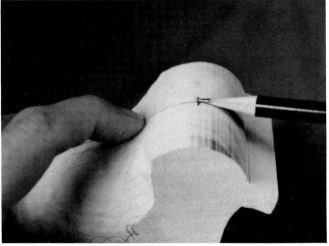

Figure 22. From the profile view, optically determine and mark the center of the head (from the back of the head to the base of the beak).

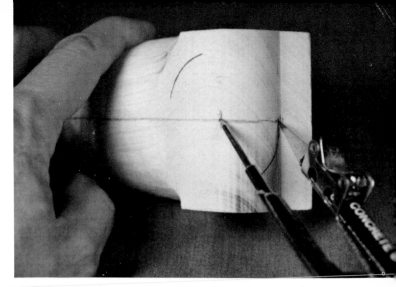

Figure 23. Using this center mark on the centerline as a pivot point, swing an arc from the base of the beak to the side to which you want the bird's head to turn and an arc on the opposite back side for the back of the head.

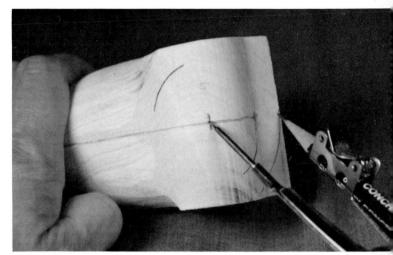

Figure 24. Swing the third arc from the end of beak to the side to which you want the bird's head to turn.

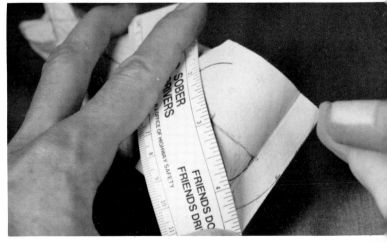

Figure 25. Draw a new centerline for the head through the pivot point that intersects all three arcs. The wider the angle between the new and old centerlines the more the head will be turned. It is helpful to erase the old centerline.

31

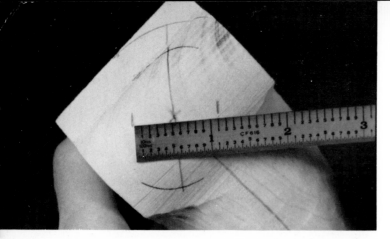

Figure 26. The widest part of the head is between the ear coverts (sometimes called "cheeks"). The plover's head width at the ear coverts is 1.1 inches. Hold a ruler perpendicular to the *new* centerline and mark in .55 of an inch on each side of the centerline.

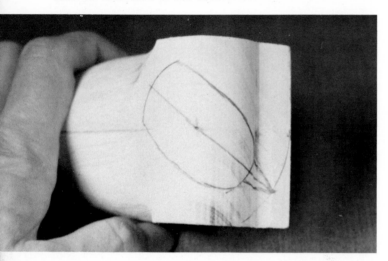

Figure 27. Roughly draw in the plan view of the head incorporating the measurement marks for the ear coverts. Allow some extra wood around beak and also allow extra wood at the back of head arc for neck thickness.

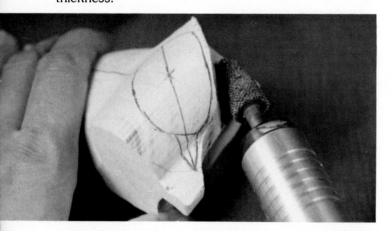

Figure 28. With a medium or large tapered carbide cutter, begin cutting away the excess wood around the head. Holding the handpiece of the flexible shaft machine as you would a knife, cut into the neck area and pull up towards the top of the head. The sides of the head need to be kept vertical.

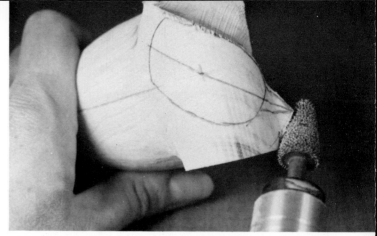

Figure 29. There will be a small bit of wood outside of the end of beak arc. Remove this excess back to the arc. A smaller carbide bit can be used on the sides of the beak. Be careful to keep the sides of the beak vertical.

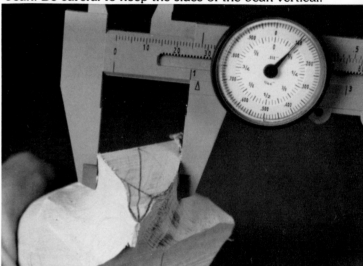

Figure 30. Continue removing the excess wood from the sides of the head until you can measure 1.1 inches with the dial calipers. Do not remove any wood from the back of the head or neck at this time. Keep equal amounts of wood on each side of the centerline.

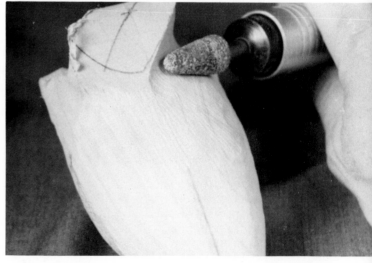

Figure 31. Flow the shelves at the neck area out onto the shoulders. Do not cut away any wood from the back of the neck.

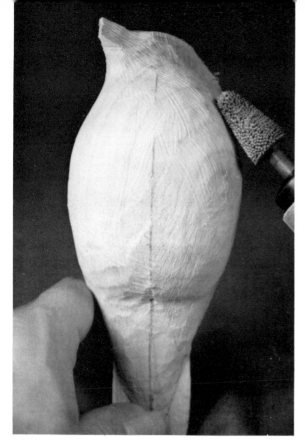

Figure 32. Round over the breast area all the way to the centerline. There is a tendency to leave this area too square. Turn the bird in your hand and check for a rounded breast from all angles.

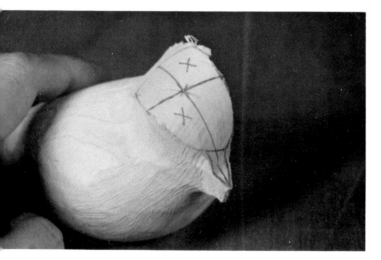

Figure 33. When the head of the bird is turned in the wood, the planes on the top of the head will not be the same as in the profile blank. To correct the skewed planes, draw a line perpendicular to the centerline at the pivot point on the top of the head, dividing the head into quadrants. Looking head-on to the bird, mark the high quadrants. The front quadrant to be marked is on the side to which the head is turned and the opposite back quadrant.

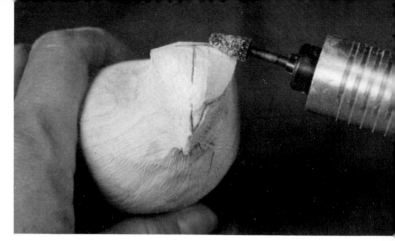

Figure 34. Cut away the excess wood on the high front quadrant so that it matches in contour the opposite side. There may be a small amount of wood on the top of the beak that will need to be removed if you turned the head more than 20 degrees.

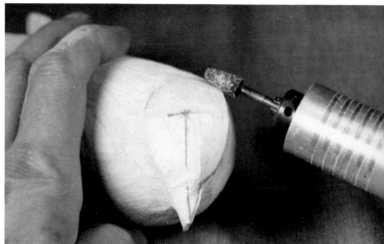

Figure 35. Cut away the excess wood on the back quadrant to level the planes on the head. You will need to level up the planes on the back of the neck as well. If you cut away the centerline, be sure to put it back. Check the distance from the end of the beak to the back of the head (1.8 inches). If necessary, remove any excess from the tip of the beak and the back of the head.

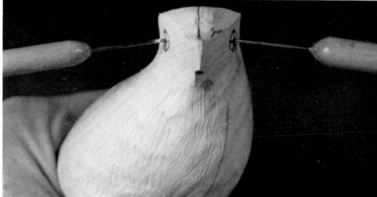

Figure 36. Transfer the eye and beak placements from the profile line drawing. Placing a dissecting or clay tool in the center of each eye, look at the bird from a head-on view to check for even eye placement and balance.

33

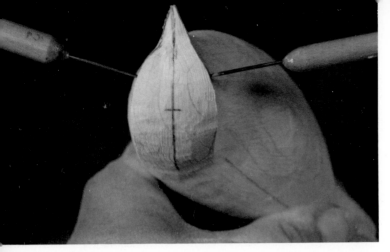

Figure 37. Also check the eye placements from the plan view.

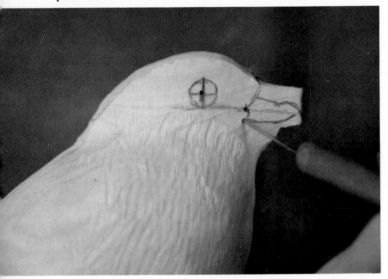

Figure 38. The bottom of the eye should rest on a line extending the commissure line to the back of the head. Pin-prick the base of the beak at the commissure line and the bottom of the lower mandible (on both sides). Pin-pricking marks allows you to cut wood away and still retain the measurements.

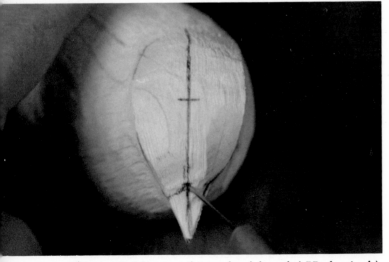

Figure 39. Measure the top beak length (.55 of an inch) and pin-prick. Draw in a "v" with its base at the measurement mark.

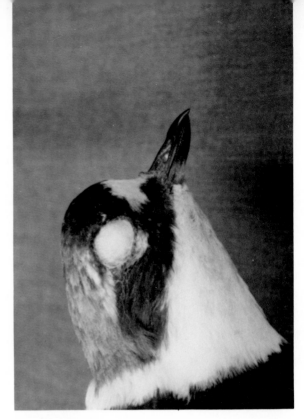

Figure 40. Note the profile shape of the beak.

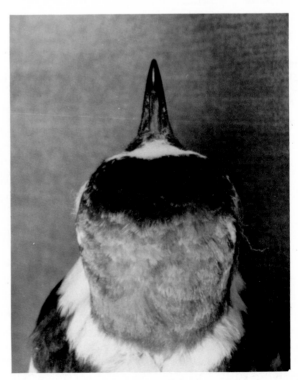

Figure 41. Here you see the plan view shape of the beak.

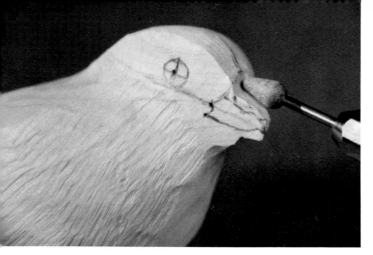

Figure 42. Using a blunt-shaped ruby carver, grind away the excess wood on top of the beak.

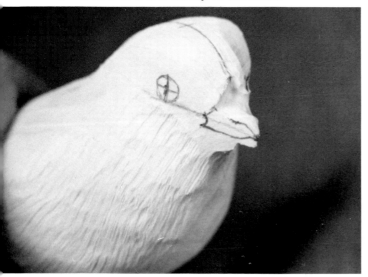

Figure 43. Remove all of the excess wood so that you have a flat contour from side to side across the top of the beak. Cut away the excess wood above the bulbous tip, but not the tip itself. Redraw the beak centerline.

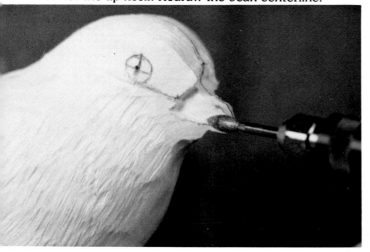

Figure 44. Begin grinding away the excess wood from each side of the beak. Keep the sides of the beak vertical. Keep checking the balance from the head-on view so that the beak has equal amounts of wood on each side of the centerline. A small pointed ruby carver will allow you to get back into the tight corners more easily.

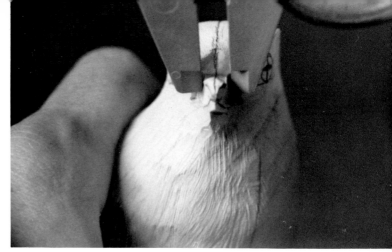

Figure 45. Keep removing wood until the beak's width measures .24 of an inch at its base.

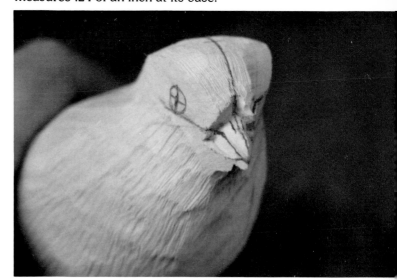

Figure 46. Redraw the commissure line.

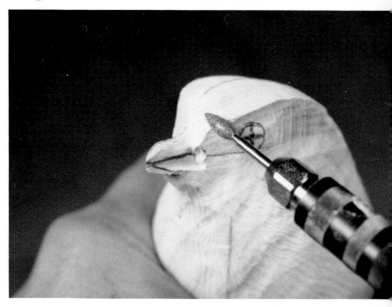

Figure 47. Flow the head down to the base of the beak while maintaining a flat plane across the forehead. Be careful not to "oops" into the beak. Slightly round the sharp corners on the upper mandible but leave the culmen (ridge) flat.

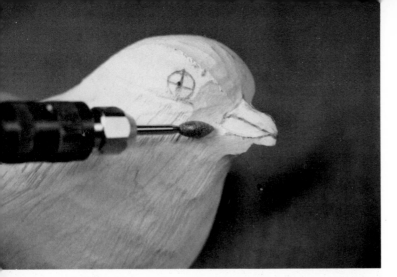

Figure 48. Flow the sides of the head down to the sides of the base of the beak.

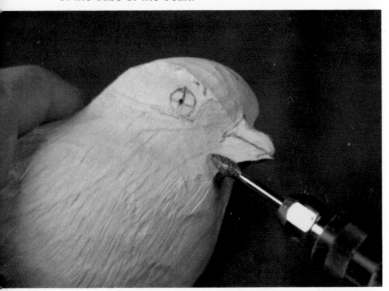

Figure 49. Grind away the shelves that were created in cutting in the proper beak width. The details underneath the beak are more narrow than the beak.

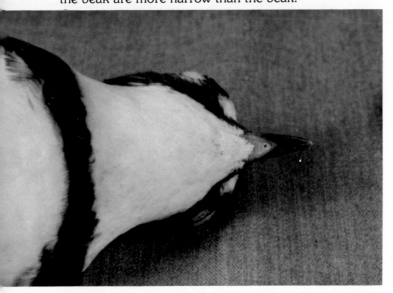

Figure 50. Note the small "v" on the base of the lower mandible.

Figure 51. Draw in the centerline on the bottom of the lower mandible. Measure and mark the bottom beak length (.35 of an inch). Draw in the v-shaped tuft of feathers.

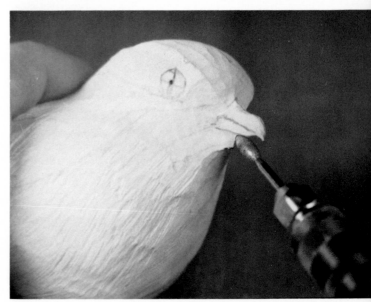

Figure 52. Remove the excess wood underneath the beak up to the bottom line of the lower mandible and back to v-shaped tuft. This will leave a vertical shelf, much like the one created around the lower tail coverts in Figure 18. Do not cut away the overhang of the upper mandible tip. Flow the chin down to the base of the beak.

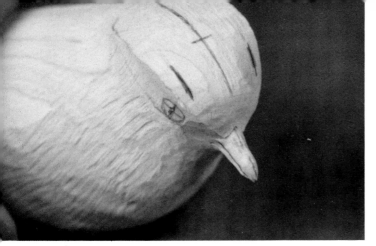

Figure 53. Across the top of the head above the eyes, measure and mark the head width (.8 of an inch). Make sure the eye centers are pricked deeply, so that the positions will be retained even when wood is cut away.

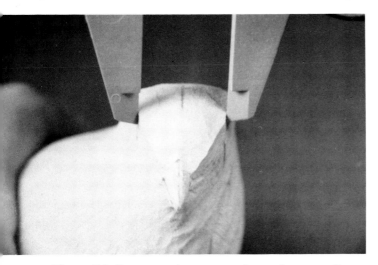

Figure 54. Cut away the excess above the eyes. Start cutting in the area where the eye sits, working towards the top of the head and keeping a gentle slope from the sides of the head to the top. Be careful to keep equal amounts of wood on each side of the centerline. Keep grinding away the excess until it measures .8 of an inch with the calipers.

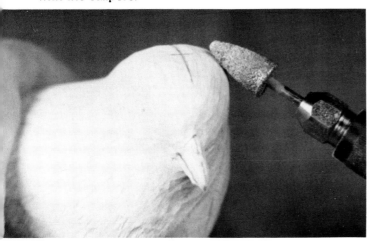

Figure 55. Round over the edges of the head from the base of the beak to the crown and down the back of the neck onto the mantle.

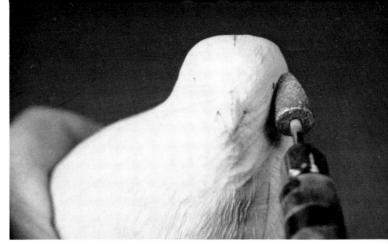

Figure 56. Create a shallow depression in the eye area on both sides.

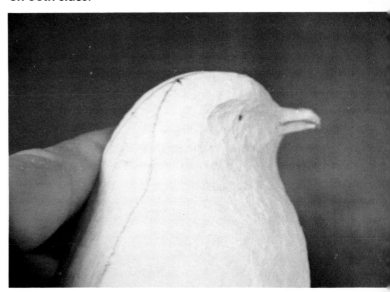

Figure 57. The eye will sit in this shallow depression.

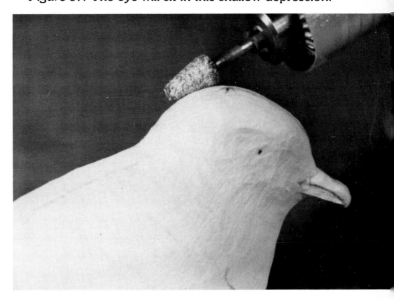

Figure 58. As you handle and work on all areas of the bird, pay attention to the surrounding areas as well. You will begin to see that some areas are too full and you will need to remove more wood or reshape the area. Pay particular attention to the head—the life of the bird is in the head.

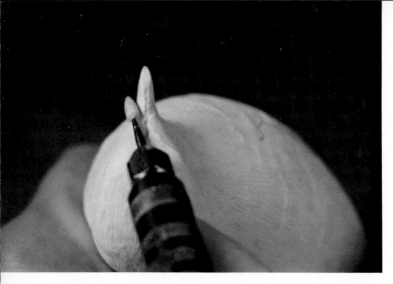

Figure 59. Using mounted stones for light wood removal will also leave the area smooth. Use a stone to shape the beak on the plan view.

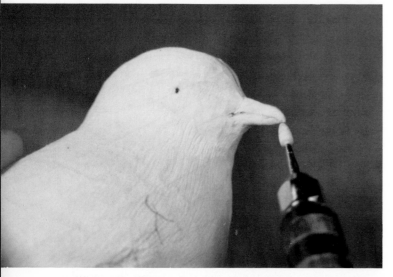

Figure 60. Round the sharp corners on the bottom of the lower mandible and narrow its tip. Be careful not to grind away the upper mandible overhang.

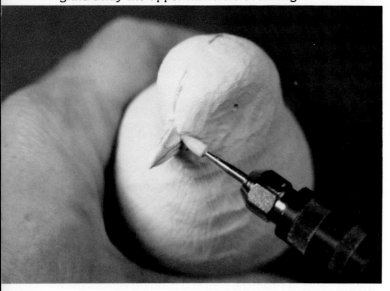

Figure 61. Create a small depression on each side of culmen. The nostrils will be located here.

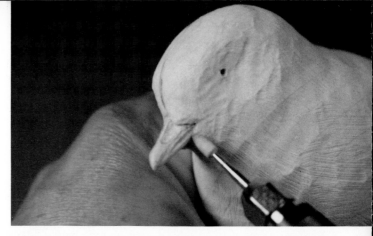

Figure 62. Just below the commissure line, there is a small depression on each side of the lower mandible. Using the tip of a pointed stone, create these depressions.

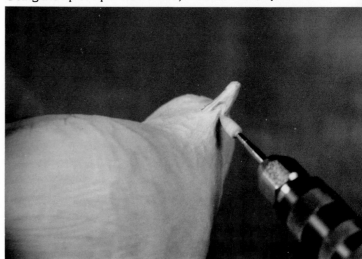

Figure 63. Using the point of a small stone, create a small channel around the v-shaped tuft of feathers on the lower mandible.

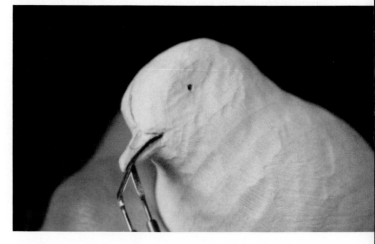

Figure 64. Using the point of a burning pen, burn in the commissure line on each side of the beak. Holding the pen vertical to the beak's surface, pull the pen from the base to the tip, lightly burning in a line. For the second burning stroke on each side, lay the pen at an angle and burn a line up to the first line. This two stroke combination depresses the width of the top edge of the lower mandible and gives the impression that the lower mandible is fitting up into the upper one.

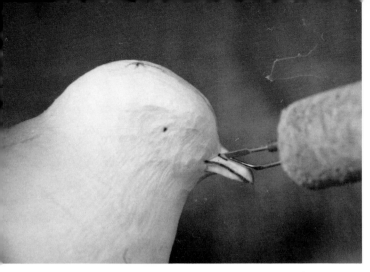

Figure 65. Sand the entire beak lightly with 400 grit sandpaper. Do not change the contour. Just remove any irregularities. Draw in the nostril holes. With the tip of the burning pen, lightly burn in the nostrils.

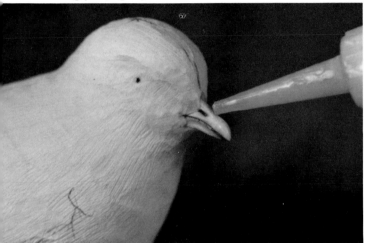

Figure 66. Lightly sand the beak again with extra-fine sandpaper. Apply super-glue to harden the beak. The super-glue will harden any fuzz. When the beak is dry, whisk away the hardened fuzz with the extra-fine sandpaper.

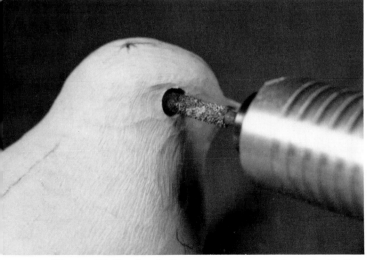

Figure 67. Recheck the eye placement from both the plan and the head-on views. Drill 6 mm. holes approximately one-quarter inch deep.

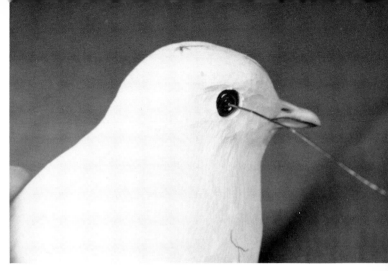

Figure 68. Check to make sure that the eyes will slip in and out easily. Too tight a fit makes it more difficult to set the eyes. A slightly oversized hole will allow adjustment of position.

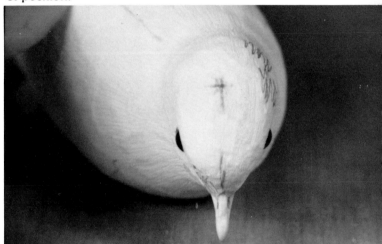

Figure 69. Fill the eye holes with oily clay, cut the eyes off the wires and seat in the clay, using the wooden handle of an awl or a piece of dowel to press into the proper depth. Check the eyes and entire head for symmetry and make any necessary adjustments.

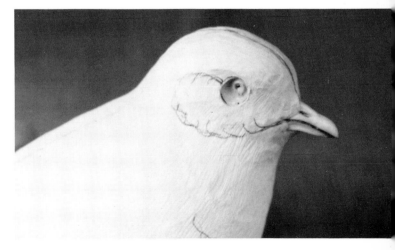

Figure 70. Referring to the profile line drawing, draw in the ear coverts. From the plan and head-on views, check for equal length, depth and height of coverts. Remove the eyes so they do not get scratched.

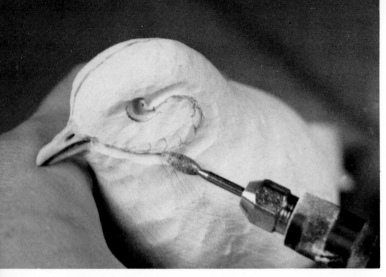

Figure 71. Using a small diameter ruby carver, make a channel on the ear covert line on both sides. Lay the tool on its side so that you are cutting with its diameter rather than its tip.

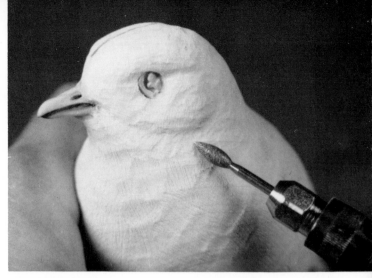

Figure 72. Flow the bottom of the channel out towards the surrounding area on the side of the neck. Round over the channel's edge on the ear covert itself. If you can still see any remnants of the channel, you will need to flow it out more.

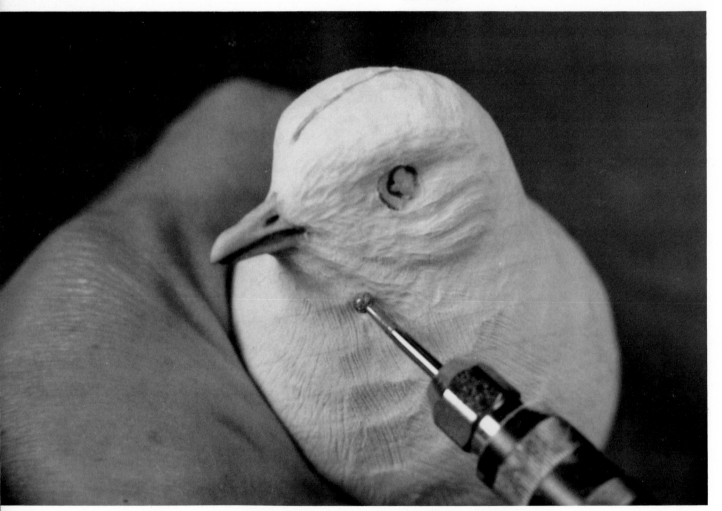

Figure 73. Using a small diamond ball, contour the ear coverts and the throat area. Make shallow channels and then round over the edges. Note the shadows created from the contouring. Creating areas of interest such as these enhance the realism of the carving. A real bird is not smooth all over. There are puffs of feathers with high points and low areas all over the entire bird.

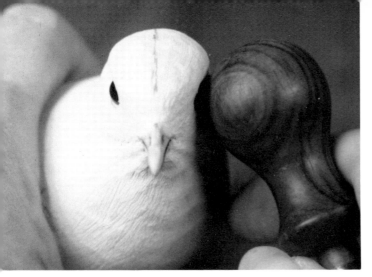

Figure 74. Keeping the eyes in while I am carving on the bird helps to keep an aliveness to the project. Note the wooden handle used to press the eyes in.

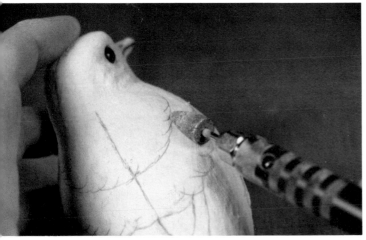

Figure 75. Using the plan view line drawing, draw in the mantle and scapulars. Refer to the profile line drawing when sketching in the little fluffs of breast feathers that cover the front of the wings. Make a channel on the mantle and breast fluff lines using a large diameter ruby carver. Flow the mantle and breast fluff channel out onto the scapulars. Round over the edge of the channel on the mantle and breast fluff line.

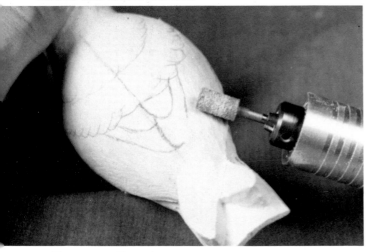

Figure 76. Flow the uppermost wing out towards the tips of its primaries.

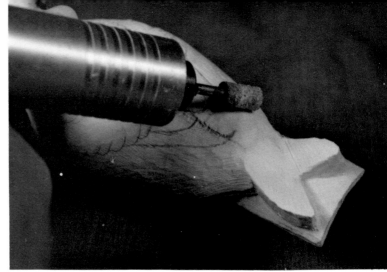

Figure 77. Using a small square-edged cylindrical carbide cutter, slope the angle of the right primaries (the ones on top) down towards the underneath set.

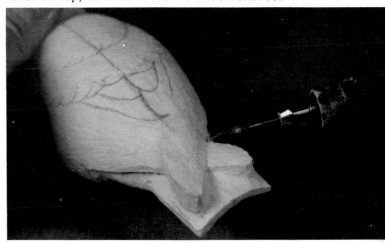

Figure 78. Remove wood from the top of the left set of primaries so that its leading edge is angled down. *Do not do any undercutting at this point.* Holding narrow strips of paper in a crossed configuration, much like crossed wing tips would be, will make this concept easier to understand. Close observation of live birds will likely help also.

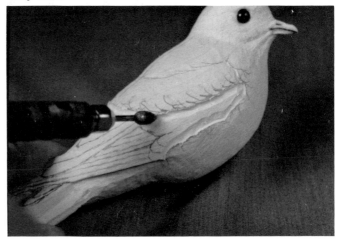

Figure 79. With a medium diameter ruby carver, channel around the edge of the scapulars and flank feathers covering the lower edges of the wings.

41

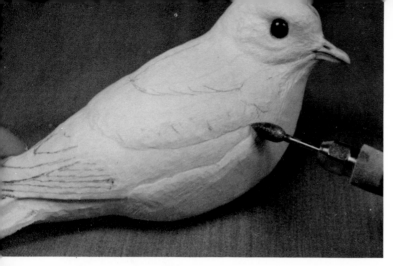

Figure 80. Flow the channels out towards the wing, leaving a slightly convex shape to the folded wings. Round over the edges of the scapulars and the flank feathers on both sides.

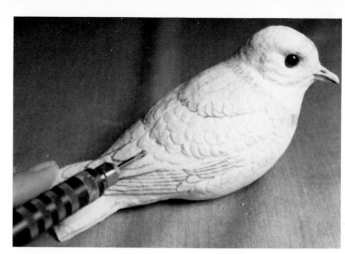

Figure 83. Make a shallow channel around each of the scapular feathers using a small diamond ball. Lightly round over each edge.

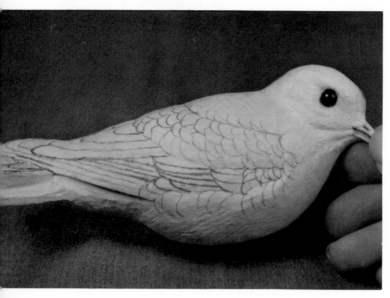

Figure 81. Using the profile line drawing, sketch in the feathers on the sides of the wings and scapulars.

Figure 82. Using the plan view line drawing, layout the tertials, tips of the primaries and the top side of the scapulars.

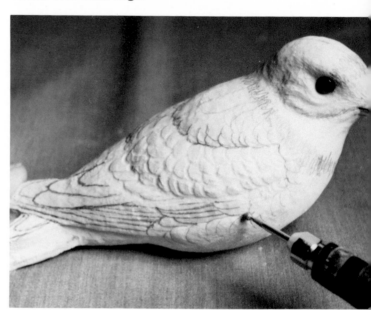

Figure 84. Beginning at the front of each wing, lightly relieve around each exposed marginal covert and round over the edge. Then proceed to relieving around each of the lesser, middle and greater secondary coverts. Rounding over each edge gives each individual feather its own convex contour.

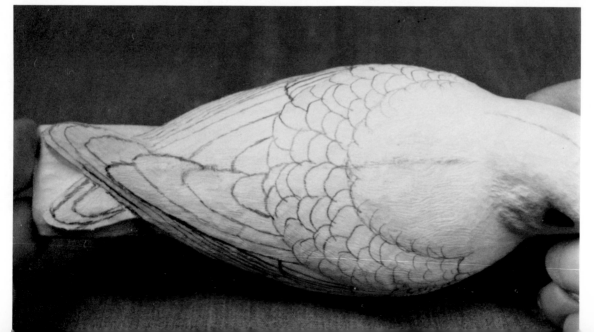

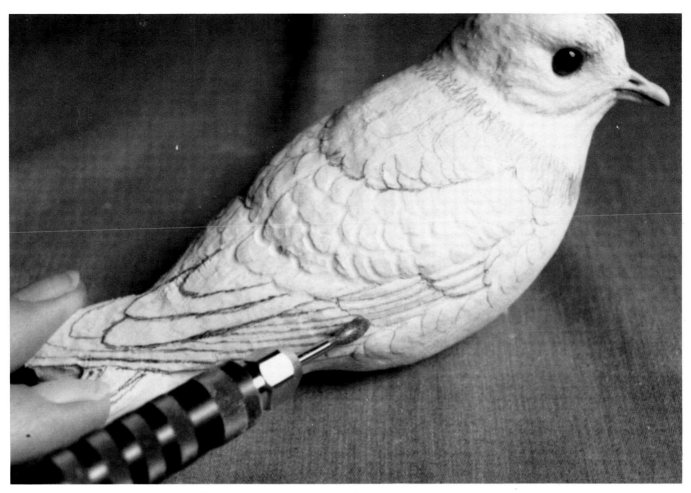

Figure 85. A small pointed ruby carver may make it easier to relieve around feathers where there is a tight grouping. Relieve around each of the exposed secondaries on the right wing.

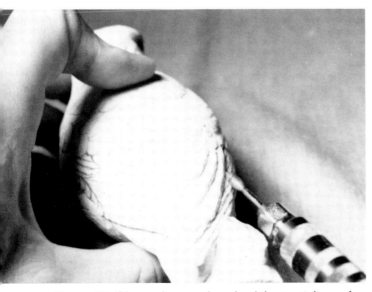

Figure 86. Channel around each of the tertials on the right wing. Flow the channel out onto the feather below and round over each tertial's edge.

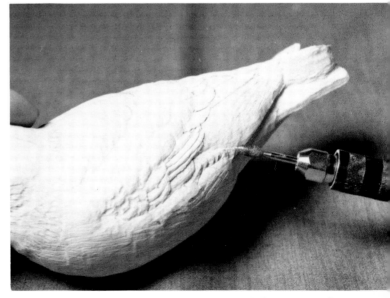

Figure 87. Relieve around the tips of the exposed primary coverts on both wings and round over the edges.

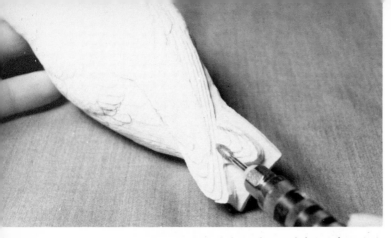

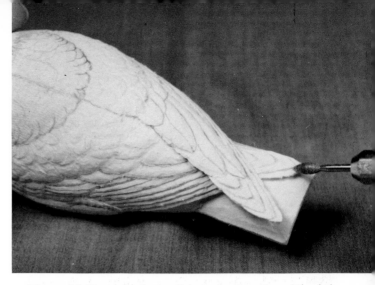

Figure 88. Relieve around the edges of the right wing primaries. It will be necessary to use the point of the small ruby to relieve around the lower edges of the right primaries. Wood must be removed from under the raised tips of the right primaries before carving finishing the rest of the feathers on the left wing.

Figure 91. Draw in the tertials and primaries of the left wing. Channel along the tertial edges, flow the channel out onto the feather below and round over the sharp edge of each feather. Relieve lightly along each primary leading edge and tip.

Figure 89. Carefully grind away the excess wood from under the right wing tip so that the front part of the wing flows gently back underneath the crossed right tips. The entire width of the primary tips do not have to be really thin, just the edges.

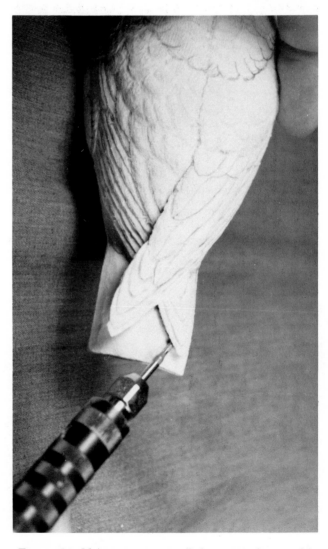

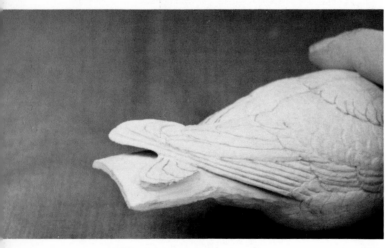

Figure 90. The left wing's lower edge will need to align with the leading edge of the tips. You may need to remove more wood from the top surface of the left wing tip, as well as its leading edge.

Figure 92. Using a very small diameter diamond bit, grind away some of the excess wood from underneath the edge of the left primary tips. Be careful not to cut into the top of the tail, thus damaging its convex contour.

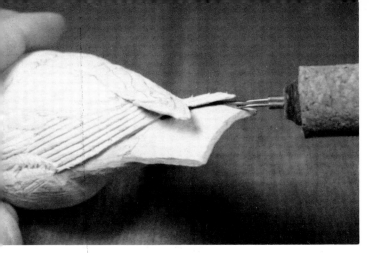

Figure 93. Use a burning pen to clean up any shaggy areas.

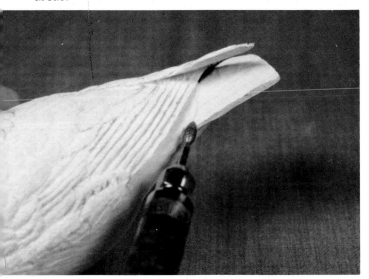

Figure 94. Draw in the edges of the upper tail coverts on each side at the base of the tail. The tips of the upper tail coverts are concealed under the crossed primaries. Relieve around the edge of the coverts and flow out onto the tail. Round over the covert edge, flowing it down to the base of the tail.

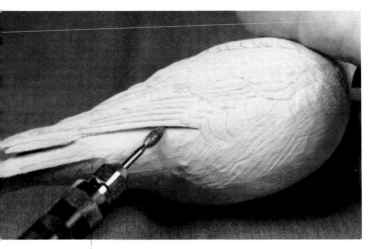

Figure 95. With the tip of a small pointed ruby carver, grind away a small amount of wood under each lower wing edge. This will create the illusion that the flank goes around and up under each wing.

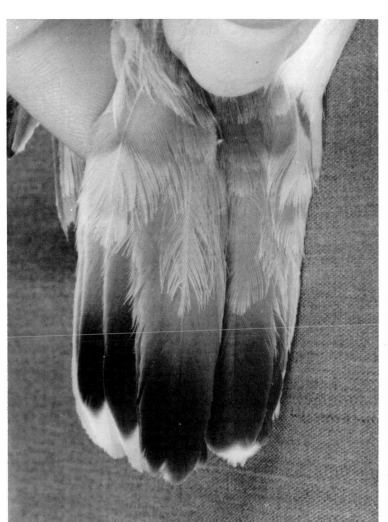

Figure 96. Note the shape of the tail feathers.

Figure 97. Layout the feathers on the top of the tail. Cut away any excess around the tail feather tips.

45

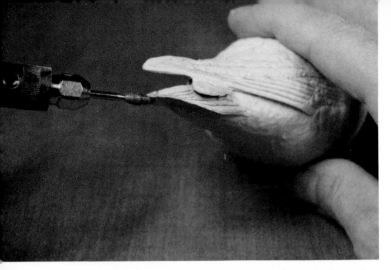

Figure 98. Thin the tip and sides of the tail along the edges on the underside.

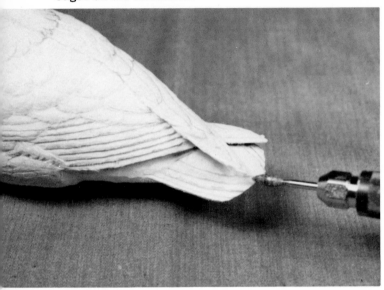

Figure 99. Beginning with the center one, relieve around the edge of each tail feather, progressing towards the outside edges. Then round over the edge to give each individual feather a convex contour.

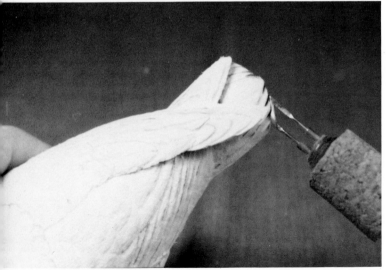

Figure 100. Using a burning pen, burn around the tip of each tail feather. This will allow you to separate the tips as well as to line up the underside edges.

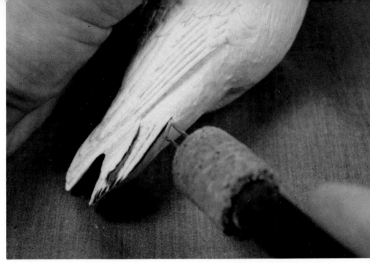

Figure 101. Burn a feather separation line each side of the outside edges of the tail, creating the effect of one feather on top of another.

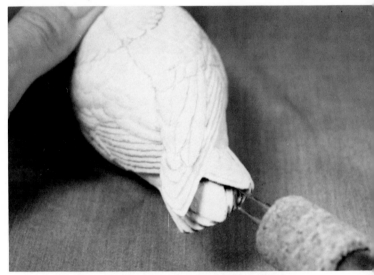

Figure 102. Some of the tail feather tips will need to be burned in underneath the left wing tip.

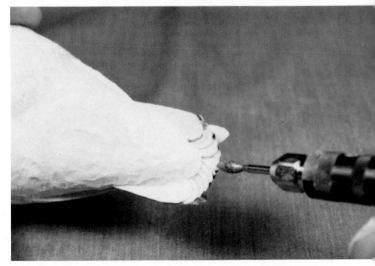

Figure 103. Draw in the feathers on the underside of the tail, corresponding to the tips lines burned in around the end. Using a small pointed ruby carver, relieve around each edge starting with the more prominent outside feathers and progressing towards the center.

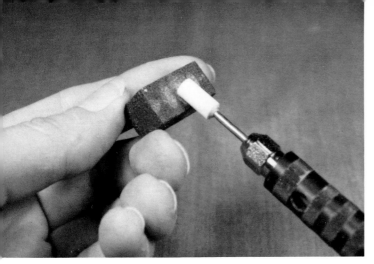

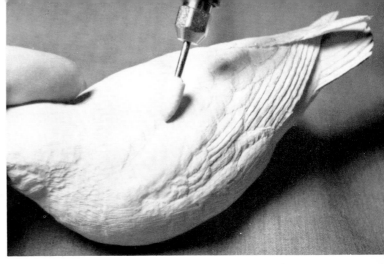

Figure 104. Mounted stones are marvelous smoothing tools. Sandpaper or even cartridge rolls so often sand away the contour that has been so diligently put in. A mounted stone, as was used in the beak procedure only larger, cuts and smooths more slowly and thus, is easier to control. Stones cannot always be bought in the needed shapes. A dressing stone is a harder surface than the mounted stones and is a handy device used to shape them.

To make a white "bullet", hold the dressing stone to the end of a chucked cylindrical stone. At slow speed, grind away the sharp edge of the spinning stone. Do not grind at high speed, since the adhesive holding the stone to the shank will melt and the stone will become a literal bullet! *Be sure to wear goggles or safety glasses and a mask when contouring stones.*

Figure 106. Use the white bullet to smooth and correct any irregularities in the scapular, wing and tail feathers.

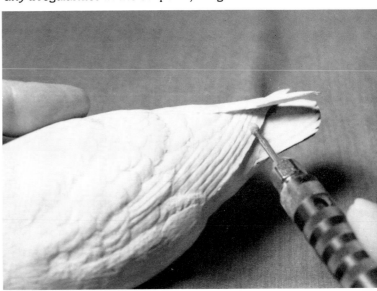

Figure 107. You will need to switch to a small bullet under the crossed primaries and tail.

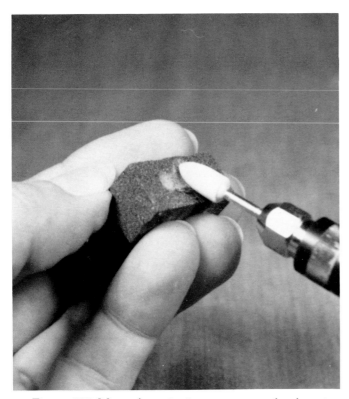

Figure 105. Move the spinning stone over the dressing stone's surface until the bullet shape is formed.

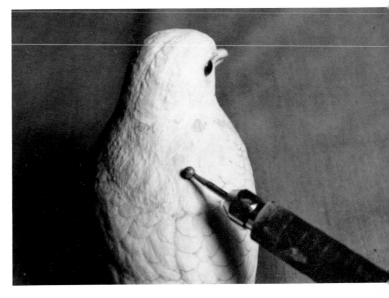

Figure 108. To create interesting areas on the head, neck and mantle, channel and round over random groups of feathers.

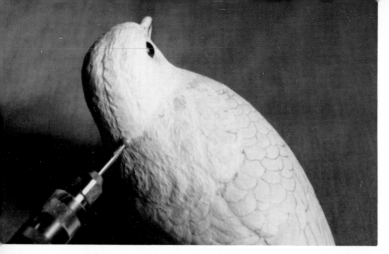

Figure 109. Grind a shallow channel at the base of the neck. Flow the channel onto the mantle and round over the edge of the neck feathers.

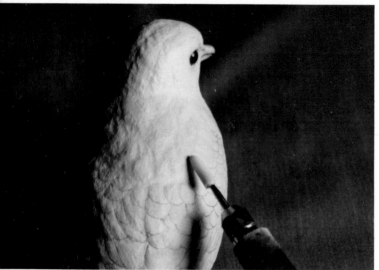

Figure 110. A medium-size white bullet is a helpful tool in smoothing and adjusting the contoured groups of feathers.

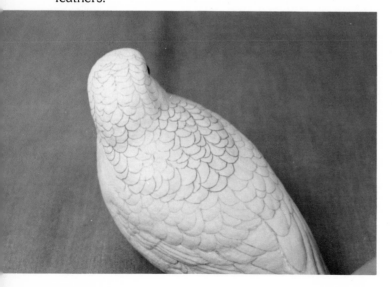

Figure 111. Layout the individual feathers on the top of the head, back of the neck and mantle. Keep varying the patterns and groups so that the areas do not become static and uninteresting.

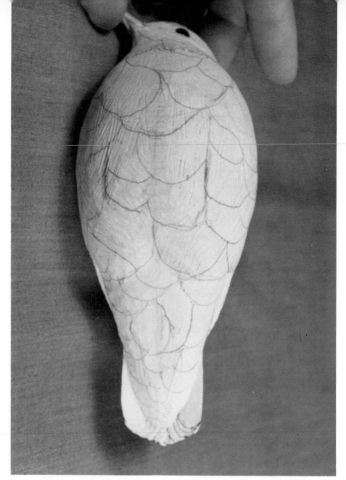

Figure 112. The lower tail coverts, belly, flanks, breast, throat and chin are other areas that need to be interesting. On a real bird, there are puffs of feathers in which there are high points and low ones. To create this look on a carving, first draw interesting patterns on the underside. Keep the shapes irregular and varied in size.

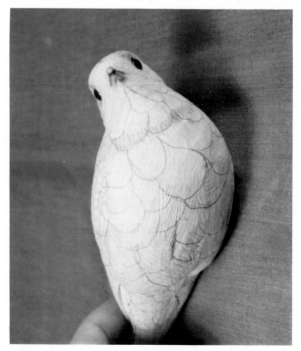

Figure 113. On the throat, sketch in the black band that encircles the neck and incorporate it into the shapes you draw in for contouring.

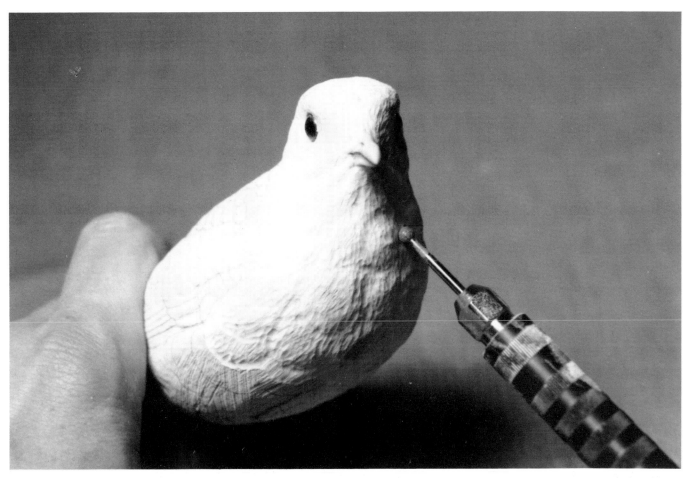

Figure 114. Channel each drawn contour line around each puff of feathers, creating a high point that flows down to low areas.

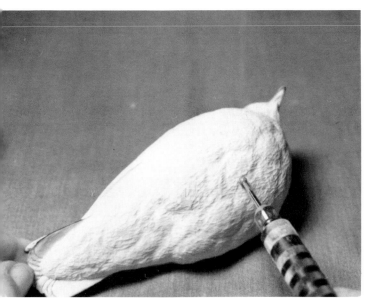

Figure 115. Making all of the channels the same depth would create a rigid look. Keep varying the depth.

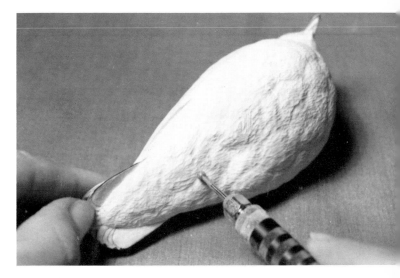

Figure 116. By starting under the chin and progressing towards the tips of the lower tail coverts, the feather puffs on top are formed first with the successive ones coming out from underneath.

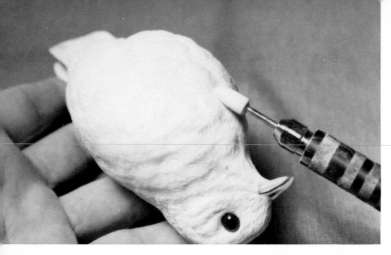

Figure 117. Use the white bullet to smooth any irregularities or if necessary, change any contours.

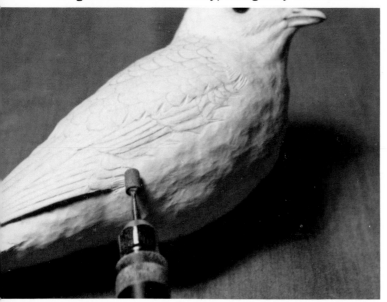

Figure 118. Use a medium size cylindrical stone to texture and break up the edges of the flank feathers laying on top of the wings.

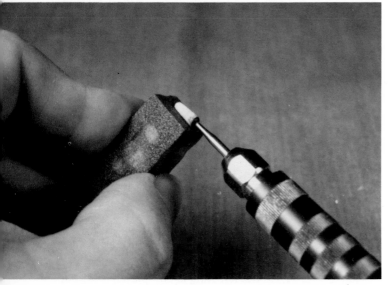

Figure 119. A dressing stone held against a spinning stone can sharpen the edge as well as grind away any chips.

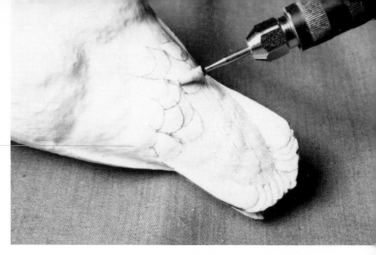

Figure 120. Draw in the feathers on the lower tail coverts. Begin stoning the individual feathers at the coverts' tip and progress up towards the belly. Working from bottom to top allows you to cover the base of the previously stoned feather with the one on top.

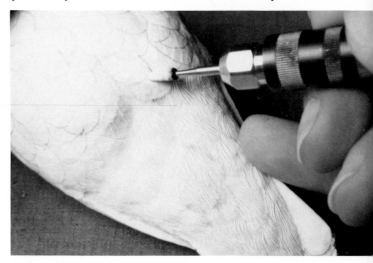

Figure 121. Try to get as much curvature as possible in each stoning stroke, changing the direction as each area indicates.

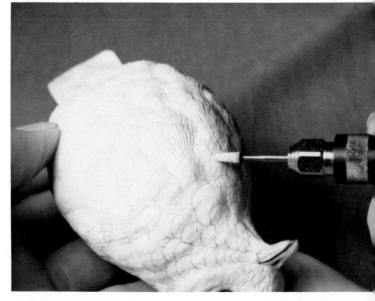

Figure 122. Stone your way up the belly, breast, throat and chin.

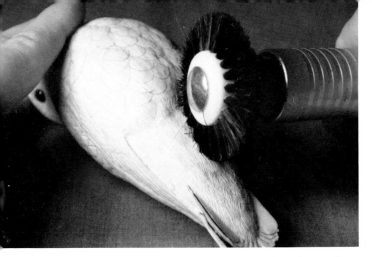

Figure 123. Use a laboratory bristle brush at *slow speed* to whisk away any fuzz.

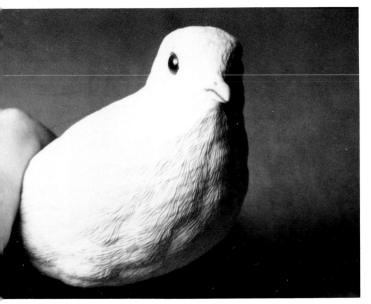

Figure 124. Note the subtle stoning and contouring effects.

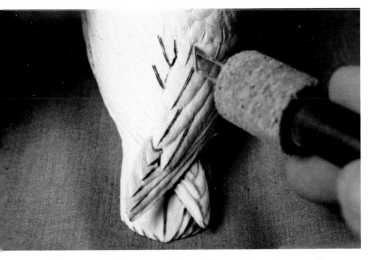

Figure 125. Draw in the quills on the wings and upper tail. To burn in a quill, begin at the base of the exposed quill, burning a line just barely outside the drawn one. Burn in a second line on the opposite side of the drawn line and converge with the first burned line approximately one-quarter inch from the feather's tip.

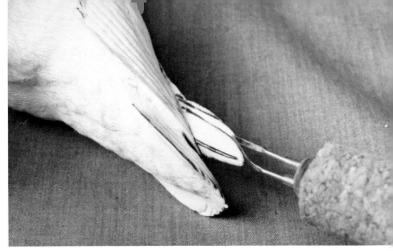

Figure 126. Burn around the edges of the primary tips and draw in the edges on the underside. Laying the burning pen on its side, burn in the trailing edge of each primary. Draw in the quill on the underside of the first primary and burn it in.

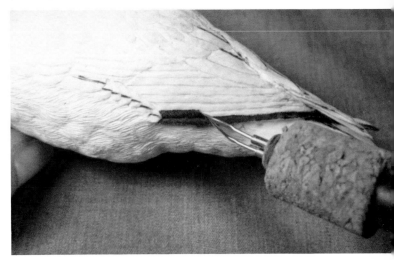

Figure 127. Begin burning in the barbs on the outside primary edge of the left wing.

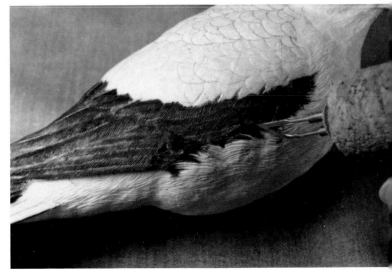

Figure 128. When the left wing is completely burned, burn the barbs on the right one. Burn in feather splits and break up the stoning finer along the flank feather edges covering the lower wing.

51

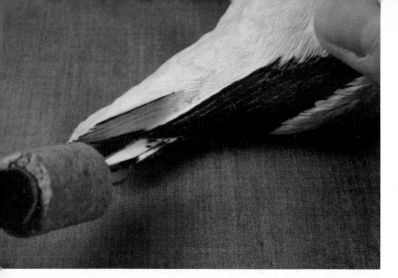

Figure 129. Burn in the barbs on the underside of the crossed primary tips.

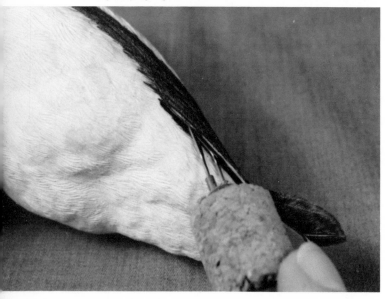

Figure 130. Use the burning pen to clean any fuzz or irregularities underneath the lower wing edges where it is difficult to sand or stone.

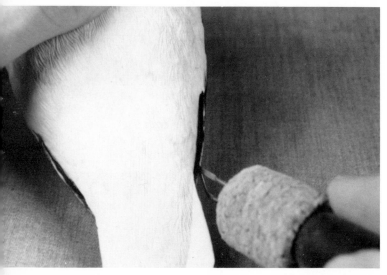

Figure 131. Burn in the barbs on the underside of the lower wing edges.

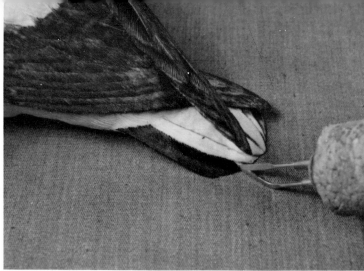

Figure 132. Beginning with the other feathers and progressing towards the middle, burn in the barbs on the upper tail.

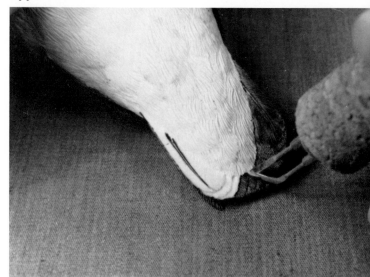

Figure 133. On the underside of the tail, begin burning in the barbs on the inner feathers and progress towards the outer ones.

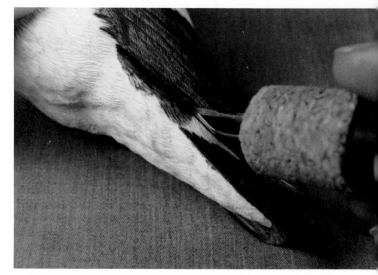

Figure 134. Burn in the barbs on the flank and lower tail coverts where you could not reach with the stoning.

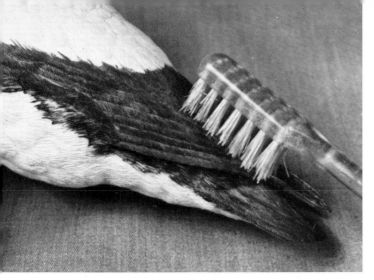

Figure 135. Clean all burning gently with a natural bristle toothbrush to remove any loose carbon.

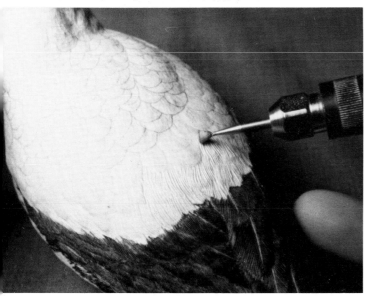

Figure 136. Stone in the texture on the scapulars beginning at their tips and progressing towards the mantle.

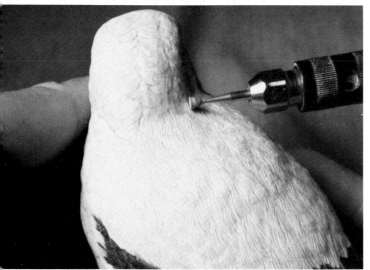

Figure 137. Stone the feathers on the mantle and up to the nape.

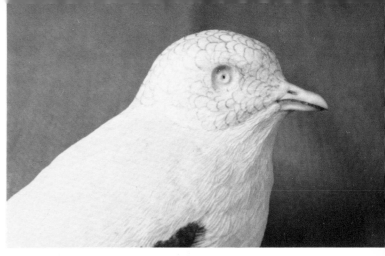

Figure 138. Draw in the remaining feathers on the top and sides of the head including the ear coverts. The feather direction flows from the base of the beak towards the back of the head on the crown and towards the back of the ear coverts on the sides.

Figure 139. Burning in the barbs from the front to back of a group of feathers enhances the trailing edges and gives a raised feather, bristly appearance. The burning stroke is slightly different from that use in burning from back to front, in that slightly more pressure is applied with the burning tip at the base of the feather. Lighter pressure is applied to the trailing edge. This type of stroke is called indent burning.

Begin burning in the feathers at the base of the beak and progress to the back of the head and on down to the stoning at the base of the neck and then on the sides of the head towards the tips of the ear coverts.

Figure 140. Note that some burn strokes were pulled into the stoned areas for a smooth transition.

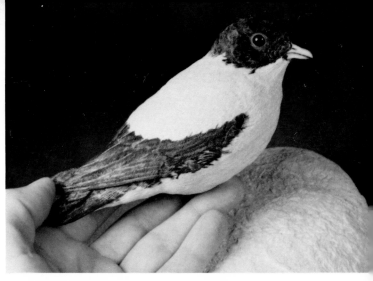

Figure 141. Burn in the barbs around the beak where the stoning could not reach without damaging the beak.

Figure 144. Determine the bird's position on the rock.

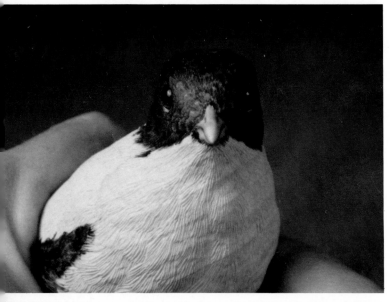

Figure 142. Replace the eyes and check their position from all angles.

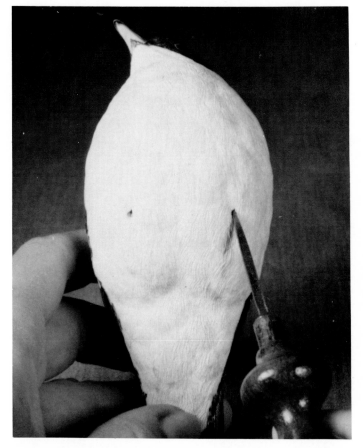

Figure 145. Mark the leg positions on the belly. The plover's legs should exit the belly feathers near the center of the bird. A shorebird's legs tend to be more forward and nearer the center of the body than other birds.

Figure 143. Set the eyes according to the directions at "Setting Eyes" in *Basic Techniques*.

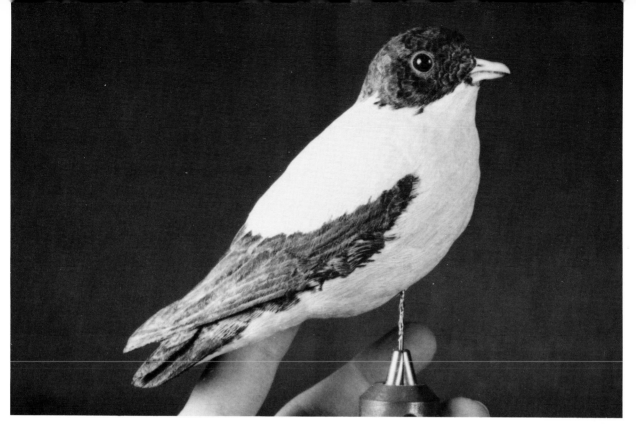

Figure 146. Drill the holes for the leg wires.

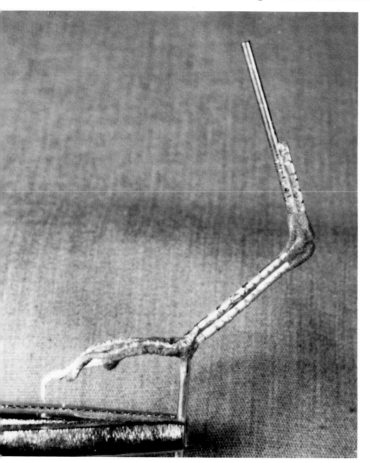

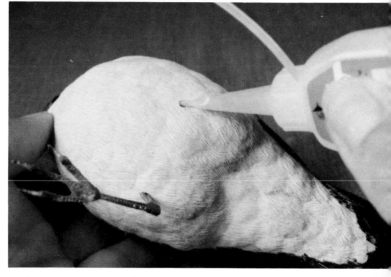

Figure 148. Super-glue the legs in place and immediately place the leg wires into the holes so that the glue hardens the feet in their proper position. *Do not glue the leg wires into the rock.*

Figure 149. There is some shaggy feathering on the plover's tibiotarsi.

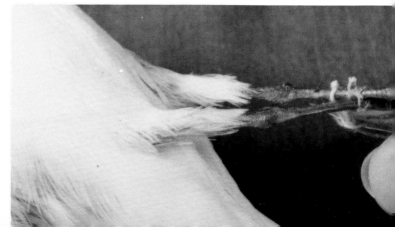

Figure 147. Make the feet according to the directions at "Feet Construction" in *Basic Techniques*. Drill the holes into the rock, making sure that the bird is balanced over its toes.

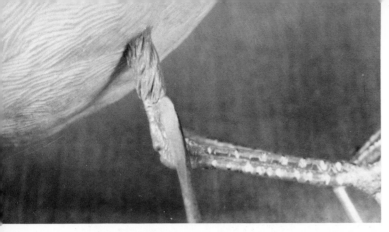

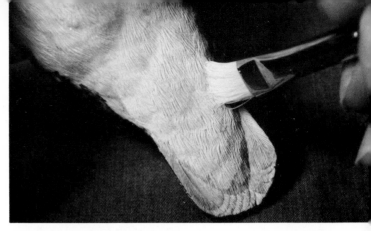

Figure 150. After the glue has hardened, mix a small amount of the *Duro* ribbon epoxy putty. Apply the putty to the tibiotarsi, and texture.

Figure 152. When the *Krylon* is dry, apply gesso with a stiff bristle brush. Fill the brush with gesso, wipe most of it on the paper towel and then scrub the remaining gesso into the texturing. The stiff bristle brush will keep the gesso from puddling in the bottom of the texture lines (burning and stoning). Use a dry-brush technique to ensure that the texture does not fill up. Apply the gesso to the entire bird, including the feet.

Figure 153. Carefully scrape the eyes.

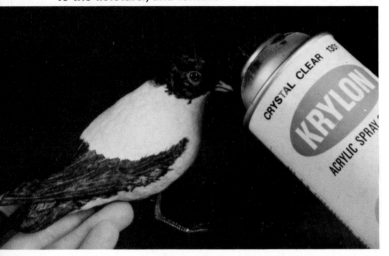

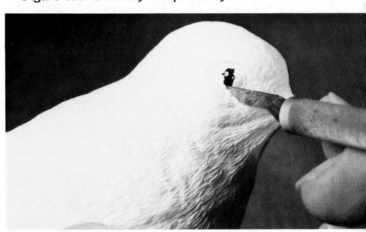

Figure 151. When the putty has hardened, spray the entire bird, including the feet, with *Krylon Crystal Clear*.

Figure 154. Ready for color!

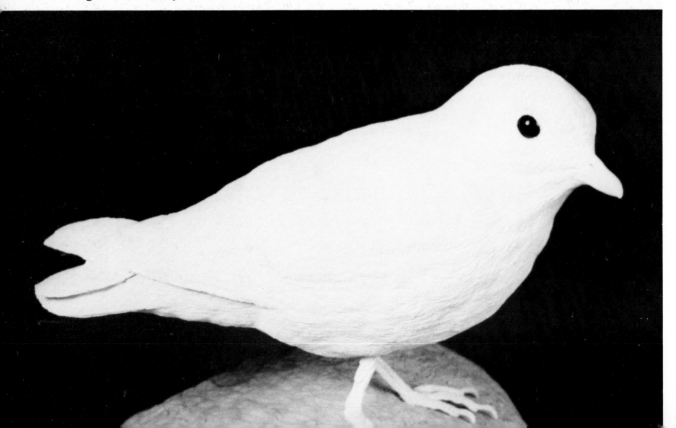

PAINTING THE SEMI-PALMATED PLOVER
(BREEDING PLUMMAGE)

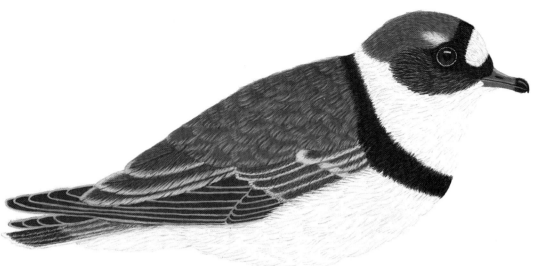

Left Foot

Ear Coverts
(Enlarged to show detail)

1. Dry-dab a thin mixture of raw umber with small amounts of cerulean blue and white.

2. Dry-dab a thin mixture of burnt umber and white. Alternate with first mixture until gesso covered.

3. Lightly streak ear coverts with a mixture of burnt umber and small amounts of black and white.

4. Blend all three mixtures and then wash with very watery burnt umber.

Acrylic Colors needed

Burnt umber
Raw umber
Cerulean blue
Cadmium yellow medium
Cadmium red light
Cadmium orange
Yellow ochre
Black
White

Ghost in blackish band on breast and nape, band across crown, band on forehead and area on ear coverts

Very thin burnt umber and black

Head, back of neck, mantle, scapulars, wings, tops of tail feathers (except tips and outer edges) and on exposed upper tail coverts

Raw umber with small amounts of cerulean blue and white

Burnt umber and white

Primaries, primary coverts and dark band near tips of upper surface at the tail

Burnt umber, raw umber, black, and a small amount of white

Scapular and wing edgings

White with small amounts of raw umber and yellow ochre

Edgings on tail feathers and tips

White and raw umber

Lower tail coverts, belly, leg tufts, throat, band around neck, forehead and light areas above and behind eyes

White and raw umber and cerulean blue

Under lower wind edge and underside of primaries except guill of upper crossed one

Burnt umber, black, and white

Narrow eye rings

Cadmium yellow medium, yellow ochre, and white

Dark band on forehead, crown, ear covert streaks, and band around breast and upper mantle

Burnt umber, black, and small amount of white

Orange area of beak

Cadmium yellow medium with small amounts of cadmium red light and burnt umber

Base coat color of feet

Cadmium orange with small amounts of white and burnt umber

1. Dry-dab a thin mixture of raw umber with small amounts of cerulean blue and white.

2. Dry-dab a thin mixture of burnt umber and white. Alternate with first mixture until gesso covered.

3. Highlight edges with a mixture of white with small amounts of raw umber and yellow ochre.

4. Wash with a very watery mixture of burnt umber and yellow ochre.

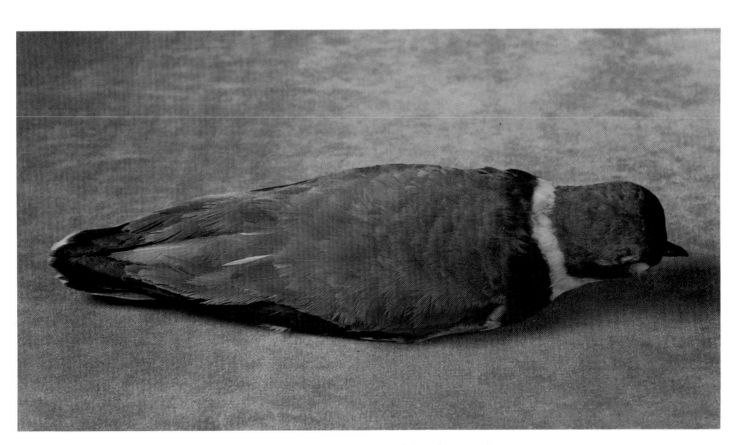

Figure 1. The overall top view of the plover is shown.

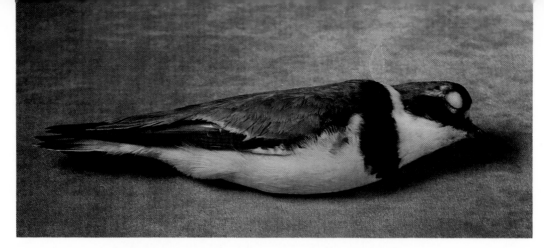

Figure 2. On the profile view of the study skin, the dark band around the neck reaches further down on the breast and mantle than on a live bird in a natural position. Be aware that study skins often will stretch out an area unnaturally.

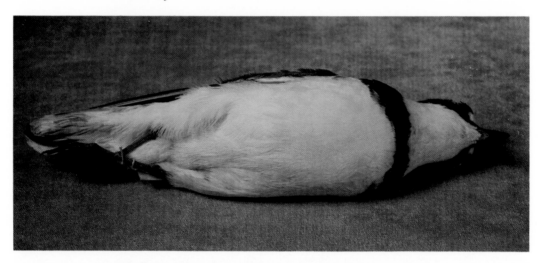

Figure 3. The color of the feet on the under view is not as bright as that of a live bird.

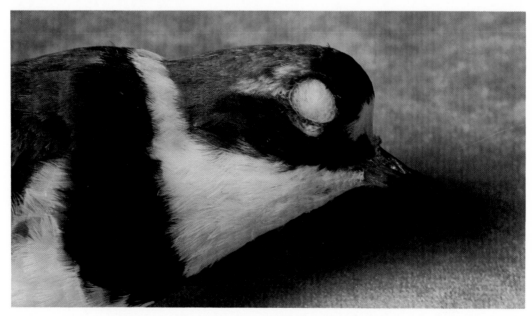

Figure 4. Notice the soft blanded transitions between the light and dark colors of the bands around the neck.

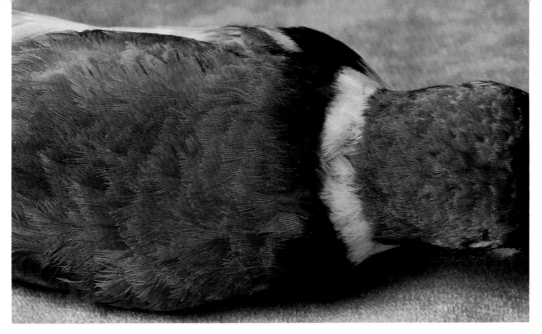

Figure 5. Notice the different light and dark values of color on the mantle feathers.

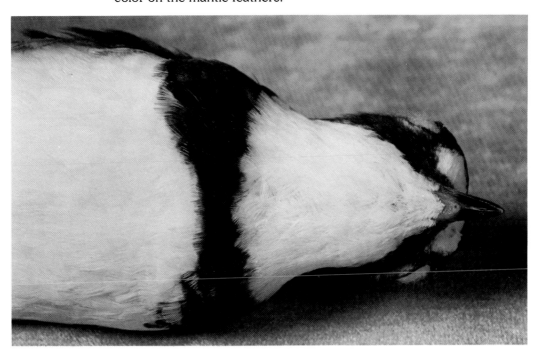

Figure 6. Note the soft blend of the light throat feathers over the dark band and the dark band over the lighter colored breast feathers.

Figure 7. The pointed brownish feathers are the plover's tertials.

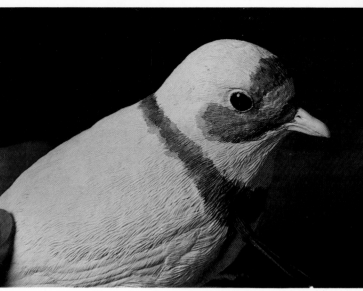

Figure 8. Note the dark bands on the tail feathers.

Figure 9. Blend a small amount of burnt umber and black into a large puddle of water. "Ghost" in the dark bands on the breast and shoulders around to the nape of the neck, the dark bank across the crown and the one at the base of the forehead, the dark streak on the lores and the ear coverts. Keeping the edges of the bands and streaks irregular will allow soft blended transitions more easily.

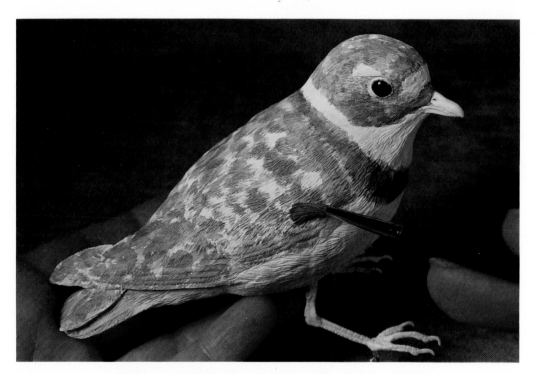

Figure 10. Make a thin mixture of raw umber with small amounts of cerulean blue and white and a second thin mixture of burnt umber and white. Fill your brush with the first mixture and dab the excess on the paper towel. Dab the mixture irregularly on the crown, back of the head, mantle, scapulars, wings, centers of the upper surface of the tail feathers and the exposed edges of the upper tail coverts. Do not include the whitish neck band, the light areas above and behind the eyes, tail feather tips and the outer tail feather edges.

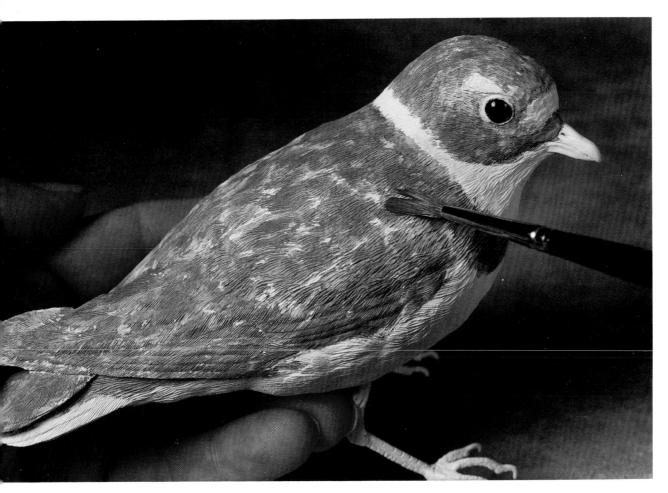

Figure 11. Clean the brush, load the second color and dab the same areas as with the first mixture.

Figure 12. Keep dry-dabbing both mixtures alternately until the gesso is covered. This will take many applications to increase the intensity of the colors. Keep the paint thin so that the texturing is not filled up. By dabbing both mixtures in different areas, you will begin to see the soft blending of both the greyish green and the brownish mixtures. Do not forget to apply the mixtures to the edges of the wings. Keeping the edges irregular along the dark bands will allow blending more easily. You may have to adjust the lightness or darkness of the mixtures as you proceed. If the color starts getting too dark, add more white to each mixture. If the color starts getting too light, add more of the umbers to the mixtures.

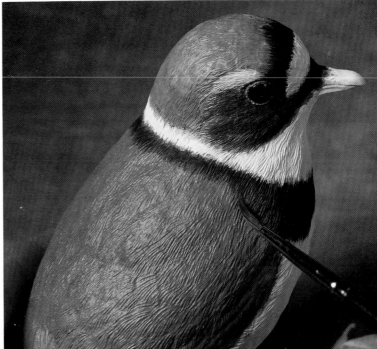

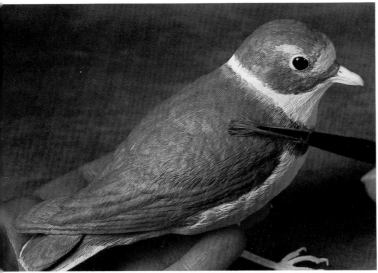

Figure 13. Mix a small amount of black into burnt umber and strengthen the color on the dark bands, streaks and ear coverts.

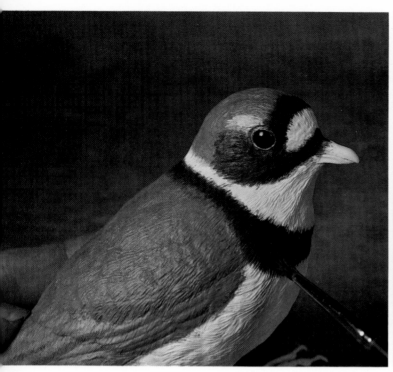

Figure 14. Blend the edges of the dark bands and streaks into the edges of the basecoat mixtures.

Figure 16. Make a very thin wash with burnt umber, raw umber and black. Darken the primary coverts, primaries and the dark bands on the tail feathers with several applications of the dark wash.

Figure 17. Mixing white with small amounts of raw umber and yellow ochre, lightly brush the edges of the scapulars and wing feathers.

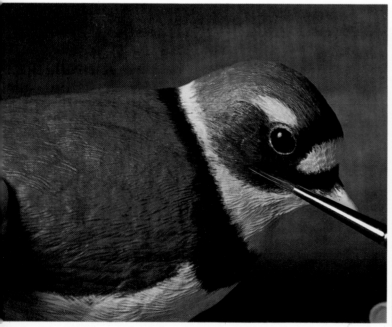

Figure 15. Lightly streak the ear coverts with both basecoat mixtures and a third mixture of burnt umber with small amounts of black and white on the ear coverts.

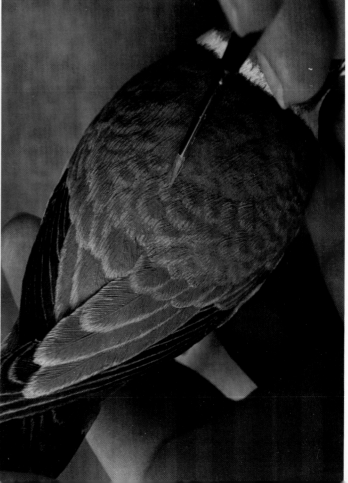

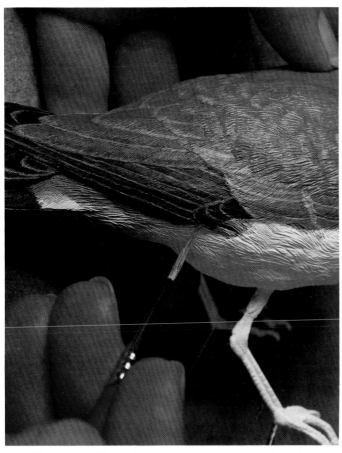

Figure 18. Use a liner brush to pull a light edge line down the leading edge of the primaries and primary coverts.

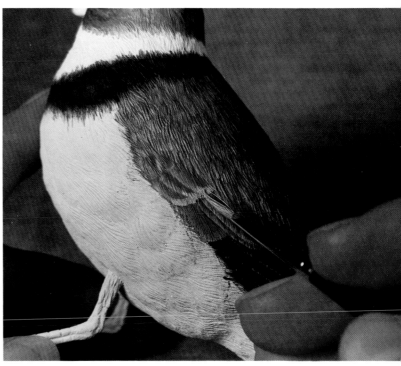

Figure 20. Lighten the tips of the greater secondary coverts with a mixture of white and raw umber (a small amount).

Figure 21. Use a liner brush and a thin mixture of burnt umber and black for a few splits on the primaries and primary coverts. Use burnt umber for the splits and quills on scapulars and the wing feathers except the primaries and primary coverts.

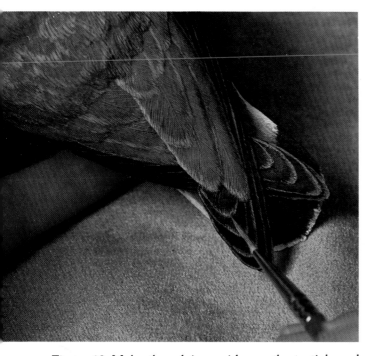

Figure 19. Make the edgings wider on the tertials and tips of the primaries.

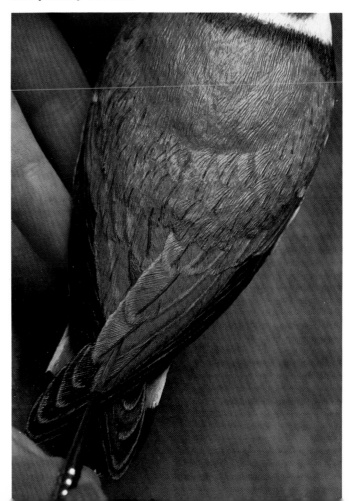

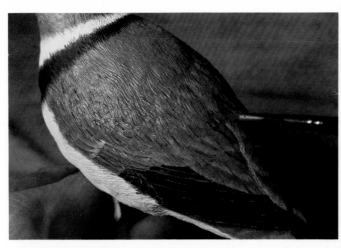

Figure 22. Apply a very thin wash of burnt umber and yellow ochre to the scapulars and wings.

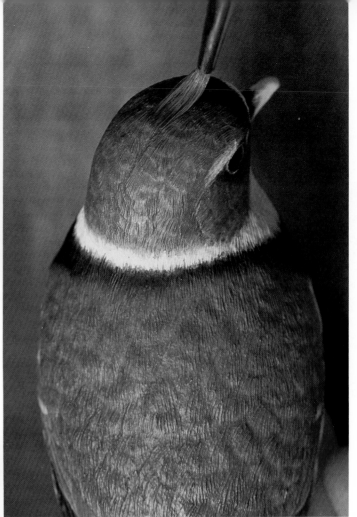

Figure 24. Then apply a very watery wash of burnt umber and yellow ochre to the mantle, head and nape of the neck.

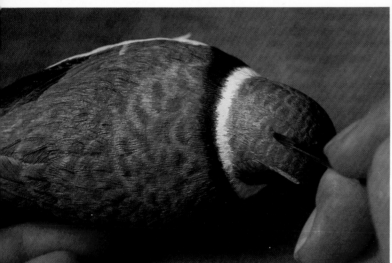

Figure 23. Lightly dry-brush a mixture of white with small amounts of raw umber and yellow ochre on the edges of the feathers on the mantle, head and nape of the neck.

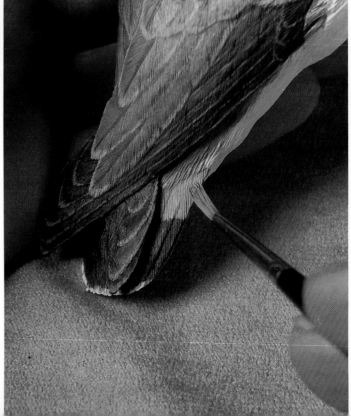

Figure 25. Apply a mixture of burnt umber and raw umber to the bases of the tail feathers. Blend this mixture into the dark band edges and the darker color into the lighter one until there is a soft transition.

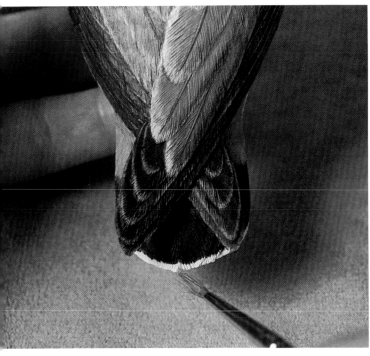

Figure 26. Mix white with a small amount of raw umber. Apply the light mixture to the tail feather tips. With a liner brush, pull a light edge on all of tail feathers and the entire surface of the shortest outer one on each side. Then apply a very thin, watery raw umber wash to the entire surface of the upper tail.

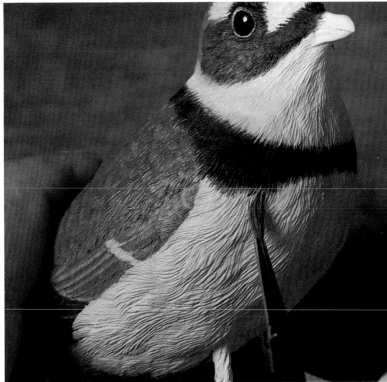

Figure 28. Blend the light basecoat color into the edges of the dark bands on the neck, breast, sides of crown and forehead.

Figure 29. Lightly dry-brush the edges of all the light grey feathers with straight white.

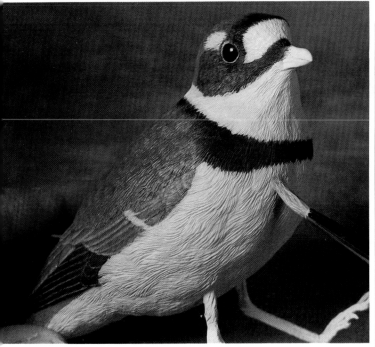

Figure 27. The basecoat color for the underside and light areas of the bird is a light grey mixture of white with small amounts of raw umber and cerulean blue. Apply several coats to the lower tail coverts, belly, leg tufts, breast, throat, the light band around the neck, forehead and the light areas above and behind the eyes. Do not use thick paint that would fill up the texture grooves.

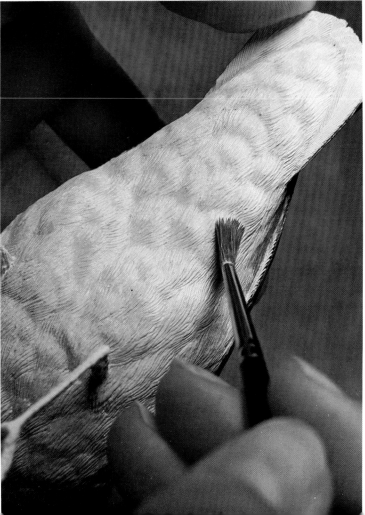

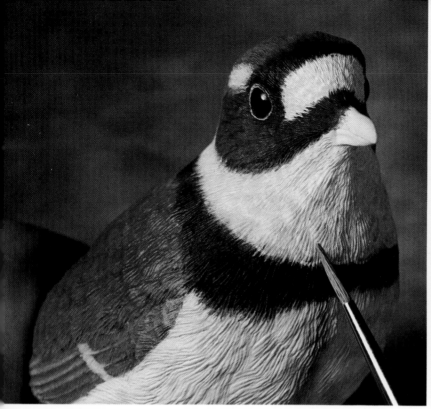

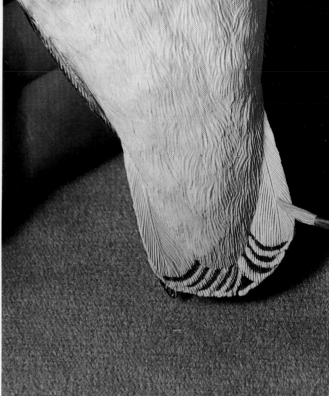

Figure 30. It will likely take two applications to make the edges lighter.

Figure 31. Use a liner brush and a medium grey mixture of burnt umber, black and white to separate the flank feather edges over the wings.

Figure 32. Apply a mixture of white with a small amount of raw umber to the entire surface of the two outer feathers and the edges of the remaining feathers of the under tail surface. Use a mixture of burnt umber with small amounts of black and white for the dark portion of the remaining feathers. Then apply a very watery wash of white and raw umber to the under tail.

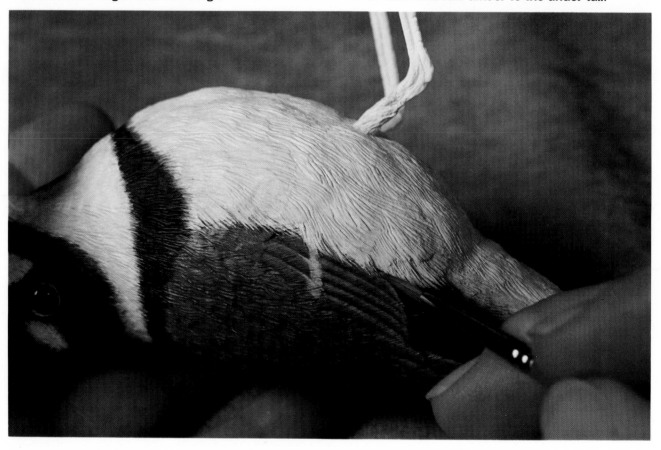

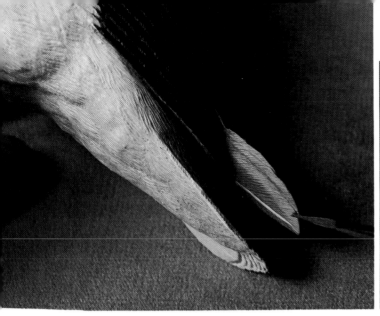

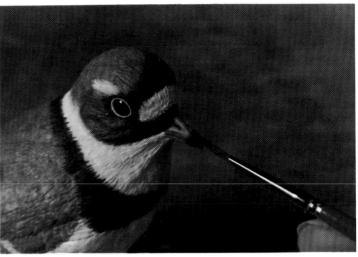

Figure 33. Use a mixture of white with a small amount of raw umber for the quills on the underside of the crossed primaries. Mix a small amount of black and white into burnt umber and apply to the remaining part of the under primaries and under the lower wing edges. Mix more white into the grey mixture and dry-brush the edges of the underside of the primaries. When this is dry, apply a very thin, watery burnt umber wash to the entire surface of the underside of the primaries.

Figure 35. Mix cadmium yellow medium with small amounts of cadmium red light and burnt umber and apply to the base of the beak. Then paint the tip of the beak with a mixture of black, burnt umber and a small amount of white. Apply a very thin, watery burnt umber wash to the entire beak.

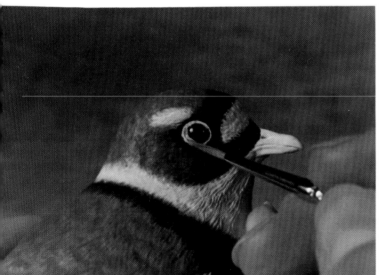

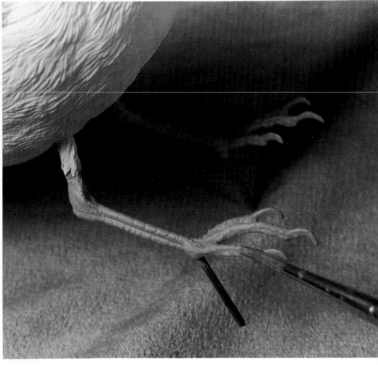

Figure 34. Reapply gesso to the beak and eye rings. Make a mixture of yellow ochre, cadmium yellow medium and white and apply to the eye rings. Then carefully scrape the eyes.

Figure 36. For the feet and legs, apply a mixture of cadmium orange with small amounts of white and burnt umber. Then apply a very thin, watery burnt umber wash to all of the feet and legs.

69

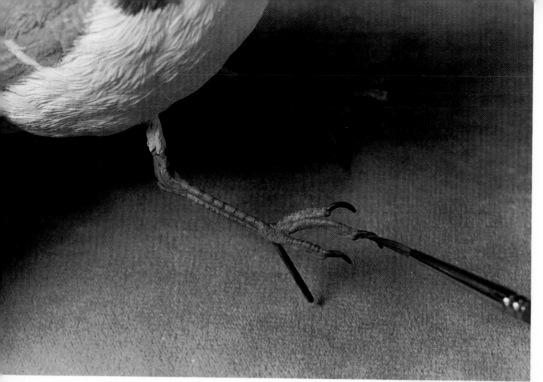

Figure 37. Dry-brush burnt umber on the claws.

Figure 38. Mix a small amount of gloss medium into a large puddle of water and apply to the feet and legs. When this is dry, apply unwatered gloss medium to the claws and the quills.

Figure 39. Make a 50/50 mixture of matte and gloss mediums and apply to the beak.

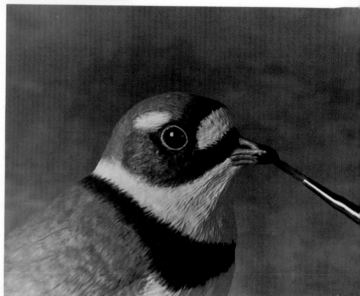

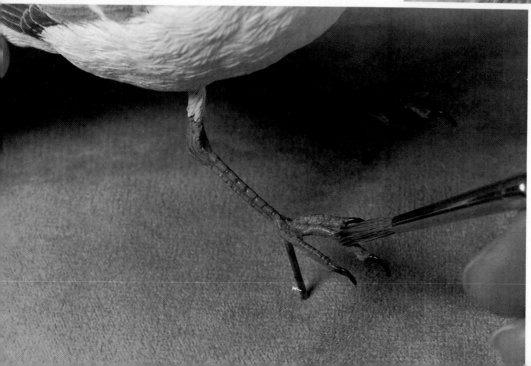

Figure 40. Glue the feet wires into the rock. Here you see the finished semi-palmated plover.

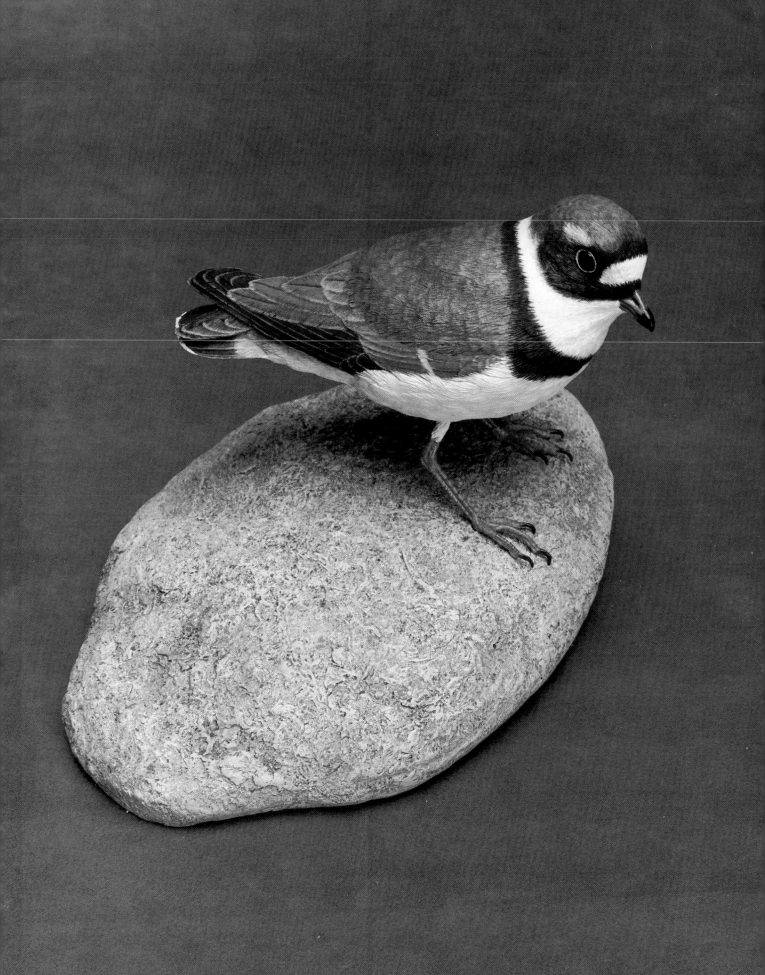

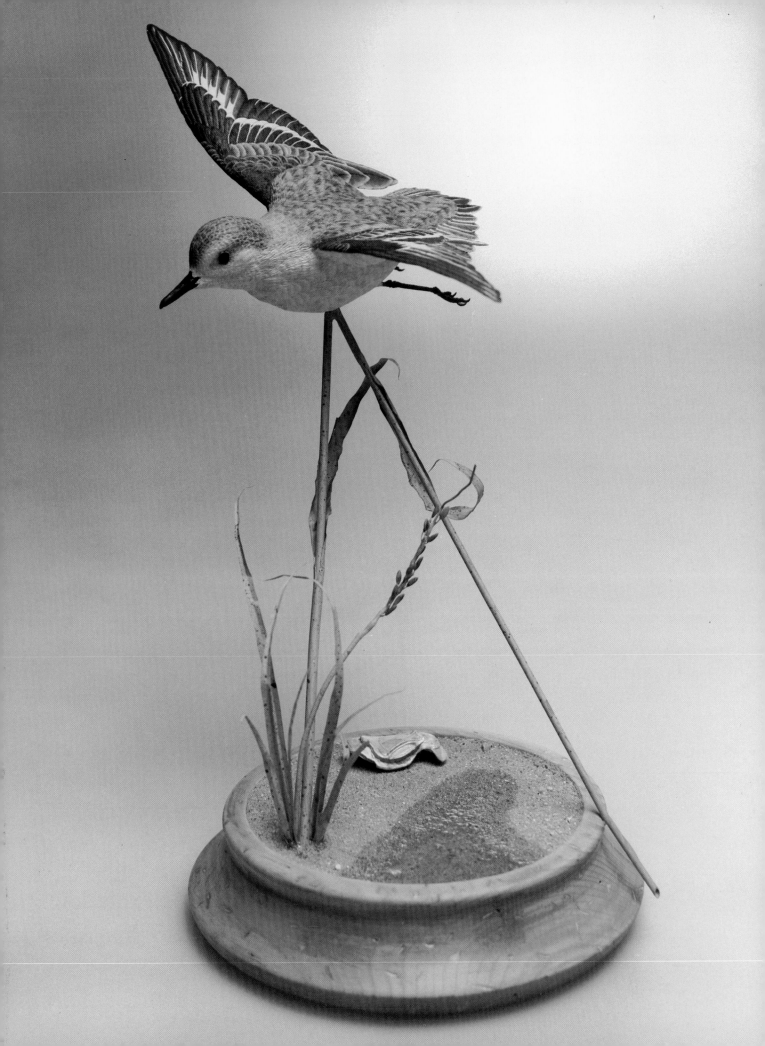

Chapter 4.

Sanderling

(Calidris Alba)

One of the favorite activities of many people at the beach is watching these delightful little birds running towards the surf, poking their beaks in the sand and then taking off when the waves start rolling in again. The sanderling is a common bird on both coasts, but it also frequents the tidal flats and marshes as well as river and lake shores. Their main food supplies consists of small crustaceans, worms, beetles, spiders and sandhoppers.

Although both sexes look similar, the females tend to be a little larger and the males slightly more brightly colored in the breeding or summer plumage. So pale are the sanderlings in their non-breeding plumage that they blend perfectly with the sand, often making them difficult to distinguish except for their movement. In non-breeding plumage, the sanderling is pale grey above with a light grey to whitish head and white underneath. In breeding plumage, this beach bird is more brightly colored with rusty coloring on its head, back and breast. The blunt-shaped bill and feet are black.

This Arctic nesting bird scrapes a depression and usually lays four eggs. Often the female will lay two clutches with the male incubating one set of eggs. Incubation takes about four weeks and the young leave the nest within a day of hatching, toddling along after their parents. The young birds will be left on their own in about three weeks.

DIMENSION CHART (for a folded wing bird)

1. End of primaries to end of tail	.2 of an inch
2. Length of wing	5.1 inches
3. End of primaries to alula	3.8 inches
4. End of primaries to top of 1st wing bar	3.0 inches
5. End of primaries to bottom of 1st wing bar	3.55 inches
6. End of primaries to mantle	3.0 inches
7. End of primaries to end of secondaries	2.4 inches
8. End of primaries to end of tertials	.7 of an inch
9. End of primaries to end of primary coverts	2.5 inches
10. End of tail to front of wing	4.9 inches
11. Tail length overall	2.2 inches
12. End of tail to upper tail coverts	.5 of an inch
13. End of tail to lower tail coverts	.1 of an inch
14. End of tail to vent	2.2 inches
15. Head width at ear coverts	1.1 inches
16. Head width above eyes	.8 of an inch
17. End of beak to back of head	2.2 inches
18. Beak length	
Top	.94 of an inch
Center	1.00 inch
Bottom	.7 of an inch
19. Beak height at base	.25 of an inch
20. End of beak to center of eye (6 mm. brown)	1.5 inches
21. Beak width at base	.22 of an inch
22. Tarsus length	1.0 inch
23. Toe length	
Inner	.63 of an inch
Middle	.8 of an inch
Outer	.68 of an inch
24. Overall body width	2.3 inches
25. Overall body length	6.5 inches

TOOLS AND MATERIALS

Bandsaw (or coping saw)
Flexible shaft machine
Carbide bits
Ruby carvers and/or diamond bits
A variety of mounted stones
Pointed clay tool or dissecting needle
Compass
Calipers measuring in tenths of an inch
Rheostat burning machine
Ruler measuring in tenths of an inch
Awl
400 grit sandpaper
Drill
Laboratory bristle brush
Drill bits
Needle-nose pliers
Toothbrush
Wire cutters
Safety glasses and dustmask
Super-glue
Oily clay
Duro ribbon epoxy putty (blue and yellow variety)
Krylon Crystal Clear
5 minute epoxy glue
Tupelo blocks
One body block 2.5" x 3.1" x 7.7"
Two wing blocks 1.0" x 4.25" x 6.25"
Pair of cast sanderling feet to use as a model
Pair of 6 mm. brown eyes
For making feet:
16 gauge copper wire
solder, flux and soldering pen or gun
permanent ink marker
hammer and small anvil
cartridge roll sander on a mandrel
small block of scrap wood and staples for holding jig (or several pairs of helping hands holding jigs)

SANDERLING

Profile line drawing of head and body

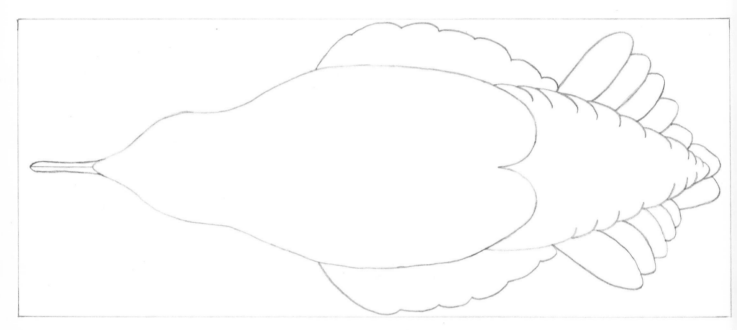

Body block 2.5" (H) x 3.1" (w) x 7.7" (l)

Under plan view ** Top plan view**

***Foreshortening may cause measurement distortion on both plan views. Check the dimension chart.**

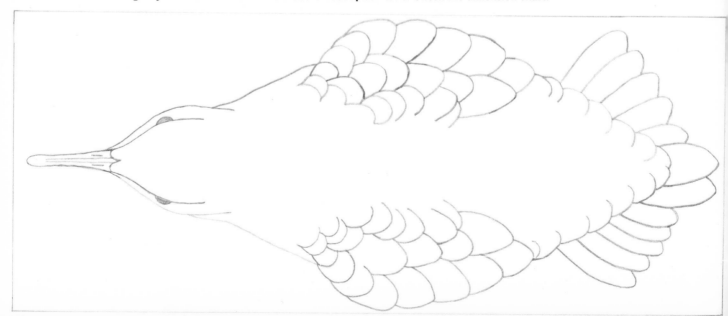

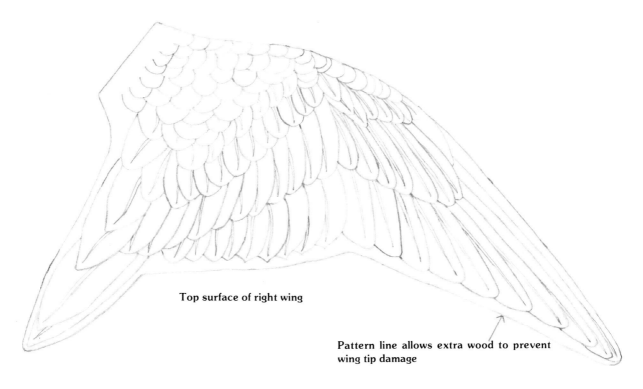

Top surface of right wing

Pattern line allows extra wood to prevent
wing tip damage

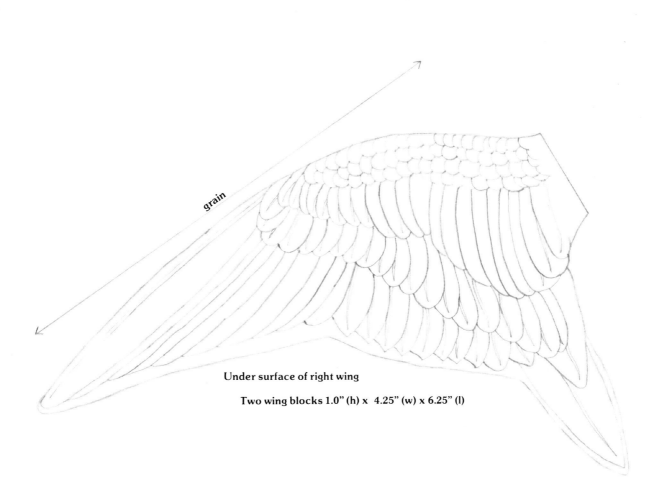

grain

Under surface of right wing

Two wing blocks 1.0" (h) x 4.25" (w) x 6.25" (l)

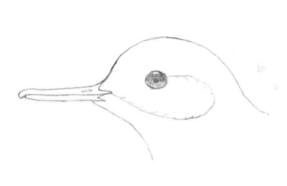

Profile view of head

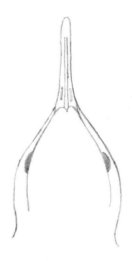

Top plan view of head

Head-on view of head

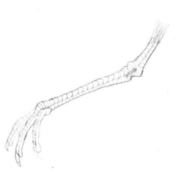

Foot

Axillaries

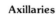

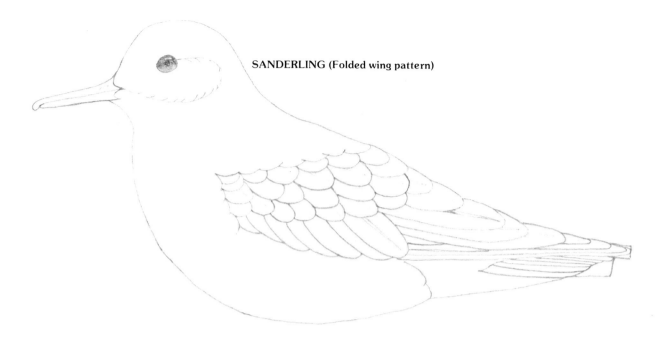

SANDERLING (Folded wing pattern)

Profile line drawing

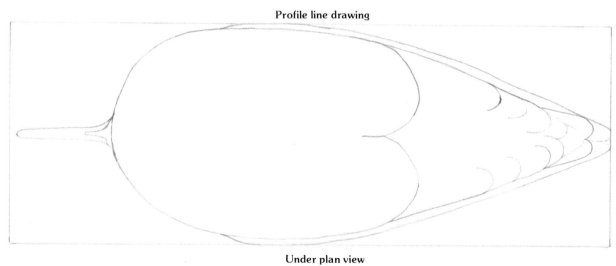

Under plan view

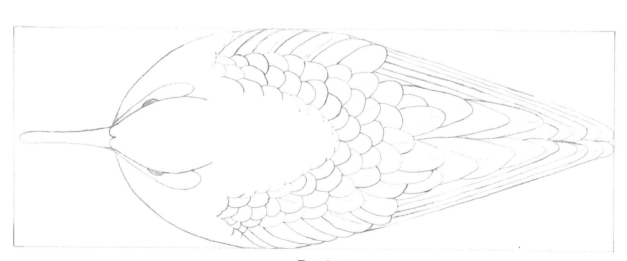

Top plan view

Foreshortening may cause measurement distortion on plan views. Check the dimension chart.

Figure 2. The tail is a piece of aluminum flashing cut to shape with an extra one-half inch tab on the front. Make a saw cut in the body support block and insert the tail. The flashing was bent to simulate the curvature of the fanned shape of a flying bird's tail.

Figure 1. Because of its complexity, this carving needed to worked out in clay. It is easier to solve problems in clay (or *Super Sculpey*), where you can add to the bird as well as subtract from it, than it is in wood. The main advantage of *Super Sculpey* is that while it is moldable, it can be baked to hardness in a regular oven.

To create an armature, bandsaw a small block of wood for the body. Drill a hole in the block the same diameter as the piece of steel rod seated in a base (scrap of 2" x 4" lumber). The base needs to be sufficiently heavy that the composition does not topple over.

Figure 3. Build up the *Super Sculpey* around the block and tail. I find it easier to over-build and carve down to shape. Details are not essential. The form of the bird is the important goal.

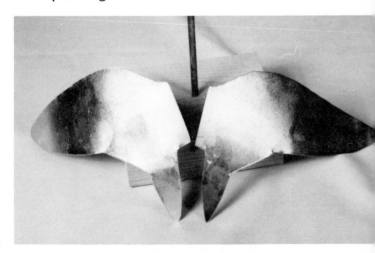

Figure 4. Cut the wings out of the flashing and bend to shape. Note the extra tabs that will be needed to seat in the *Super-Sculpey*. The tabs are also essential for the pattern in wood.

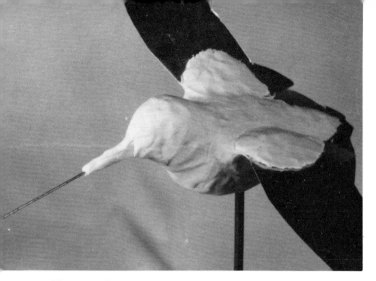

Figure 5. Determine the position of the wings and then shape *Super-Sculpey* for the scapulars. A wire in the beak is necessary for support.

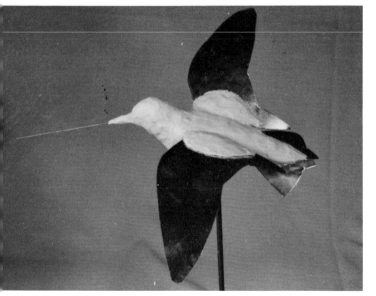

Figure 6. Any alterations should be made before the material is baked, although you can cut away, add additional material and rebake if necessary.

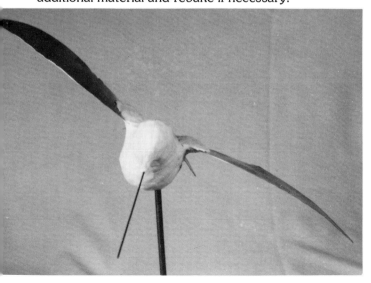

Figure 7. Check the composition from every angle.

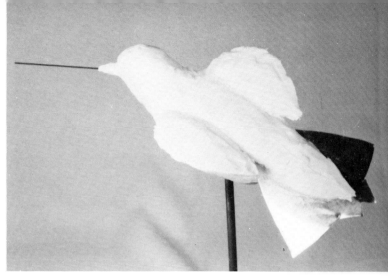

Figure 8. Carefully remove wings. The slot for each wing should still be open. Bake the body for 15-20 minutes at 300 degrees.

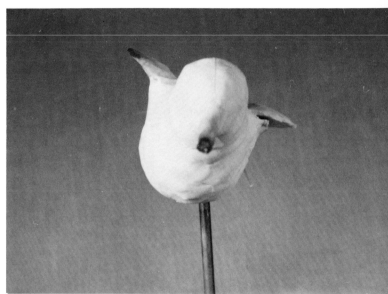

Figure 9. Clip the wire at the end of the beak.

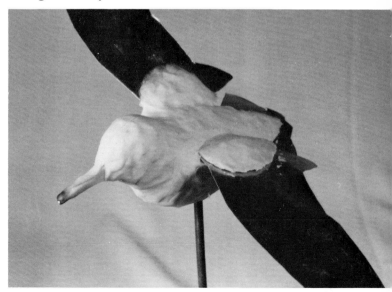

Figure 10. When the model is almost cool, put wings back in the slots until its completely cool.

79

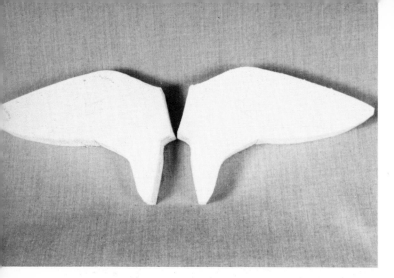

Figure 11. For the wings, you need 2 blocks 4.5" x 1" x 6.25". Bandsaw the pattern out of each. Lay them out as in the photo and mark the left one "top left" and the other "top right". It is amazing how easy it is to get them confused.

Figure 12. This is the left wing with the tab to the left and the wing tip curved on the right. Sketch in the wing curvature on both wing blocks from the head-on view.

Figure 13. Note the curvature of the wing from front (on the right) to back (on the left). Sketch in the front to back contour on both wing blocks.

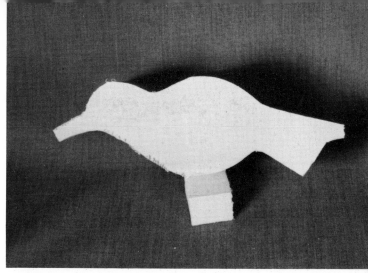

Figure 14. Here you see the profile of the body blank.

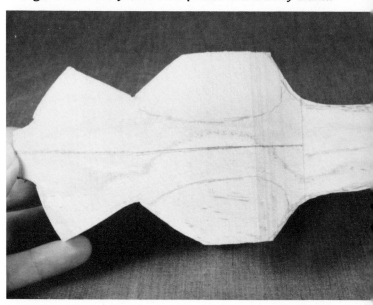

Figure 15. Draw the centerline on the body. Roughly sketch in the scapular areas. Draw in the centerline for the head.

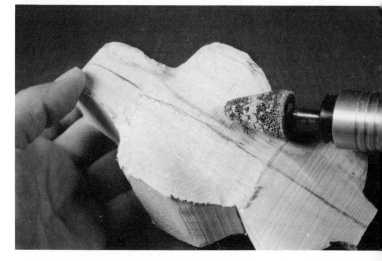

Figure 16. With a large tapered carbide bit, channel on each scapular line. Round over both sets of scapulars. Remove some wood in the back area and contour it to a convex shape.

80

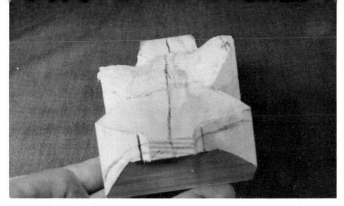

Figure 17. Redraw the body centerline. Draw the top contour of the tail, giving it a convex shape. Allowing approximately .2 of an inch for its thickness, draw in the lower tail contour. Note the twist in the tail: on the left side of the tail, most of the excess wood is above the actual tail and on the right side, most of the excess wood is underneath.

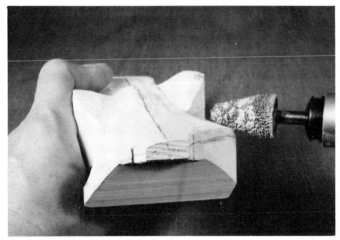

Figure 18. Cut away the excess wood on top of the tail area. As you are grinding the wood away, keep checking the contour from the end view. Redraw the tail centerline if necessary.

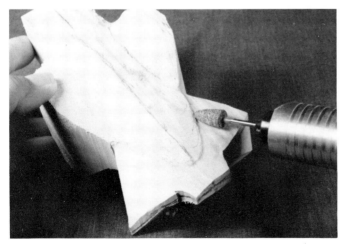

Figure 19. From the end of the tail, measure and mark the distance to the tip of the upper tail coverts (.5 of an inch). Roughly draw in the shape of the coverts. Using a large diameter ruby carver, lightly channel around the edge of the coverts. Flow the channel out all around towards the end and sides of the tail feather tips. Round over the covert edges.

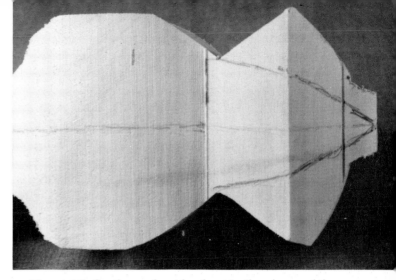

Figure 20. On the underside, draw in the shape of the lower tail coverts .1 of an inch from the end of the tail.

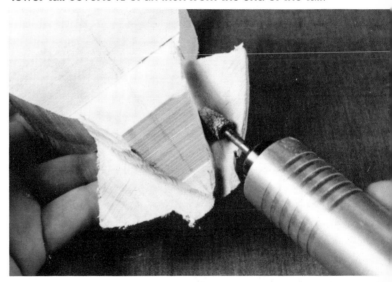

Figure 21. Grind away the excess wood around the lower coverts.

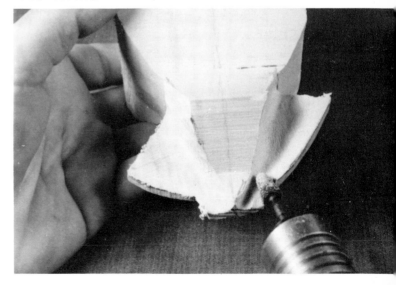

Figure 22. Keep the sides of the coverts vertical. The tail should be a uniform thickness. Check the thickness optically and tactilely. You will need to use a small carbide bit or ruby carver to get down in the crease.

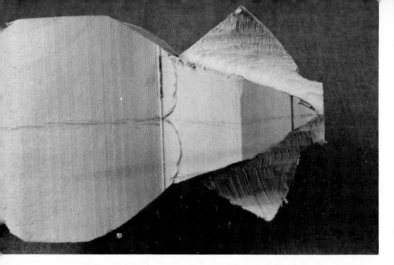

Figure 23. Measure and mark in the location of the vent 2.2 inches from the end of the tail. Draw in the vent shape.

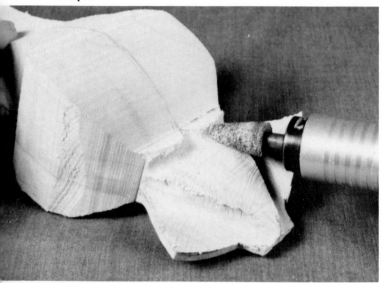

Figure 24. Using a medium-sized tapered carbide bit, channel around the vent lines, lowering the height of the base of the lower tail coverts.

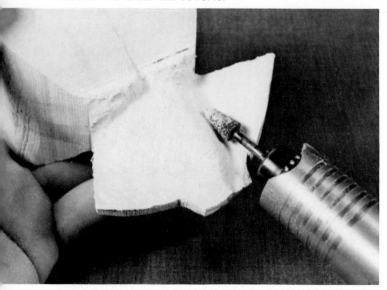

Figure 25. Round over the lower coverts and flow the tip down to the base of the tail.

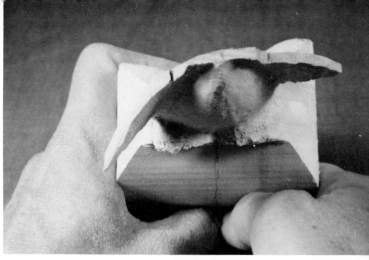

Figure 26. Working on the underside, thin the tail down to .15 of an inch. Using a ruby carver will leave a smoother surface that will require less sanding.

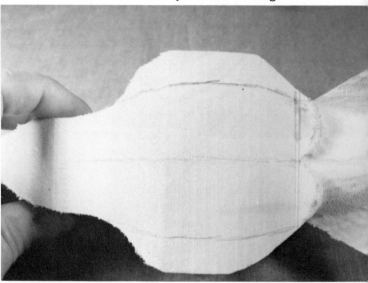

Figure 27. Draw in the outside body lines on the underside 1.0 inch on each side of the centerline. The lines should curve in slightly toward the breast and toward the vent.

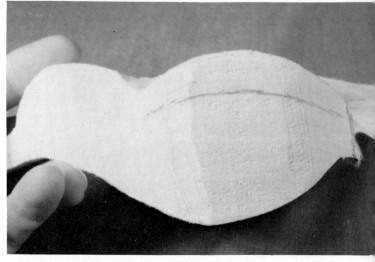

Figure 28. Draw a curved line under each scapular group slightly less than one-half inch from the upper edge.

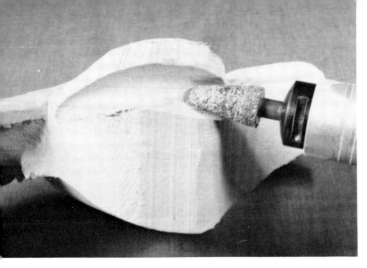

Figure 29. With a tapered carbide cutter, make a deep channel on the lines under each scapular edge.

Figure 30. The x-ed in area is excess wood.

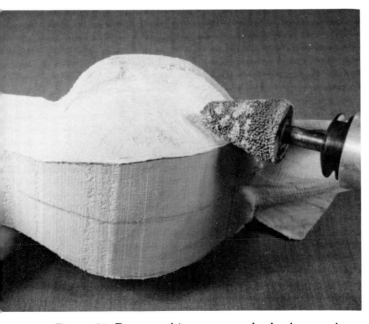

Figure 31. Remove this excess under both scapulars.

Figure 32. Make a shallow channel one inch long channel on the centerline at the vent. Round over the breast (up to the neck area) and belly, flowing the vent area down to the base of the lower tail coverts.

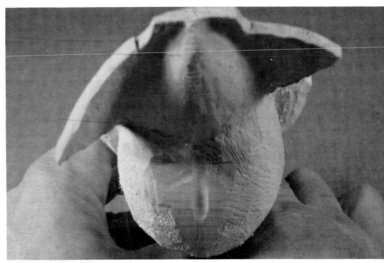

Figure 33. Note that the flanks curve in underneath the scapular overhangs.

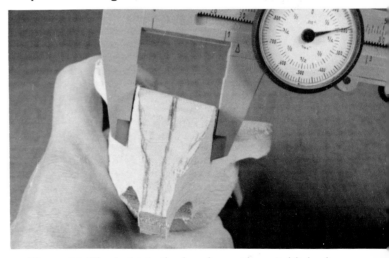

Figure 34. The twist in the head must be established. Keeping equal amounts on each side of the centerline, narrow head width at the ear coverts to 1.1 inches. More wood will need to be removed on the bird's bottom right side and top left side to establish the twist. When judging the twist optically, hold the body horizontal and note the angle of the head cock.

Figure 35. Twisting the head will cause the plane of the head to be angled. Cut away the excess wood on the top of the right side of the bird's head, back of the neck and beak.

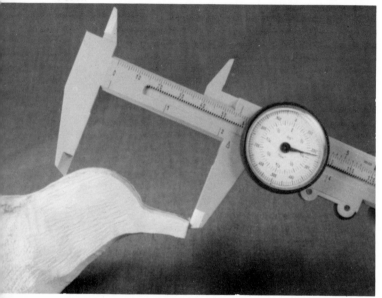

Figure 36. Check the measurement from the end of the beak to the back of the head (2.2 inches). If necessary, cut away small amounts from the back of the head and/or the end of the beak.

Figure 37. Using the profile line drawing, transfer the dimensions and shape of the beak and eye to both sides of the birds head. Check the balance of both the eyes and the beak from the head-on view. It is far easier to adjust pencil lines for imbalance than a crooked beak!

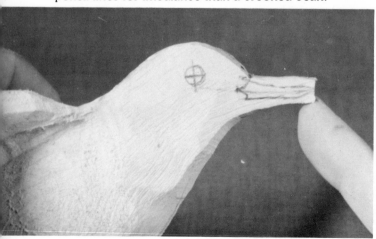

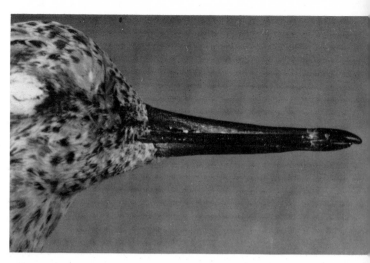

Figure 38. Note the profile shape of the sanderling's beak.

Figure 39. Here you see the plan view of the beak.

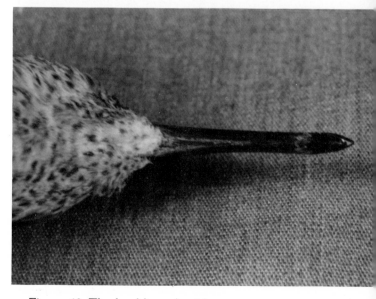

Figure 40. The beak's underside.

84

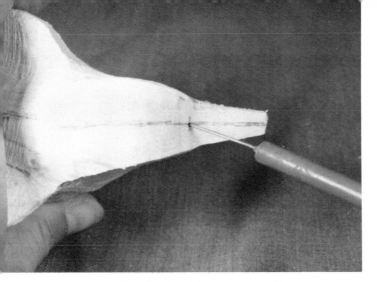

Figure 41. On the beak's top centerline, measure, mark and pinprick the top beak length (.94 of an inch).

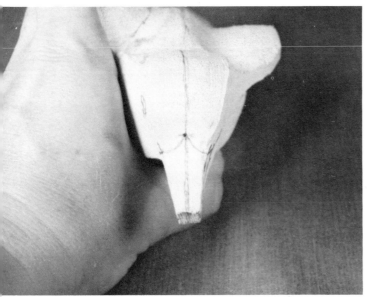

Figure 42. Draw in the v-shape with its point at the measurement mark.

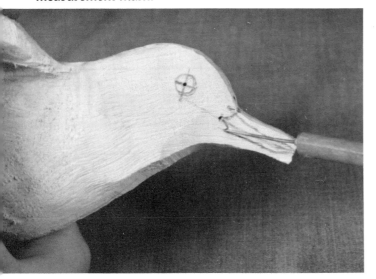

Figure 43. Pinprick the base of the beak at the commissure line and at the bottom of the lower mandible.

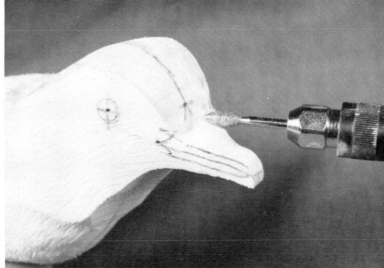

Figure 44. With a small pointed ruby carver, grind away the excess wood above the beak, keeping the top surface a flat plane at this point. Do not be afraid to cut down to the line. Redraw the centerline.

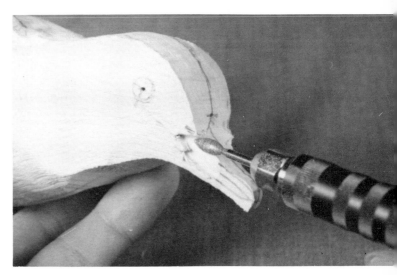

Figure 45. Begin cutting in the sides of the beak. Frequently checking from the head-on view, keep equal amounts on each side of the centerline.

Figure 46. Keep removing wood until the base of the beak measures .22 of an inch. If there is too much extra wood behind the marks at the beak's base, some of this can be removed in order to be able to get the calipers back to the base.

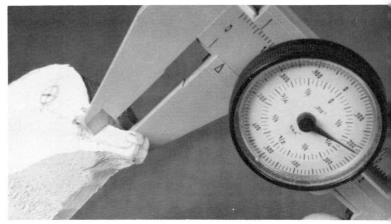

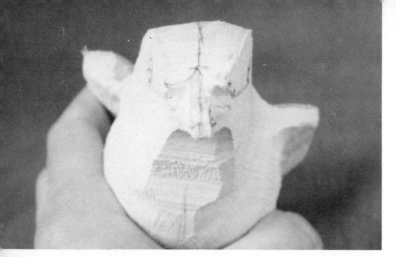

Figure 47. Note that the sides of the beak have been kept vertical at this point.

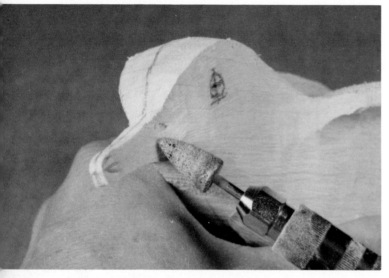

Figure 48. Flow the sides of the head down to the base of the beak, cutting away the shelves caused by cutting in the beak's sides. Flow the forehead down to the base of the beak, cutting away the shelves there.

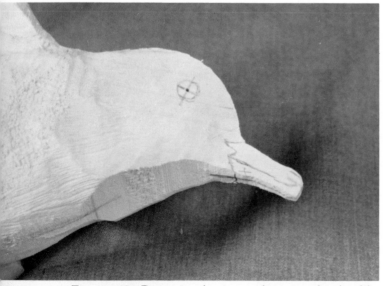

Figure 49. Draw in the centerline on the beak's underside. Measure and mark the base .7 of an inch from the tip. Draw the u-shaped tuft of feathers at the mark.

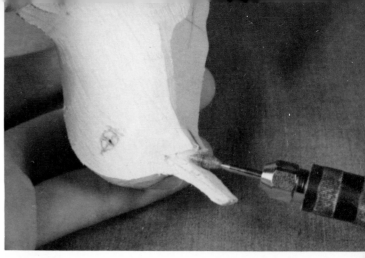

Figure 50. Cut a channel around the tuft of feathers and grind away the excess wood underneath the beak.

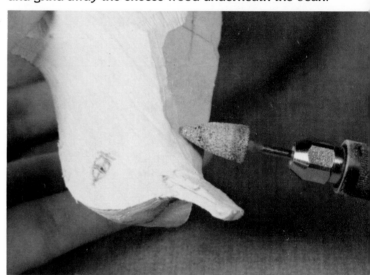

Figure 51. Flow the chin and u-shaped tuft down to the base of the beak's underside.

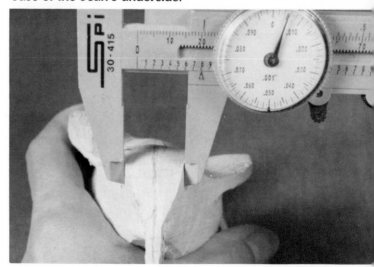

Figure 52. Pinprick the center of both eyes deeply, so that their placement will be retained after wood is cut away from these areas. Across the crown above the eyes, measure and mark the width (.7 of an inch), leaving .35 of an inch on both sides of the centerline. Remove the excess wood from the eye area up to the top of the head, creating a gentle slope.

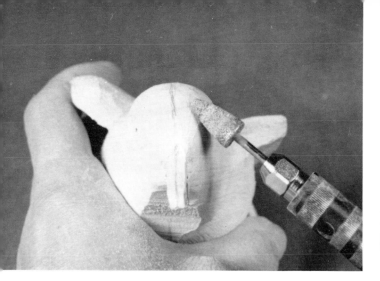

Figure 53. Round the sharp corners on both sides of the head from the forehead to the crown and on down the back of the neck.

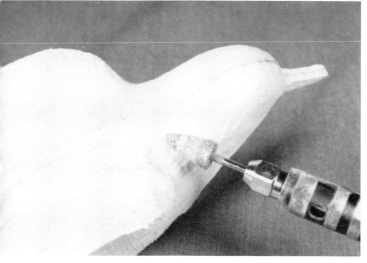

Figure 54. Remove a small amount of wood at the nape of the neck on both sides so that there is a sloping transition from the head to the body.

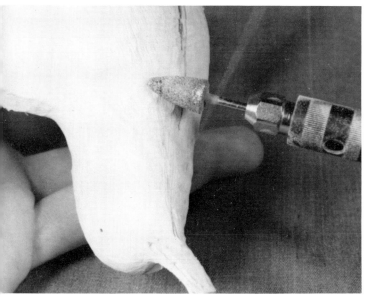

Figure 55. Remove some of the excess wood on the throat and sides of the neck.

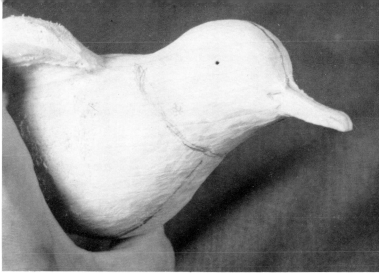

Figure 56. A flying bird generally has its neck stretched out. Draw a neck line between the head and the body.

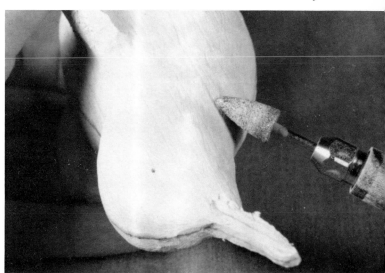

Figure 57. Make a channel along this neck line. Flow the channel's edges out in both directions (towards the body and the head). This will create a broad depression between the head and body.

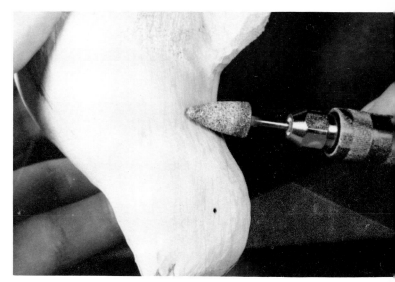

Figure 58. Do not leave this neck area too full. This is a lean flying bird, not a linebacker.

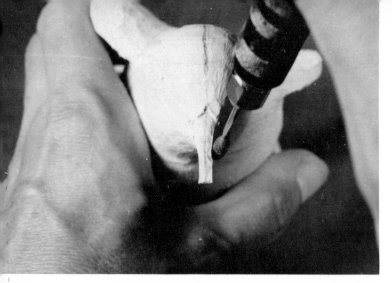

Figure 59. For the details on the beak, first narrow the width from the base out to the tip. Review the plan view on Figure 39.

Figure 60. The beak's width one-half inch from the tip should be .12 of an inch. Keep the side planes vertical at this point. Remember to keep equal amounts on each side of the centerline. Work slowly and carefully to keep the beak balanced. Take a little bit off and then look!

Figure 61. Make the tip slightly rounded on the sides and top. Redraw the commissure line. Leaving a narrow flat area along the top ridge (the culmen), round over the sharp corners on the upper and lower mandible.

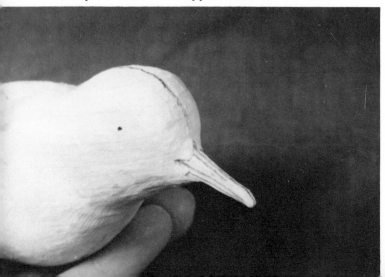

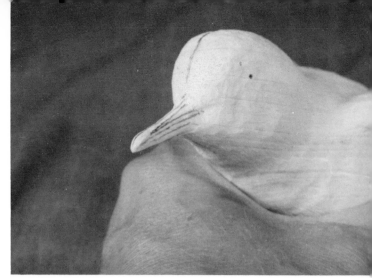

Figure 62. Draw in the triangles on the upper mandible's base. This will be the depressed area on each side of the culmen where the nostrils will be located. There is also a small linear depression just below the commissure line on the sides of the lower mandible's base. Draw in this line from the base that ends .3 of an inch from the tip.

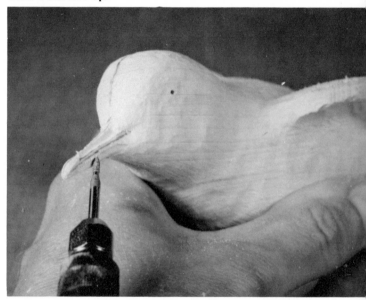

Figure 63. Using a very small diamond bit, create the depressions for the nostrils and the narrow linear depressions on the lower mandible.

Figure 64. Carefully shorten the tip of the lower mandible so that it fits up into the upper mandible's overhang.

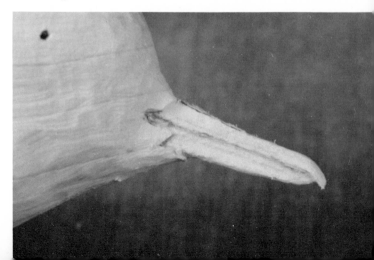

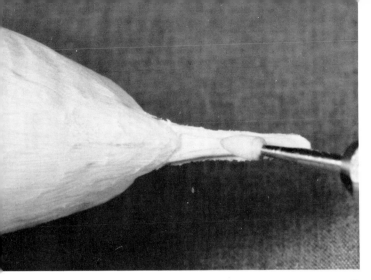

Figure 65. Using a small pointed stone, create a small v-shaped depression at the base of the lower mandible. This stone is very useful in smoothing the entire beak. Then lightly sand with very fine sandpaper. Do not sand away the details. Just remove any glitches.

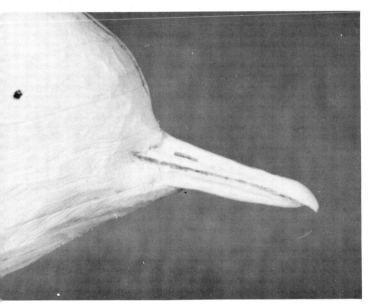

Figure 66. Redraw the commissure line. Mark in the nostril placement. Checking from the head-on and plan views, determine that the commissure lines and nostril marks are balanced.

Figure 67. Burn in the commissure lines. The first burn stroke should be perpendicular to the side of the beak. Lay the burning pen on its side for the second stroke and burn up to the first one. This creates the effect of the lower mandible fitting up into the upper one.

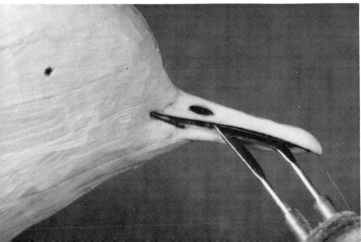

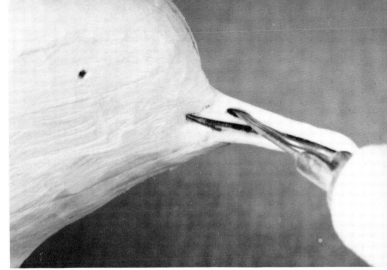

Figure 68. With a very small pointed burning pen, burn in the nostrils.

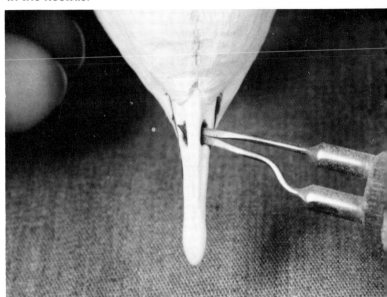

Figure 69. Carefully continue burning in from each nostril until finally the burned in slot goes completely through the bill beneath the culmen. Do not shoot your heat control too high for this, because you can easily burn through the top of the beak. Patience and time are the operative words in this procedure! If your burning pen is perpendicular to the beak, eventually the opening will be clear.

Figure 70. Fine sand along the commissure and nostril lines. Apply super-glue over the beak's surface. When the glue is dry, fine sand again with 400 grit paper.

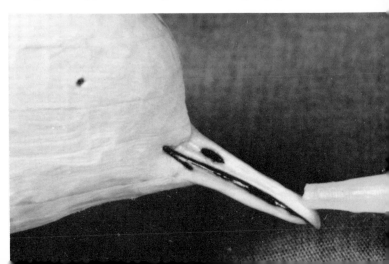

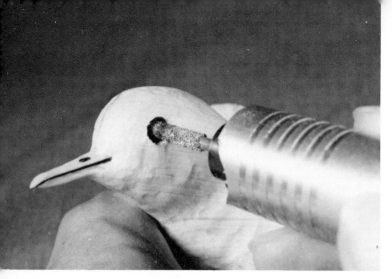

Figure 71. Recheck the eye positions from all angles. Adjust the positions if necessary. Drill 6 mm. eye holes approximately one-quarter inch deep.

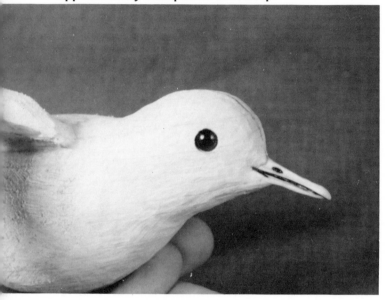

Figure 72. Fill the eye holes with oily clay. Clip the eyes off the wires and insert them, pushing them into place with the wooden handle of an awl or a dowel. Check the eyes from all angles and adjust if necessary.

Figure 73. Draw in the ear coverts on both sides of the head, making sure that they are equal in depth and length. Note that the ear covert divides the back of the eye equally and that it originates at the commissure line.

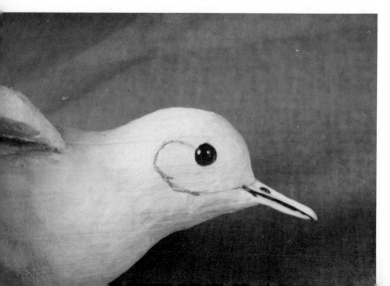

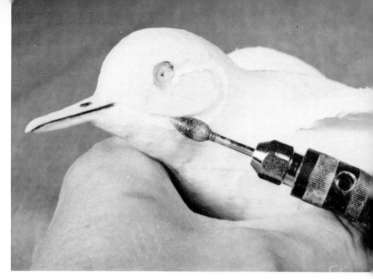

Figure 74. Remove the eyes to prevent scratching. Using a medium diameter ruby carver, make a channel around the ear covert. Be careful working near the beak.

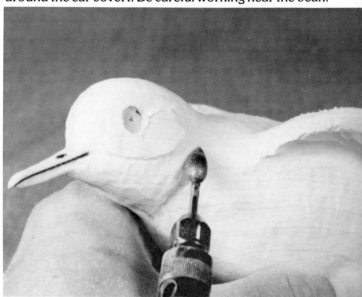

Figure 75. Flow the channel out onto the surrounding neck and throat area.

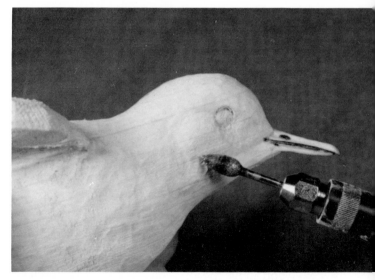

Figure 76. Round over the sharp channel edge on the ear coverts.

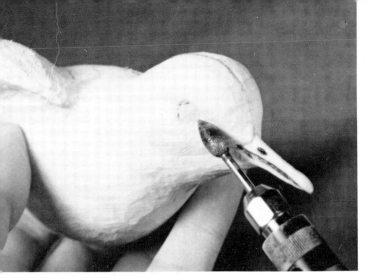

Figure 77. Relieve a small amount of wood in the front corner of each eye and the space between the eyes and base of the beak (lores).

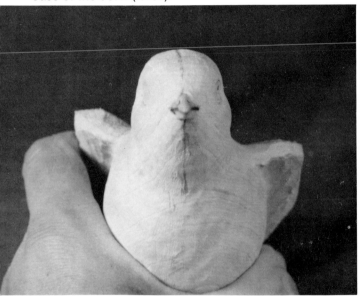

Figure 78. Note the fluffy look created in the ear coverts and the narrowness in front of the eyes.

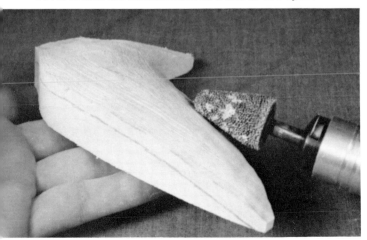

Figure 79. Using a large carbide cutter, remove the excess wood above the top wing line. Refer to Figures 12 and 13. All of the following procedures should be done on both wings.

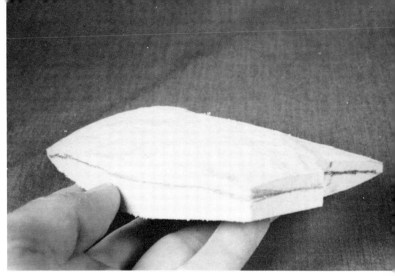

Figure 80. Note the curvature of the wing from the front tab area. The tab will be the part of the wing that will be glued into the body under the scapulars.

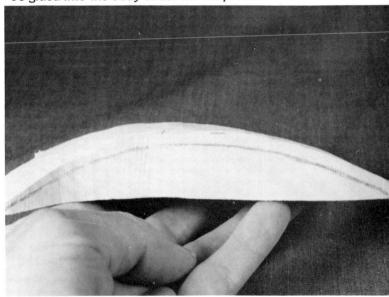

Figure 81. Here you see the contour from the back view of the right wing.

Figure 82. Remove the excess wood from the underside. For this roughing out stage, the front edge (leading edge) of each wing should be .2 of an inch thick and the back edge (trailing edge) .1 of an inch thick. The middle of the wing will be thicker. This will be thinned with each successive step.

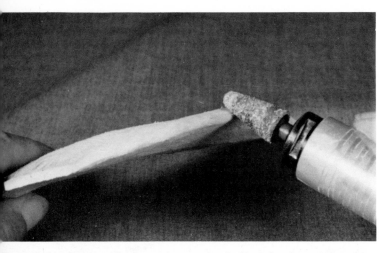

Figure 83. Round over the half of the front edge that will be nearest the body.

Figure 84. Draw a slightly curved line from the wrist to the leading edge of the tertials.

Figure 85. Make a shallow channel along this line with a medium tapered carbide bit.

Figure 86. Flow the channel out toward the wing tips, and round over the channel edge near the tab. This will further thin the middle and tip of the wing and leave a fullness to the part of the wing near the body. On a real bird, most all of the wing feathers are attached in this area near the wrist and along the forearm. The bulk of all these feathers and their quills causes a fullness not present in the rest of the wing.

Figure 87. Sand the upper and lower surface of the wings with a cartridge roll sander. Yes, the wing is getting thinner bit by bit!

Figure 88. Trace the feathers on the upper wing line drawing on tracing paper. Turn it over on a piece of scrap paper and go over the lines again with a soft pencil. Tape the traced wing on the wrist of one of the contoured wings and trace the wing feathers again. Some of the graphite on the tracing's underside will be pressed onto the wood. When the first wing is finished, turn the tracing over, tape it to the other wing's wrist and trace again. You may have to adjust some of the feather groups on the contoured wings.

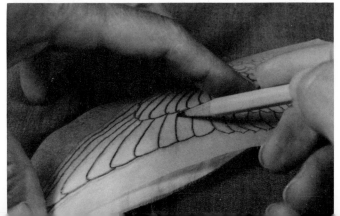

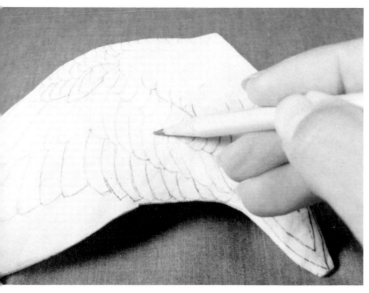

Figure 89. You will probably need to reinforce the graphite lines.

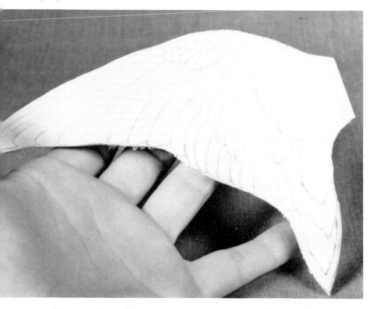

Figure 90. Cut away any excess along the wings' trailing edges with a carbide bit or bandsaw.

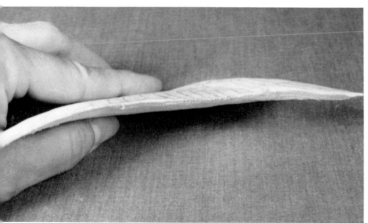

Figure 91. Using a carbide bit, thin the trailing edge of the wing from the *underside.*

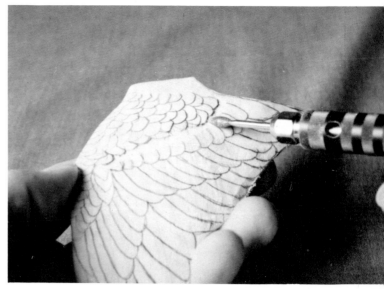

Figure 92. Using a pointed ruby carver or diamond bit, begin cutting out of the groups of wing feathers. The first group to cut around is the lesser secondary coverts. With this and all successive groups, you will need to cut around the whole group first and then each individual feather within the group. This is called stepping down or creating different levels for each group and each feather.

Every feather on a bird has a convex contour not only from base to tip of the quill but also from side to side (leading edge to trailing edge). The process of creating different levels helps to create each group contour and each feather contour within the group. When you have cut each group out, you will need to flow the channel out towards the surrounding areas, generally towards the wing tip and trailing edge of the wing. If in the process of flowing out you have to grind away other feather lines, put them back in right away. If you need to, you can use your tracing for reference. The last step is to round over each individual feather to give it contour.

In the next several pictures, note the different bits used to accomplish this contouring. A pointed diamond bit or ruby carver will be needed to get into tight corners. The small cylindrical stones are useful on longer straight runs, in that stones leave a smoother surface, requiring less sanding. Laying the cylindrical stone on its side will not only step down the level but also flow the surrounding area out in one step.

Figure 93. Relieve or step down the area around each of the three alula feathers.

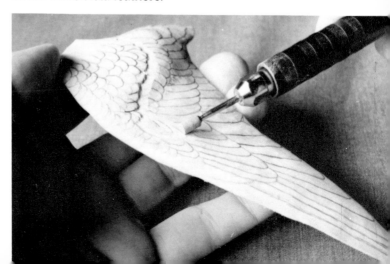

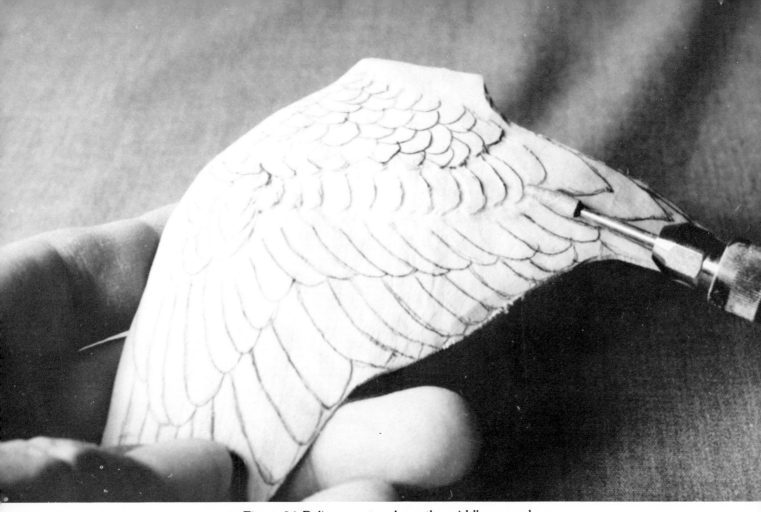

Figure 94. Relieve or step down the middle secondary coverts. Note the reverse overlap on this group.

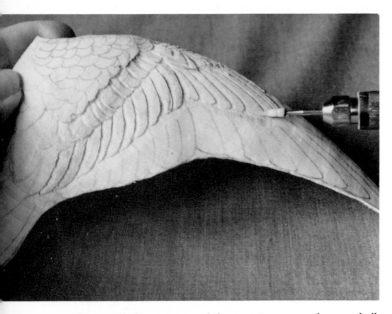

Figure 95. Carve around the greater secondary and all of the primary coverts.

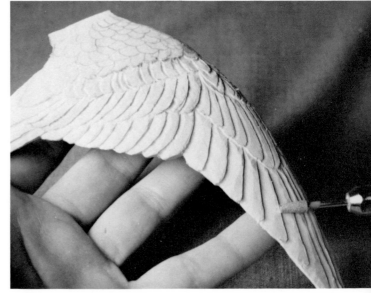

Figure 96. Relieve around the tertials, secondaries and primaries. You will need a sharp knife or pointed ruby carver to shape the tips.

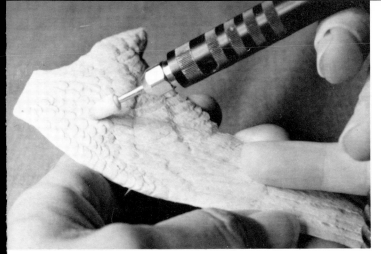

Figure 97. Using a bullet-shaped stone, relieve around each of the marginal coverts and round over each edge. Round over all of the feather edges on the top surface of the wings.

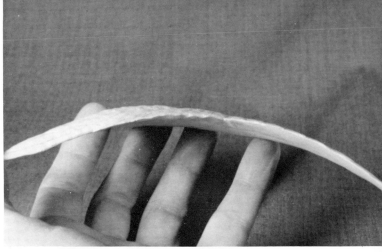

Figure 100. Thin the tips of the tertials, secondaries and primaries.

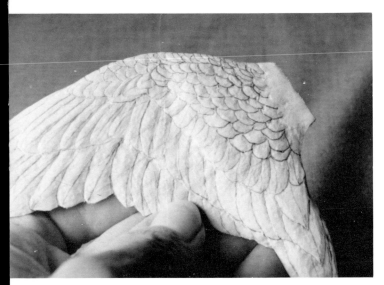

Figure 98. Use the bullet stone to alter shapes and sand the surface as necessary.

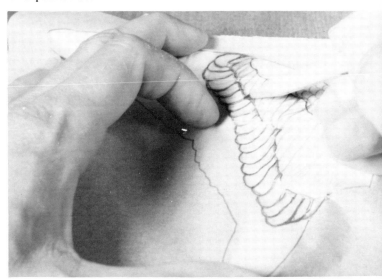

Figure 101. Trace the feathers on the underwing drawing. Transfer them to the contoured wings as you did the top surfaces.

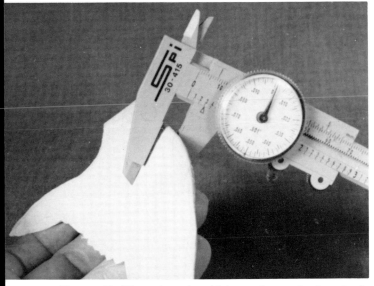

Figure 99. The wing should be at least .3 of an inch thick at this point. If you need to, thin it from the underside.

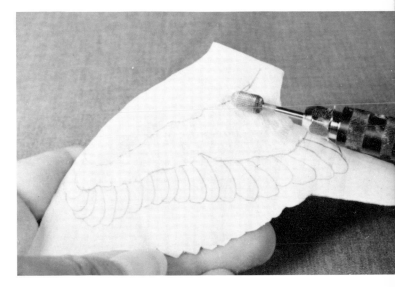

Figure 102. Channel around the lesser underwing and under primary coverts. Flow the channel out towards the wing's tip and trailing edge. Round over the channel's sharp edge on the coverts.

95

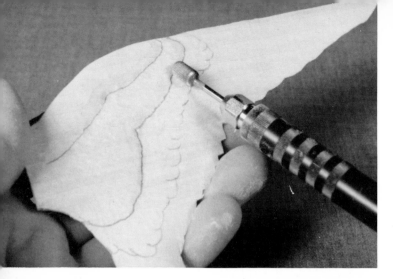

Figure 103. Channel around the middle underwing and under primary coverts. Flow the channel out and round over its other edge.

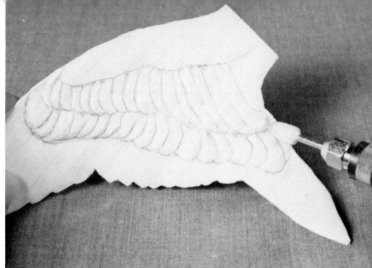

Figure 106. Using the white bullet stone, make a shallow cut around each greater and middle underwing primary and secondary covert. Round over each feather.

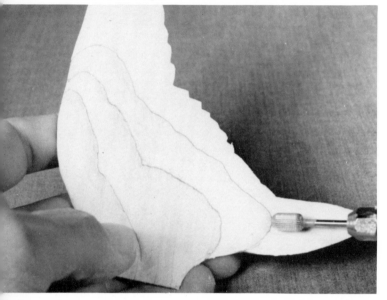

Figure 104. Channel around the greater underwing and under primary coverts. Flow the channel out and round over its other edge.

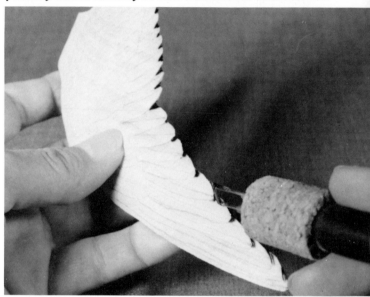

Figure 107. Starting on the topside of the wing, burn in around each primary and secondary tip. Then layout the trailing edges of the primaries and secondaries on the wing's underside.

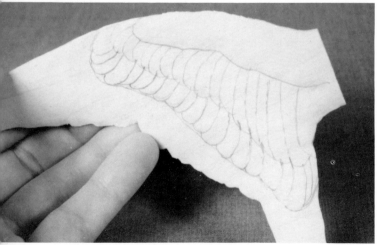

Figure 105. Redraw the individual feathers. Pay particular attention to the way in which the feathers overlap.

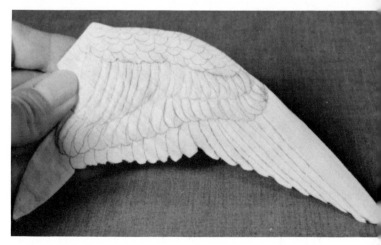

Figure 108. Draw in the underwing marginal and lesser coverts.

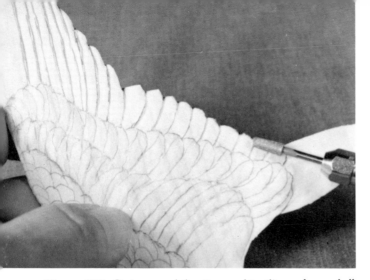

Figure 109. Cut around the tips and trailing edges of all of the primaries and secondaries.

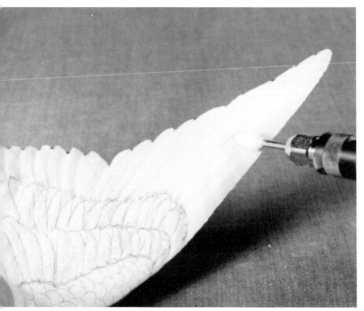

Figure 110. Using the white bullet, round over the edges.

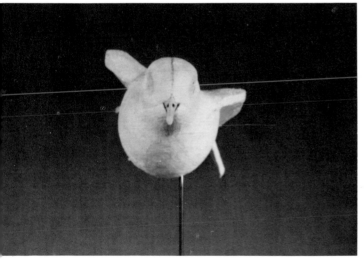

Figure 111. For temporarily mounting the sanderling, I used a rod and 2" x 4" scrap lumber. When you mount the bird, remember to keep the head level.

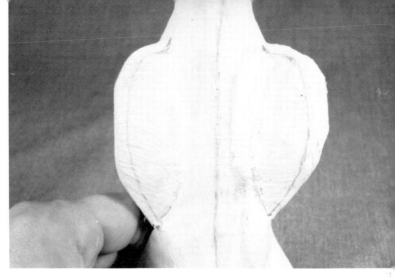

Figure 112. Referring to the plan view drawings, sketch in the proper size and shape of the scapular groups.

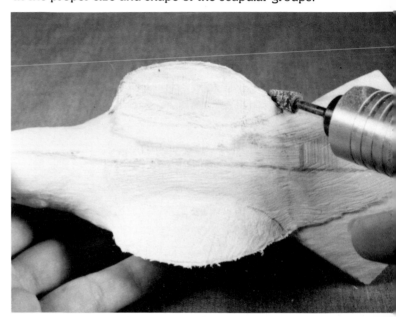

Figure 113. Cut away the excess around the scapulars.

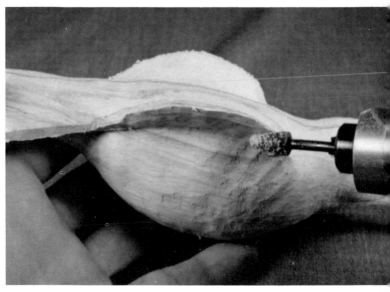

Figure 114. Thin the outer scapular edges on both sides of the body block.

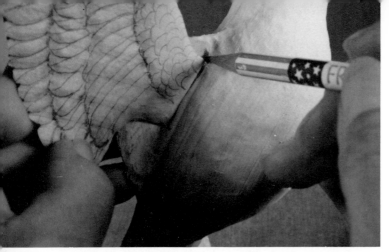

Figure 115. Holding each wing in place, mark the tab placements of each wing under the scapulars.

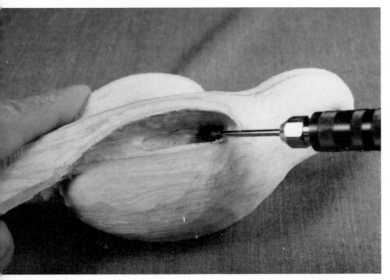

Figure 116. Remove enough wood for the wing tab to be inserted. You will find that it is a "try and see" procedure, removing wood and then seeing if the tab will fit.

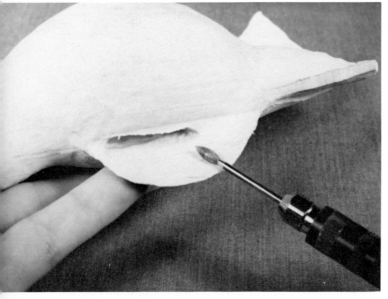

Figure 117. Carefully thinning the scapulars from underneath will facilitate the wing fitting.

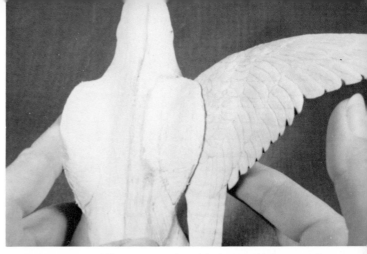

Figure 118. The wing should fit as tight to the underside of the scapulars as possible. This will necessitate you peeking under the scapular edge to see where its underside is too full. Minimizing the gap between the scapular underside and the top of the wing will enhance the realistic look and lessen any putty filling.

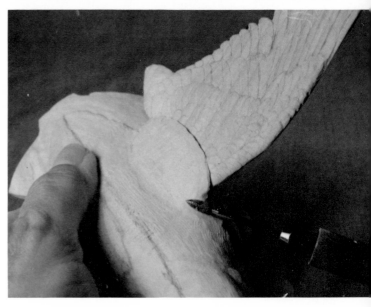

Figure 119. Shape the front of each scapular group so that there is a smooth flow from the body to wing.

Figure 120. Place both wings in their respective holes, but do not glue. If you inadvertently oversized the slots, use small wedges to hold wings in place. Check the bird's overall look.

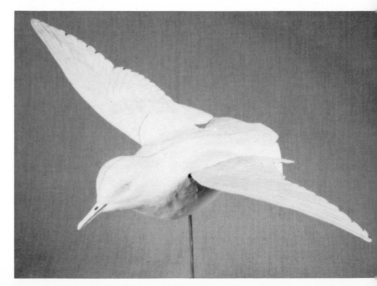

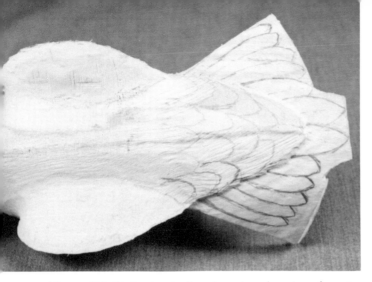

Figure 121. Referring to the plan view drawing, draw in the tail feathers on the top surface.

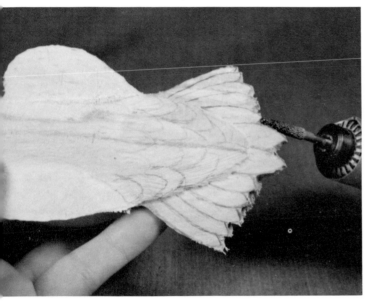

Figure 122. Cut away any excess around the tail feather tips.

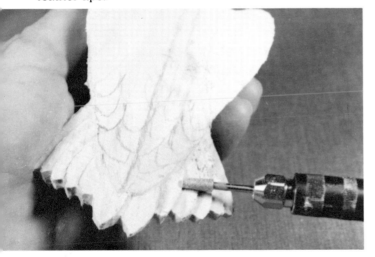

Figure 123. Starting with the center feathers, cut around each feather edge. Holding a cylindrical stone or bit horizontally will not only step down each edge but will also flow it out in one operation.

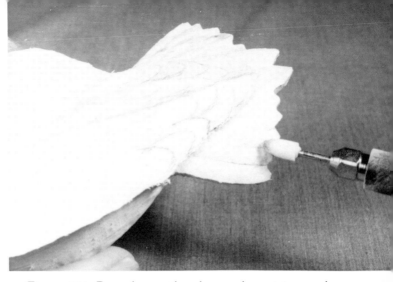

Figure 124. Round over the sharp edge, giving each feather a rounded contour.

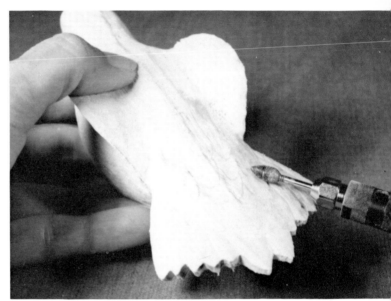

Figure 125. Draw in the upper tail coverts and relieve around each one.

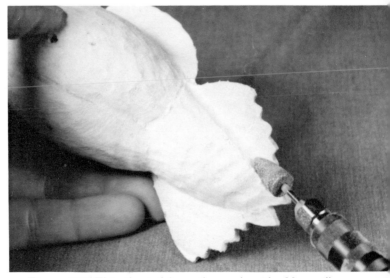

Figure 126. Thin the tail from the underside. You will need to deepen the channel around the lower tail coverts to reduce the bulk of the tail at its base.

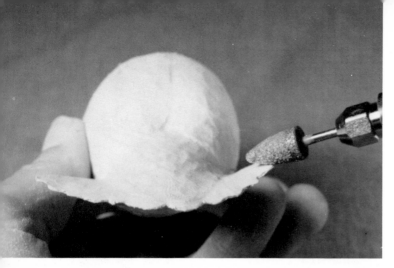

Figure 127. The base of each tail feather need not be as thin as the tip.

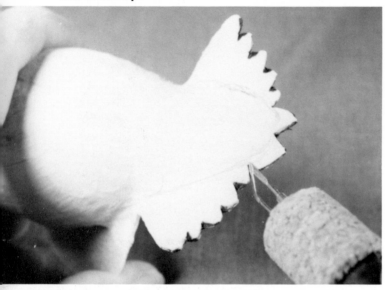

Figure 128. To separate each feather, burn in around each tip.

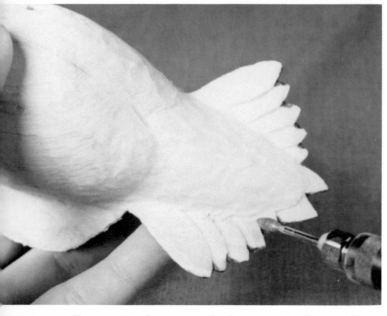

Figure 129. Starting with the outer feathers, relieve around each edge.

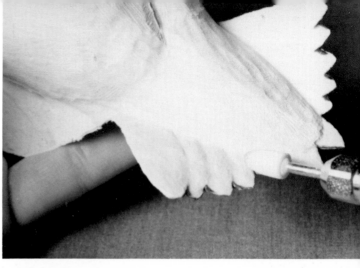

Figure 130. Using the white bullet, round over the sharp edge so that each feather has a rounded contour.

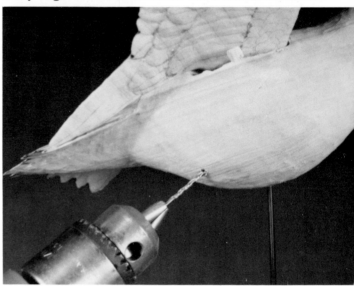

Figure 131. Place the bird back on its temporary mount and put the wings in the slots. Determine the placement of the trailing feet. Construct feet according to the directions in "Feet Construction" in *Basic Techniques*. Drill one-half inch deep holes for the feet.

Figure 132. Place the constructed feet in the holes, but do not glue. Check for desired position.

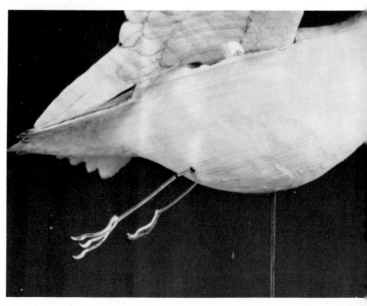

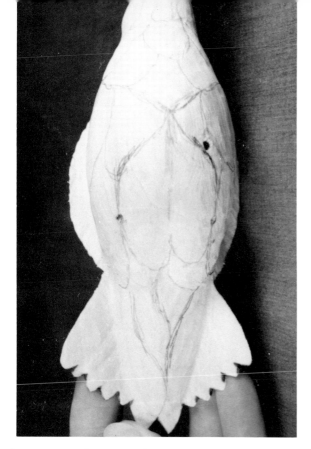

Figure 133. Draw in the feather contouring on the lower tail coverts, flanks, breast, belly, throat and chin.

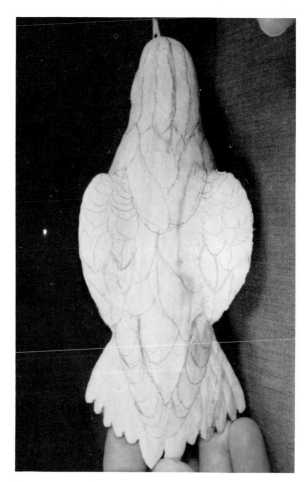

Figure 135. On the upper surface, draw in the contouring and the individual feathers on the scapulars.

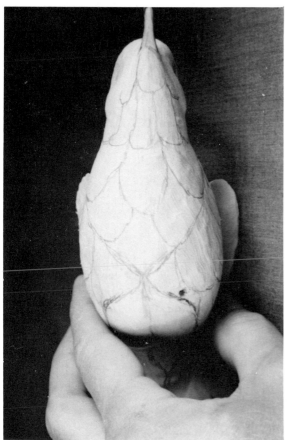

Figure 134. The puffs of feathers on the throat and chin should be smaller than those on the belly and lower tail coverts.

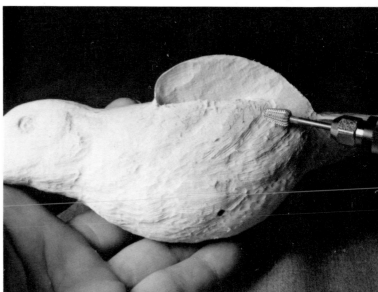

Figure 136. Begin cutting in the channels under the chin and work towards the under tail. Work in small areas at a time, cutting in the channels, flowing out and rounding over.

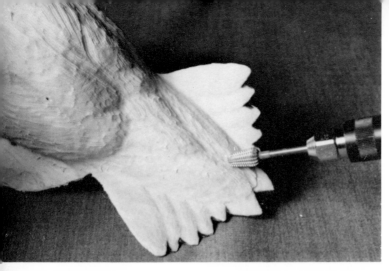

Figure 137. Remember to vary not only the size and shape of each feather puff, but also to vary the depth of the channels.

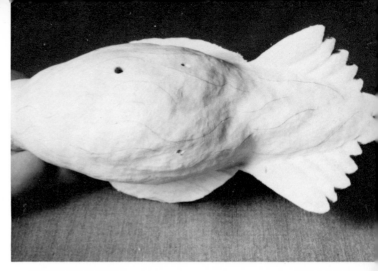

Figure 140. Here you see the subtle contouring on the belly and lower tail coverts.

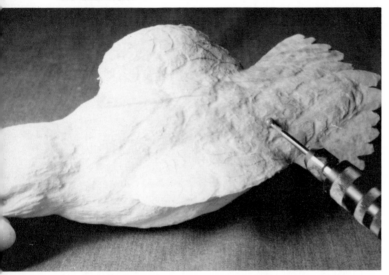

Figure 138. Contour the feather groups and the individual scapulars on the upper surface.

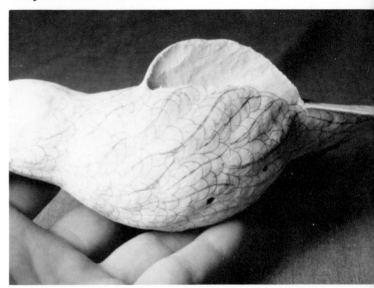

Figure 141. Draw in the feathers and their flow patterns.

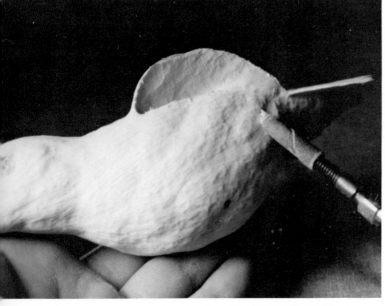

Figure 139. Sand and refine the contouring with a worn cartridge roll sander.

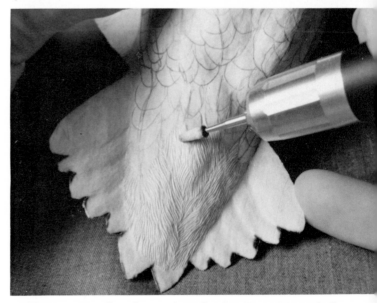

Figure 142. On the underside, begin stoning each feather at the tip of the lower tail coverts, working forward on the bird.

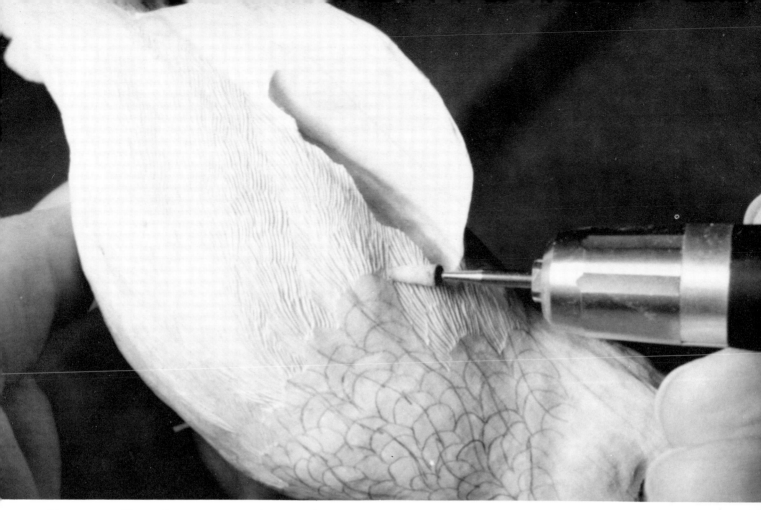

Figure 143. Keep the stoning strokes as close as possible. Leave no blank places. An adjustable light will allow you to see the stoning strokes more easily.

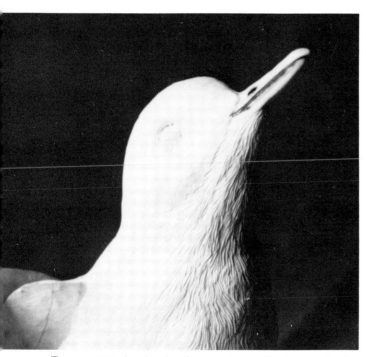

Figure 144. As the feathers get smaller towards the head, so should the stoning strokes. Smaller feathers require shorter barbs.

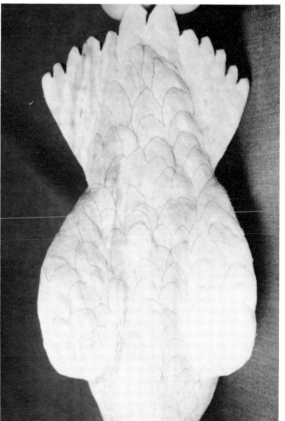

Figure 145. Draw in the remainder of the feathers on the upper surface.

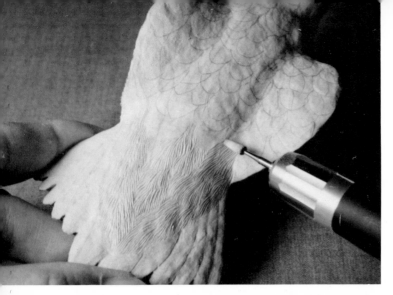

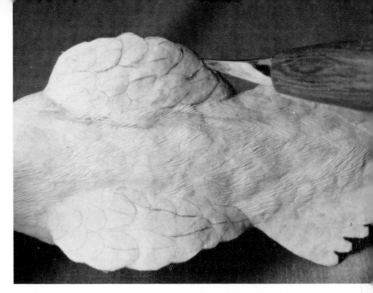

Figure 146. On the upper surface, begin stoning in the feathers at the base of the tail and work your way forward on the body.

Figure 148. Cut away any excess along the outer scapular edge. Note that the outer edges of the scapulars are not smooth, but that the edges vary.

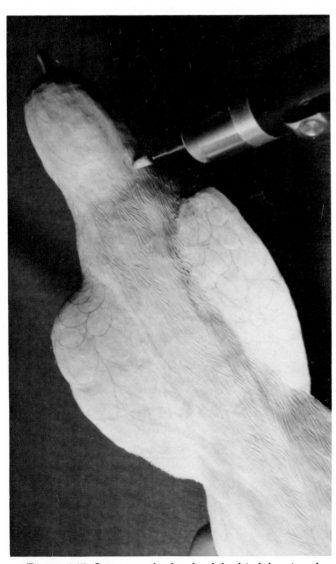

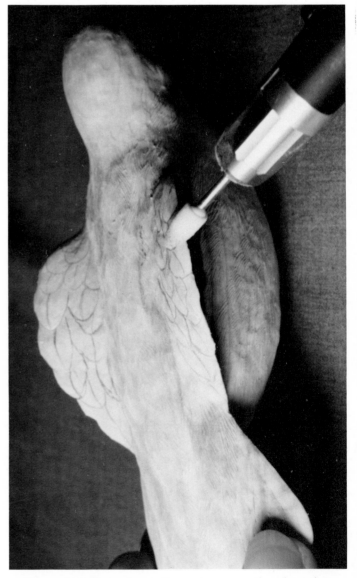

Figure 147. Stone up the back of the bird, leaving the scapulars unstoned at this point. Stop the stoning at the base of the neck.

Figure 149. Round over the outer scapular edges that needed trimming.

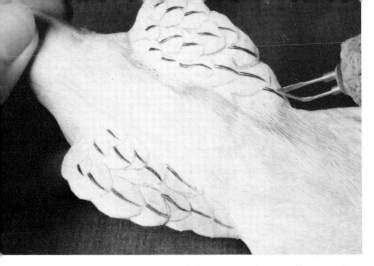

Figure 150. Draw and burn in the quills on the scapulars. Note the curvature of the quills.

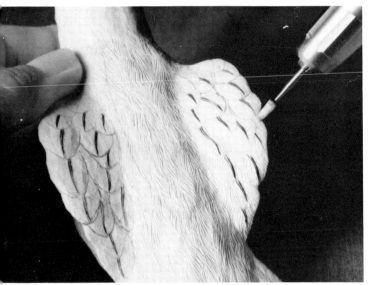

Figure 151. Beginning at the tip, stone in the barbs on the scapulars.

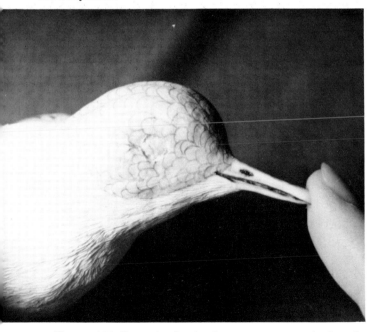

Figure 152. Draw in the feather patterns on the head.

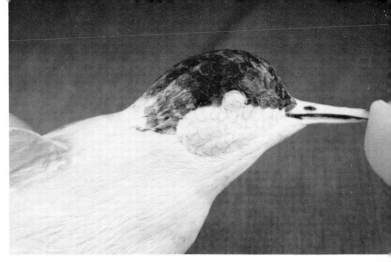

Figure 153. Starting at the base of the beak, burn in the barbs of the head feathers, working your way towards the back of the head. Burning from the front to the back of the bird will enhance a ruffled feather appearance.

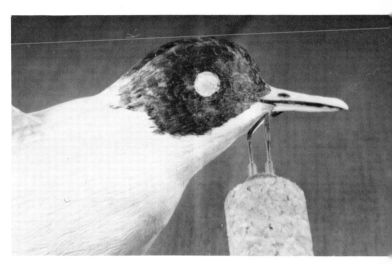

Figure 154. Burn in the barbs on the feathers around the beak where the stoning could not reach. Burn in the feather barbs on the ear coverts, sides of the head and lores.

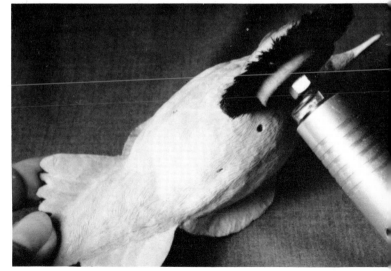

Figure 155. Clean up the stoning using a laboratory bristle brush with a light touch at slow speed. High speed or hard pressure will erase stoning.

105

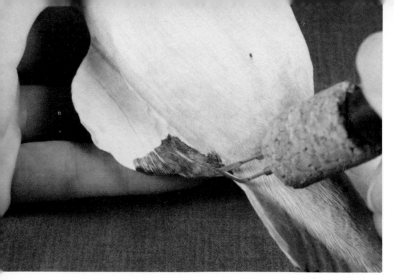

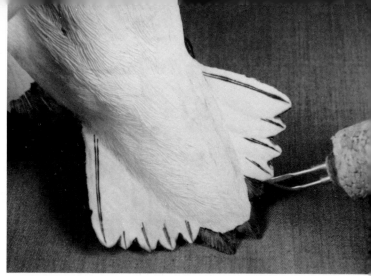

Figure 156. On the underside of the scapular tips, draw in the individual feathers that can be viewed from the underside with the wings in their slots. Draw and burn in the quills and then burn in the barbs.

Figure 159. On the underside of the tail, draw and burn in the quills. Begin burning in the barbs on the center feathers and progress towards the outer ones.

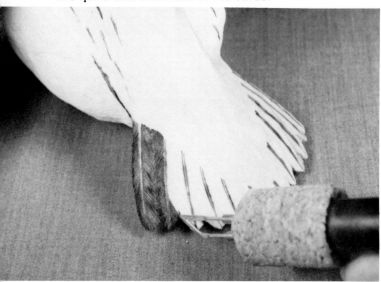

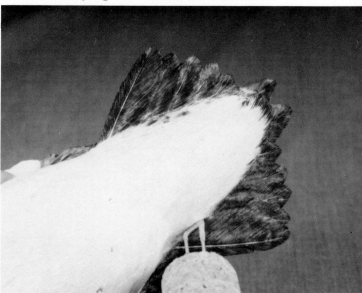

Figure 157. Draw and burn in the quills on the upper surface of the tail. Begin burning in the barbs on the outer feathers, working your way towards the center ones.

Figure 158. All burning should be cleaned up with a toothbrush.

Figure 160. Burn in the barbs and a few splits on the tips of the lower and upper tail coverts where the stoning could not reach.

Figure 161. Burn in a few splits and vary the edges on the outer scapulars.

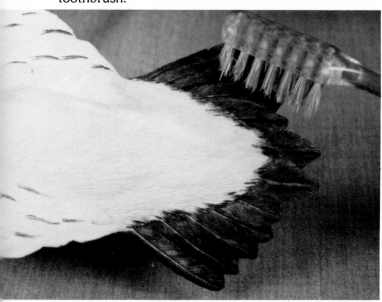

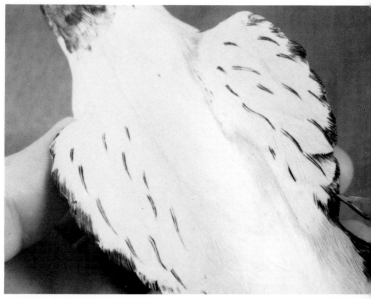

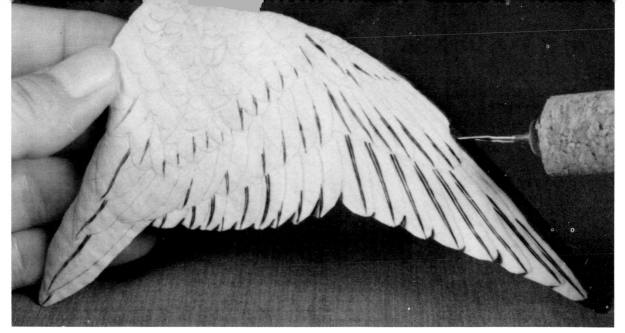

Figure 162. Draw and burn in the quills on the wings. Begin burning in the barbs on the outer primaries and progress inward toward the secondaries and then the longer tertials. Burning the feather underneath first and then the one on top creates and smooth, tightly knit appearance to feathers.

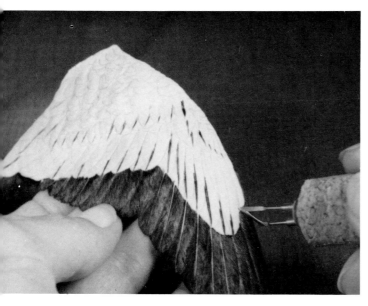

Figure 163. Begin burning barbs on the outer greater primary covert and progress inward toward the greater secondary coverts and the mid-length tertials.

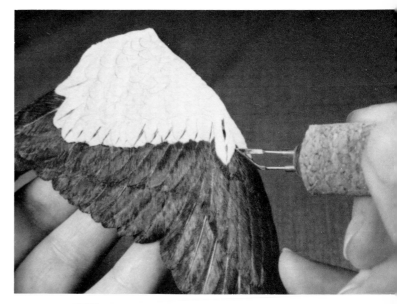

Figure 164. Next burn in the barbs on the middle primary coverts, alula and the middle secondary coverts.

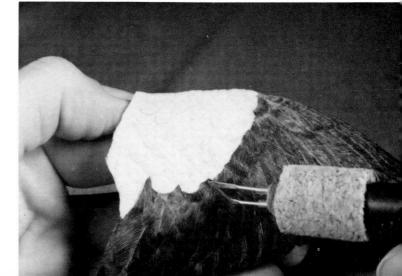

Figure 165. Then burn in the barbs on the lesser secondary and primary coverts, shorter tertials and marginal coverts.

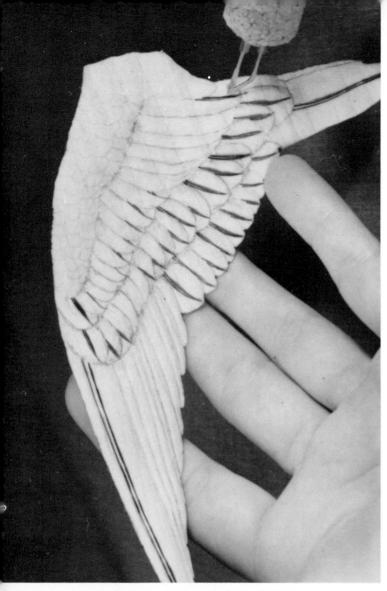

Figure 166. Draw and burn in the quills on the under surface of both wings.

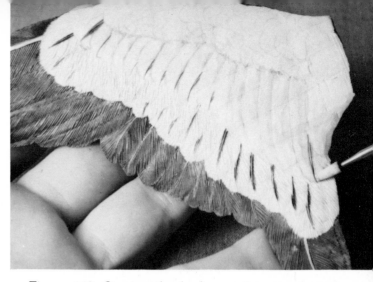

Figure 168. Stoning the barbs on the greater and middle underwing secondary coverts will give them a hair-like and fluffy look.

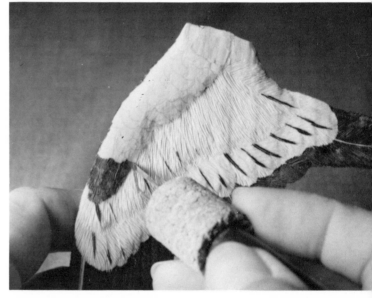

Figure 169. Burn in the barbs on the lesser and marginal underwing coverts. When the burning and stoning on both wings are completed, check their fit into the slots. Adjust the fit if necessary.

Figure 170. Insert the eyes according to the Eye techniques in *Basic Techniques.*

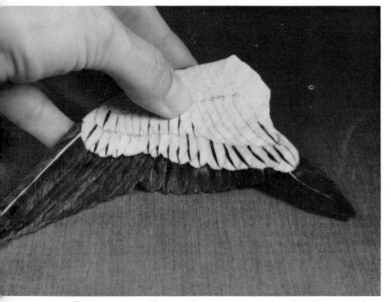

Figure 167. Begin burning in the barbs on the underside at the tertials and secondaries, progressing outward toward longest primary.

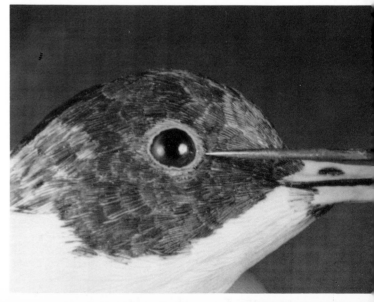

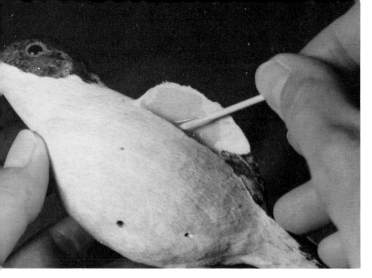

Figure 171. Mix up a batch of 5 minute epoxy. Put a small amount into one of the wing slots. Put the wing in place and hold until the glue has hardened. Then do the other wing. Do not use so much glue that it dribbles out onto the wing, flank or scapular.

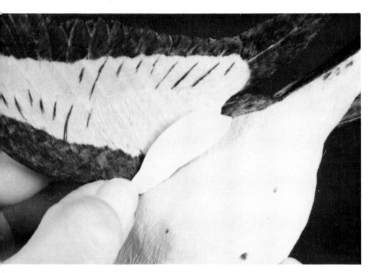

Figure 172. When the glue on the second wing has hardened, cut a piece of paper in the shape of the axillaries.

Figure 173. Using the axillary pattern, cut a piece of tupelo .3 of an inch thick.

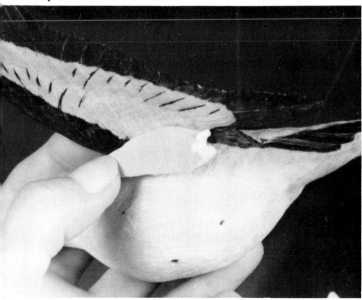

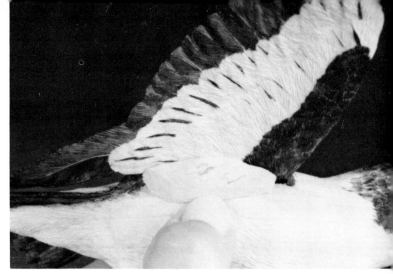

Figure 174. Shape the axillary blocks so that there is a tight fit between the block, the underside of the wing and the flank. You will need to cut and then fit, cut and fit, etc.

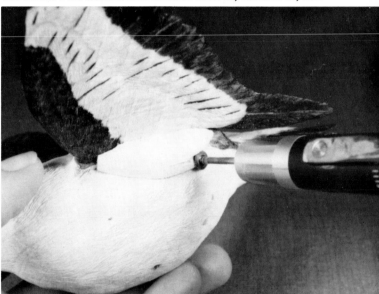

Figure 175. Stagger the ends of the axillaries so that the longest feathers are not even.

Figure 176. Glue each axillary group in place one at a time. Do not use so much glue that it runs out onto the wing or flank. When the glue is dry, cut around the axillary edges to create different feather levels and round over the edges.

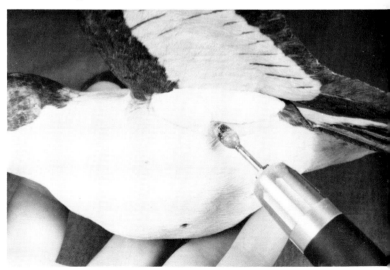

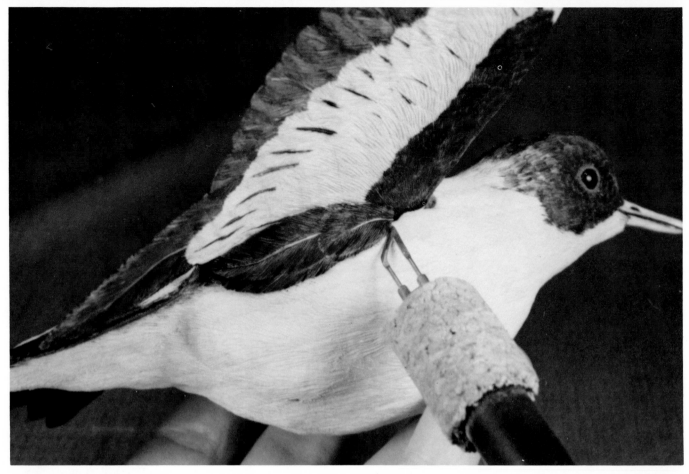

Figure 177. Draw and burn in the axillary quills and then burn in the barbs.

Figure 178. Mix up a small amount of the ribbon epoxy putty. Apply a small amount to the front edge of the wing and the underside in front of the axillary block. Create the small axillary feathers by pressing in the detail before the putty hardens.

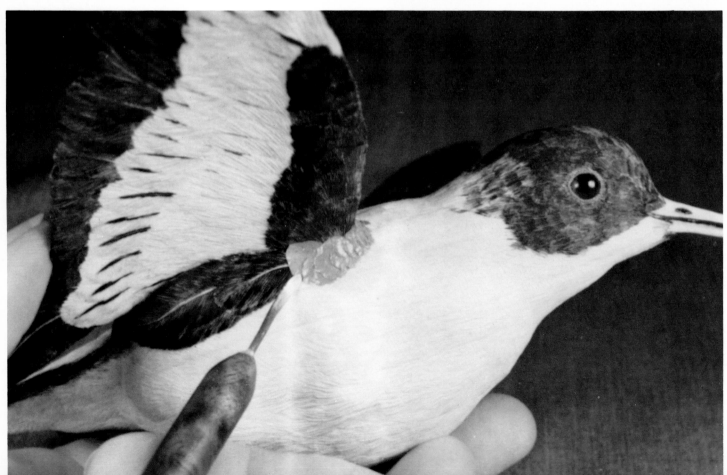

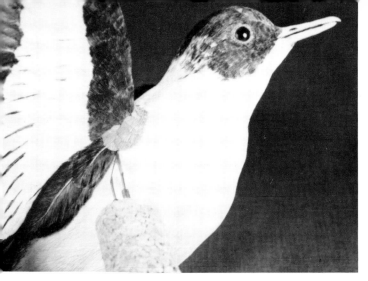

Figure 179. You can use a burning pen with *NO HEAT* to put in the barbs on the small axillaries.

Figure 180. If you have any gaps along the scapular/wing joint, use a small amount of the putty to create a smooth transition.

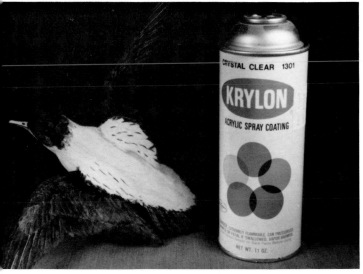

Figure 181. When the putty has hardened, spray the bird with *Krylon Crystal Clear* and allow to dry.

Figure 182. When you have constructed the support and habitat, you may need to apply a small amount of the ribbon putty to the belly entrance hole.

Figure 183. Blend the putty into the surrounding texture lines.

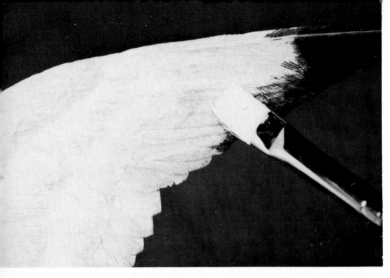

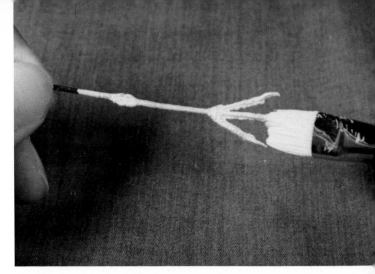

Figure 184. Using a stiff bristle brush, apply gesso to the entire bird using a dry-brush technique.

Figure 185. Also gesso the sanderling's feet. The feet will not be glued in place until the painting has been completed.

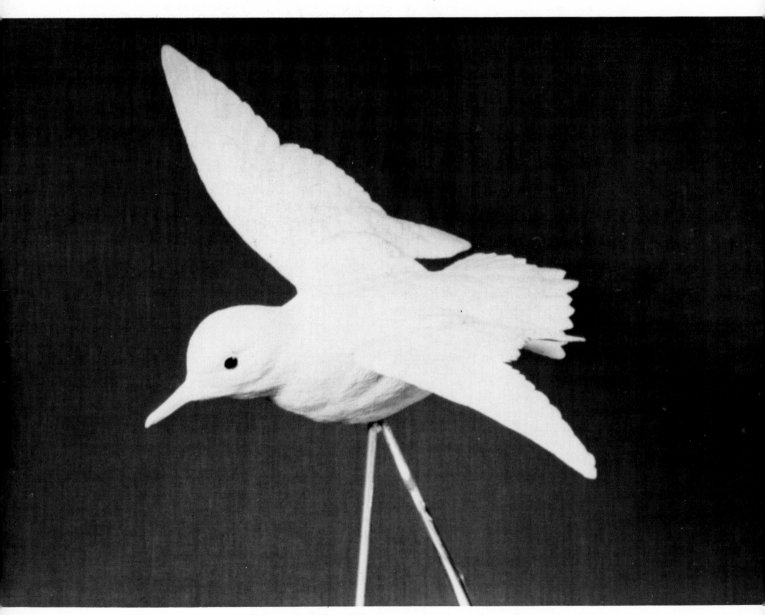

Figure 186. Carefully scrape the gesso from the eyes and the bird is ready for painting!

PAINTING THE SANDERLING
(Non-breeding Plumage)

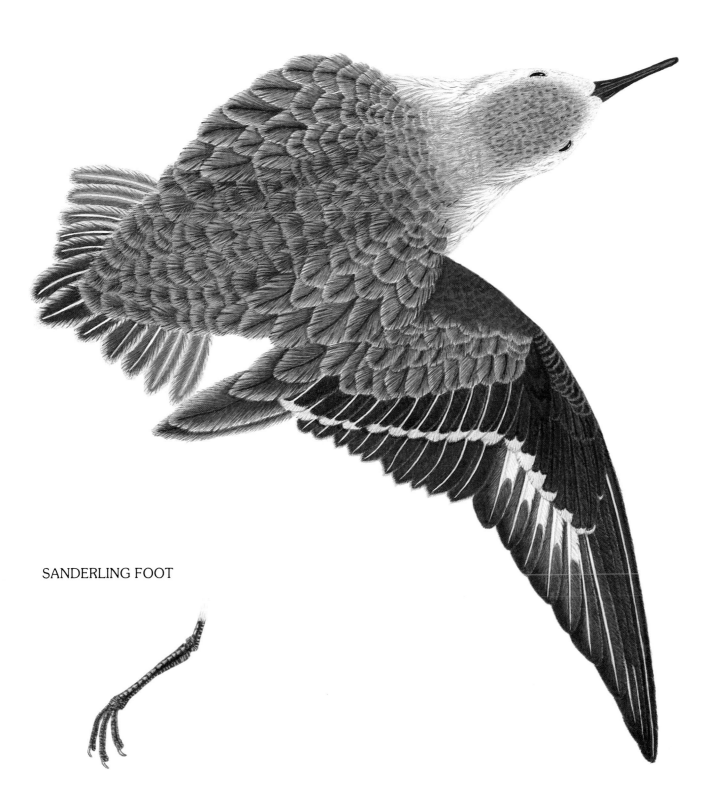

SANDERLING FOOT

Acrylic Colors needed

Payne's grey
Cerulean blue
Burnt umber
Raw umber
Black
Gesso (for white)

Upper wing surfaces and scapulars

Burnt umber with small amounts of payne's grey and gesso (white)

Use a very thin wash to blend light centers and dark edges of primaries

Burnt umber with a small amount of payne's grey

Thin wash to secondaries and primaries (except for white areas) and to greater secondary and greater primary coverts

Burnt umber with small amount of white

Darken leading edges of greater and middle primary coverts and the leading and trailing edges of all three alula feathers

Burnt umber and payne's grey

For all whites on wings, including edgings on middle secondary coverts and tertials

White (gesso) with small amount of raw umber

Interior of tertials, middle secondary coverts and scapulars

Burnt umber, payne's grey and white (gesso)

Dark centers of middle secondary coverts and tertials

Burnt umber, payne's grey and small amount of white (gesso)

Very thin wash over all whites on wings

Burnt umber

Back of neck, back, rump, scapulars, and upper tail coverts

Cerulean blue,
burnt umber,
and white

Raw umber,
peyne's grey,
and white
(gesso)

Centers of upper tail surface

Burnt umber, payne's grey, and white (gesso)

Belly, flanks, lower tail coverts, breast, chin, and a small amount on ear coverts

White (gesso) with small amounts of burnt umber and payne's grey

Sanderling
Tertials
(Enlarged to show detail)

1. Burnt umber, payne's grey, and white to base coat tertials, leaving edges light.

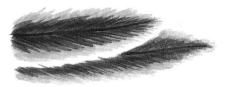

2. Darken quills and interiors of tertials with a mixture of burnt umber and payne's grey.

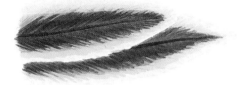

3. Apply a light mixture of white with small amounts of burnt umber and payne's grey.

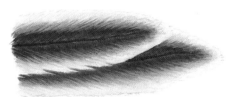

4. Blend all three values into soft transition, and apply a very thin burnt umber wash.

Top of Head
(Enlarged to show detail)

1. Burnt umber, cerulean blue, and white dry-dabbing strokes.

2. Raw umber, payne's grey, and white dry-dabbing strokes. Alternate two mixtures.

3. Highlight edges with white and small amounts of raw umber and payne's grey.

4. Darken quills and centers of feathers with a mixture of burnt umber and payne's grey.

115

Figure 1. Note the subtle shades of grey in the non-breeding (winter) plumage in the profile view of the sanderling.

Figure 2. There is a band of lighter greys at the base of the hind neck.

Figure 3. Here you see the upper surface of the sanderling's wing.

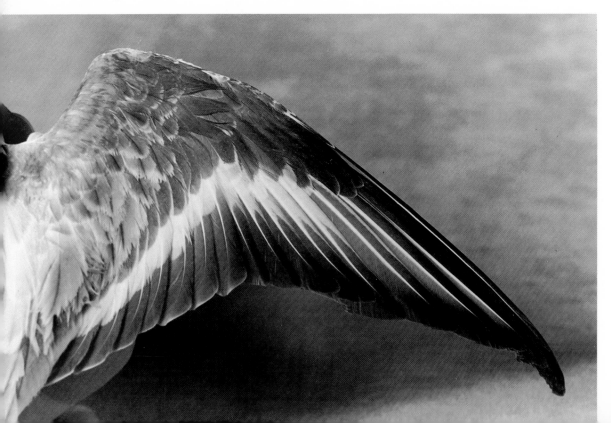

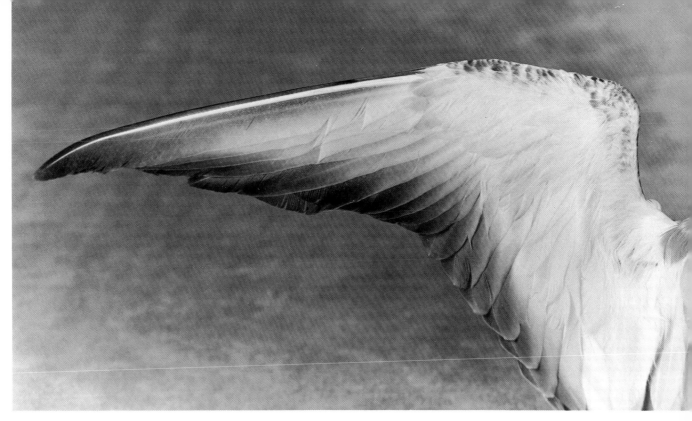

Figure 4. Note the hair-like quality of the underwing coverts.

Figure 5. The upper bird is the non-breeding (winter) sanderling and the lower one, the breeding (summer) plumage.

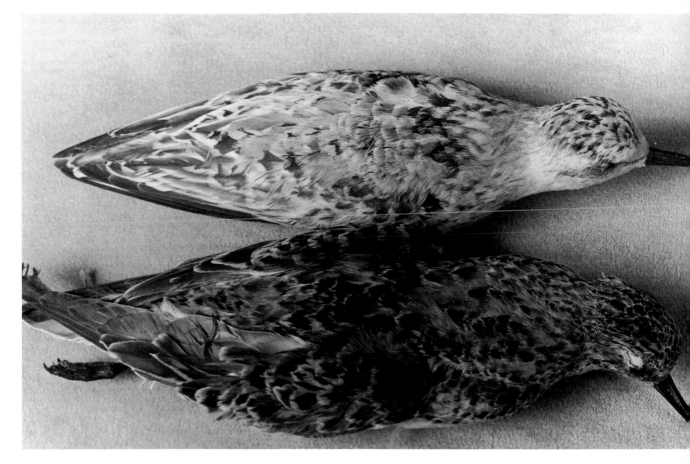

Figure 6. The discrepancy is size between the breeding and non-breeding sanderlings is due to the difference in the amount of cotton stuffing and the resulting skin stretching of the different study skins. Accurate body size cannot be obtained from study skins.

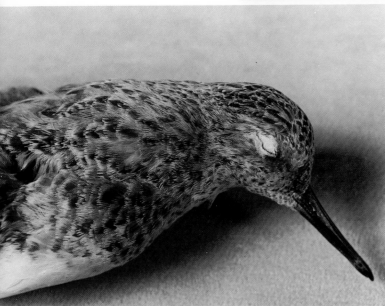

Figure 7. Note the amount of chestnut coloring in the summer bird.

Figure 8. The darker grey centers of the scapulars and tertials are characteristic of the non-breeding bird.

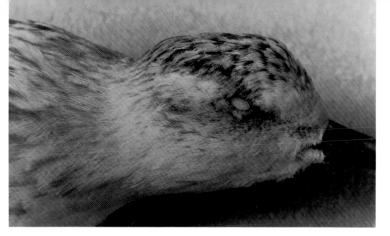

Figure 9. The darker grey centers are also evident on the crown feathers.

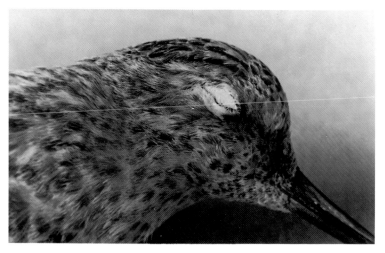

Figure 10. The head of a breeding plumage sanderling.

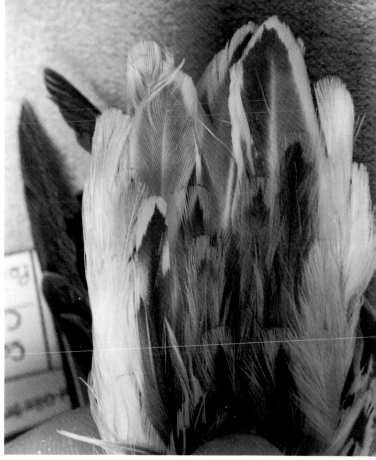

Figure 11. The dark centers of the tail feathers gradually lighten towards the outer ones.

Figure 12. Note the feather patterns on the scapulars and tertials.

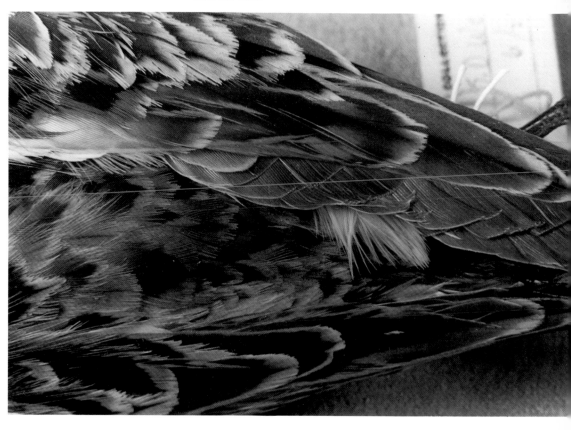

Figure 13. Add payne's grey and white to burnt umber to make a medium charcoal mixture and apply to the scapulars and wings. While the charcoal is still wet, blend more white into the scapular, tertial and middle secondary covert areas. It will take several applications of the paint mixture and then additional white to cover the original gesso and to obtain softly blended areas. Keep your paint thin so that it does not fill in the texture grooves.

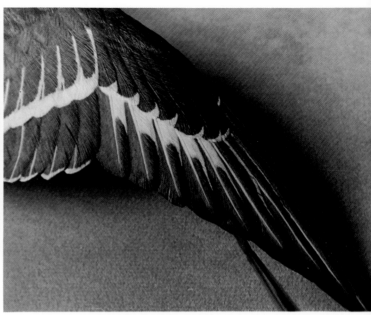

Figure 15. Darken the edges of the secondaries and primaries with a mixture of burnt umber, payne's grey and a small amount of white.

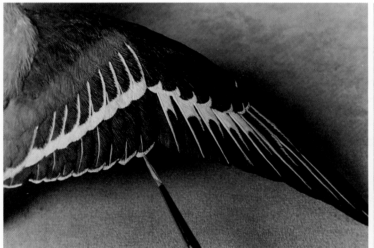

Figure 14. Use a liner brush and straight gesso to lighten the quills of the secondaries and primaries, the secondary tips, the tips and leading edges of the greater secondary coverts, the tips of the greater primary coverts and the light areas at the leading edges at the bases of the primary feathers.

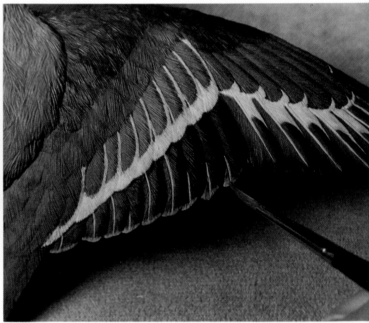

Figure 16. You will need to blend the medium centers with the dark outer portions and then the light tips of the secondaries and primaries.

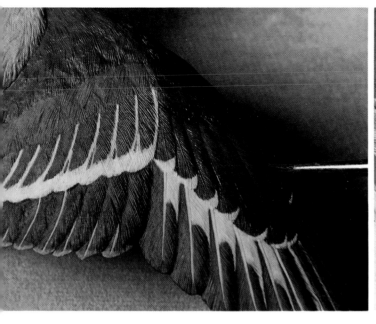

Figure 17. Apply a very thin burnt umber and payne's grey wash mixture on the dark areas of the greater secondary and primary coverts, the alula and the middle and lesser primary coverts.

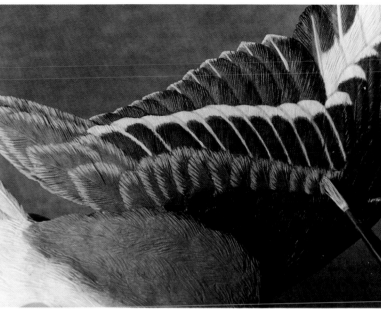

Figure 19. With a mixture of white with a small amount of raw umber, reinforce the white areas on the wing and dry-brush light edgings on the middle secondary coverts and tertials.

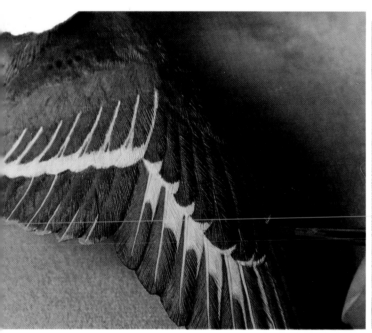

Figure 18. Using a very thin mixture of burnt umber and payne's grey, darken the leading edges of the greater and middle secondary edges, the leading and trailing edges of all three alula feathers and the quills of the greater and middle primary coverts and the alula.

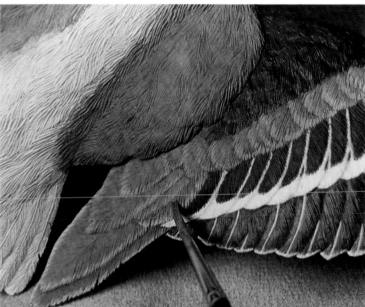

Figure 20. Mix burnt umber, payne's grey and white to a medium grey and apply to the interior of the tertials, middle secondary coverts and the scapulars.

121

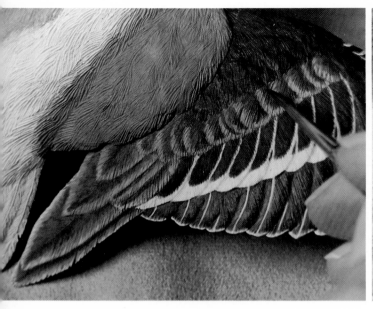

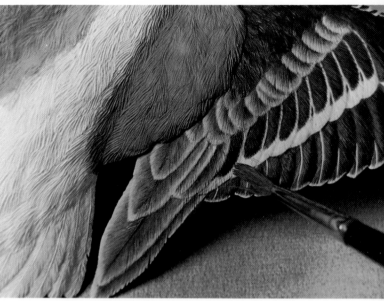

Figure 21. Using payne's grey, burnt umber and a small amount of white, darken the centers of the tertials and the middle secondary coverts.

Figure 23. Apply a very thin, watery burnt umber wash to all of the white areas of the wings.

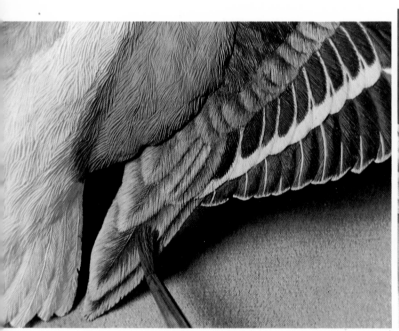

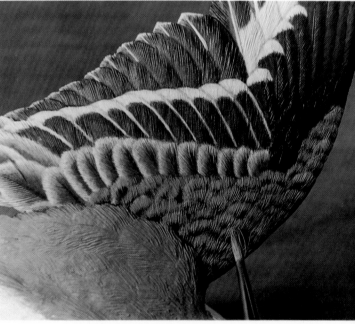

Figure 22. Apply a very thin, watery burnt umber wash to the tertials and middle secondary coverts. Then apply the dark, medium and light grey applications again. It will take several applications and burnt umber washes to obtain a soft, natural transition between dark, medium and light greys.

Figure 24. Apply a medium grey mixture of burnt umber, payne's grey and white to lesser secondary and primary coverts and the marginal coverts. Lighten the edges of the lesser secondary and primary coverts and the marginal coverts.

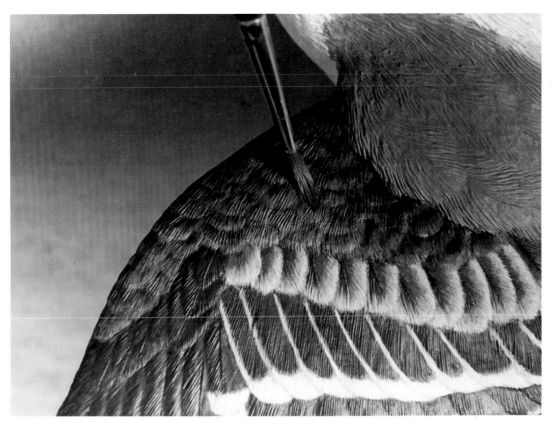

Figure 25. Apply a very thin, watery burnt umber wash to the lesser secondary and primary coverts and marginal coverts.

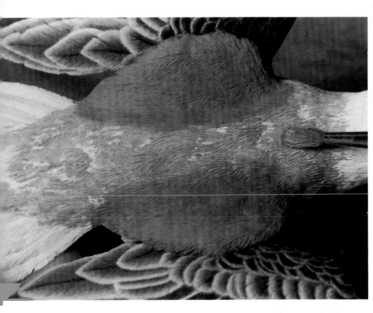

Figure 26. Mix cerulean blue, burnt umber and white to a soft grey. Fill the brush with paint, wipe the excess on a paper towel and apply in a random, dabbing strokes to the back of the neck, back, rump, scapulars and upper tail coverts. This is not an all over coat of paint but a hit and miss pattern.

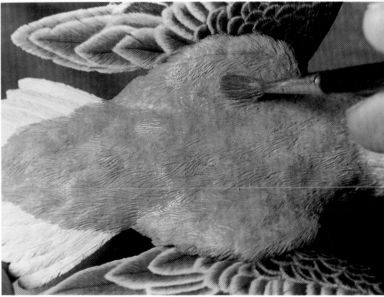

Figure 27. Make a second grey mix with raw umber, payne's grey and white. Again fill the brush with paint, wipe the excess on a paper towel and apply dabs of dry-ish paint to the same areas. Keep alternating the two grey colors until the gesso is covered and both colors of grey are evident.

123

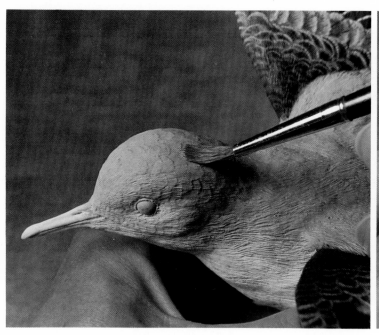

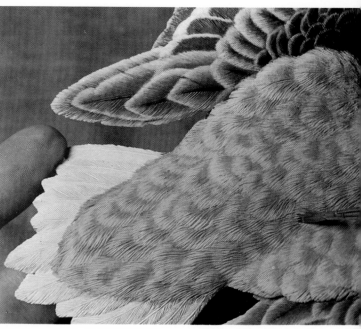

Figure 28. Adding more white to both mixtures, alternate the two on the top of the head and down the back of the neck.

Figure 29. Lightly dry-brush white with small amounts of raw umber and payne's grey on the edges of the feathers on the head, back, scapulars, rump and upper tail coverts.

Figure 30. Mix burnt umber and payne's grey to a dark charcoal color and darken the centers and major quills on the head, back, scapulars, rump and upper tail coverts.

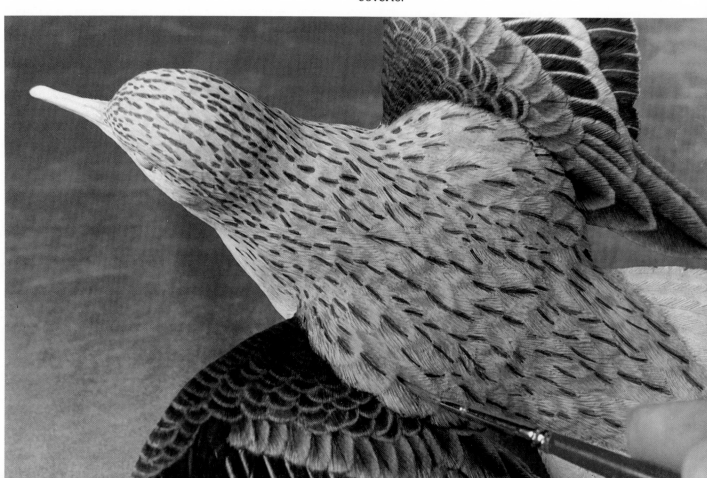

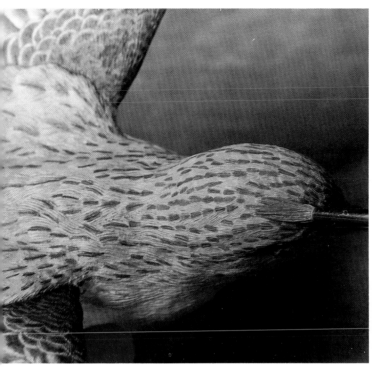

Figure 31. Make a very light grey mixture with white and small amounts of burnt umber and payne's grey and apply to the edgings of the feathers on the head, back, scapulars, rump and upper tail coverts. Then apply a wash of burnt umber, payne's grey and a small amount of white. It will take several edging and wash applications to get a soft transition. Adjust the colors with each wash and edging application so that the dominant color is a soft, medium grey.

Figure 33. Make a dark grey mixture with burnt umber, payne's grey and a small amount of white and apply to the interior of the two center tail feathers, leaving the quills and the edges white. Add a little more white to the dark grey mixture and do the next two feathers (leaving the edges white) outside the center ones. Continue adding more white and proceeding to do the interiors of the tail feathers toward the outer edges. Mix a small amount of raw umber and white and reinforce the white on the quills and edges, blending them into the darker centers. Then apply a very thin, watery burnt umber wash.

Figure 34. Basecoat the entire under wing surfaces with a mixture of white with a small amount of raw umber. Mix burnt umber, payne's grey and a small amount of white to the centers of the marginal coverts in the wrist area.

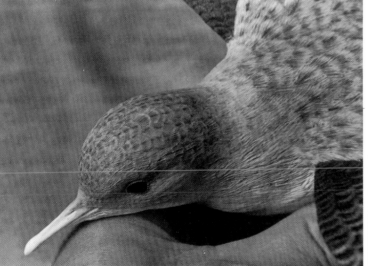

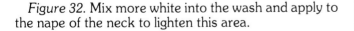

Figure 32. Mix more white into the wash and apply to the nape of the neck to lighten this area.

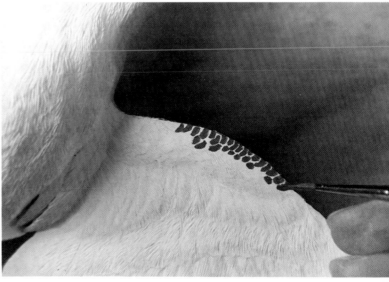

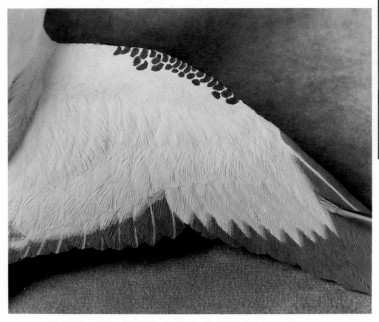

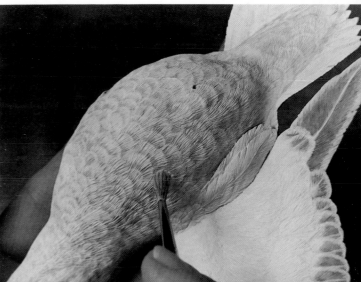

Figure 37. Make a light grey mixture with white and small amounts of burnt umber and payne's grey and apply several basecoats to the belly, flanks, lower tail coverts, breast, throat and chin. Lightly dry-brush the light grey mixture on the ear coverts.

Figure 35. Make a medium grey mixture with burnt umber, payne's grey and white and apply to the primaries, secondaries and tertials, leaving their quills the basecoat white. Blend the grey into the whitish basecoat. Keep working the medium grey into the grey mixture and the whitish grey mixture into each other until there is a soft blend.

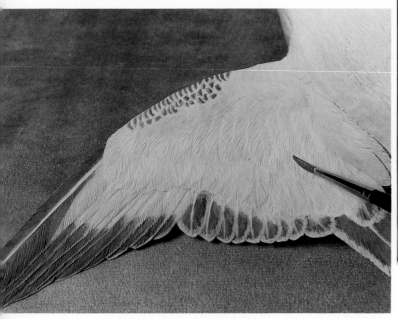

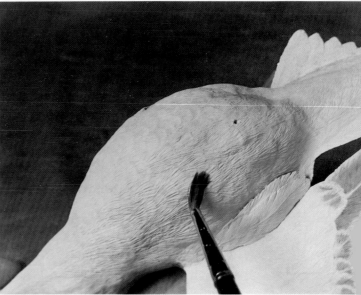

Figure 36. Using straight white, lightly dry-brush all the edges of the underwing feathers.

Figure 38. Lightly dry-brush straight white on these same feathers on the underside of the bird. Apply a very thin, watery wash of a mixture of white and a small amount of raw umber. Repeat the white edgings and the wash again.

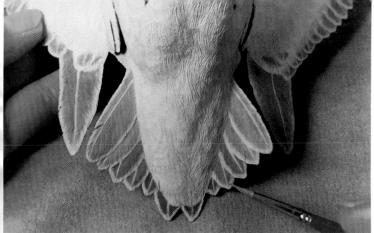

Figure 39. The under surface of the tail is similar to the top surface except the greys are lighter and more silvery. Use a medium grey mixture of burnt umber, payne's grey and white for the center feathers, leaving the quills and edgings white. Adding a little more white to the grey mixture, begin painting the remaining feathers progressing toward the outside edge and getting lighter toward the outer feathers. Add a small amount of raw umber to white and reinforce the quills and the light edgings. Apply a thin wash of white with a small amount of raw umber to the entire under surface of the tail.

Figure 42. Then apply a very thin, watery burnt umber wash to the area around the eyes.

Figure 43. Paint the beak a mixture of black and burnt umber.

Figure 40. Make a dark grey mixture with burnt umber, payne's grey and a small amount of white and lightly apply to the centers of the feathers around the eyes in a spotty pattern.

Figure 41. Using a liner brush and straight white, highlight the edges of the feathers on the ear coverts and around the eye.

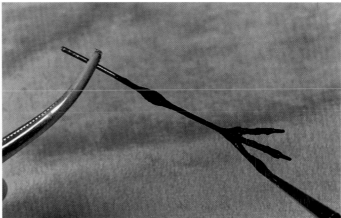

Figure 44. Paint the feet and legs a mixture of black and burnt umber. It will take several applications. When this is dry, mix a small amount of gloss in a large puddle of water and apply to the feet. When this is dry, apply straight gloss medium to the claws and all of the quills.

127

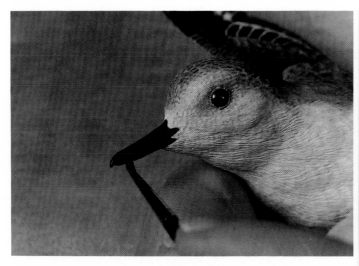

Figure 45. Apply a 50/50 mixture of matte and gloss mediums to the beak. Carefully scrape the eyes.

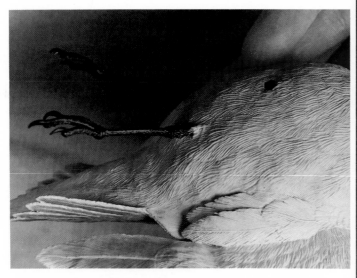

Figure 46. Glue the legs in place with super-glue. When the glue is dry, mix some ribbon putty and apply a leg tuft around the joint. Texture in a feathery pattern. When the ribbon putty has hardened, apply several coats of gesso, drying in between. The basecoat for the leg tufts is a mixture of white with small amounts of burnt umber and payne's grey. Lightly highlight with straight white. Wash with a mixture of white and a small amount of raw umber.

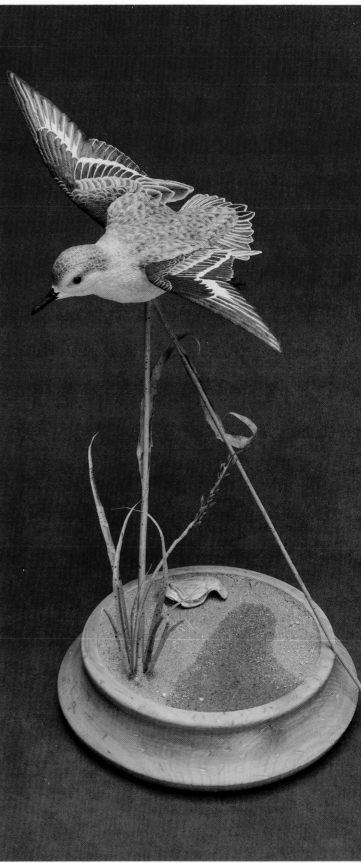

Figure 47. When this is dry, carefully slide the bird onto the square tubing coming out of the reed. The sanderling is flying!

Chapter 5.

Greater Yellowlegs

(Tringa Melanoleuca)

The greater yellowlegs, a tall elegant wader, is a bird common to the tidal mudflats and marshes, small pools and edges near lakes, rivers and occasionally the ocean beaches. It has a characteristic bobbing walk in which its whole body goes up and down. Both sexes are similar in their plumages, with the female tending to be slightly larger in size. The yellowlegs' long, slightly upturned beak, long neck and long.

Feding singly or in small flocks, the yellowlegs' food supply consists of small crustaceans, worms and insects and their larvae. Rather than probing the mud or sand with its long beak, as some of the other long-beaked shorebirds do, the yellowlegs swings its beak back and forth in the water trapping food stuffs between the mandibles. Sometimes this wader will open its beak and plow straight ahead like a bulldozer and clamp its beak shut on a surprised creature.

The breeding yellowlegs usually lays four eggs in a depression on the ground in a marshy or boggy area. The eggs are incubated by both parents for about three weeks. Within approximately three weeks, the young birds will be flying about and left to their own resources.

DIMENSION CHART

1. End of primaries to end of tail	.4 of an inch
2. Length of wing	7.5 inches
3. End of primaries to alula	5.5 inches
4. End of primaries to top of 1st wing bar	4.5 inches
5. End of primaries to bottom of 1st wing bar	5.6 inches
6. End of primaries to end of tertials	2.0 inches
7. End of primaries to mantle	5.0 inches
8. End of primaries to end of secondaries	3.9 inches
9. End of primaries to end of scapulars	3.2 inches
10. End of primaries to end of primary coverts	3.5 inches
11. End of tail to front of wing	7.1 inches
12. Tail length overall	3.3 inches
13. End of tail to upper tail coverts	1.2 inches
14. End of tail to lower tail coverts	.3 of an inch
15. End of tail to vent	3.3 inches
16. Head width at ear coverts	1.2 inches
17. Head width above eyes	.9 of an inch
18. End of beak to back of head	3.9 inches
19. Beak length	
Top	2.2 inches
Center	2.3 inches
Bottom	1.9 inches
20. Beak height at base	.31 of an inch
21. End of beak to center of eye (7 mm. brown)	2.85 inches
22. Beak width at base	.3 of an inch
23. Tarsus length	2.4 inches
24. Toe length	
Inner	1.35 inches
Middle	1.7 inches
Outer	1.4 inches
Hind	.4 of an inch
25. Body width	3.0 inches
26. Body length	
Front of breast to end of primaries	8.4 inches

GREATER YELLOWLEGS

Profile Line Drawing

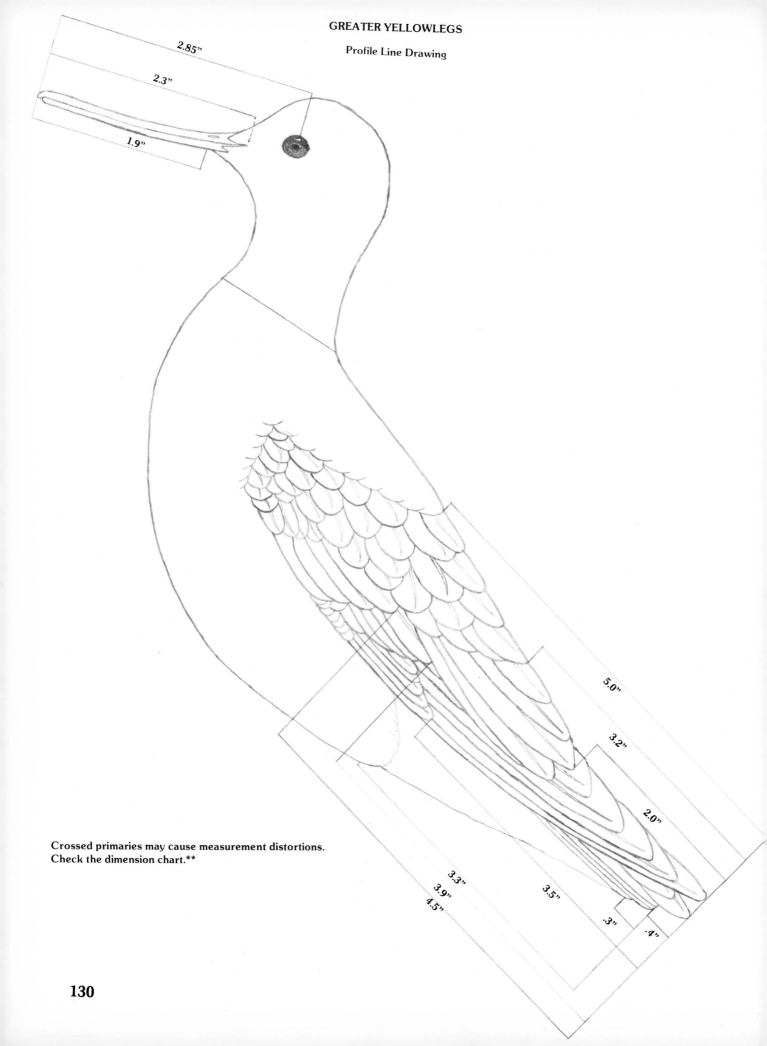

2.85"

2.3"

1.9"

Crossed primaries may cause measurement distortions.
Check the dimension chart.**

5.0"

3.2"

2.0"

3.3"

3.9"

4.5"

3.5"

.3"

.4"

130

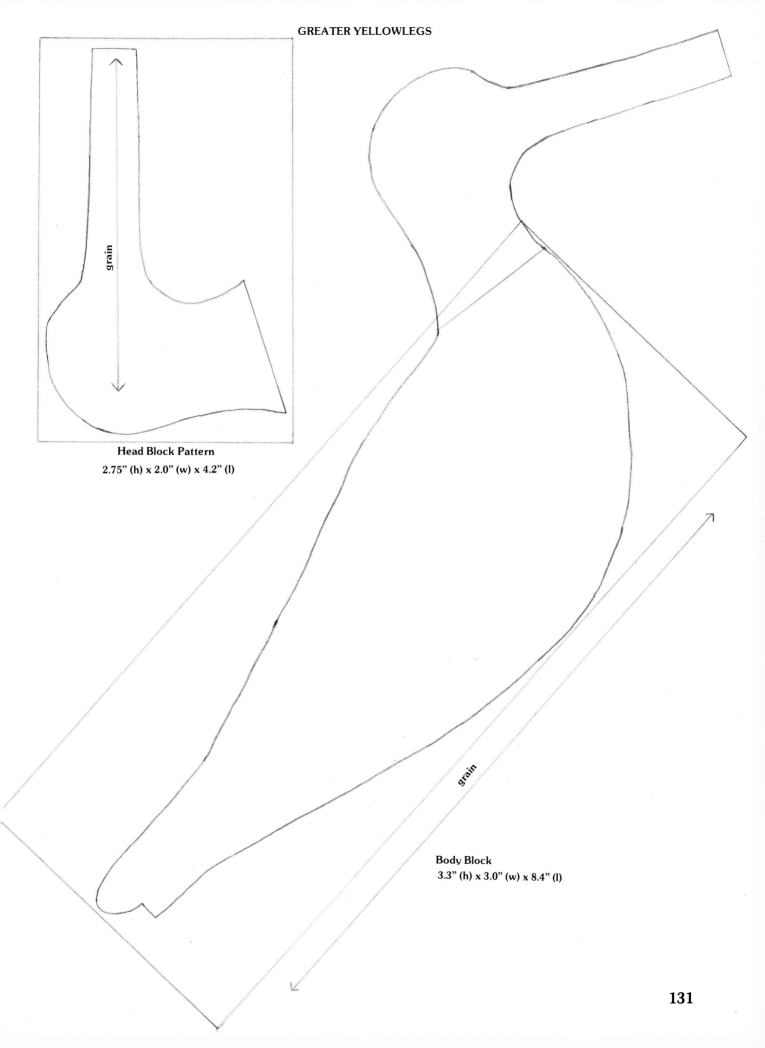

GREATER YELLOWLEGS

grain

Head Block Pattern
2.75" (h) x 2.0" (w) x 4.2" (l)

grain

Body Block
3.3" (h) x 3.0" (w) x 8.4" (l)

131

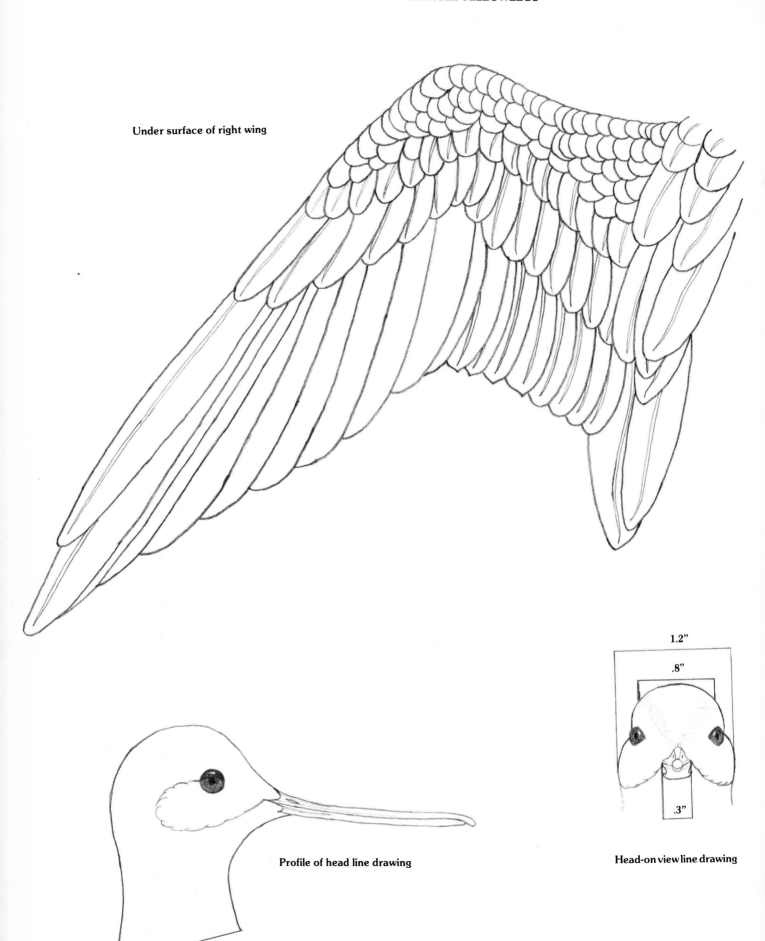

Under surface of right wing

Profile of head line drawing

1.2"

.8"

.3"

Head-on view line drawing

132

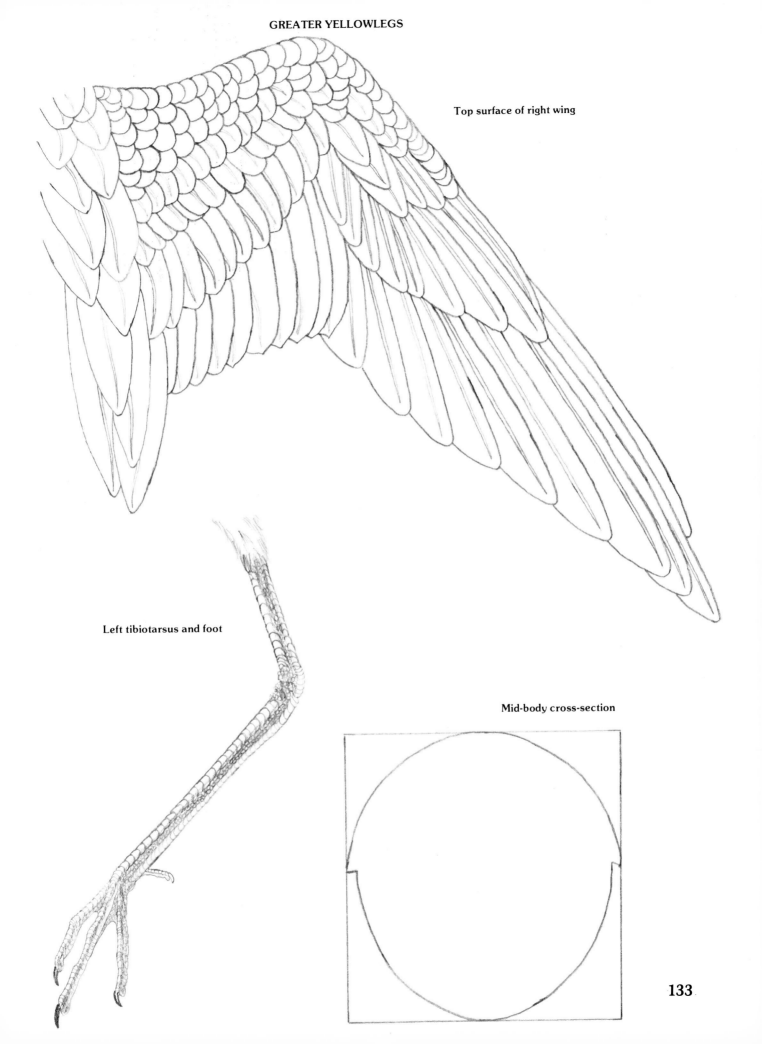

Top surface of right wing

Left tibiotarsus and foot

Mid-body cross-section

133

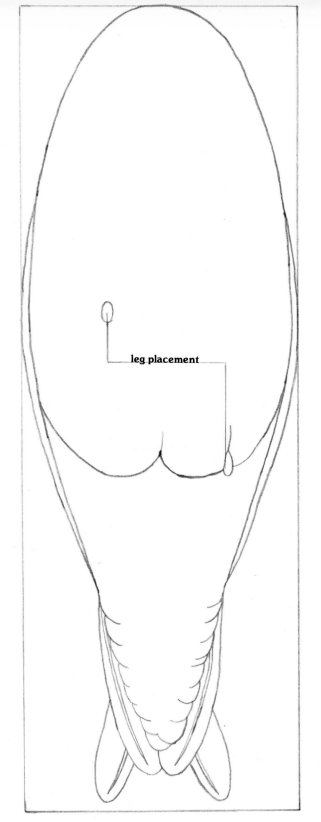

leg placement

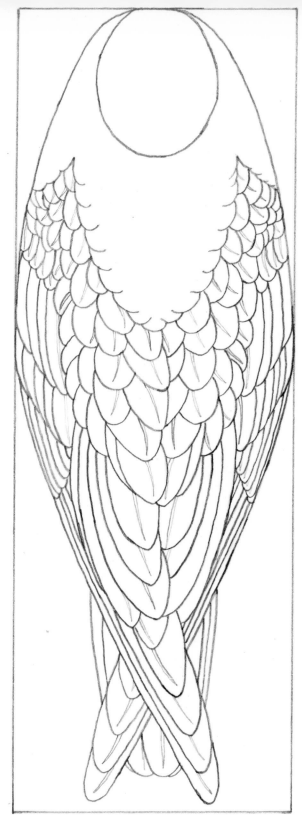

GREATER YELLOWLEGS

Under plan view line drawing

*Foreshortening may cause measurement distortion. Check dimension chart.** Head top plan view.

Top plan view line drawing

134

TOOLS AND MATERIALS

Bandsaw (or coping saw)
Flexible shaft machine
Carbide bits
Ruby carvers and/or diamond bits
Variety of mounted stones
Pointed clay tool or dissecting needle
Compass
Calipers measuring in tenths of an inch
Rheostat burning machine
Ruler measuring in tenths of an inch
Awl
400 grit sandpaper
Drill
Drill bits
Laboratory bristle brush
Needle-nose pliers
Toothbrush
Safety glasses and dustmask
Wire cutters
Super-glue

5 minute epoxy
Oily clay
Duro ribbon epoxy putty (blue and yellow variety)
Krylon Crystal Clear
Tupelo blocks
Body block 3.3" x 3.0" x 7.7"
Head block 2.75" x 2.0" x 4.2"
Pair of cast greater yellowlegs feet to use as a model
Pair of 7 mm. brown eyes
For making feet: 3/32" brazing rod
16 gauge copper wire
solder, flux and soldering pen or gun (silver solder and butane
torch)
permanent ink marker
hammer and small anvil
cartridge roll sander on a mandrel
small block of scrap wood and staples for holding jig (or several
helping hands holding jigs)

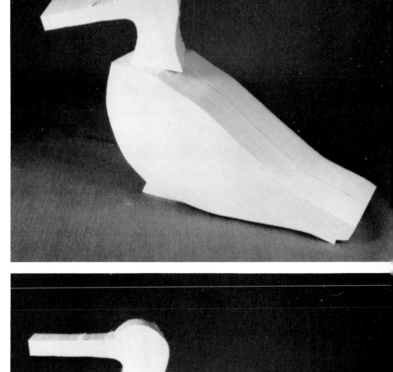

Figure 1. Cut the head and body profile patterns from the blocks of tupelo or basswood. I chose tupelo for its non-fuzzing quality when stoned. The basswood bird would require extra care in the sanding and stoning procedures so that fuzzing would be kept to a minimum.

Figure 2. Wedges of various depths could be added to the head or body blocks to totally change the attitude of this pattern.

Figure 3. Drawing lines from corner to corner and drawing a centerline allows you to find the center of both the head block and the body block.

Figure 4. Using the top plan view as reference, draw in the crossed wings. Draw in the centerlines.

Figure 5. With the bandsaw or coping saw, cut away the excess wood from around the wings, crossed primaries and tail area.

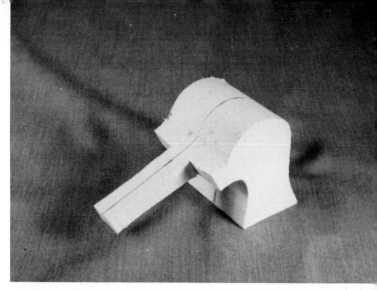

Figure 6. Some of the excess wood from the sides of beak can be cut away.

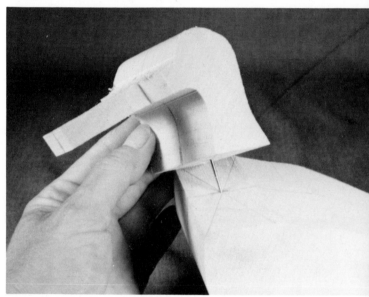

Figure 7. Drill a 1/16" diameter hole one-half inch deep in the center of both the head and body block. Insert a piece of 16 gauge galvanized wire or 1/16" brazing rod. Glue the head in place turning it to the desired angle.

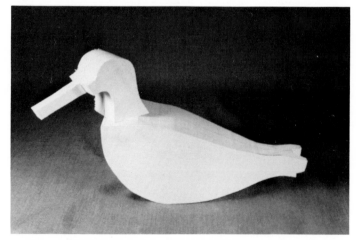

Figure 8. Varying the angle of the turned head can create an entirely different attitude to the bird.

136

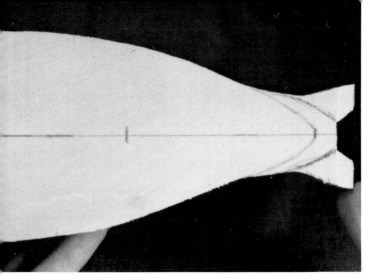

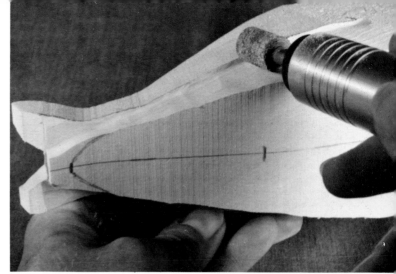

Figure 9. On the underside of the body, measure and mark on the centerline the distance from the end of the tail to the lower tail coverts (.3 of an inch) and the vent (3.3 inches). Draw in the shape of the lower tail coverts.

Figure 12. Remove the wood on the flank all the way to the edge of the block on the belly. The raised edge of the lower wing should be .1 of an inch higher than the flank.

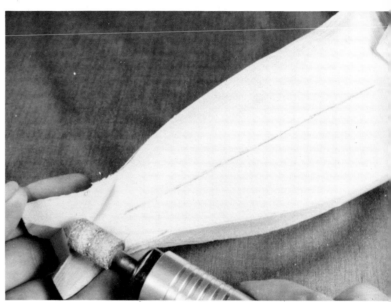

Figure 10. Using the profile line drawing, draw in the lower wing edges on each side of the bird.

Figure 11. With the square edge of a cylindrical carbide bit, remove some wood from underneath each lower wing edge.

Figure 13. Round the left wing from the centerline to the lower wing edge and from the base of the neck to the tip of its longest primary. This will necessitate an angle cut with the square-edged cylinder along the lower wing edge where the wings cross.

Figure 14. Round over the right wing from the centerline to the lower wing edge and from the base of the neck to the point where the primaries cross. You can not round the right wing tip since it will go underneath the crossed left wing.

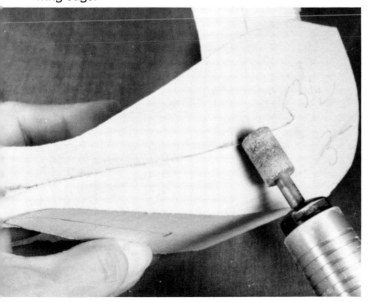

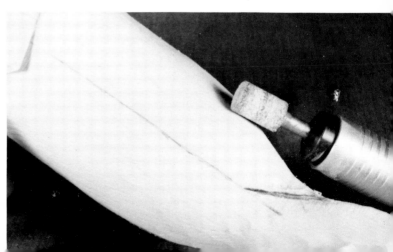

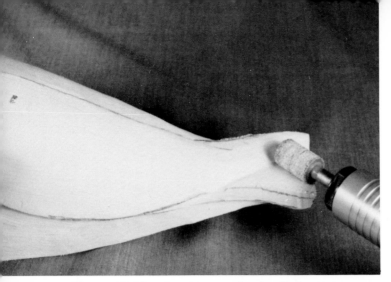

Figure 15. Use the square-edged cylinder to remove some of the waste wood on top of the right wing primary tips.

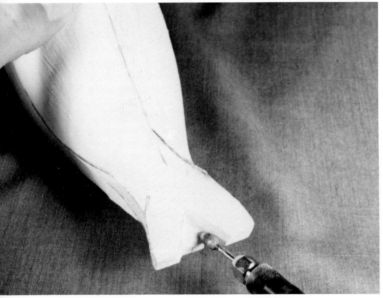

Figure 16. Using a medium pointed ruby carver, remove the excess wood on top of the tail between and on both sides of the crossed primaries.

Cut away .1 of an inch from underneath the primary tips.

Figure 17. With the ruby carver, angle the tips of the right wing down and clean up the scratches and digs that the carbide cutter leaves.

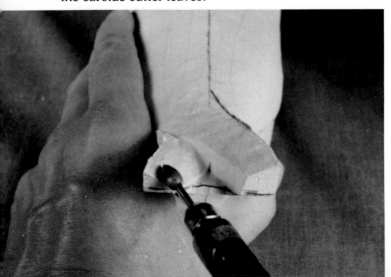

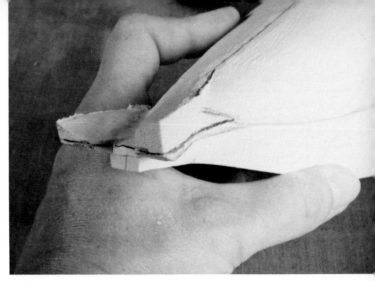

Figure 18. Here you see another view of this area which can be confusing. Using pieces of paper or popsicle sticks may help you visualize this wing tip crossing more easily. The leading edge of the underneath right wing tip should line up with the leading edge of the right wing with the left tip crossing it. Use your pencil freely to mark the areas to be removed and those that should remain.

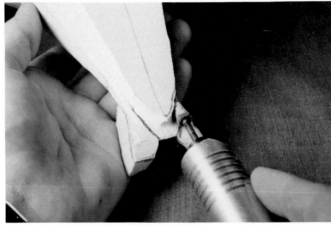

Figure 19. Draw in the tail thickness (.15 of an inch) on its sides and end. Using a small tapered carbide bit, remove the excess wood from around the lower tail coverts, leaving the tail .15 of an inch thick.

Figure 20. Using the underview plan drawing, draw in the vent shape. Channel around the vent line with a medium tapered carbide bit. Carry the channel around the corner of the blank so that it tucks up underneath the lower wing edge.

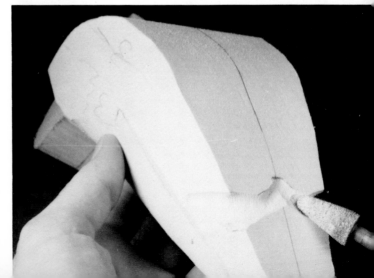

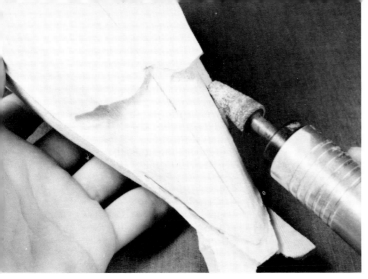

Figure 21. Round over the lower tail coverts and flow them down to base of the exposed tail feathers.

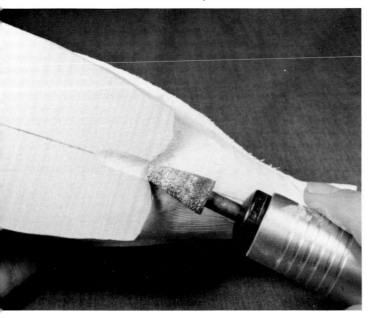

Figure 22. Make a shallow channel one inch long on the centerline at the vent.

Figure 23. Round over the belly and vent area. Flow the high corners of the vent channel down to the base of the lower tail coverts, thus rounding over each side of the vent.

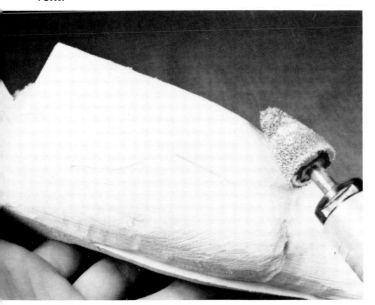

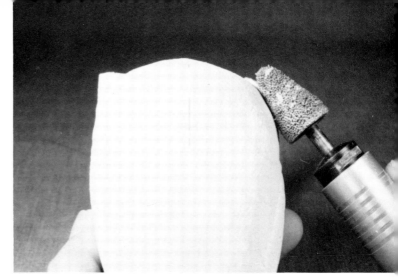

Figure 24. Round over the lower breast area, but do not work in the upper breast, throat or chin areas.

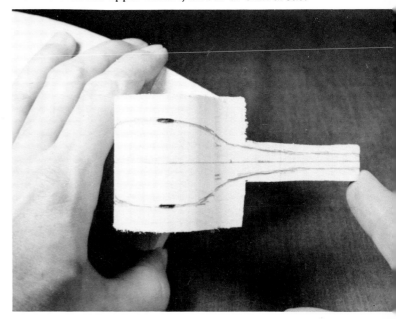

Figure 25. Across the centerline on the top of the head, measure and mark in the width of the head at the ear coverts (1.2 inches). This will leave .6 of an inch on each side of the centerline. The head width at the ear coverts is the widest part of the head. Draw in the plan view of the head encompassing these marks for the width at the ear coverts. Allow excess wood around the beak and forehead. Leave some extra fullness in the back of the head to allow for width of the neck.

Figure 26. Using a large carbide cutter, begin removing the excess wood outside of the plan view lines. Keep the sides of the head vertical planes.

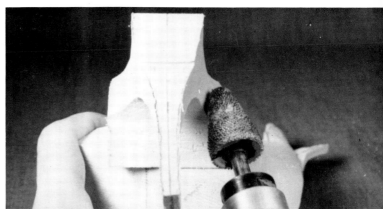

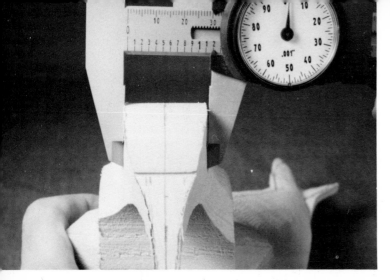

Figure 27. Keeping equal amounts of wood on both sides of the centerline, continue removing excess wood until the calipers measure 1.2 inches. Note that no wood has been removed from the neck yet. At this point, you will be getting the proper width at the ear coverts and removing the excess wood outside of the plan view beak lines.

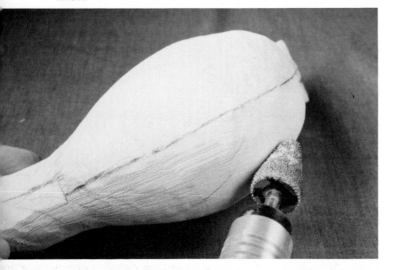

Figure 28. Round over the upper breast, throat and neck areas.

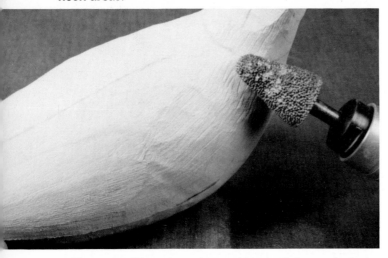

Figure 29. Flow the sides and back of the neck down onto the mantle and shoulder areas.

Figure 30. Note the shape of the body. The widest part of the body is the upper third of the wing. From this point, the body rounds gently around the breast much like the fat end of an egg.

Figure 31. Note the gentle flow from the shoulders to the side of the neck and up to the top of the head.

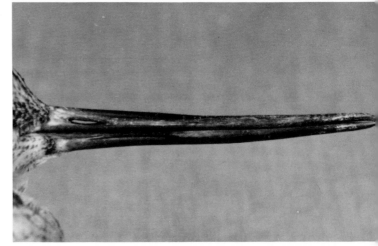

Figure 32. Note the slight upward curve of the commissure on the profile view of a yellowlegs' beak.

140

Figure 33. There is a small triangular depression on the underside.

Figure 34. Here you see the top plan view of the beak.

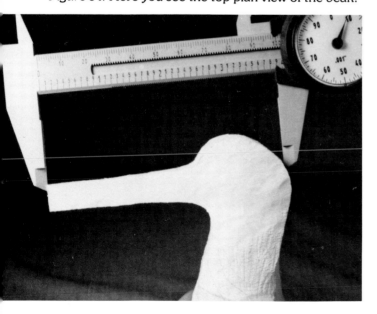

Figure 35. Check the measurement from the end of the beak to the back of the head (3.9 inches). Adjust, if necessary, by taking equal amounts off the end of the beak and the back of the head until it measures 3.9 inches.

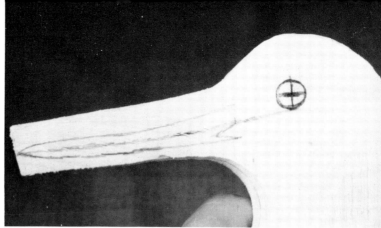

Figure 36. Transfer the beak and eye placements from the profile line drawing. You may have to adjust the placement since the drawing is two dimensional and the carving three dimensional. To check for accuracy, use the Dimension Chart and a ruler. Keep the sides of the beak and the eyes equally balanced on both sides of the head.

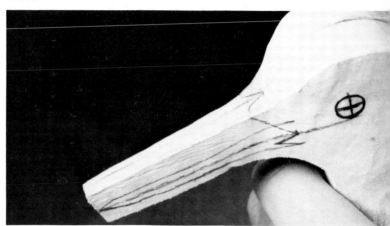

Figure 37. Measure and mark in the top beak length (2.2 inches) on the centerline. Draw in the shape of the base of the beak's top surface and connect the lines around the sharp corners of the blank.

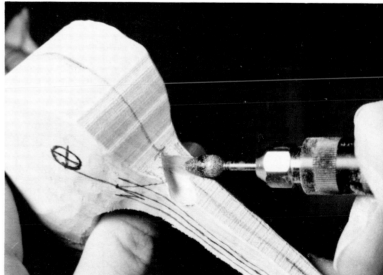

Figure 38. Using a medium pointed ruby carver, begin cutting away the excess wood above the line of the upper mandible.

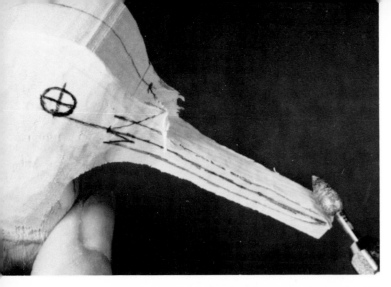

Figure 39. Continue removing the excess wood until you get down to the top beak line. Keep the plane flat at this point.

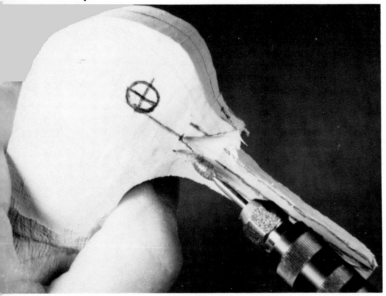

Figure 40. Begin narrowing the sides of the beak with a smaller pointed ruby carver that will fit back in the sharp corners. Redraw the centerline on the top plane. Keep equal amounts of wood on each side of the centerline so that the beak itself is balanced.

Figure 41. Keep removing wood from the sides until the calipers will get back to the sides of the base of the beak and measure .3 of an inch.

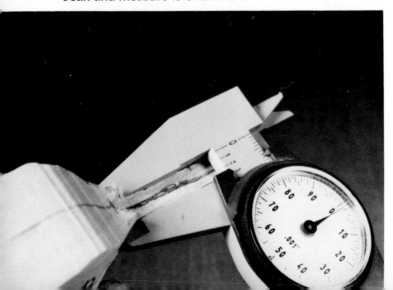

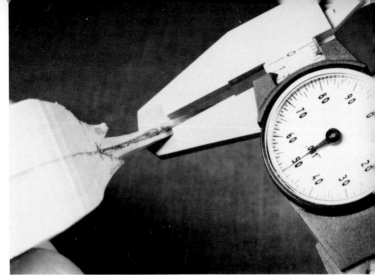

Figure 42. Now that the base of the beak is the proper dimension, shape the remainder of the sides to the tip. Keep the sides parallel flat planes equally balanced across the centerline. The beak should measure .15 of an inch at the mid-point of its length. Work slowly and carefully with this procedure as it is easy to get the beak unbalanced and crooked.

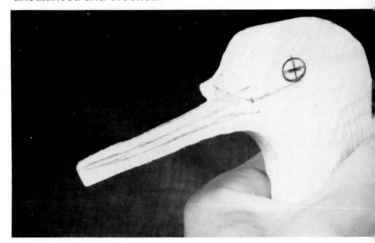

Figure 43. Redraw the commissure line and lower mandible lines on both sides. You will find that the more wood you remove from around the beak, the more fragile it becomes. You will feel it move when you work on it. Begin to support it with your other hand so that it does not break.

Figure 44. Flow the head down to the beak on the top and sides by cutting away the shelves formed by cutting the beak into the head. Maintain the same planes as on the top and sides of the head. Do not round the sharp corners at this point.

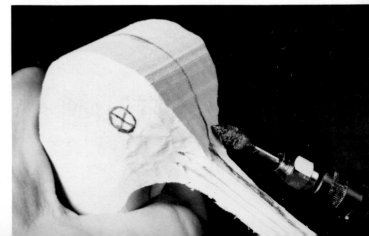

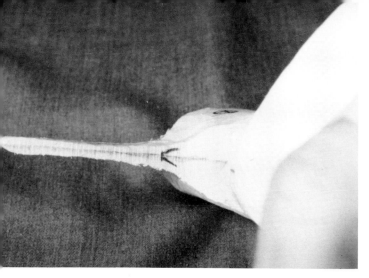

Figure 45. Draw in the centerline on the bottom of the lower mandible. Measure and mark the bottom length (1.9 inches). Draw in the v-shaped tuft of feathers.

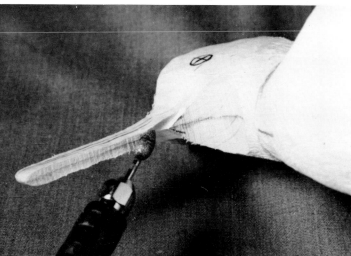

Figure 46. With a medium pointed ruby carver, cut around the tuft of feathers and remove the excess wood outside of the bottom lower mandible line.

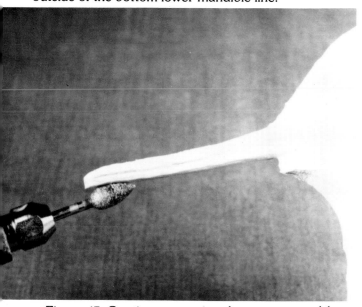

Figure 47. Continue removing the excess wood from underneath the full length of the beak.

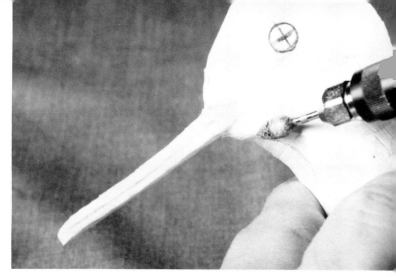

Figure 48. Flow the little v-shaped tuft of feathers down to the base of the lower mandible. Round over the little tuft.

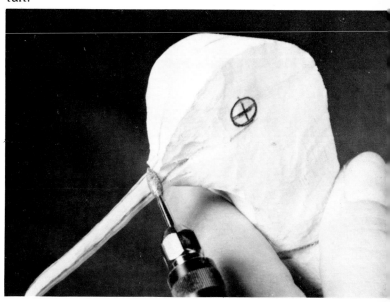

Figure 49. Now that the beak is the proper length, width and height (except the very tip), it is time to work on the details. First, round over all of the sharp corners on the upper and lower mandibles and make the tip narrower.

Figure 50. When rounding the corners on the base of the upper mandible, the v-shaped group of feathers on the forehead will need to be lowered so that it flows down to the base.

Figure 51. Generally smooth the beak with a fine, bullet-shaped stone.

Figure 52. You can make a cylindrical stone bullet-shaped by holding it to a dressing stone. Chuck the cylindrical stone in the flexible shaft machine and hold the dressing stone up to it while spinning. Be sure to wear a dustmask and eye protection.

Figure 53. Use a smaller bullet stone to create the depressions on each side of the culmen (ridge). Be careful to support the beak throughout these procedures.

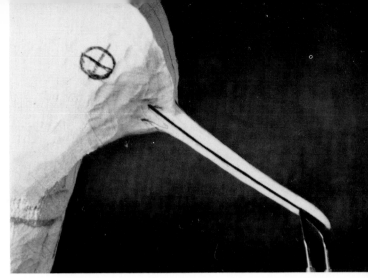

Figure 54. Redraw the commissure line on both sides. Burn along the commissure with the pen held perpendicular to the beak for the first stroke. Then, lay the pen on its side and burn up to the first burn line. This will create the effect of the lower mandible fitting up into the upper one.

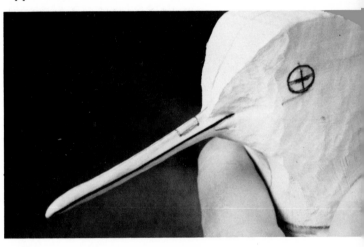

Figure 55. Draw in the nostrils on each side of the culmen. Each nostril should be .25 of an inch in length and .1 of an inch from the v-shaped tuft of feathers. Drawing lines across the culmen will enable you to see if the position of each is balanced or equal to the other.

Figure 56. With a very small pointed burning pen, begin burning in the nostril from each side. By holding the pen perpendicular to the beak and burning in from both sides, somewhere in the middle the two directions will meet and you will be able to see light through the narrow slit. Do not have the pen too hot as it will burn through the top quickly. Use low heat, minimal pressure, time and patience.

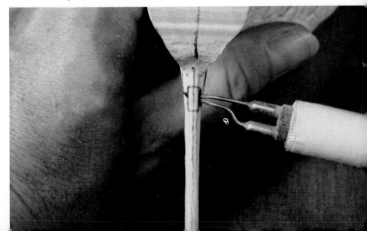

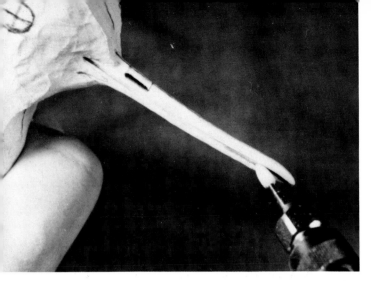

Figure 57. With a small pointed stone, go over the commissure lines and nostril hole to smooth and slightly widen.

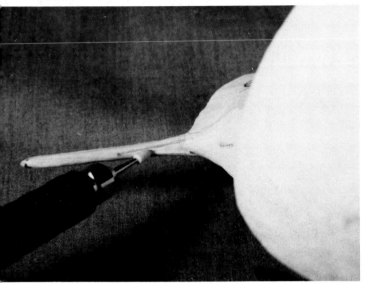

Figure 58. On the bottom of the lower mandible, create the small v-shaped depression with the point of a small stone. See Figure 33. You will have to flow the little tuft of feathers down to the bottom of the shallow depression.

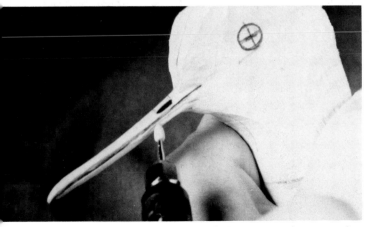

Figure 59. Draw in the small depression lines on the sides of the lower mandible. Use the small pointed stone to create these depressions.

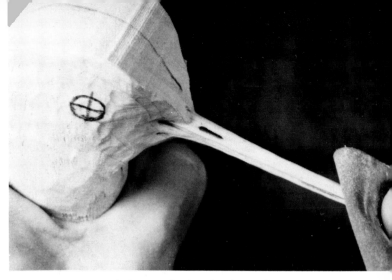

Figure 60. Lightly sand the beak with 400 grit sandpaper.

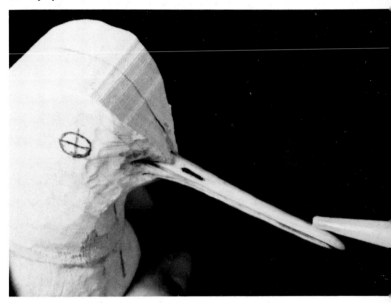

Figure 61. Saturate the beak with super-glue so that it soaks in and hardens the beak. When the super-glue has hardened, fine sand the beak again.

Figure 62. Recheck the balance of the eyes by pressing in the points of two clay tools. Check the head-on and plan views for balance. Pin-pricking deeply will allow you to retain the marks when cutting away wood to narrow the eyes and crown area.

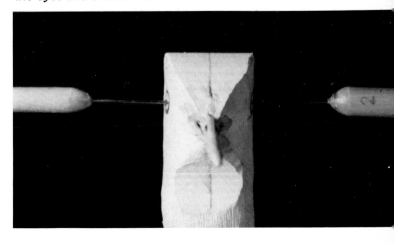

145

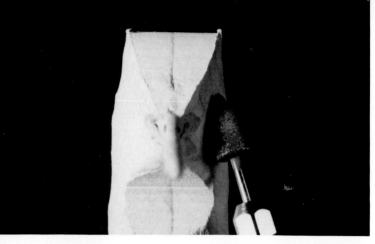

Figure 63. On the top of the head above the eyes, measure and mark .9 of an inch with .45 of an inch on each side of the centerline. Narrow the head through the eye and crown areas. Keep the planes flat so that there is a smooth transition from the sides of the neck to the sides of the head up to its top corner.

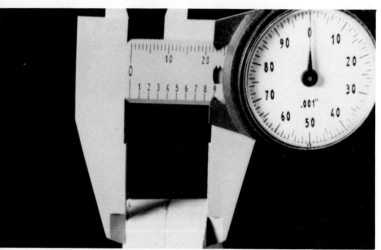

Figure 64. Keep the head balanced across the centerline and keep removing wood until the head width measures .9 of an inch above the eyes.

Figure 65. Round over the sharp corners on the head from the forehead to the crown and on down the back of the neck. Scoop out a small amount of wood on the forehead for that characteristic yellowlegs look.

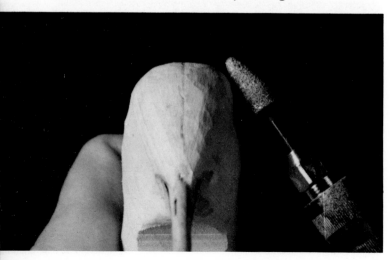

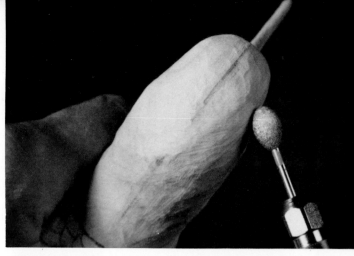

Figure 66. Narrow the back of the head by removing wood from the sides of the head back towards the centerline on the neck.

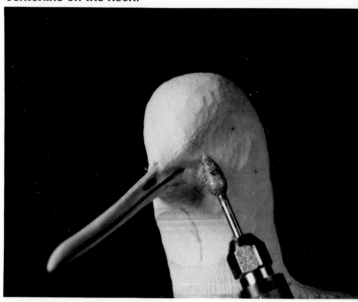

Figure 67. Create a shallow depression from the base of the beak to each eye position.

Figure 68. Drill 7 mm. eye holes approximately one-quarter inch deep, keeping them balanced. Check the eyes for a proper fit. It is advisable to have slightly larger holes that will allow you to adjust the eyes.

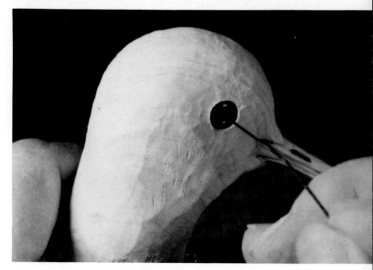

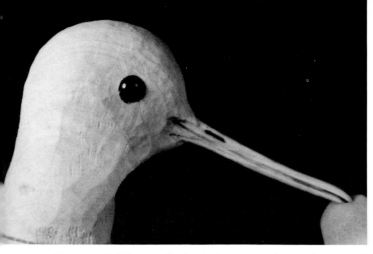

Figure 69. Place a ball of clay in each eye hole and press the eyes into place using the wooden end of an awl or other tool. Check their positions and the general shape of the head. Adjust if necessary and remove eyes to prevent scratching.

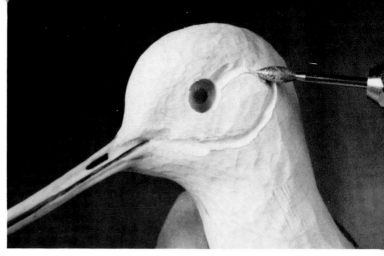

Figure 72. Using a small diameter ruby carver, make a channel around both coverts.

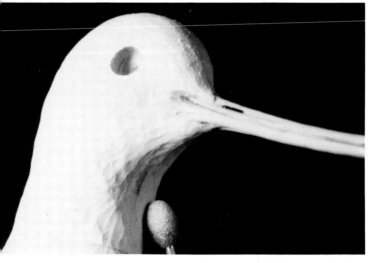

Figure 70. Round over the front of the neck, throat and chin.

Figure 71. Draw in the ear coverts using the profile line drawing for reference. Check for equal height, depth and length from all views.

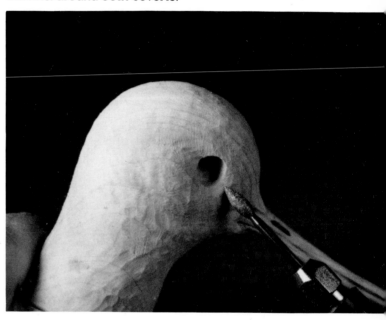

Figure 73. Flow the channel out toward the surrounding neck area and round over the sharp edge on the covert itself. Remove a small amount of wood from the front corner and bottom ledge of both eyes.

Figure 74. Replace the eyes and check for the overall effect.

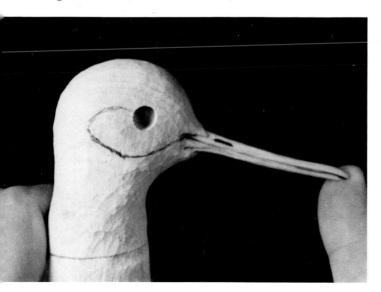

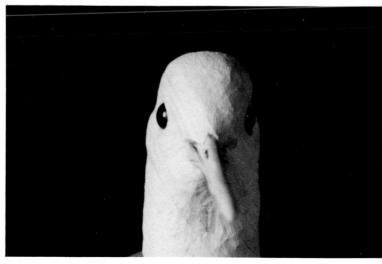

147

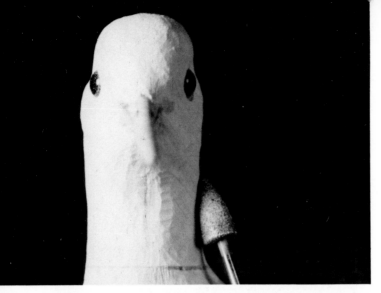

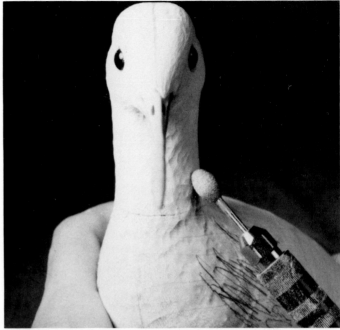

Figure 75. Thin the neck to 1.1 inches wide, keeping equal amounts on each side of the centerlines front and back.

Figure 76. Before putting in more details on the bird, I find that observing it from all angles is essential. This is the center table in my shop and my normal set-up. Every picture from books, calendars and magazines is in view along with the carving and study skins. I look for balance and overall characteristic yellowlegs shape. If I find discrepancies, I will use my pencil freely and then make any necessary corrections. It is helpful to walk away for awhile and then come back later for a fresh perspective.

Figure 77. Note the pencil scribbles. This tells me that the bird is too bulky here and needs to be put on a wood removal diet.

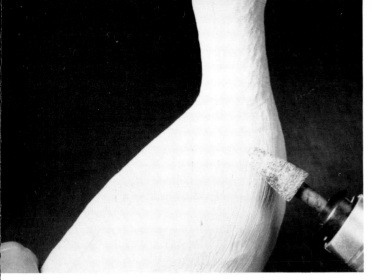

Figure 78. Remove some of the bulk from the upper back, breast and shoulder areas so that there is a graceful flow from the body to the neck to the head.

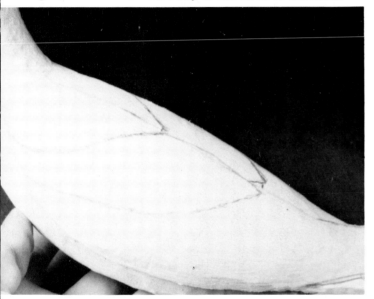

Figure 79. Draw in the mantle, scapulars and puffs of feathers on the sides of the breast that cover the front of the wings.

Figure 80. Channel along the mantle and side breast lines. Flow the bottom of the channel out toward the scapulars and wings. Round over the sharp channel edge on the mantle.

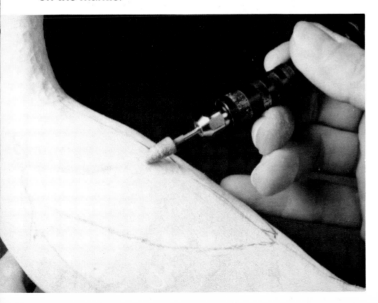

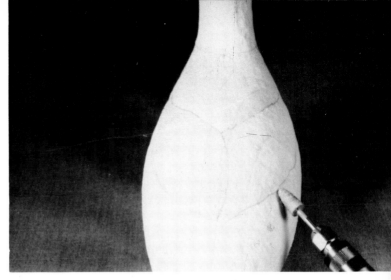

Figure 81. Channel along the scapular lines. Flow this channel out toward the wings and then round over the scapulars to the bottom of the channel. Use a bullet stone or cartridge roll sander to smooth the mantle, scapulars and the wings.

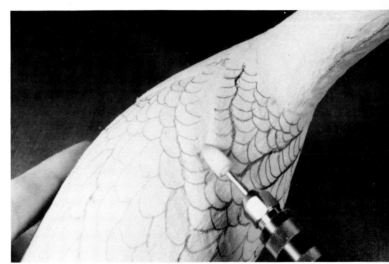

Figure 82. Using the plan and profile line drawings for reference, draw in the individual feathers on the mantle, scapulars and wings. With a large white bullet stone, lightly channel around some of the feather puffs on the mantle. Roll over both edges of the channels.

Figure 83. Using a small bullet stone, lightly channel around the individual feathers. Flow the light channel out onto the next feather below or beside it and round over the edge, giving each feather its own rounded contour.

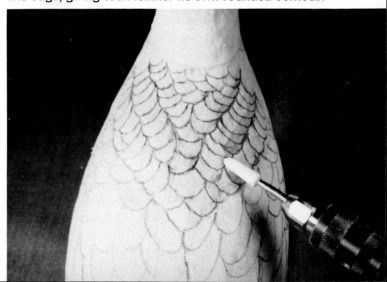

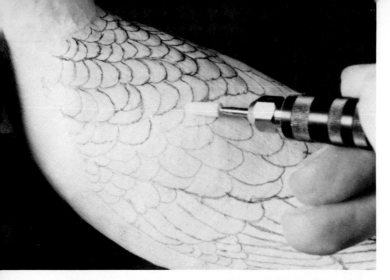

Figure 84. Channel around the scapular feathers. Flow out each channel and round over the edge.

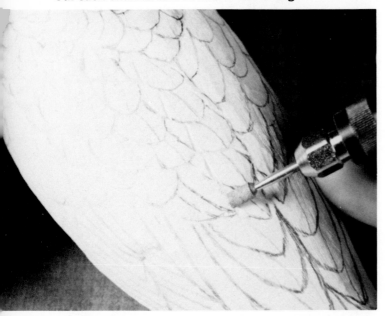

Figure 85. Draw in the larger feather splits. Using the edge of a cylindrical stone, carve in the larger splits on the scapulars.

Figure 86. Draw in the quills on the scapulars paying particular attention to the feather flow created. Laying a small cylindrical stone on its side, relieve a small amount of wood on each side of the quill line, thus leaving a small, raised ridge (the quill).

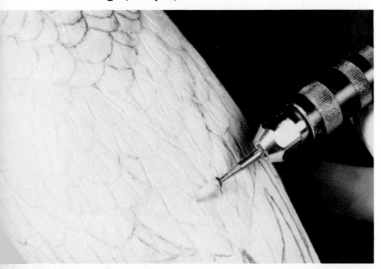

Figure 87. Working on the left wing first, begin relieving around each of the feather groups and then each individual feather within the group. Begin with the marginal coverts and then the lesser secondary coverts, middle secondary coverts, etc. progressing back toward the wing tip.

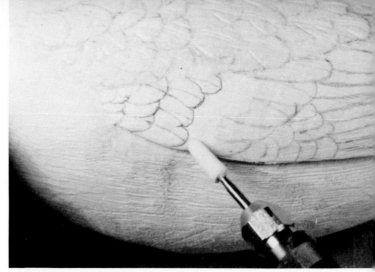

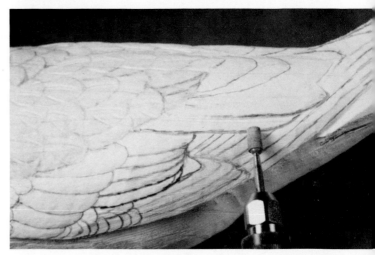

Figure 88. A larger cylindrical stone laid on its side will be easier to use with the larger feathers such as the tertials.

Figure 89. When you get to the primary edges, it will make it easier to cut away the excess along the top side of the tail.

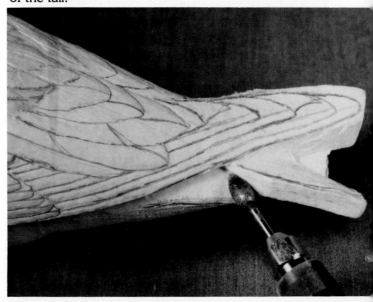

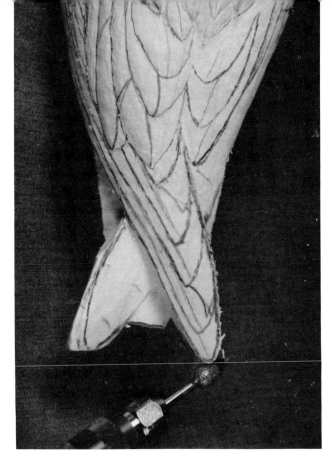

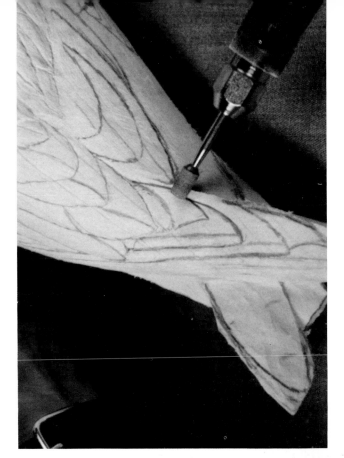

Figure 90. Trim any excess from around the primary tip.

Figure 91. Here you see a flip-over in which some of the barbs of a real feather lay on top of a lower section.

Figure 92. To do this flip-over on a carving, first draw it on the trailing edge of a primary. Using a cylindrical stone on its side, relieve around the part to lay on top. Then, relieve around the lower portion. A flip-over is particularly effective with a dark colored primary with a light line trailing edge such as a yellowlegs has.

Figure 93. Round over all of the feather edges on the left wing. Draw in the quills and splits.

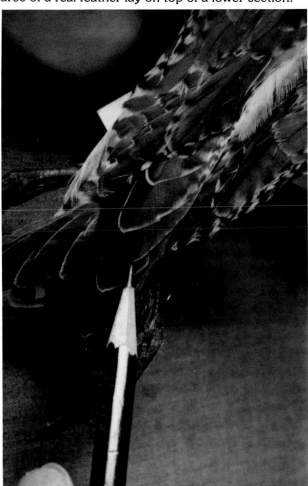

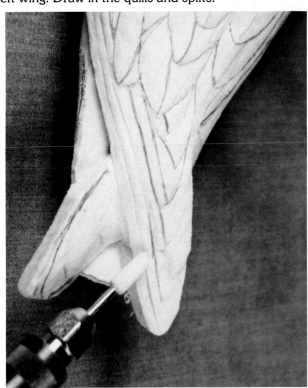

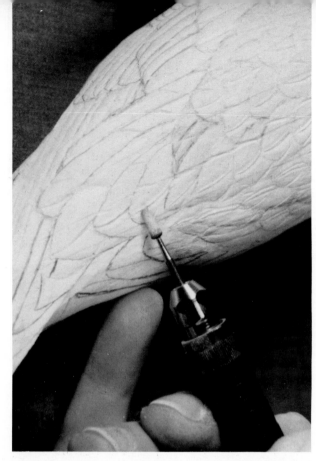

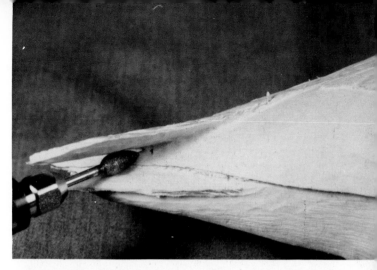

Figure 96. Carefully begin undercutting the upper crossed primary tips. You will have to remove some of the wood in the tertial and mid-wing area on the right wing to get a graceful flow from front to tip. It is not necessary for the left primary tips to be paper thin; the edges should be thin, but the middle of the stack needs wood for support.

Figure 94. Burn or grind in the quills. Create the larger splits with a small cylindrical stones.

Figure 95. Make sure there is continuity of the outer primary edge on the right wing. Check the line from the plan view of the carving. Adjust if necessary.

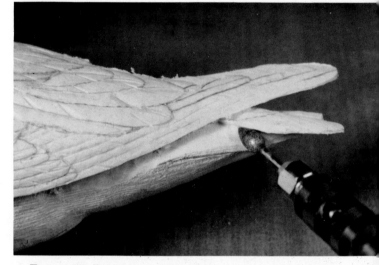

Figure 97. Round over the outer edges of the tail so that the entire tail's upper surface is convex.

Figure 98. Layout the feathers on the right wing. Beginning with the front of the wing, relieve around each of the feather groups and the individual feathers as you did on the left wing. Round over the edges and generally smooth with a white bullet stone. Draw and carve in the quills and feather splits.

Use a burning pen for cleaning up under the upper primaries and for sharpening up the tight space between the crossed tips.

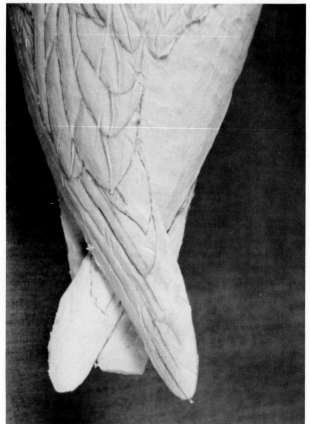

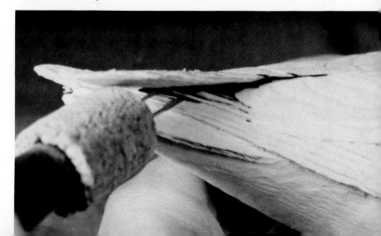

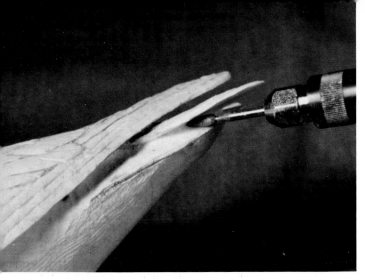

Figure 99. Use a very small pointed ruby carver or diamond bit to sharpen and deepen the spaces between the crossed primaries and the tail.

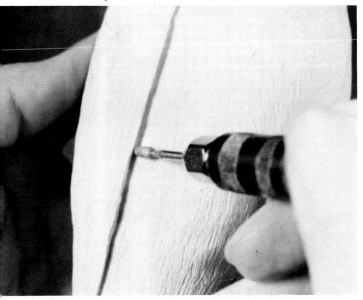

Figure 100. The small ruby carver is useful for clearing away the excess wood under the lower wing edges.

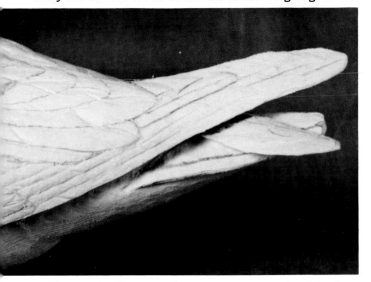

Figure 101. Draw in the two top exposed tail feather edges.

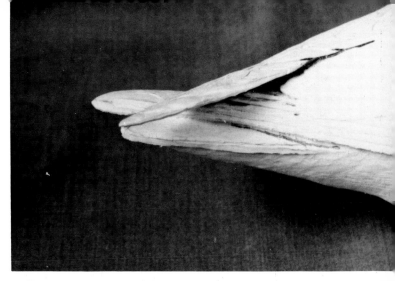

Figure 102. Burn in the edges of the right wing primaries where its too narrow to get to with even the smallest stone.

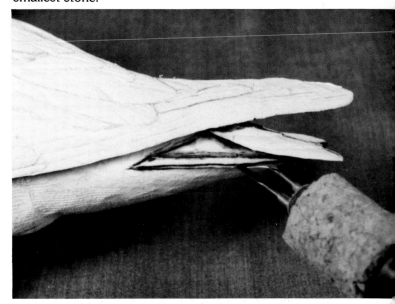

Figure 103. Laying the burning pen on its side, burn in the small exposed edge of the upper tail coverts and the edges of the stacked tail feathers.

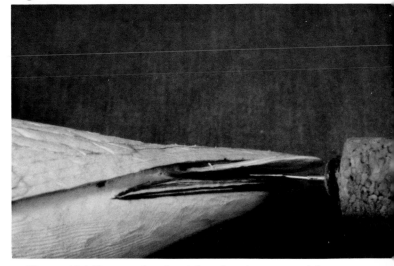

Figure 104. Burn under the right wing tip on top of the tail to separate the two.

153

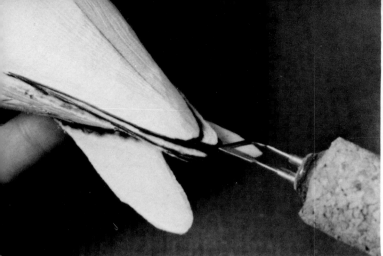

Figure 105. Draw and burn in the edges of the underside of the tail.

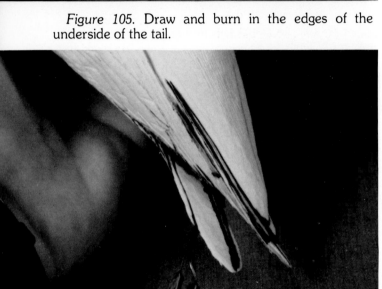

Figure 106. Separate the edges of the primaries by burning around the corner. Draw in the edges of the primaries on the underside and burn in their edges.

Figure 107. Draw and burn in the quills on the upper tail.

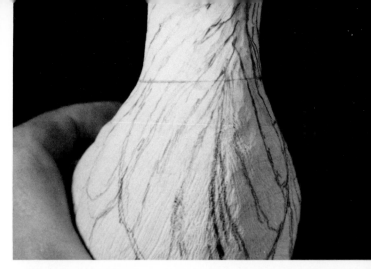

Figure 108. Draw in the puffs of feathers to be contoured on the breast, head and neck.

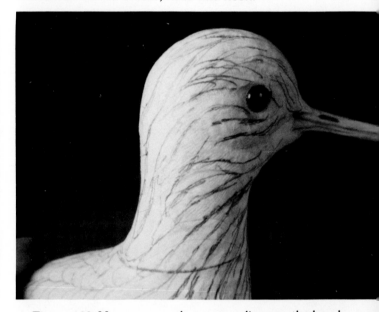

Figure 109. Here you see the contour lines on the head and neck.

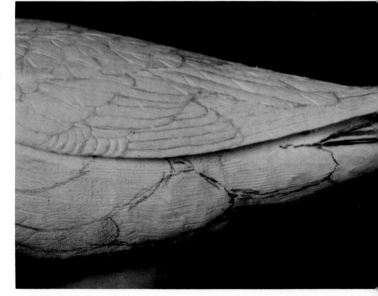

Figure 110. Using an awl, mark the position for the "up" leg.

154

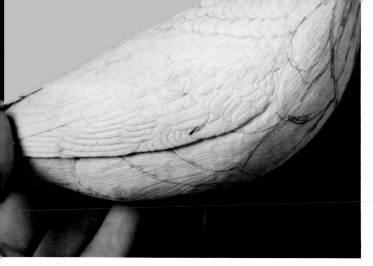

Figure 111. Holding the bird in the desired body position and attitude, mark the position of the "down" leg so that the bird will be balanced over its toes.

Figure 113. Using a blunt-nosed ruby carver, begin making the shallow channels and grooves on the head, rounding each over as you progress down the back and sides.

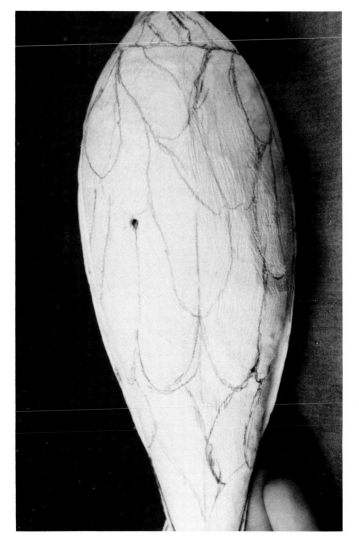

Figure 112. The contouring for the belly incorporates the positions of both legs.

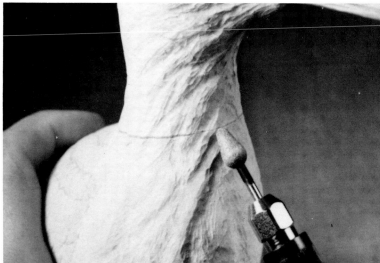

Figure 114. Note the channels and grooves on the sides of the neck have a graceful flow towards the back of the bird.

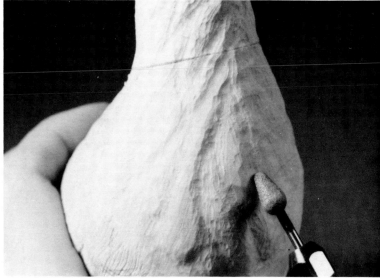

Figure 115. The puffs of feathers get larger on the breast and belly.

155

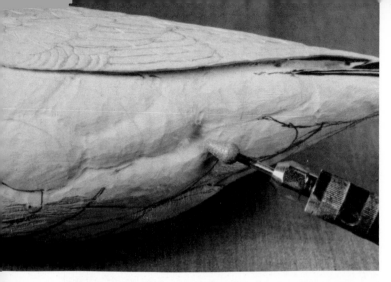

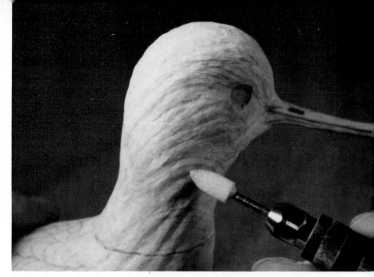

Figure 116. The placement of the "up" leg will need some of the extra wood removed to allow for the tibiotarsus thickness.

Figure 119. The diameter of the bullet stone is the right size for smooth and adjusting the contours of the puffs of feathers on the head and neck.

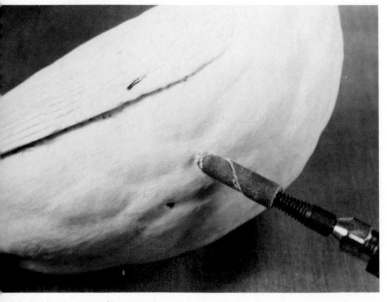

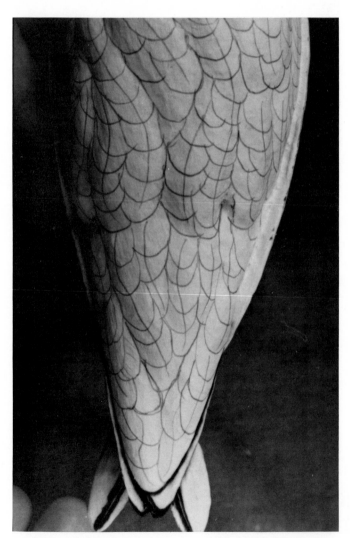

Figure 117. When the contouring is completed, smooth the puffs of feathers with a fine cartridge roll sander. Always sand with the grain so that the surface will be smooth.

Figure 118. Use a bullet stone to smooth the areas that the cartridge roll sander can not reach.

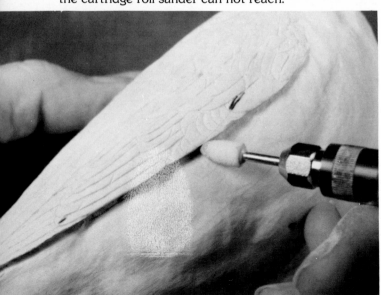

Figure 120. Draw in the individual feathers and the flow lines on the underside of the bird. Remember to vary the size of the feathers to keep the area interesting to look at.

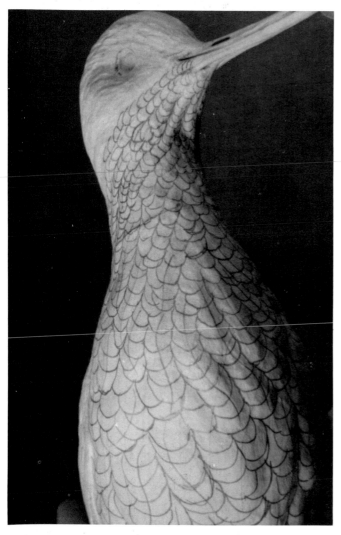

Figure 121. Note that the size of the feathers gets smaller on the breast, neck, throat and chin.

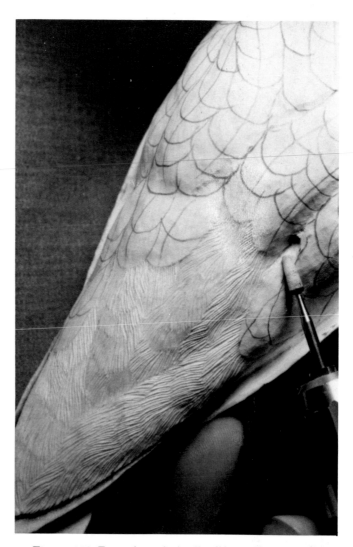

Figure 123. Even though the "up" leg will cover part of the feathers near the vent, stone each individual feather.

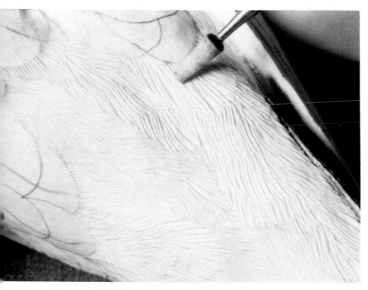

Figure 122. Begin stoning in the texture of the barbs of the individual feathers at the edge of the lower tail coverts and work your way forward toward the belly.

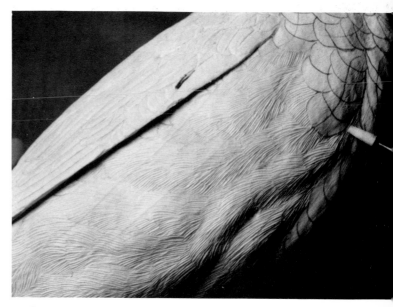

Figure 124. Note the different feather flows created for a realistic effect on the flank and belly.

157

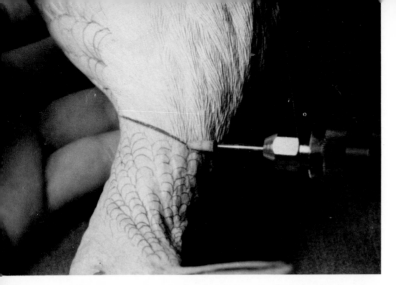

Figure 125. Stone the feathers on the glue line as you do the others.

See detail below.

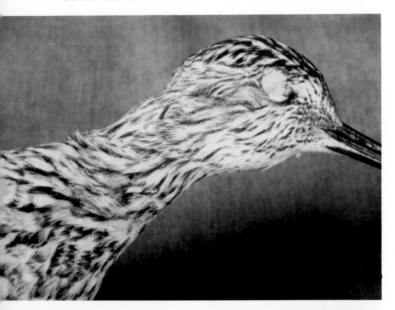

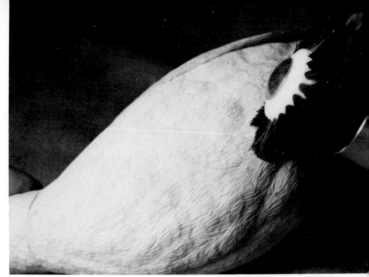

Figure 127. Most of the fuzz created by the stoning can be removed with a laboratory bristle brush on the flexible shaft machine. Use light pressure and slow speed so that the brush does not obliterate the stoned lines.

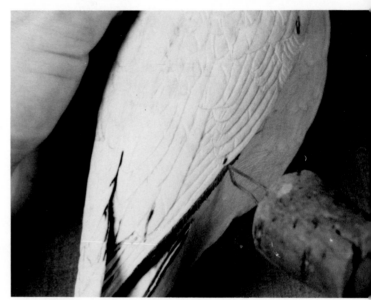

Figure 128. Burn in the barbs on the wing feathers starting with the outer and lower edge of the primaries on the under (right) wing.

Figure 129. Burn your way up the primaries on the right wing.

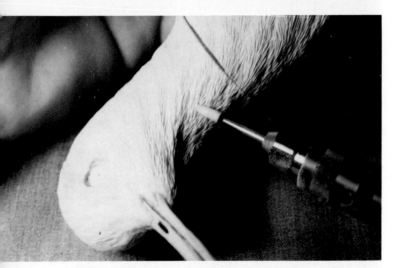

Figure 126. Stone the feathers on the neck, throat and those on the chin that you can reach without nicking the beak.

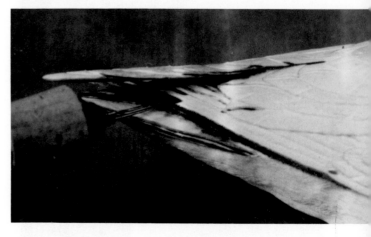

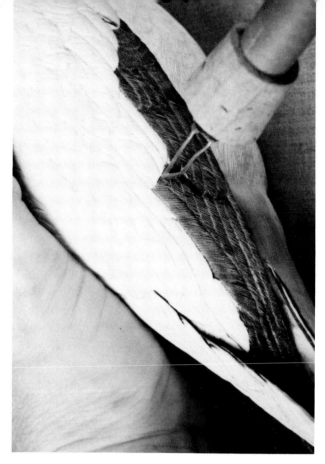

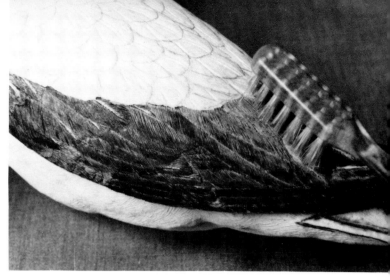

Figure 132. When the right wing is completely burned, burn in the barbs on the left wing. When the left wing is completed, clean all of the burning with a toothbrush to remove any loose carbon.

Figure 130. Keep your burn lines as close as possible.

Figure 131. Because of the reverse overlap of the middle secondary coverts, burn in the barbs on the top feather first and then progress toward the bottom edge of the group.

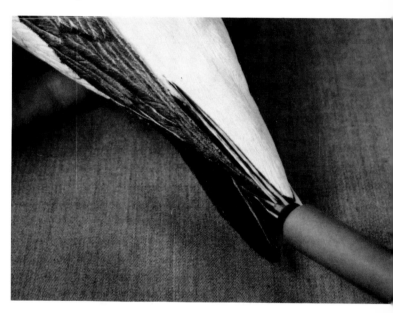

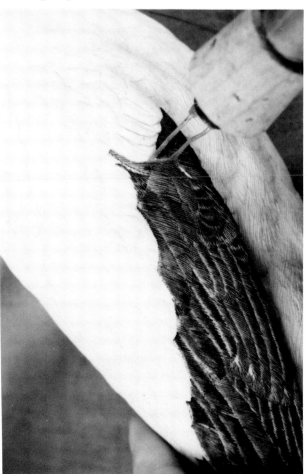

Figure 133. Burn in the barbs on the underside of the crossed primaries, taking care not to burn the tail.

Figure 134. Burn in the barbs on the lower wing edges.

159

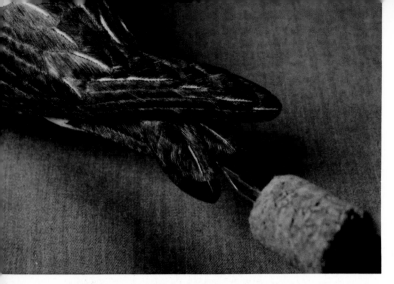

Figure 135. Starting with the outer edges, burn in the barbs on the upper surface of the tail.

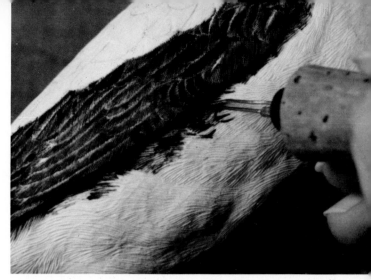

Figure 137. Burn in the barbs on the flanks up close and under the lower wing edges where the stoning could not reach.

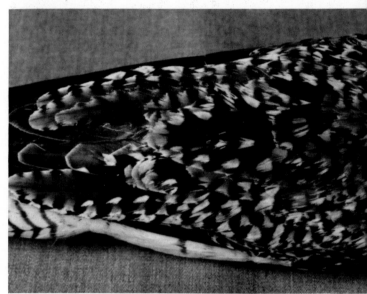

Figure 138. Using a small cylindrical stone, texture the barbs on the scapular feathers beginning with the edges and progressing forward and upward.

See detail below.

Figure 136. Burn in the barbs on the underside of the tail.

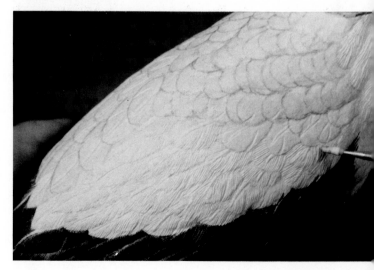

160

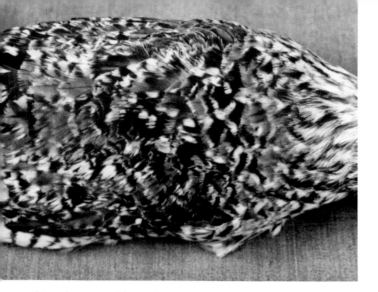

Mantle area of breeding yellowlegs.

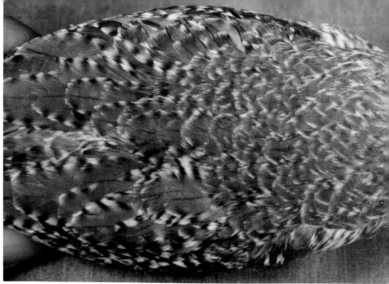

Mantle area of non-breeding yellowlegs.

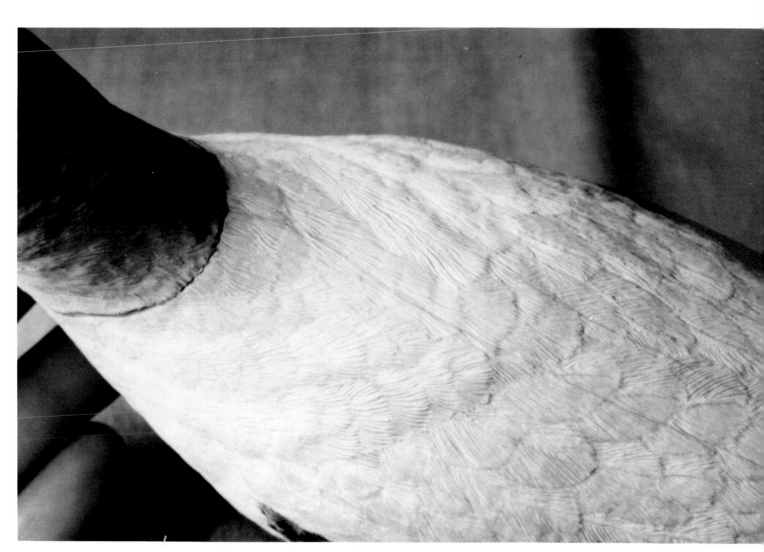

Figure 139. Starting with the outer edges of the mantle, grind in the barbs working toward the neck.

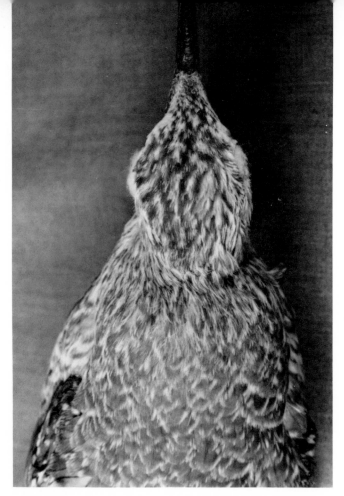

More detail on head.

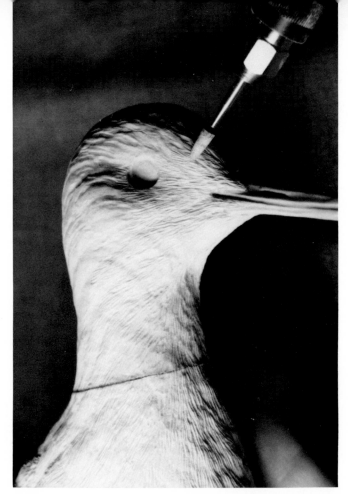

Figure 140. The stoning strokes should get shorter on the small feathers on the head.

Figure 141. Note the effect of the stoning and contouring on the back of the neck.

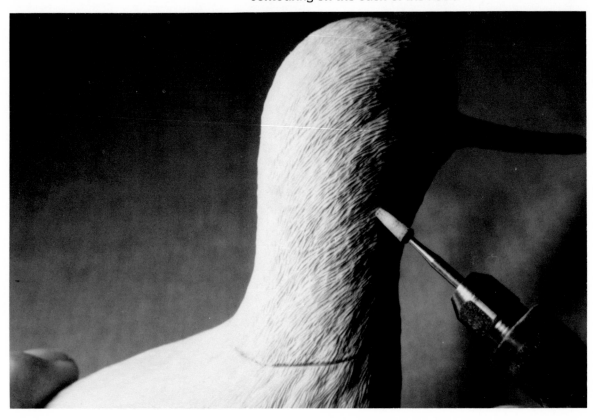

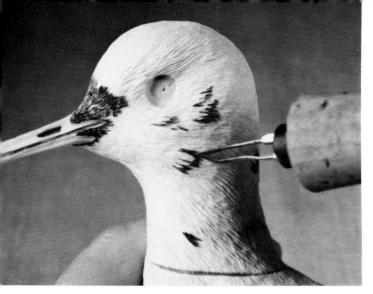

Figure 142. Burn the feather barbs around the beak that the stoning could not reach. Also create interesting breaks in the feathers on the sides of the head and neck.

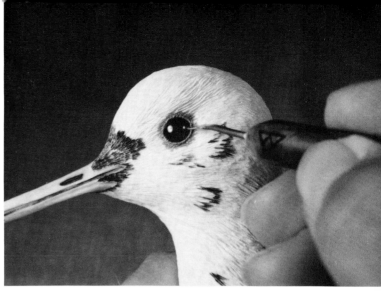

Figure 143. Insert the eyes according to the "Eye Techniques" in *Basic Techniques*.

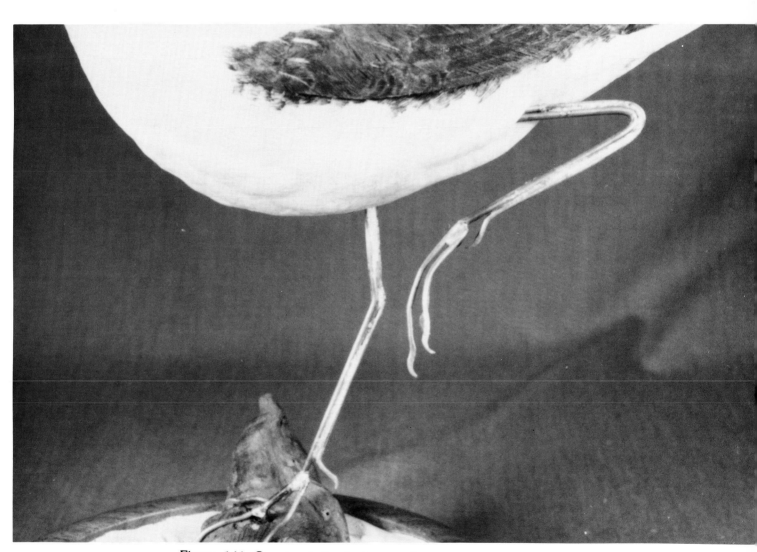

Figure 144. Construct the feet according to "Feet Construction" in *Basic Techniques*. When fitting the "up" leg, you may need to remove a small amount of wood behind the hole for insertion room. Re-texture any area that needs it.

163

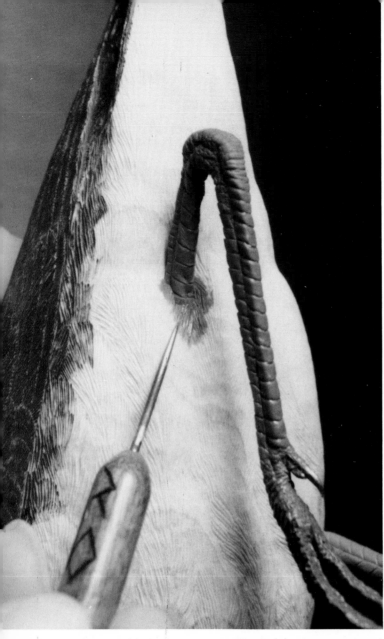

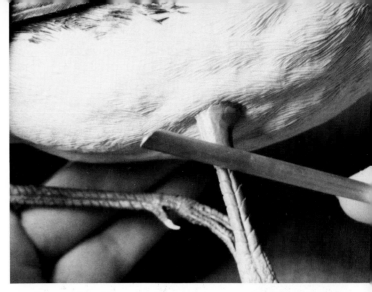

Figure 146. Glue the "down" leg into position. Apply some ribbon putty around the joint and down the tibiotarsus to form a leg tuft of feathers. Texture the tuft and blend the edges into the surrounding texture.

Figure 145. After the putty has hardened on the feet and legs, insert and glue the "up" leg in place. To cover the joint, apply a small amount of the ribbon putty, pulling it into the surrounding texture.

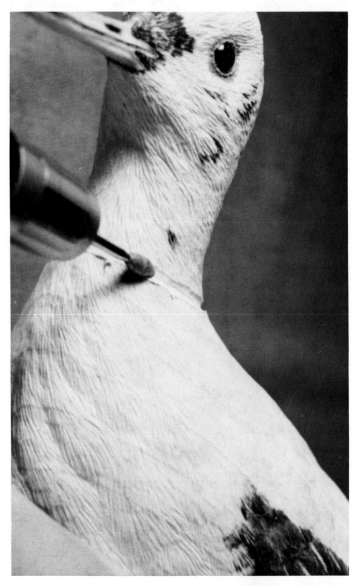

Figure 147. Using a medium diameter ruby carver, channel along the glue line around the neck.

164

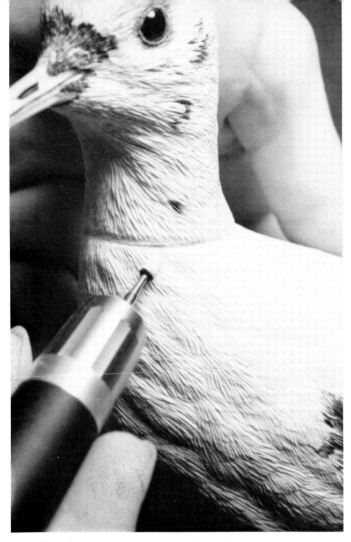

Figure 148. Texture the edges of the channel so that they do not raise up through the putty.

Figure 149. Roll a small worm of putty and press it into the channel. You will need to smooth the putty over the adjacent texturing above and below the channel. Work a small area at a time (one-half to three-quarters of an inch).

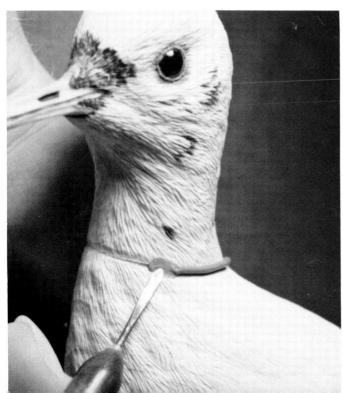

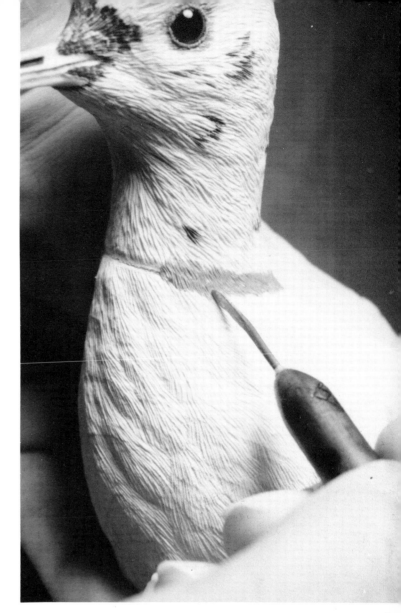

Figure 150. Using a cold burning pen or a clay tool, pull the putty down into the texture lines above and below the joint. The texturing of the putty needs to be accomplished before it hardens. If, however, you find that there is a small piece of putty sticking up or any irregularity after the putty has hardened, use a cylindrical stone to lightly texture a small area.

165

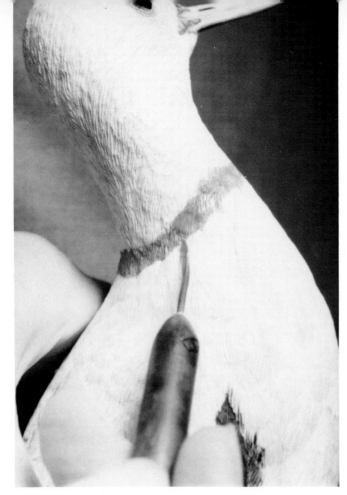

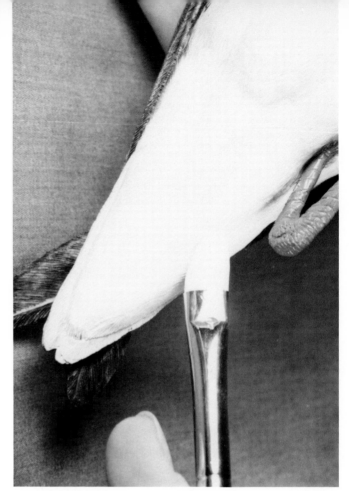

Figure 151. Continue pressing the putty worm into the channel, blending and texturing around the entire neck joint. Checking each fraction of an inch of joint from the profile view will allow you to press the putty into place, hiding the joint.

Figure 152. Spray the carving with *Krylon Crystal Clear*. When the coating is dry, apply gesso with a stiff bristle brush. Load the brush with gesso, wipe the brush on a paper towel and dry-brush the surface of the entire bird (feet and legs included). The burned areas may need a second coat, but do not apply the gesso thickly anywhere on the bird.

Figure 153. When the gesso is dry, carefully scrape and clean the eyes with a sharp knife held at an angle such as would be used in scraping paint from a window.

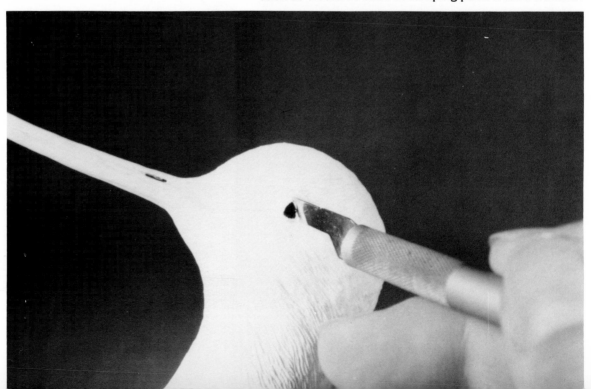

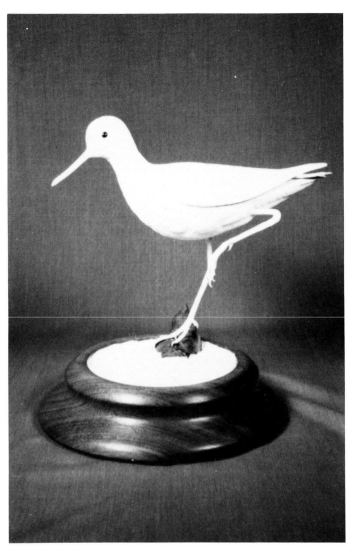

Figure 154. The yellowlegs is ready for color!

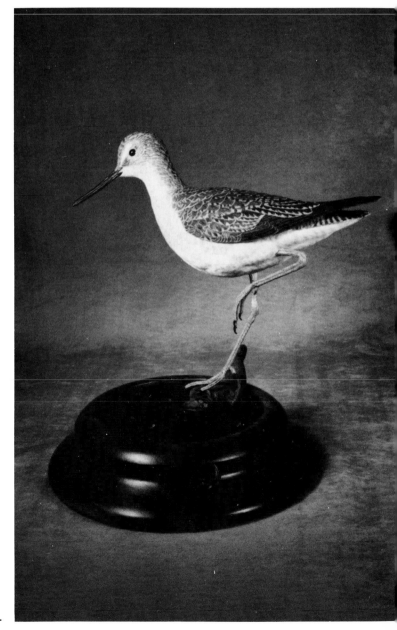

Close-up of finished yellowlegs.

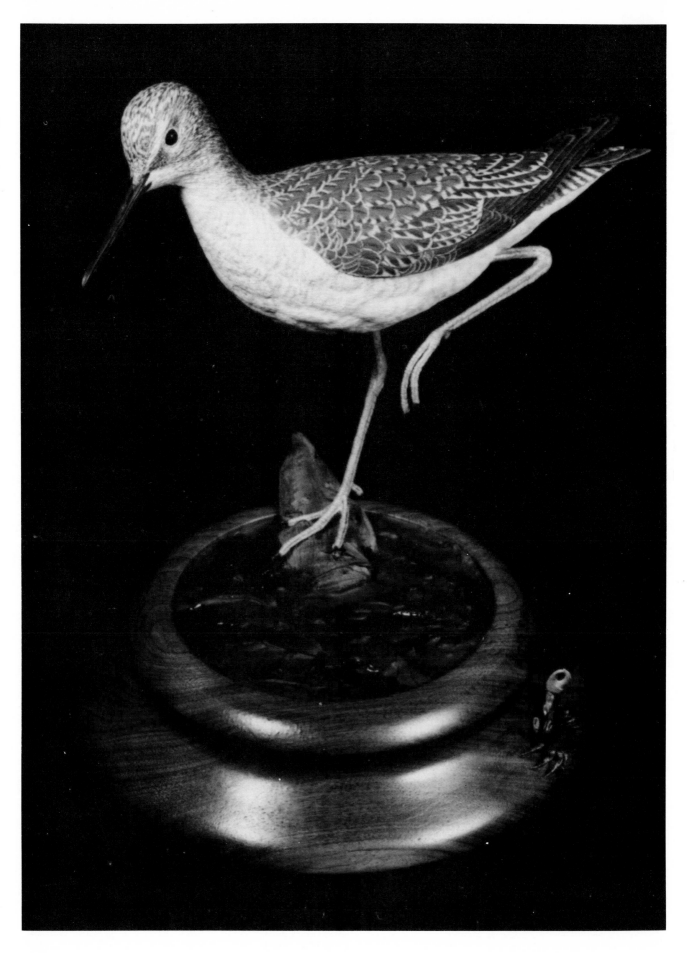

PAINTING THE GREATER YELLOWLEGS
(Non-breeding Plumage)

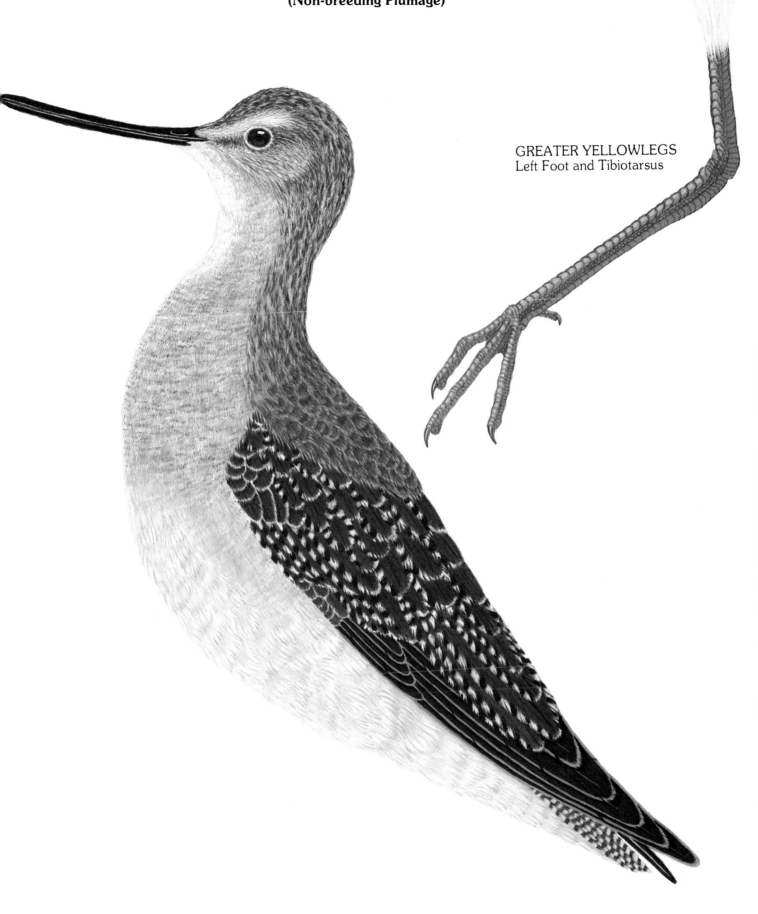

GREATER YELLOWLEGS
Left Foot and Tibiotarsus

Acrylic Colors needed

Burnt umber
Raw umber
Payne's grey
Cerulean blue
Raw sienna
Yellow ochre
Black
White

Alternate two mixes over top of head, neck, mantle, scapulars, wings, underside of primaries and top of tail

Burnt umber, cerulean blue, and small amount of white

Raw umber, cerulean blue, and white

Dark areas on scapulars

Burnt umber, raw umber, and payne's grey

Light areas on scapulars

White, raw umber, and payne's grey

Light edgings on wings

White with small amounts of raw umber and payne's grey

Dark areas on wings

Burnt umber and payne's grey

Edgings for primary coverts and primaries

Burnt umber with small amounts of payne's grey and white

Base coat for belly, lower tail coverts, throat, chin, and ear coverts; dry brush above eyes

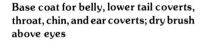

White, raw umber, and cerulean blue

Three colors for ear coverts, breast, neck sides, and narrow strip on flanks

Under lower wing edges, undersides of primary tips and underside of tail

Burnt umber, payne's grey, and white

Feet

Yellow ochre, raw sienna, and a small amount of white

Beak

Burnt umber and black

Mantle
(Enlarged to show detail)

1. Burnt umber, cerulean blue, and white mixture with dry-dabbing stroke.

2. Raw umber, cerulean blue, and white with dry-dabbing stroke. Keep alternating the two until the gesso is covered.

3. Edge detail with a mixture of white with small amounts of raw umber and cerulean blue.

4. Very thin wash of a mixture of raw umber, cerulean blue, and white.

Breast

1. Base coat of white with small amounts of raw umber and cerulean blue.

2. Medium grey mixture (burnt umber, payne's grey, and white) applied with the tips of a round brush held vertically.

3. Lighter grey value (white and raw umber) applied the same way.

4. Alternate two grey mixtures until there is a soft blend. Then apply a very thin, watery wash of a mixture of burnt umber and payne's grey.

171

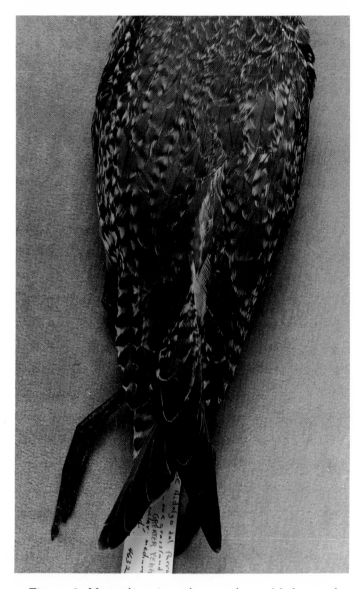

Figure 2. Note the triangular patches of lights and darks on the scapulars and tertials.

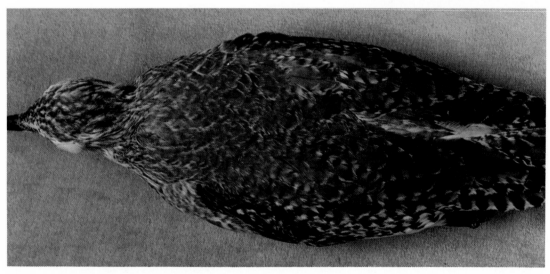

Figure 1. Here you see the plan view of the yellowlegs in non-breeding (winter) plumage.

Figure 3. The pale grey and white striping is the under surface of the tail feathers.

Figure 4. Notice the soft brownish grey streaking on the breast.

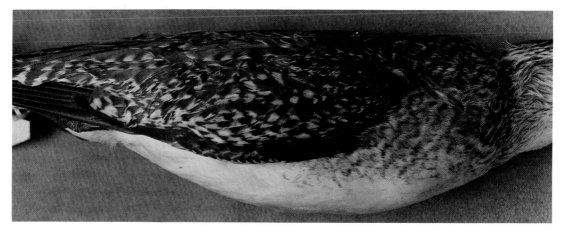

Figure 5. Here you see the profile view of the yellowlegs in non-breeding plumage.

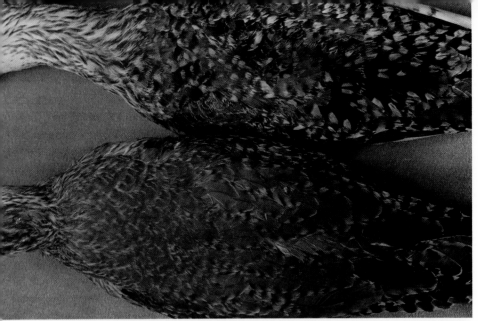

Figure 6. The study skin above is a bird in breeding (summer) plumage and the one below in non-breeding (winter) plumage.

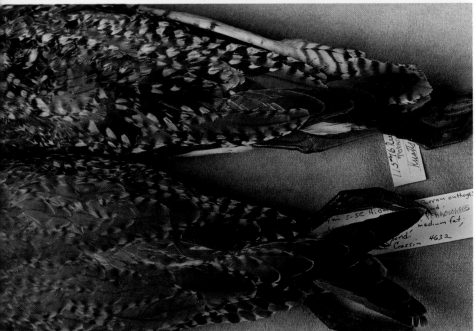

Figure 7. Note the darker areas on the breeding plumage of the study skin above.

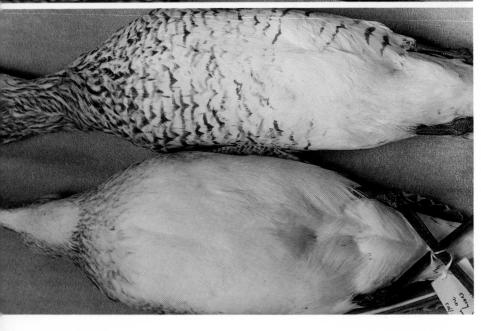

Figure 8. Note the dark chevrons on the breast of the breeding plumage bird.

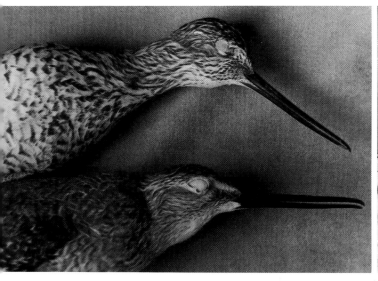

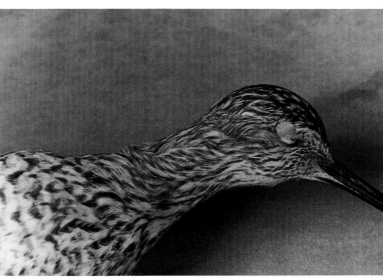

Figure 9. Note the softer greys on the non-breeding study skin below.

Figure 11. The breeding bird's streaking is more pronounced.

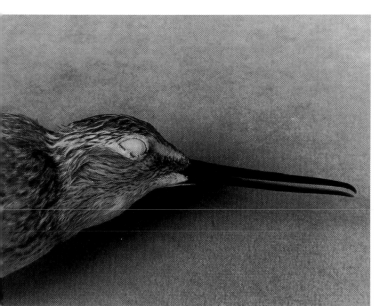

Figure 10. Notice the areas on soft streaking on the head of the non-breeding yellowlegs.

Figure 12. Here you see the softer patterns on the tertials and scapulars on the non-breeding bird.

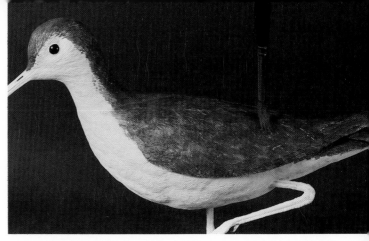

Figure 15. Mix raw umber, cerulean blue and white to a soft, medium greenish grey. Again, load the brush, wipe the excess on a paper towel and apply in a random dry-dabbing stroke to the same areas as the brownish grey mixture.

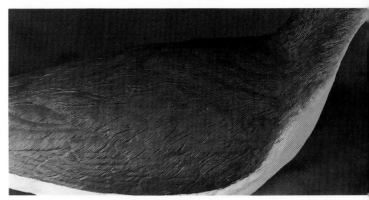

Figure 13. The patterns on the tertials and scapulars of the breeding bird are more vivid.

Figure 16. Keep alternating the two mixtures until the gesso cannot be seen through the paint. It will take many applications of thin paint, but there will be a soft blending of the two greys. Both greys should be evident in the final coats. If the bird starts getting too dark, add more white to each mixture. If it starts getting too light, add less white. You may need to adjust the value and color with each application.

Figure 17. Make a mixture of white with small amounts of raw umber and cerulean blue to a light grey. On the head, back of the neck and mantle, paint in light leading and trailing edges of the feathers. It will take several applications to cover the darker grey. Vary the length of the strokes so that the actual edge of the feather is the brightest part. The pattern on the actual bird appears to be streaks of light due to the fact that the trailing edge of one feather lays next to the leading edge of the feather beside it.

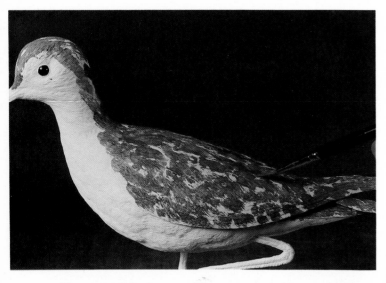

Figure 14. Mix burnt umber, cerulean blue and white to a soft, medium brownish grey. Load the brush, wipe the excess on a paper towel and apply in a random dry-dabbing stroke to the top of the head, back of the neck, mantle, scapulars, wings, upper tail and the primaries' underside. Do not entirely cover the areas at this point, but leave areas of the gesso unpainted.

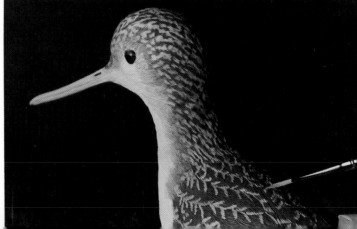

The pattern on the head and back of the neck feathers:

Enlarged to show detail

The pattern on the mantle feathers:

Enlarged to show detail

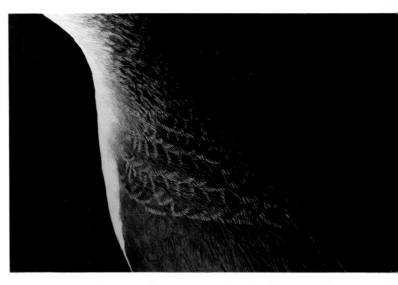

Figure 19. Keep applying the wash and reinforcing the light and dark areas until there are softly, blended transitions.

Figure 20. With a dark mixture of burnt umber, raw umber and payne's grey, paint in the spots on the leading and trailing edges of the scapular feathers. Add a small amount of white to this mixture and paint the quills. Then, wash the scapulars with a thin, watery mixture of burnt umber, raw umber, payne's grey and white several times. Keeping the wash watery thin allows you to control the wash results more effectively than with a heavy, thick application. The wash is used to blend and subdue the dark edges of the spots with the basecoat color.

The light and dark pattern on the scapular feathers:

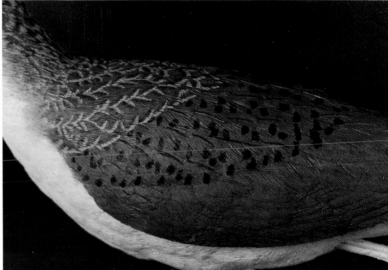

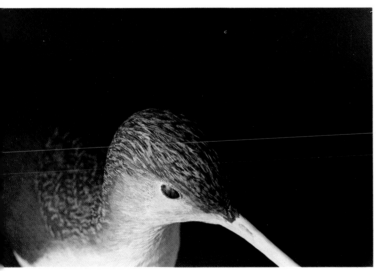

Figure 18. With a mixture of burnt umber and payne's grey, paint in splits and darken the base of the feathers on the head and neck. Wash the entire area with a very thin, watery mixture of raw umber, cerulean blue and white. Then, reinforce the light and dark areas with their respective mixtures.

Scapular

Enlarged to show detail

177

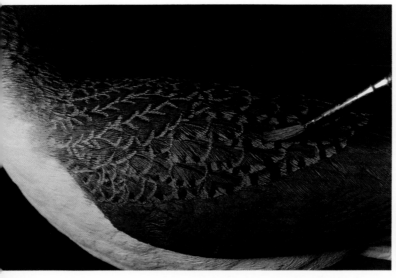 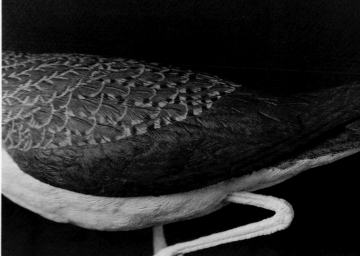

Figure 21. For the light areas on the scapulars, mix white with small amounts of raw umber and payne's grey. Apply the light grey mixture to the areas between the dark spots and also the tips of the longer feathers. It will take several applications to obtain sufficient intensity covering the basecoat. Then apply a thin, watery wash of raw umber, payne's grey and white (medium grey) to the scapulars. To obtain a soft, blended appearance, reinforce the dark and light spots several times with thin, watery washes in between. Thin the dark color and paint in shadows at the bases of some of the scapulars and a few random splits.

Figure 22. Make a dark brown wash with burnt umber and a small amount of payne's grey and apply to the wings and top surface of the tail.

Figure 23. With a mixture of white with small amounts of raw umber and payne's grey, pull a very thin light edge on each of the lesser and middle secondary and marginal coverts. Paint the line edging first and thin a slightly wider edging on each feather tip. On the greater secondary coverts, begin painting in the triangular light spots along the leading portion of each feather.

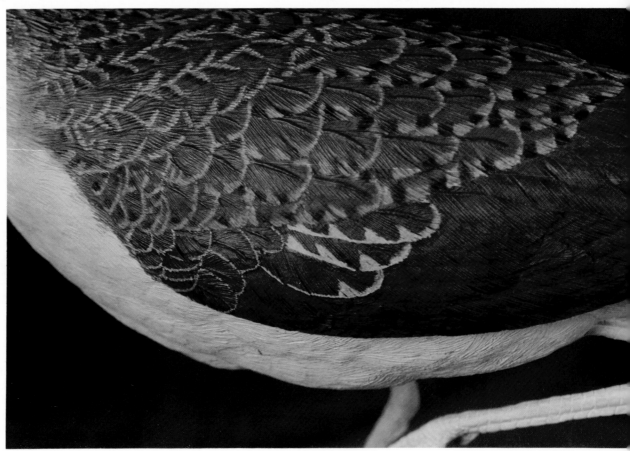

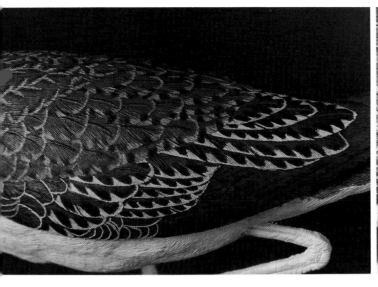

Figure 24. Finish painting in the spots on the greater secondary coverts. Then paint in light edge lines on the lesser and middle primary coverts. Using the light grey mixture (white with small amounts of raw umber and payne's grey) and a liner brush, paint in the triangular spots on the tertials and secondaries.

With a dark mixture of burnt umber and a small amount of payne's grey, paint in the dark spots between the light ones on the greater secondary coverts, tertials and secondaries.

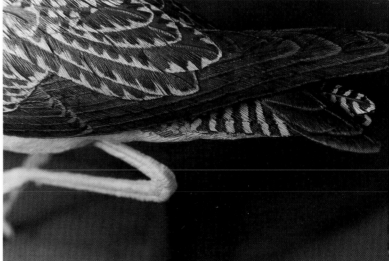

Figure 26. Blending burnt umber with small amounts of payne's grey and white to a medium greyish brown, paint in the single line edging on each primary covert and primary. With a liner brush, pull the single line edging first and then widen the light edge on each of the feather tips. Use a thin mixture of burnt umber with a small amount of payne's grey for a few random splits and shadows at the bases of the feathers.

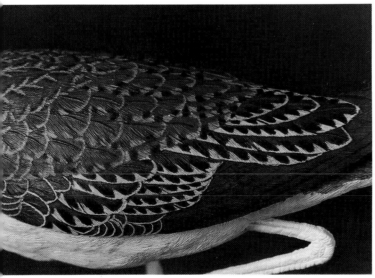

Figure 25. It will take several applications of both the light and dark mixtures. Blend the edges of the two contrasting colors until there are soft blended transitions. Apply thin, watery washes consisting of raw umber, payne's grey and white in between applications. Do not apply any washes to the primary coverts or primaries.

Figure 27. Blend a light grey mixture with white and small amounts of payne's grey and burnt umber. Paint the dark barring on the top of the tail. On each side of each light stripe, dot a dark line with a mixture of burnt umber and payne's grey. Thin the dark mixture with water and do a few random splits. Blend the lights and darks together until there is a gradual transition. Then, apply a thin, watery medium grey wash with a mixture of burnt umber, payne's grey and white.

179

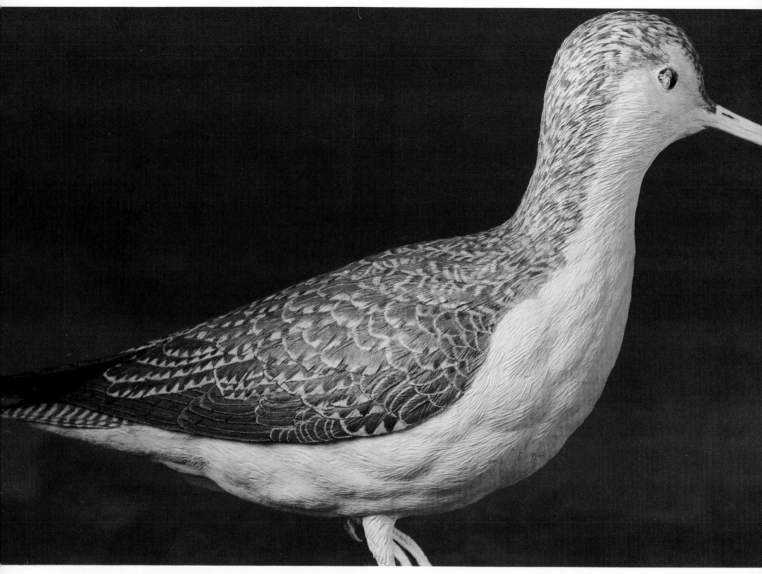

Figure 28. The basecoat for the belly, lower tail coverts, flanks, throat, chin and ear coverts is a mixture of white with small amounts of raw umber and cerulean blue. It will take several thin applications. Lightly dry-brush the light mixture above the eye, blending it into the surrounding areas.

Figure 29. There are two mixtures used in the soft streaking on the ear coverts, breast, sides of the neck and the narrow band on the flanks. The first mixture is a medium value of grey obtained by blending burnt umber, white and a small amount of payne's grey. Keep your paint thin. On the ear coverts, sides of the neck and the upper breast use the point of a round brush such as a *Grumbacher Beau Arts Series 190 #3* to paint in the streaks. On the flanks and breast, use the thin mixture and apply it with a flared round brush such as a *Grumbacher Beau Arts Series 190 #5* held vertically. Just touch the tips of the flared bristles so that there is an irregular line of the thin paint deposited on the textured surface.

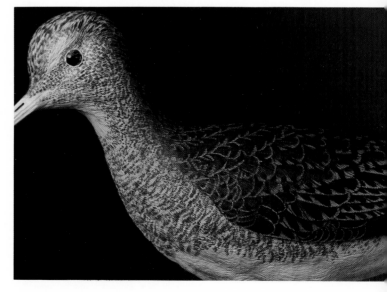

Then, apply a lighter grey value consisting of white and a small amount of raw umber. Apply the thin light grey using the same techniques.

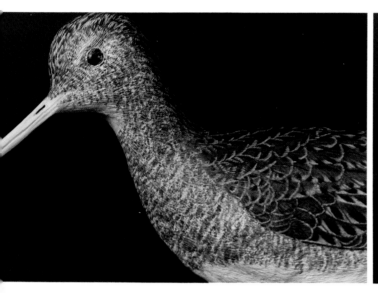

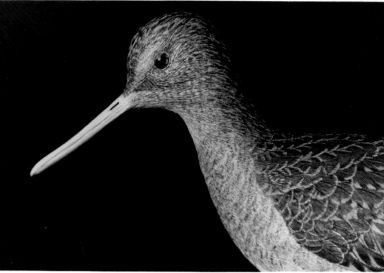

Figure 30. Keep alternating the two mixtures until there are soft blends between the lights and darks. Apply a very thin, watery wash of a burnt umber and small amount of payne's grey mixture.

Figure 31. With a mixture of raw umber and payne's grey, paint in the very small dark streaks on the lores, ear coverts, the area behind the eye and the side of the neck. The transition along the side of the neck will need to be blended pulling the light values into the darks and the darks into the lights.

Figure 32. Use straight white and a large round brush with its bristles fanned to edge the feathers on the leg tuft, lower tail coverts, belly and flanks. To fan the brush, scrub the bristles around in the creamy white paint and lift the brush off the palette vertically. When the brush is pulled straight up, its bristles will form a convex shape at their ends. This convex shape is the perfect cup-shape for the ends of the larger feathers on the belly, flanks and lower tail coverts. Hold the brush at a 90 degree angle above the wood surface and touch the end of a feather with the tips of the fanned bristles, pull the brush toward you just a little and then lift off the surface of the bird. You will need to apply the white edgings twice. Then wash over the areas with a very thin, watery mixture of white and a small amount of raw umber.

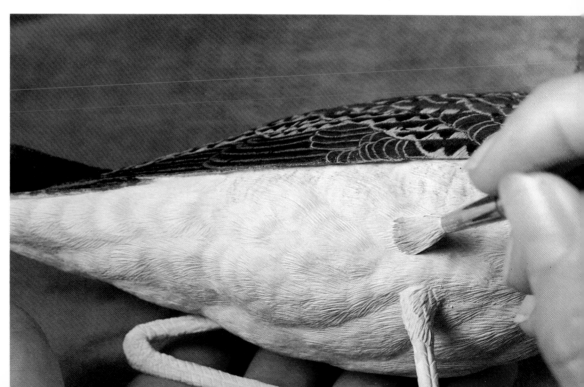

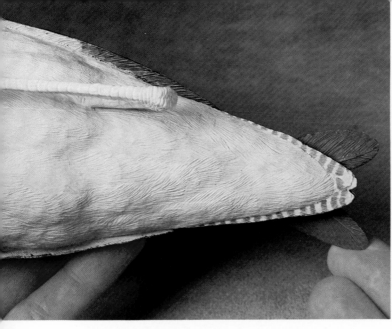

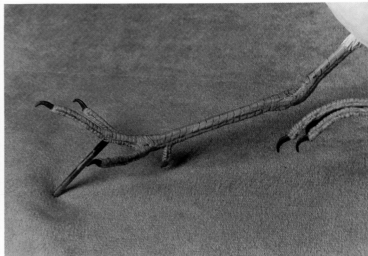

Figure 33. Carefully paint the area under the primaries and under the lower wing edges with a medium grey mixture of burnt umber, payne's grey and white. For the barring on the under tail area, use a medium grey mixture of burnt umber, payne's grey and white. The whitish bars are a mixture of white with a small amount of raw umber. Blend the edges of the bars. Then, apply a thin, watery wash of a mixture of white with a small amount of raw umber.

Figure 34. Blend yellow ochre, raw sienna and white to an orange-yellow color and apply to the feet and legs. It will take several thin applications. Do not apply thick paint that will fill up the texturing. Apply a thin, watery wash of a mixture of burnt umber and raw sienna. Paint the claws with a mixture of burnt umber and raw sienna.

Figure 35. Blend burnt umber with a small amount of black and white to a dark charcoal color and apply to the beak. It will take a couple applications to obtain sufficient coverage so that the gesso cannot be seen through the paint. Then, add a small amount more of white to the basecoat mixture and lighten the lower edge of the upper mandible and the base of the lower mandible on both sides. Use a mixture of burnt umber and payne's grey to darken the commissure lines, nostril depressions and the narrow depressions on the sides of the lower mandible.

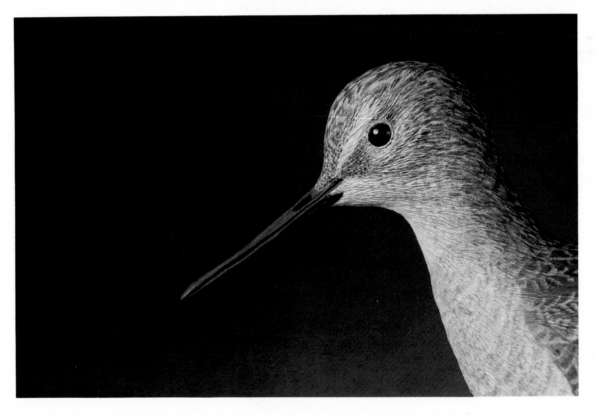

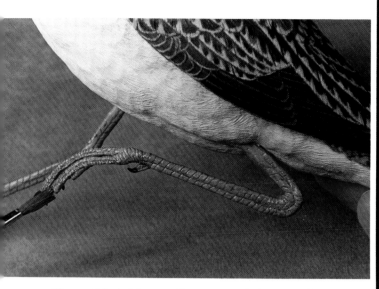

Figure 36. Add a small amount of gloss medium to a large puddle of water and apply to the feet and legs. When this is dry, apply straight gloss medium to the claws.

Figure 37. Make a 50/50 mixture of matte and gloss mediums and apply to the beak. Using a liner brush and straight gloss mediums, paint the quills on the scapulars, wings and tail. Carefully scrape the eyes and glue the completed bird into the habitat.

Figure 38. The completed greater yellowlegs.

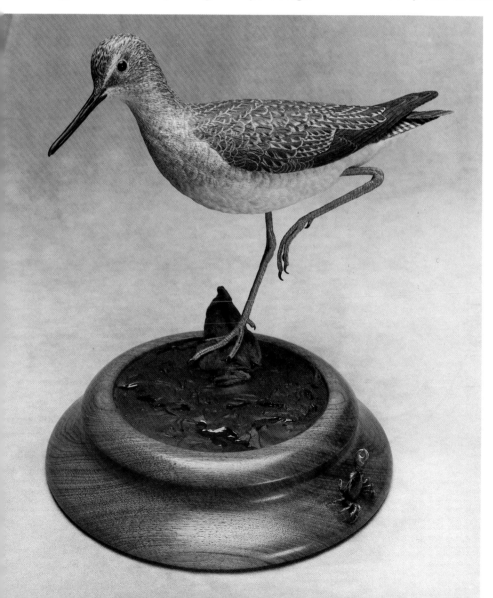

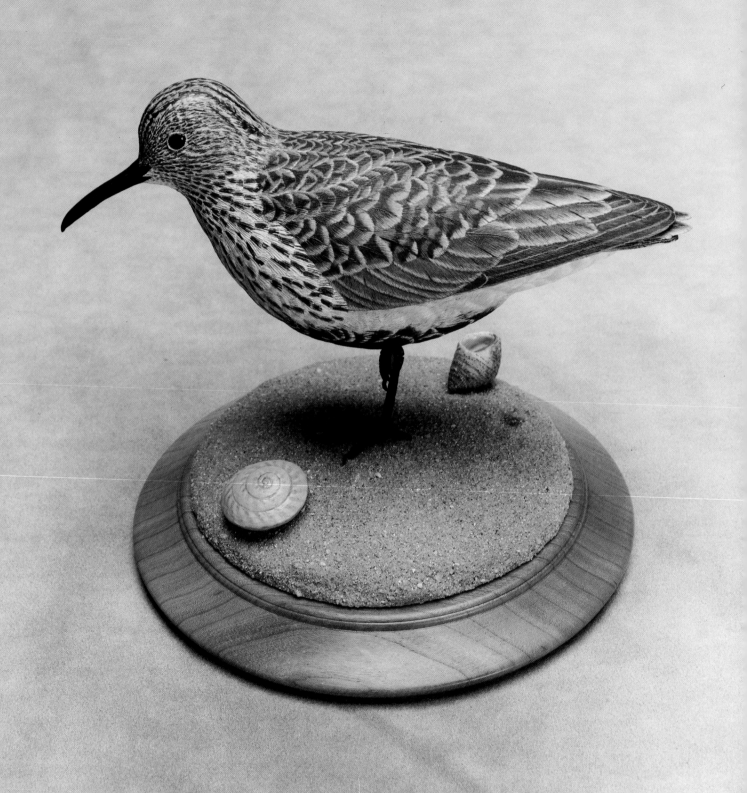

Chapter 6.

Dunlin

(Calidris Alpina)

The dunlin, one of the sandpiper family, is a bird found along both sea coasts of the United States. Though the sexes are outwardly similar, the female tends to be slightly larger. Dunlins can be found on the mudflats or sandy shores of the sea coasts, marshes, lakes and rivers. They use their bent-tip beak to probe the mud or sand for small crustaceans, worms, small mollusks and insects and their larvae.

The dunlin, in its breeding plumage (summer), is a distinctive bird with its chestnut coloring on the crown,

back and scapulars and the black belly patch, allowing easy identification in the field. The crown and upper parts are a brownish grey with dark streaks in the centers of feathers in its non-breeding (winter) plumage. The beak has a characteristic droop at its blunt tip.

A tundra nester, the dunlin scrapes a small depression in a grassy area. The usual clutch is four eggs, incubated by both parents. The young birds will be left to their own resources in approximately three weeks.

DIMENSION CHART

1. End of tail to end of primaries	.3 of an inch
2. Length of wing	4.9 inches
3. End of primaries to alula	3.8 inches
4. End of primaries to top of 1st wing bar	2.0 inches
5. End of primaries to bottom of 1st wing bar	3.3 inches
6. End of primaries to mantle	2.7 inches
7. End of primaries to end of scapulars	1.6 inches
8. End of primaries to end of secondaries	2.6 inches
9. End of primaries to end of tertials	.8 of an inch
10. End of primaries to end of primary coverts	2.4 inches
11. End of tail to front of wing	5.2 inches
12. Tail length overall	2.3 inches
13. End of tail to upper tail coverts	.6 of an inch
14. End of tail to lower tail coverts	.5 of an inch
15. End of tail to vent	2.3 inches
16. Head width at ear coverts	1.1 inches
17. Head width above eyes	.85 of an inch
18. End of beak to back of head	2.6 inches
19. Beak length	
Top	1.35 inches
Center	1.4 inches
Bottom	1.2 inches
20. Beak height at base	.27 of an inch
21. End of beak to center of eye (6 mm. brown)	1.9 inches
22. Beak width at base	.23 inches
23. Tarsus length	1.0 inch
24. Toe length	
Inner	.68 of an inch
Middle	.9 of an inch
Outer	.75 of an inch
Hind	.25 of an inch
25. Overall body width	2.5 inches
26. Overall body length	7.5 inches

TOOLS AND MATERIALS

Bandsaw (or coping saw)
Flexible shaft machine
Carbide bits Ruby carvers and/or diamond bits
Variety of mounted stones
Pointed clay tool or dissecting needle
Compass
Calipers measuring in tenths of an inch
Rheostat burning machine
Ruler measuring in tenths of an inch
Awl
400 grit sandpaper
Drill
Drill bits
Laboratory bristle brush
Needle-nose pliers
Toothbrush
Wire cutters
Safety glasses and dustmask
Super-glue
Oily clay
Duro ribbon epoxy putty (blue and yellow variety)
Krylon Crystal Clear
Tupelo or basswood block 3.6" x 2.5" x 7.5"
Pair of cast dunlin feet to use as a model
Pair of 6 mm. brown eyes
For making feet:
1/16" brazing rod
20 gauge copper wire
solder, flux and soldering pen or gun permanent ink marker
hammer and small anvil
cartridge roll sander on a mandrel
small block of scrap wood and staples for holding jig (or several pairs of helping hands holding jigs)

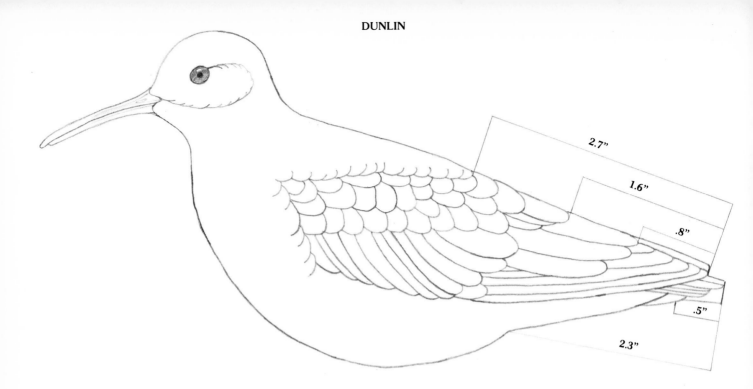

Profile line drawing

Pattern

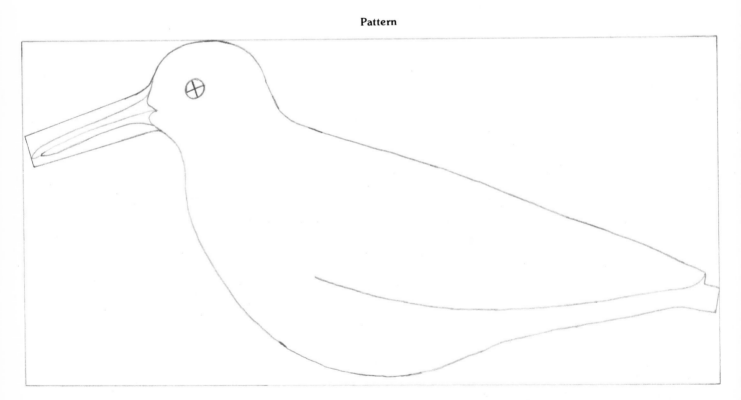

Block: 3.6" (h) x 2.5" (w) x 7.5" (l)

DUNLIN

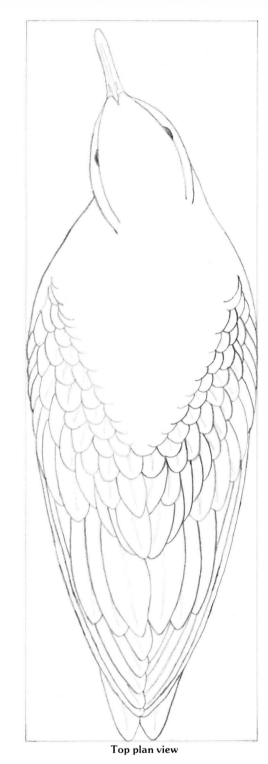

Under plan view

Top plan view

*Foreshortening may cause distortions in measurements on plan views. Check the dimension charts.

Mid-body cross-section

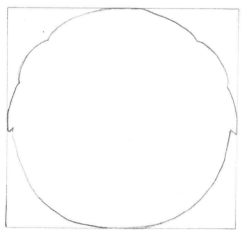

Foot

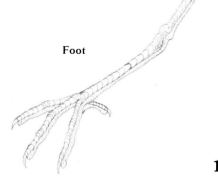

187

DUNLIN

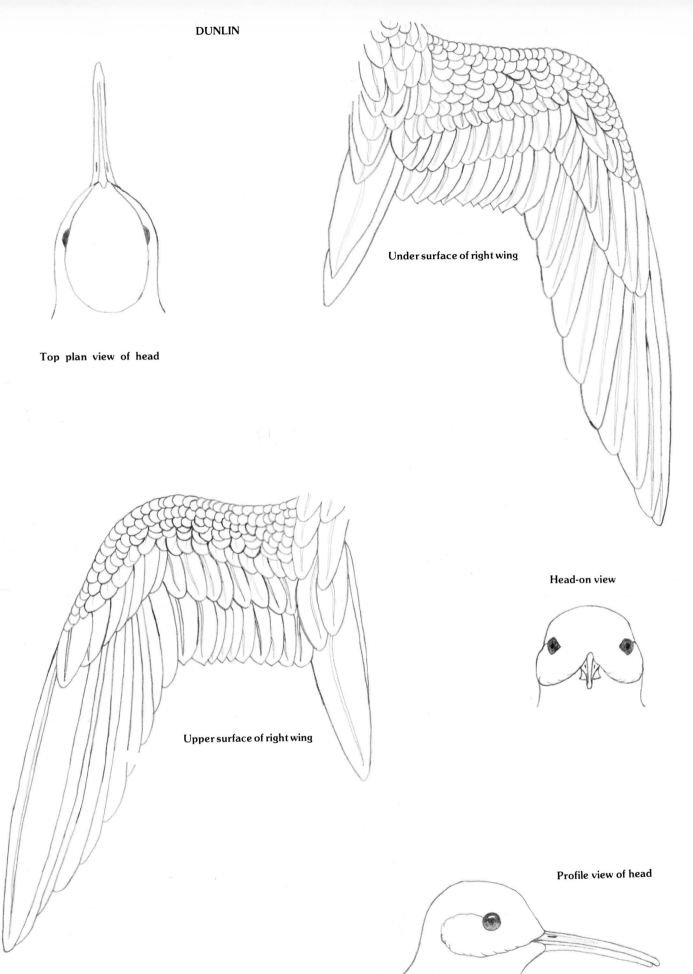

Top plan view of head

Under surface of right wing

Upper surface of right wing

Head-on view

Profile view of head

Figure 1. Cut the profile pattern out of a block of tupelo or basswood. Draw in the centerline on the top and underneath surface. Draw in the wings using the top plan view as reference. Using a bandsaw or coping saw, remove the excess wood outside of the wing and tail lines.

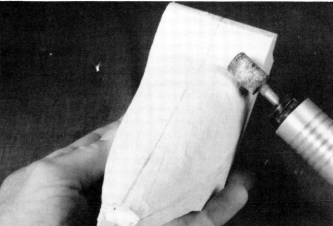

Figure 4. Round over the wings from the centerline to the lower wing edges and from the base of the neck to the tips of the primaries.

Figure 2. Using the profile line drawing as reference, draw in the lower wing edge lines. Note that there will be a small patch of side breast feathers covering the front portion of the wings.

Figure 3. With a medium square-edged carbide cutter, remove the excess wood from under the lower wing edges all the way to the edge of the belly and flank. Keep the flank planes flat and vertical. The cut starts gradually from the breast feather area and then deepens to .15 of an inch in middle of the wing. Near the tail area, the cut should gradually lessen so that no wood is removed from the tail itself.

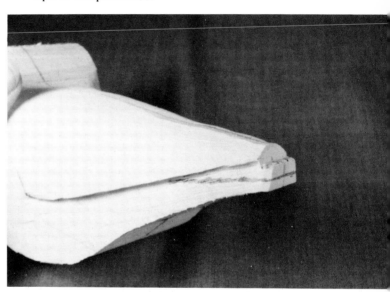

Figure 5. On the sides and end of the tail, draw in the tail thickness (.2 of an inch).

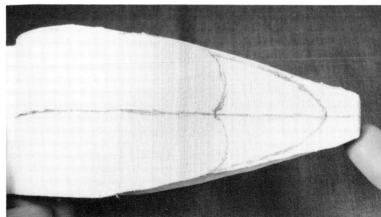

Figure 6. On the underneath centerline, measure and mark in the distance from the end of the tail to the lower tail coverts (.5 of an inch) and the vent (2.3 inches). Draw in the shapes of the lower tail coverts and the vent area encompassing these marks.

189

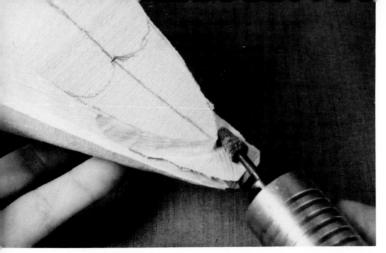

Figure 7. Using a small tapered carbide bit, remove the excess wood from under the tail up to the lower tail covert line.

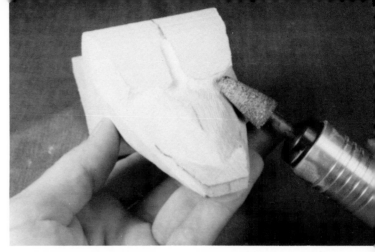

Figure 10. The lower tail coverts should be a large rounded puff of feathers at this point.

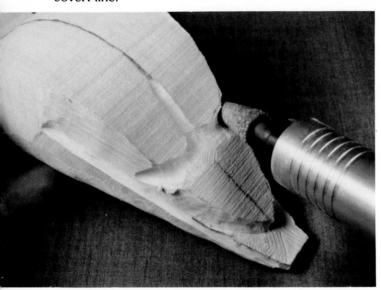

Figure 8. With a medium tapered carbide bit, channel around the vent lines. Work the channel around the corners of the flank and up to the lower wing edges. Be careful not to nick the wings. Create a shallow channel on the centerline and vent 1.0 inch in length.

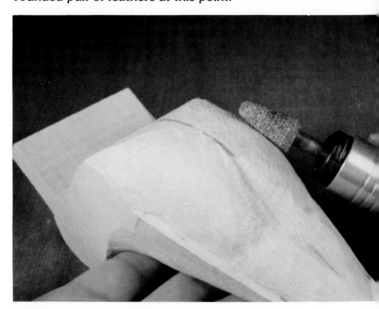

Figure 11. Round the belly and lower breast to the centerline. Flow the ledges of the vent channel down to the base of the lower tail coverts. Round over the vent area at the midline.

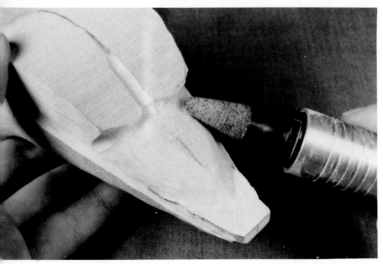

Figure 9. Round over the lower tail coverts and flow them down to the base of the tail.

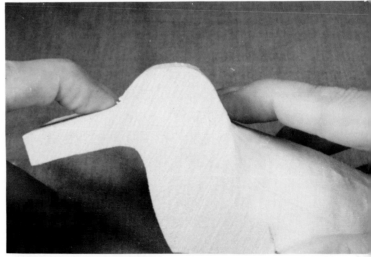

Figure 12. Holding one index finger at the base of beak and the other at the back of the head, optically determine and mark the center of the head on the top centerline.

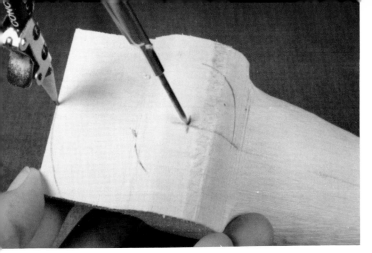

Figure 13. Using the center mark as a pivot point, swing an arc from the end of the beak and base of the beak to the side to which you want to turn the bird's head. Swing another arc to the opposite side the same distance as the back of the head.

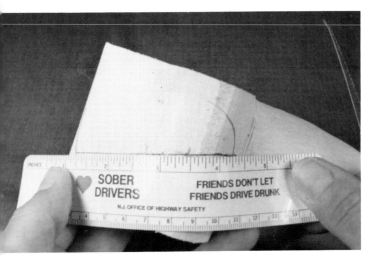

Figure 14. Draw a new centerline through the pivot point and intersecting all three arcs. The angle between the new and old centerlines will be the degree to which the head will be turned. It will be helpful and less confusing to erase the old centerline.

Figure 15. The widest part of any bird's head is the width at the ear coverts. Holding a ruler across the new centerline, measure and mark the ear covert width (1.1 inches). There should be .55 of an inch on each side of the centerline. Draw in the plan view of the head encompassing these marks. Allow extra wood around the beak. Extra wood should also be allowed at back of the head for the width of the neck.

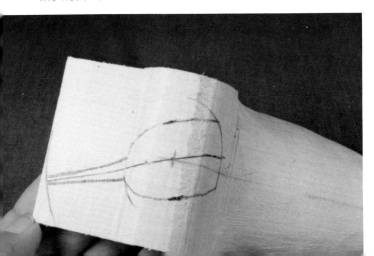

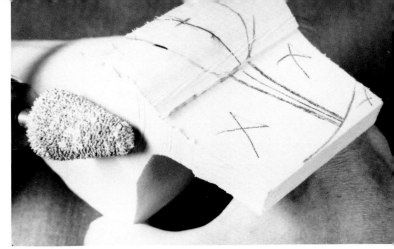

Figure 16. Using a large tapered carbide bit, begin cutting the excess wood from the sides of the head and the sides and end of the beak.

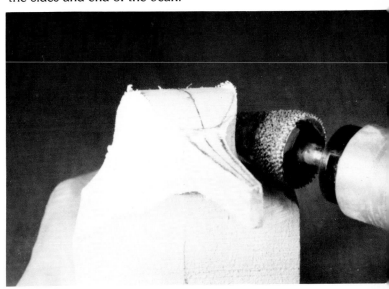

Figure 17. Keep the sides of the head and beak vertical. Do not do any rounding yet. Keep equal amounts of wood on each side of the centerline.

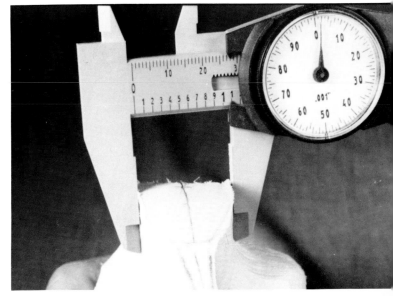

Figure 18. Continue removing the excess wood until the calipers measure 1.1 inches.

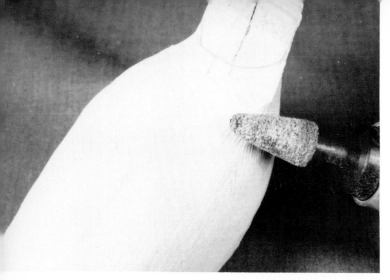

Figure 19. Flow the ledges created from narrowing the head down onto the mantle and shoulder area. Do not remove any wood from the back of the neck yet.

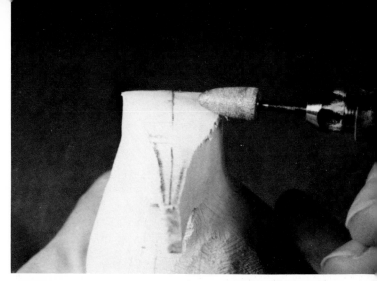

Figure 22. With a ruby carver, remove the excess wood on the high front quadrant so that it is the same plane as the other side.

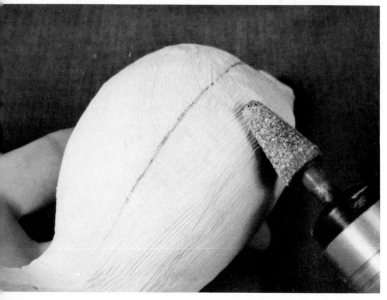

Figure 20. Round over the breast and throat area to the centerline. Do not remove any wood from under the beak or chin area.

Figure 21. Draw a line across the top of the head through the pivot point, dividing the top of the head into quadrants. Turning the head of the bird in the wood causes to angle of the head plane to be off. The quadrants with the "x" are the high ones: the front quadrant on the side to which the head is turned and opposite back one.

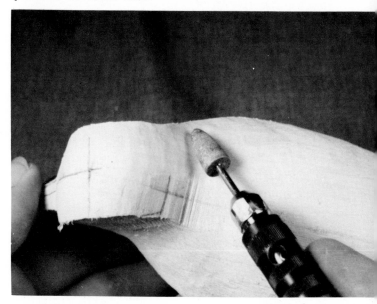

Figure 23. Remove the excess wood off the high back quadrant of the head and on down the back of the neck so that they are on the same plane as the other side. The more the head is turned, the more wood will need to be removed from the high quadrants. Sometimes wood beyond the centerline will need to be removed. If you cut away the centerline, it is important to remember to redraw it.

Figure 24. Check the distance from the end of the beak to the back of the head (2.6 inches). Adjust, if necessary, by removing small amounts from the back of the head and the end of the beak.

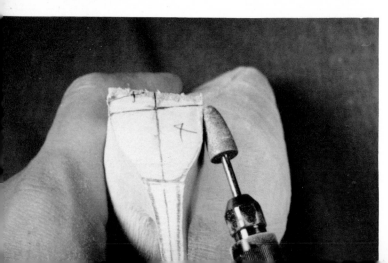

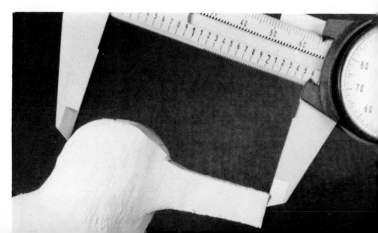

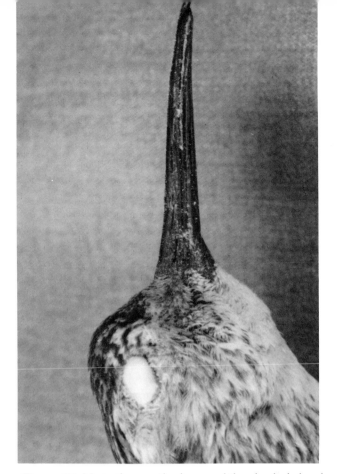

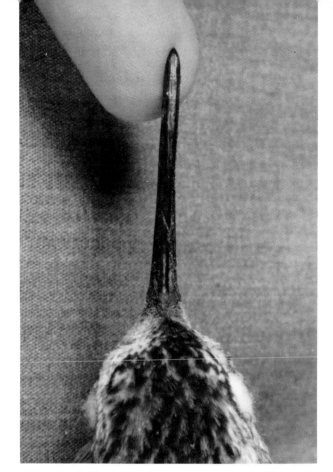

Figure 25. Note the gentle droop of the dunlin's beak.

Figure 26. There is a shallow v-shaped depression on the bottom of the lower mandible.

Figure 27. Note the shape of the top plan view of the beak.

Figure 28. Transfer the eye and beak placement from the profile line drawing, making sure that both sides are balanced. Check the distance to the center of the eye, center beak length and beak height with the measurements listed on the Dimension Chart.

Pinprick the center of the eyes, the commissure line and the bottom of the lower mandible at its base. On the top centerline, measure, mark and pinprick the top beak length (1.35 inches). Draw in the shape of the base of the beak on the top view.

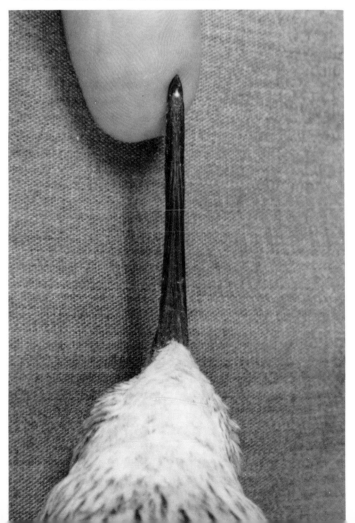

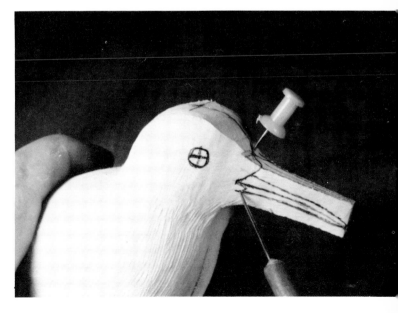

193

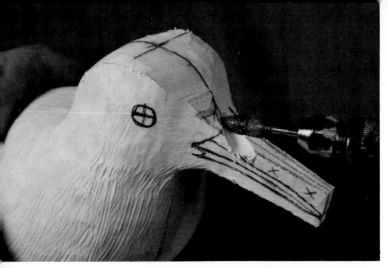

Figure 29. Using a medium diameter pointed ruby carver, begin removing the excess wood from above the top line of the upper mandible.

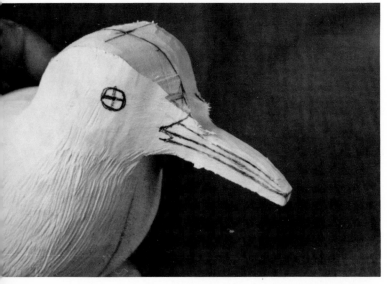

Figure 30. Keep the beak's top surface a flat plane at this point, removing all of the excess wood. Redraw the centerline.

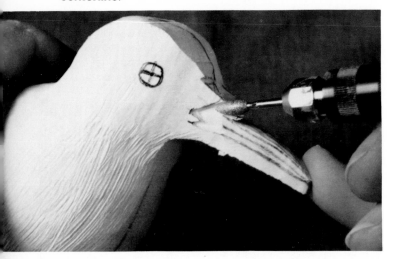

Figure 31. Using a narrow diameter pointed ruby carver, begin grinding away the excess wood on the sides of the beak. Keep the beak balanced across the center-line.

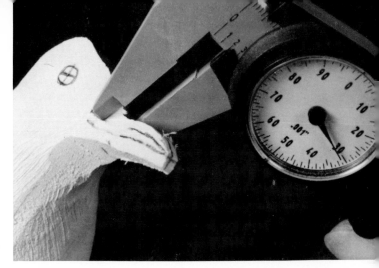

Figure 32. Keeping the sides of the beak vertical at this point, continue removing the excess wood until the calipers can measure .23 of an inch at the beak's base.

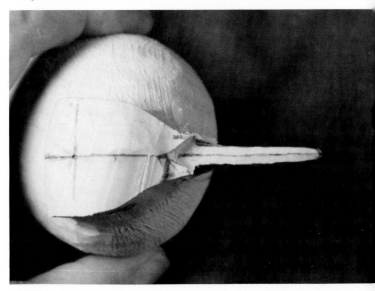

Figure 33. Narrow the remainder of the beak's sides, keeping them vertical planes. At the mid-point of the beak, the width should measure .14 of an inch. Round the tip of the beak on its sides (plan view). Redraw the commissure and lower mandible lines on both sides.

Figure 34. Leaving a narrow flat area on the top ridge (the culmen), angle the sides from the ridge to the commissure line on each side.

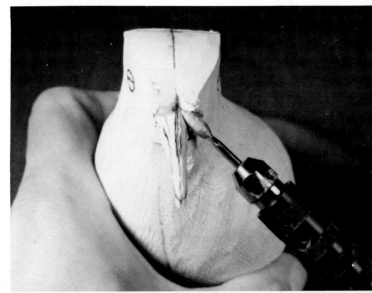

194

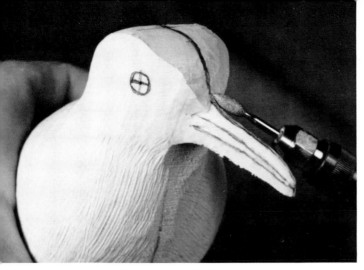

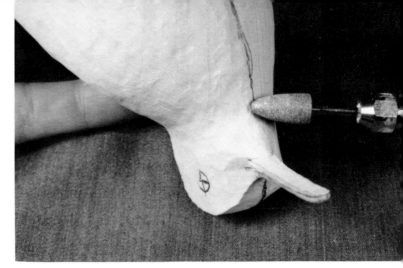

Figure 35. Flow the forehead and sides of the head down to the base of the beak and eliminate the sharp angled shelves remaining from cutting the beak into the head. Do not round the head.

Figure 38. Flow the tuft of feathers down to the base of the bottom of the beak and round over the throat, neck and chin.

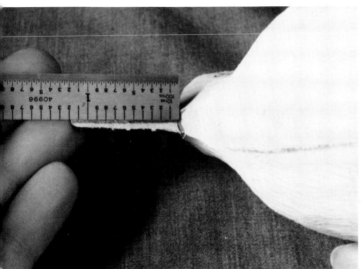

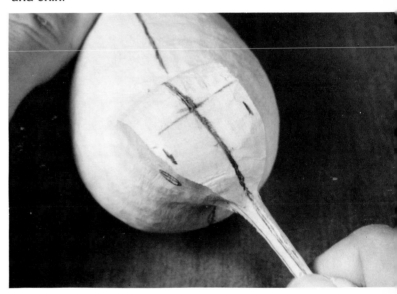

Figure 36. Draw in the centerline on the bottom of the lower mandible. Measure and mark the bottom beak length (1.2 inches). Draw in the rounded shape of the feather tuft underneath the beak.

Figure 37. Using a narrow diameter ruby carver, remove the excess wood from under the lower mandible around the little tuft of feathers. Grind away all of the excess below the bottom of the beak out to the tip.

Figure 39. Across the top of the head, measure and mark the head width above the eyes (.85 of an inch) with .425 of an inch on both sides of the centerline.

Figure 40. Pin-pricking the eye centers deeply will allow the marks to be retained when cutting wood away. Grind away wood on the sides of the head from the eye area up to the top of the head, keeping the planes flat and not rounded. Note the wedge shape of the plan view of the head.

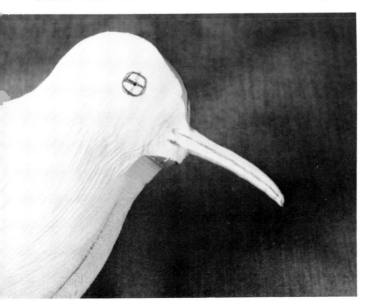

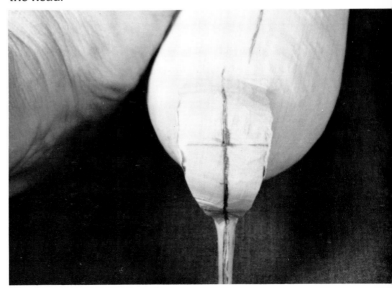

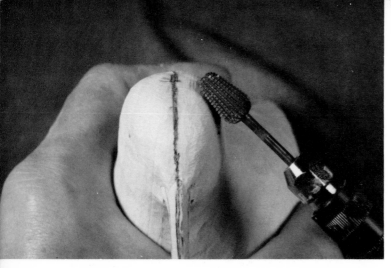

Figure 41. Round the sharp corners of the head from the forehead to the back of the head and on down the back of the neck.

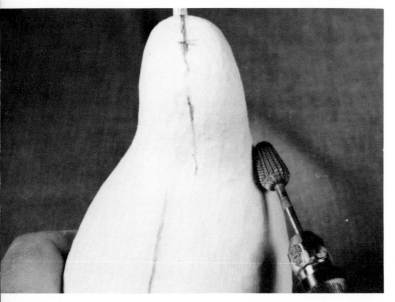

Figure 42. Thin the sides of the neck so that its width is 1.2 inches. There should be a gentle flow from the sides of the head to the neck and down to the breast and shoulder area.

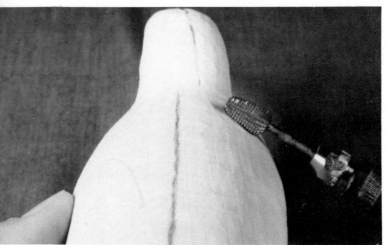

Figure 43. Remove more wood from the sides of the mantle and the shoulder area so that there is a definite rounded contour.

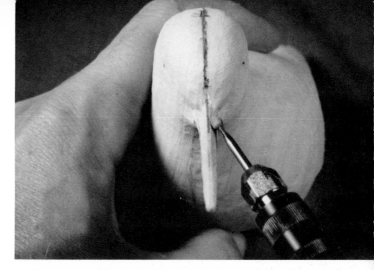

Figure 44. Using a narrow diameter pointed stone, create the small depressions for the nostrils on each side of the culmen. Round over the sharp edges of the culmen.

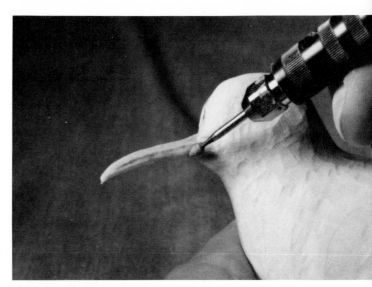

Figure 45. Round over the sharp edges on the bottom of the lower mandible.

Figure 46. Check from the head-on view to make sure that the commissure lines on each side are balanced. Burn in the commissure with the burning pen held vertical to the side of the beak. Burn a second line laying the burning pen on its side and burning up to the first line. This creates the effect of the lower mandible fitting up into the upper mandible.

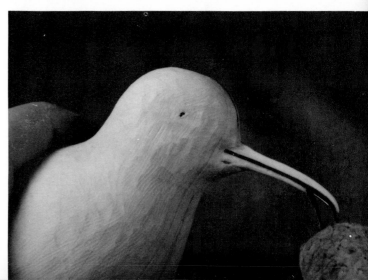

196

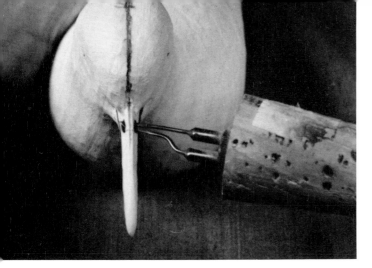

Figure 47. Draw in the nostril on each side of the culmen. Carefully burn through the nostril from each side until a small slit is open through the top of the upper mandible. Do not use high heat or heavy pressure causing the slit to be too large or the beak to break.

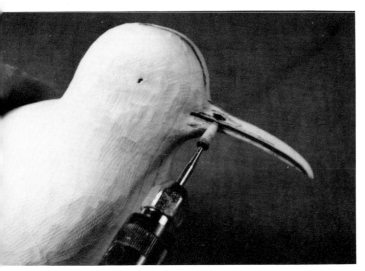

Figure 48. Using the edge of a small cylindrical stone, grind a sharp angled line above and below the commissure line.

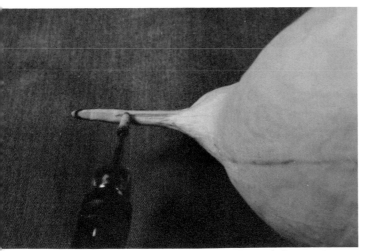

Figure 49. Create the shallow v-shaped depression on the bottom of the lower mandible. Sand the entire beak with 400 grit sandpaper.

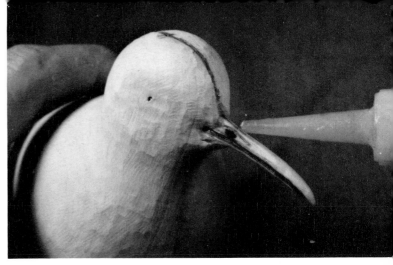

Figure 50. Saturate the entire beak with super-glue. When the glue has hardened, fine sand again.

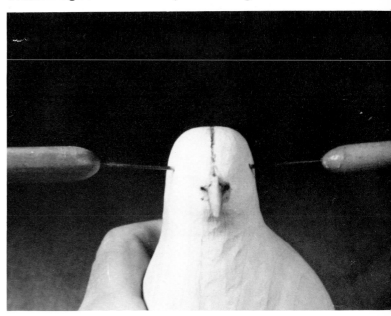

Figure 51. Inserting two pointed clay tools into the centers of the eyes will allow you to check for balance of the eyes more easily. Adjust if necessary.

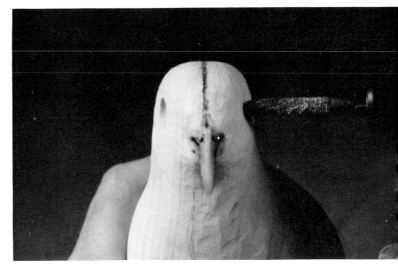

Figure 52. Drill balanced 6 mm. eye holes at least .2 of an inch deep.

197

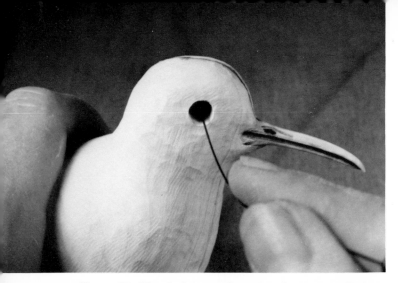

Figure 53. Check the eyes for ease of insertion. Slightly oversized holes will allow adjustment of the eyes.

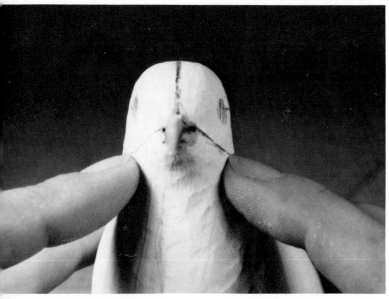

Figure 54. Draw the ear coverts on the sides of the head. Holding your index fingernails on the line will aid in checking for equal depth.

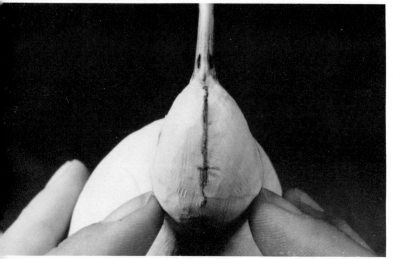

Figure 55. On the top plan view, holding your index fingernails on the back of the ear covert lines will aid in checking for equal length.

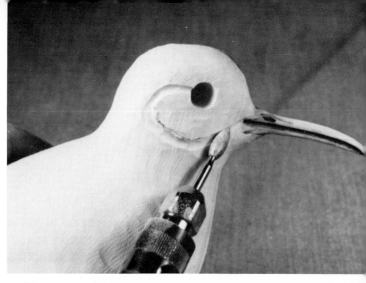

Figure 56. Using a narrow diameter ruby carver, channel around the ear covert lines.

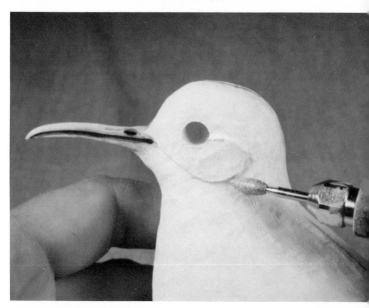

Figure 57. Flow the channel out toward the surrounding neck area.

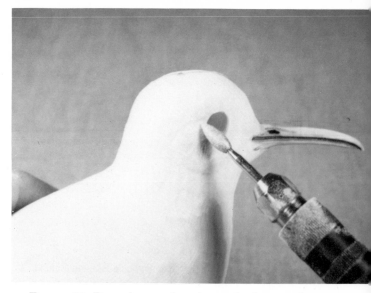

Figure 58. Round over the channel edge on the ear covert.

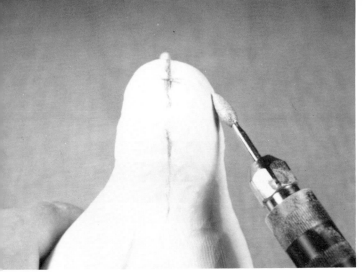

Figure 59. Remove a small amount of wood from above the ear covert channel to the centerline on the back of the head and neck.

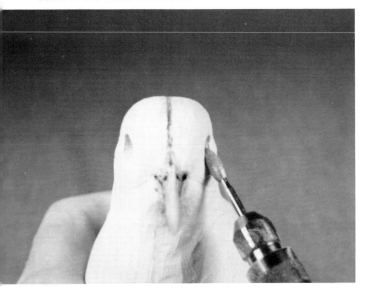

Figure 60. Remove a small amount of wood from in front of and below each eye to create a small depression.

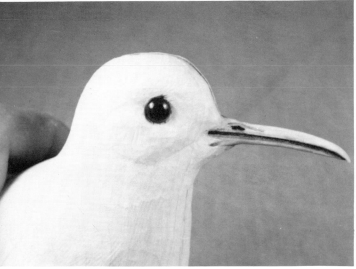

Figure 61. Fill each eye hole with clay and insert the eyes. Check for balance from the head-on and top plan view. Adjust or change if not balanced.

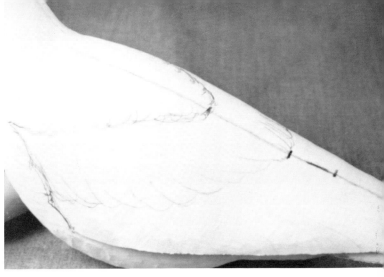

Figure 62. On the top centerline, measure and mark the distance from the end of the primaries to the mantle (2.7 inches) and to the scapulars (1.6 inches). Using the profile and plan view drawings as reference, draw in the shapes of the mantle and scapulars.

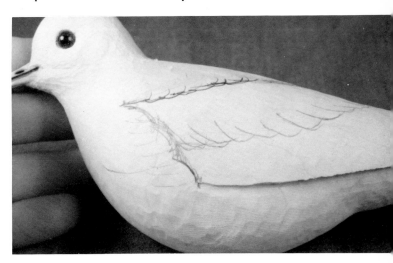

Figure 63. Also draw in the little patches of side breast feathers that cover the front portion of the wings.

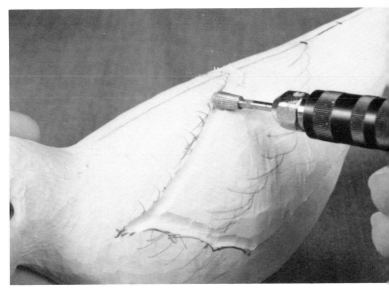

Figure 64. Using a medium diameter bit, channel along the mantle and side breast lines along the shoulder.

199

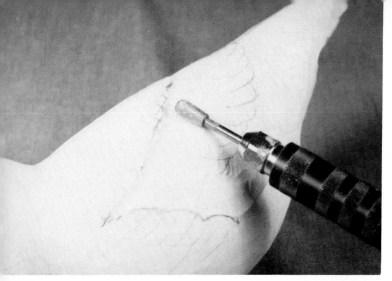

Figure 65. Flow the channel out onto the scapulars.

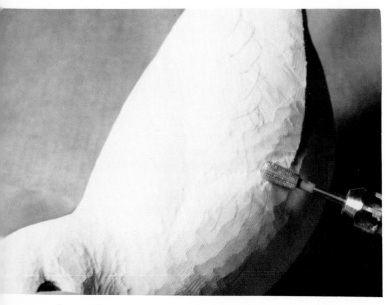

Figure 66. Round over the edge of the channel on the mantle and the shoulder patches.

Figure 67. Note the gradual slope of the mantle onto the scapulars. By carving in a channel, flowing it out and rounding over the edge, a different level is created so that it gives the effect of the scapulars coming out from underneath of the mantle.

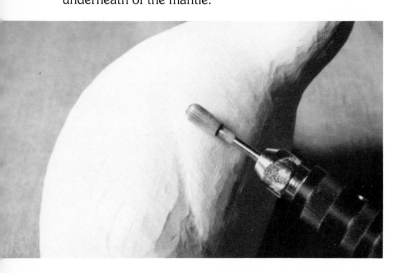

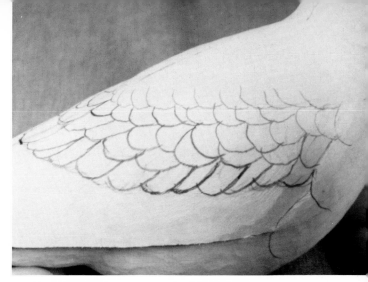

Figure 68. Draw in the shapes of the individual scapular feathers, varying their edges around the outer perimeter.

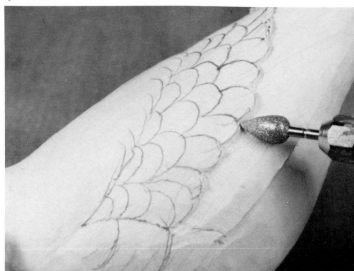

Figure 69. Using a medium pointed ruby carver, relieve around the scapular edges. Create a sharp shelf on the edges and flow the wood below it out toward the wings.

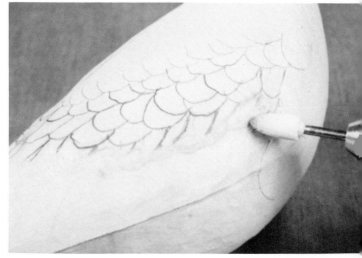

Figure 70. With a white bullet stone, round over the scapular feather edges.

Figure 71. Remove some wood on the center portion of the wings so that the height of the primaries above the top of the tail is .1 of an inch.

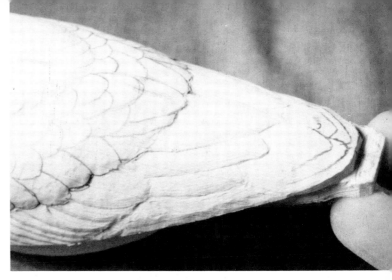

Figure 74. When cutting around the tertials, flow the channels out toward the wings tips. This will lower the level of the primaries even more.

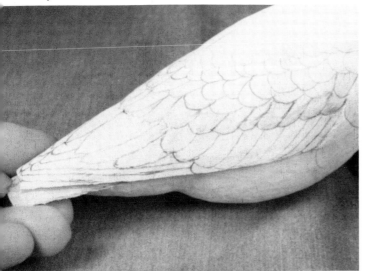

Figure 72. Draw in the wing feathers referring to the profile and plan view drawings.

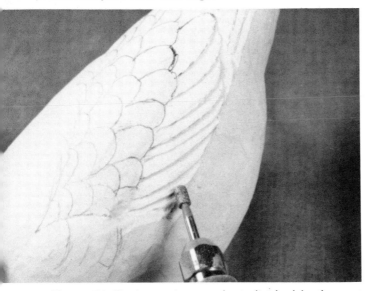

Figure 73. Begin cutting out the individual feathers at the front of the wing with the drooped greater secondary coverts and progress back toward the wing tips.

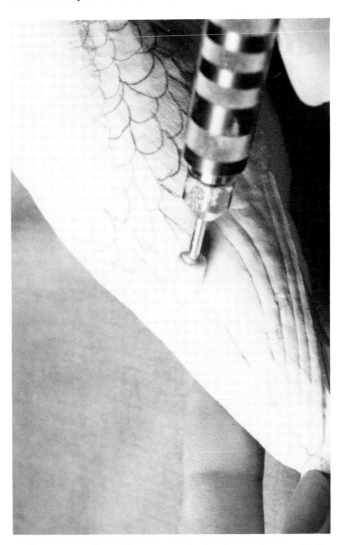

Figure 75. Round over each feather edge with the white bullet, shaping each feather to its rounded contour.

201

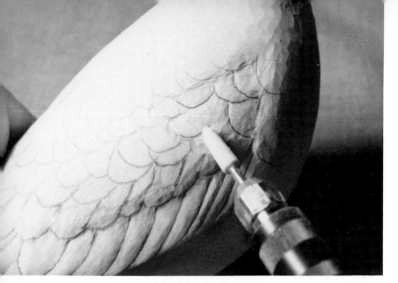

Figure 76. Using a smaller bullet stone, lightly relieve around each of the scapular feathers, giving each its own convex contour. Remember to flow the shallow channel out onto the surrounding feathers. When finished, there should be no evidence of the channel.

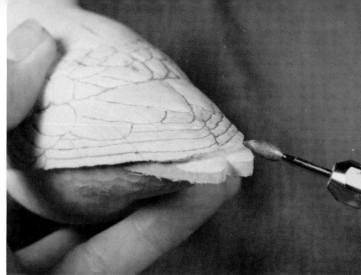

Figure 79. Using a small pointed ruby carver, round the top surface of the two longer tail feathers and clean out the wood underneath the primary tips and edges.

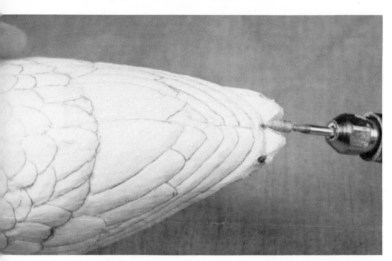

Figure 77. If there are any bandsaw marks on the top of the tail, remove them with a stone. Draw in the tips and edges of the tail feathers. Cut away the excess around the tips and between the two prominent center feathers.

Figure 80. Draw in the side edges of the shorter tail feathers which are .2 of an inch less than the longer two in the center.

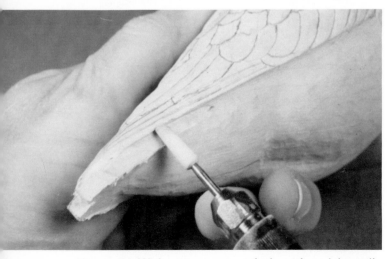

Figure 78. With a stone, smooth the sides of the tail's feather edges.

Figure 81. Carefully thin the height of the two longer tail feathers by cutting away the .2 of an inch extra on the tips of the shorter ones.

Figure 82. Using a burning pen, burn in the edges and tips of the stack of tail feathers.

Figure 83. There is some excess wood at the base of the tail that will need to be removed.

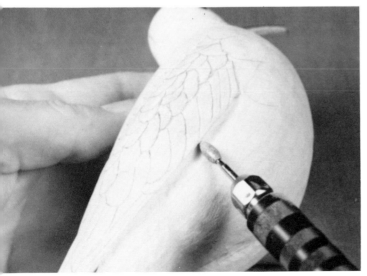

Figure 84. Relieve underneath the lower wing edges with a pointed ruby carver. This gives the effect that the bird's body goes up and under the wings.

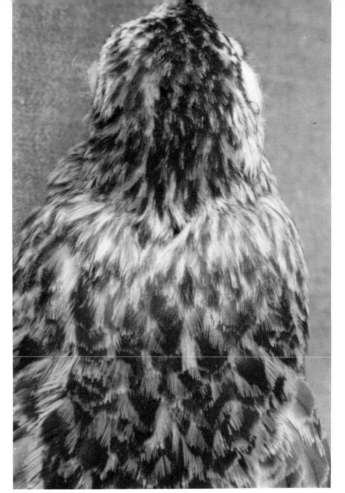

Figure 85. Note the feather patterns, shapes and sizes on the dunlin's head, neck and mantle.

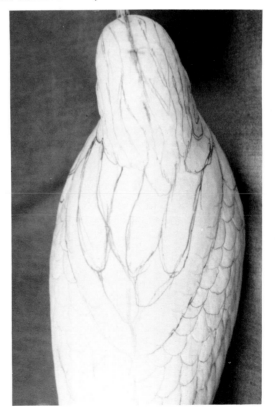

Figure 86. Draw in the feather flows on the mantle, neck and head.

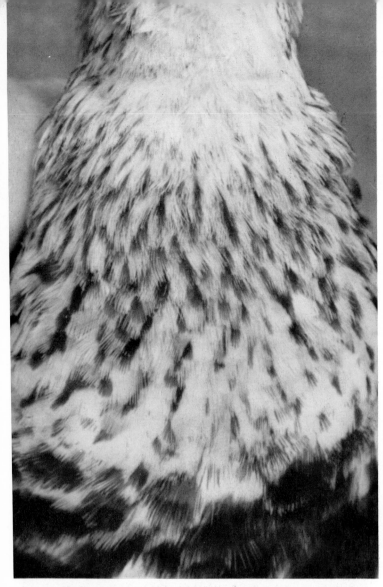

Figure 87. Note the patterns on the throat, neck and upper breast.

Figure 88. This is the dunlin's dark belly patch characteristic of its breeding plumage. On a live dunlin in an upright natural position, this dark patch would be almost solid with very little light evident. A stretched out study skin is sometimes deceptive in the placement of some feather areas.

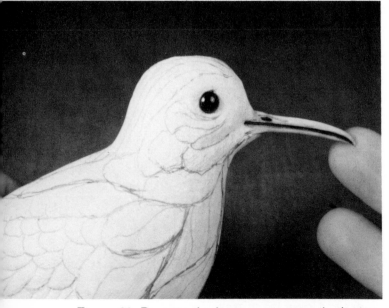

Figure 89. Draw in the larger groups on the breast, shoulders and throat.

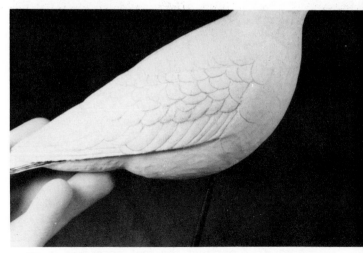

Figure 90. Determine the positions of the legs and mark with an awl. The bird needs to be positioned and balanced over its supporting leg and toes.

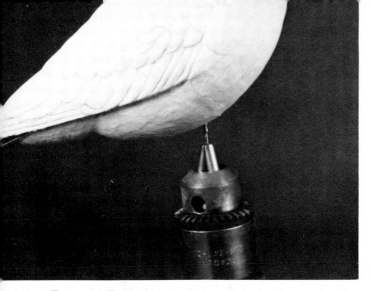

Figure 91. Drill a half-inch deep hole for the supporting leg.

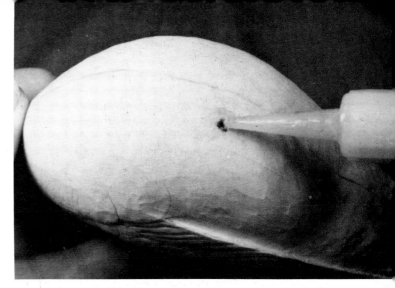

Figure 93. Sometimes in fitting feet into tupelo, the hole becomes enlarged because the wood is so soft. After drilling the hole for the supporting leg, saturate the hole with a small amount of super-glue and let harden.

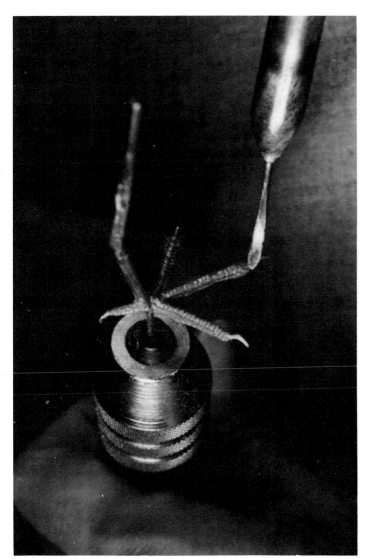

Figure 92. Construct the feet according to "Feet Construction" in *Basic Techniques*. Do not glue into place just yet.

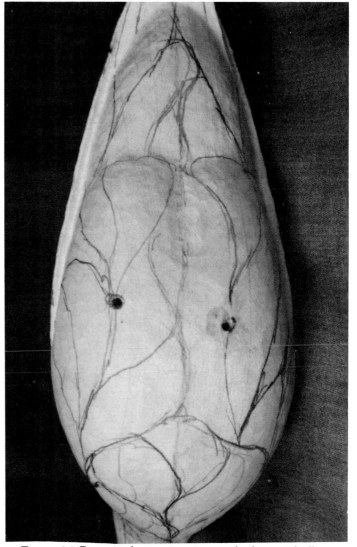

Figure 94. Draw in the contouring on the breast, belly, flanks and lower tail coverts. Vary the shapes and sizes of the groups.

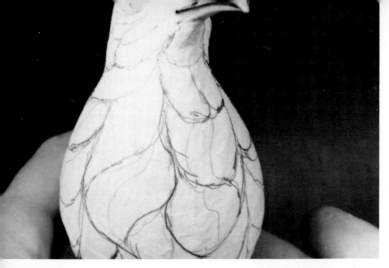

Figure 95. Note the flow and movement of the puffs of feathers on the breast. Remove the eyes so that they do not get scratched when contouring.

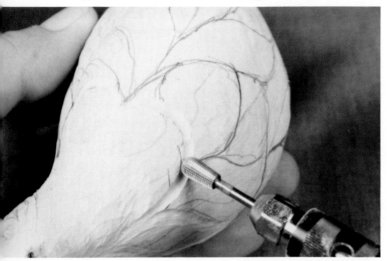

Figure 96. Channel around the puffs of feathers and flow out onto the surrounding area. Round over each puff so that it has a high point that flows down to its edges.

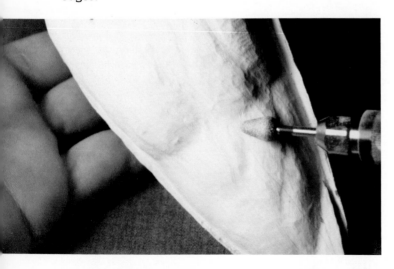

Figure 97. Progressing down the underside of the bird, work in small areas at a time varying the depths and heights. This creates an interesting contouring where light and shadows play an important role.

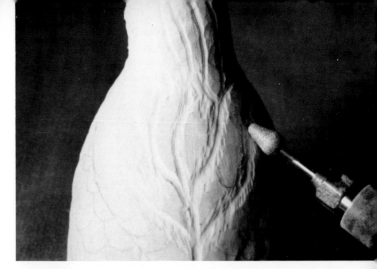

Figure 98. Channel along the lines of the head, neck and mantle and round them over.

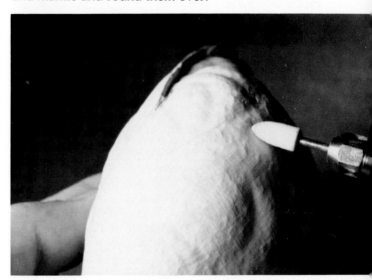

Figure 99. Smooth all of the contouring with a cartridge roll sander or bullet stone, changing any areas as needed.

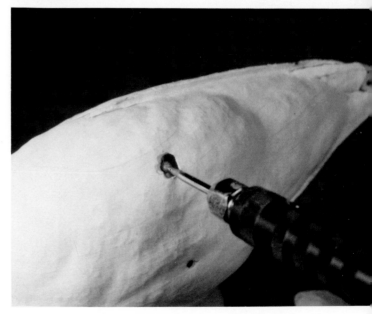

Figure 100. Widen the entrance for the dangling set of toes.

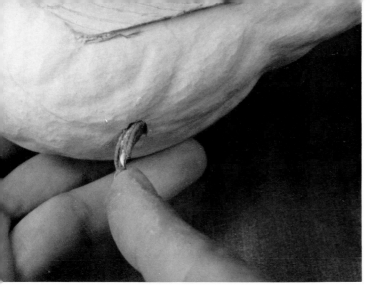

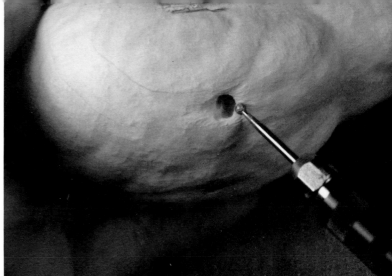

Figure 101. Keep cutting and fitting until the set of toes fit naturally into the belly.

Figure 102. Contour around the opening for the toes.

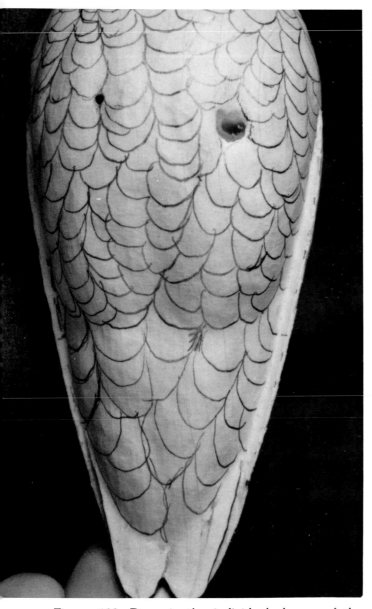

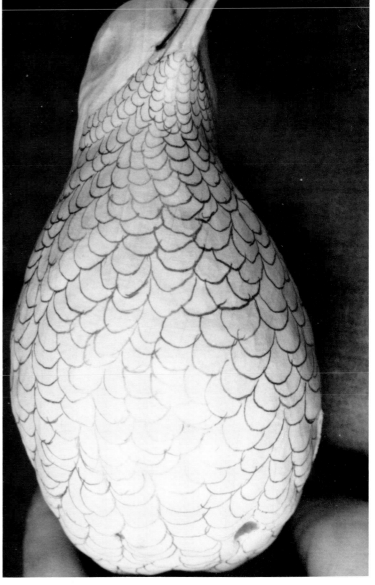

Figure 103. Draw in the individual shapes of the feathers on the contoured groups.

Figure 104. Note that the feathers get smaller in size on the breast, throat and chin.

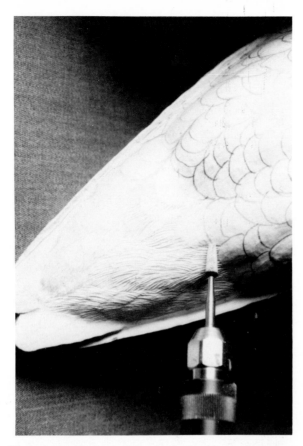

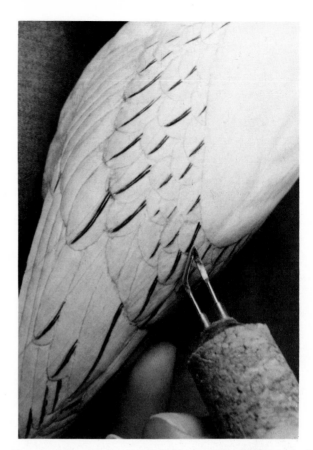

Figure 105. Begin stoning in the barbs on the lower tail coverts at their tip and work forward on the bird's belly.

Figure 106. The stoning strokes should get smaller as the feathers do. Keep as much curvature in each stoned stroke as possible.

Figure 107. Draw and burn in the quills on the scapulars and wings, paying particular attention to their direction.

Figure 108. Begin burning in the barbs on the outer primary of the right wing whose tips are underneath the left one.

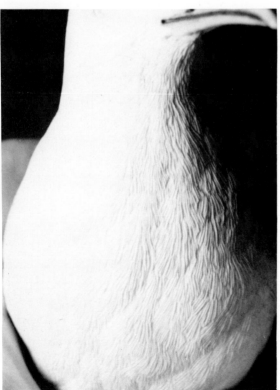

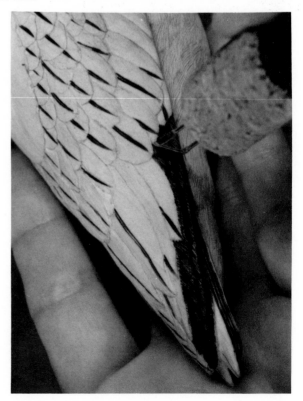

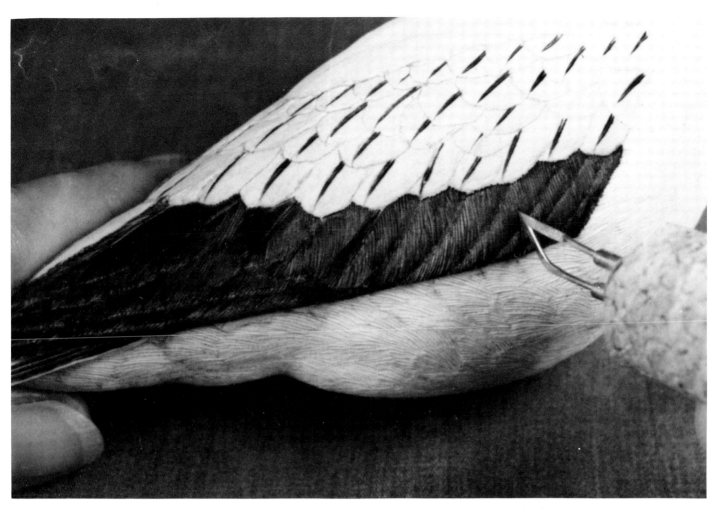

Figure 109. Progress burning forward on the wing, always burning in the barbs on the feather underneath first.

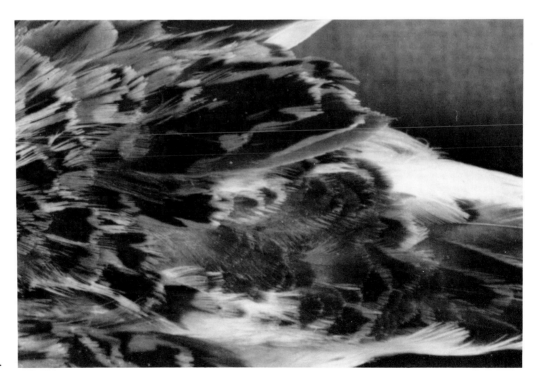

Note detail.

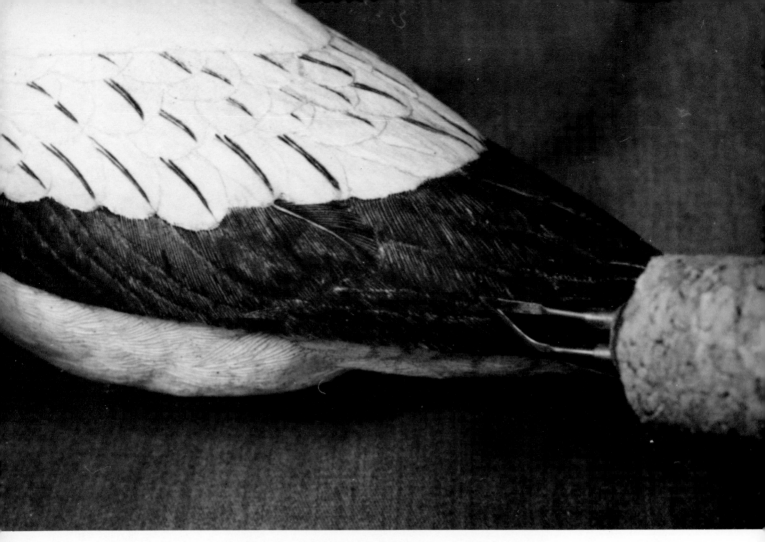

Figure 110. When the right wing is completely burned,
burn in the feathers on the left wing.

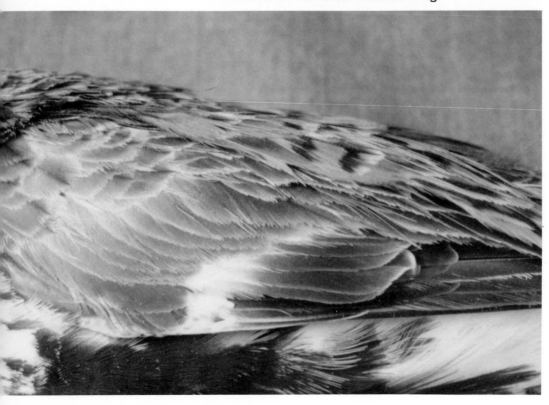

Note detail.

210

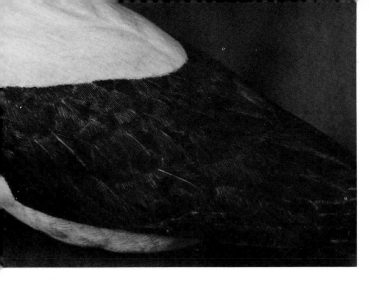

Figure 111. Then burn in the barbs on the scapular feathers starting at their tip and edges and working forward.

Figure 112. Draw and burn in the quills on the upper and lower surface of the tail. Burn in the barbs on the upper tail starting on the outer feathers and working toward the center. On the underside of the tail, burn from the middle outward.

Note feather configuration.

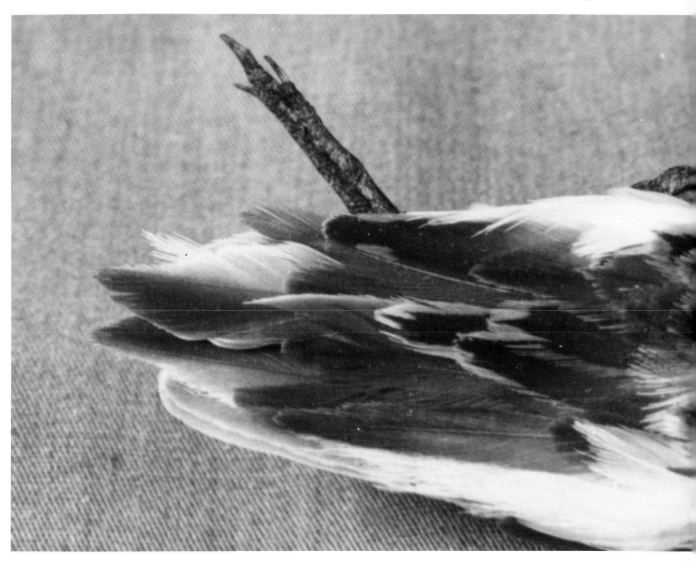

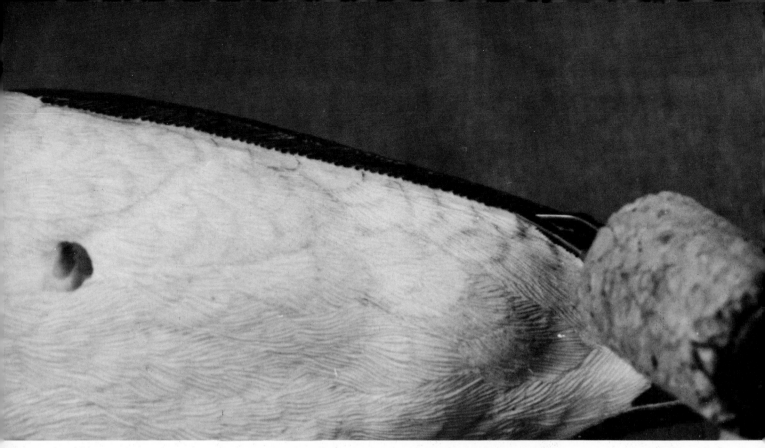

Figure 113. Burn in the barbs on the underside of the lower wing edge (outer primary).

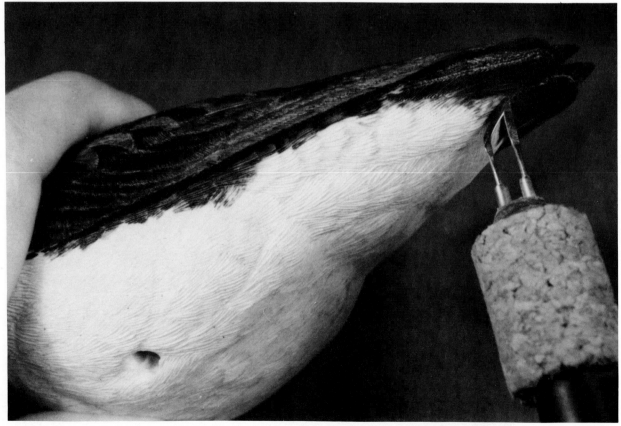

Figure 114. Burn in the barbs along the top of the flank near the lower wing edge and around the edge of the lower tail coverts where the stoning could not reach.

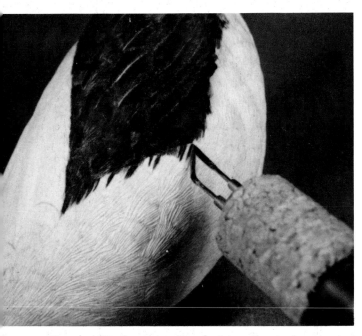

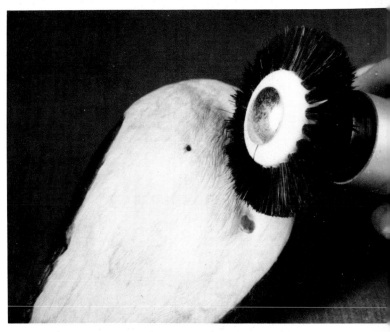

Figure 115. Create splits and break up the stoning even further along the edges of the patch of side breast feathers covering the front of the wing.

Figure 116. Clean any fuzz off of the stoned areas with a laboratory bristle brush. Using light pressure and slow speed will not obliterate any of the stoning.

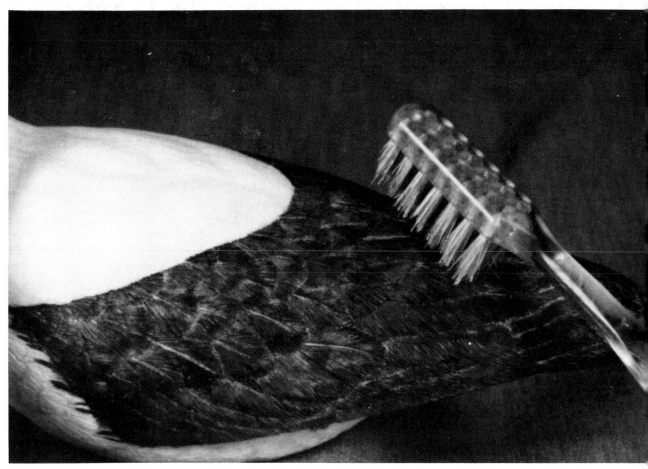

Figure 117. A toothbrush should be used to clean any carbon residue from the burning.

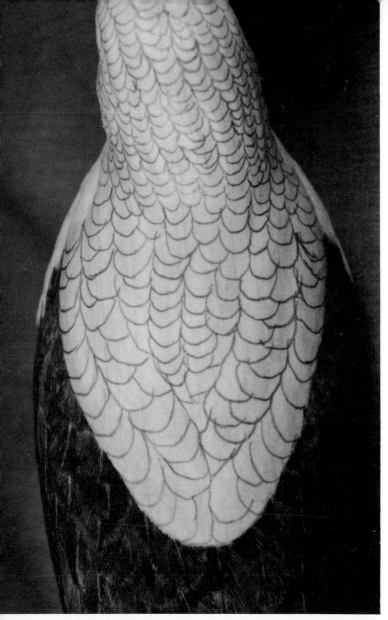

Figure 118. Draw in the feather patterns on the mantle, neck and head.

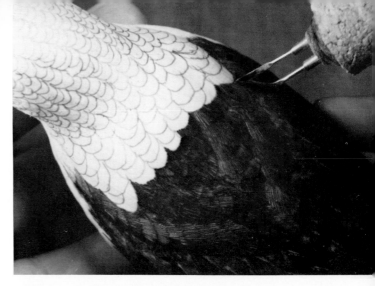

Figure 120. Begin burning in mantle feathers at their edges and work forward toward the neck.

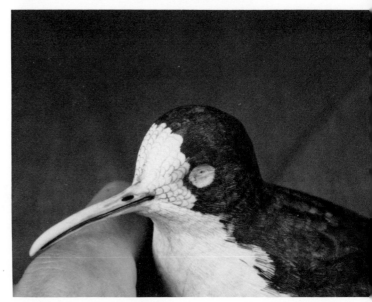

Figure 121. Burn the barbs of the feathers up the neck to the top of the head.

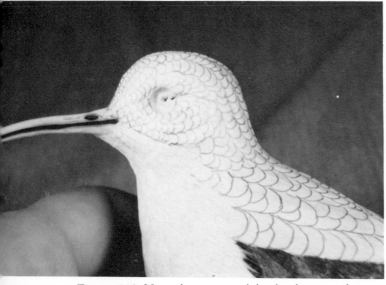

Figure 119. Note the sweep of the feathers on the ear covert.

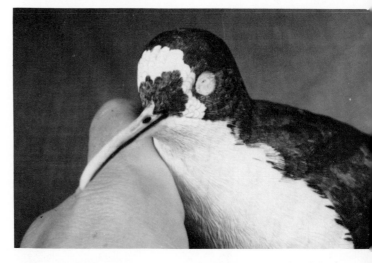

Figure 122. Burning in the barbs on the forehead feathers from front to back will create a raised feather edge appearance. The forehead feathers are bristly and often raised.

214

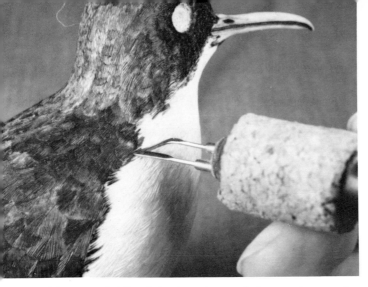

Figure 123. Blend the burning and the stoning on the side neck and shoulder areas by burning some of the stoning.

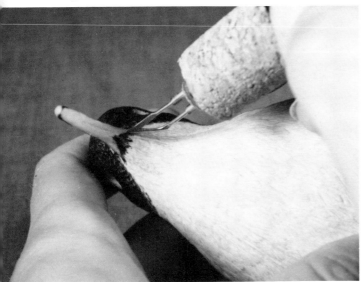

Figure 124. Burn in the barbs around the beak where the stoning could not reach.

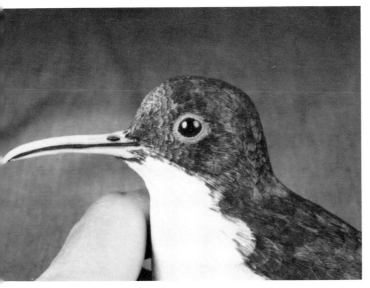

Figure 125. Insert the eyes according to the "Eye Techniques" in *Basic Techniques.*

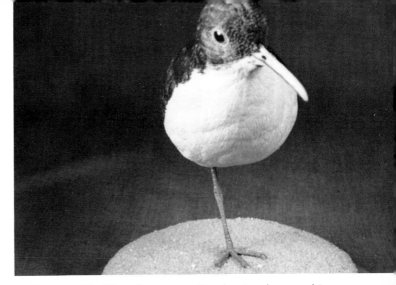

Figure 126. Glue the supporting leg in place making sure that the bird is balanced over his toes. Note the angle of the leg in a raised leg position.

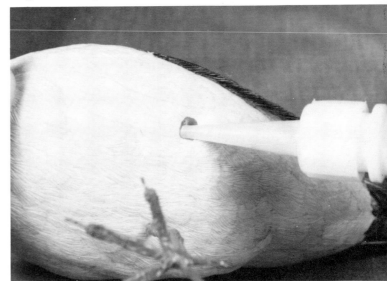

Figure 127. Apply super-glue in the hole for the toes.

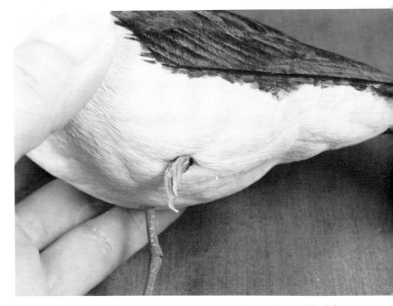

Figure 128. Quickly place the toes in the hole and hold in place without gluing your fingers to the bird!

215

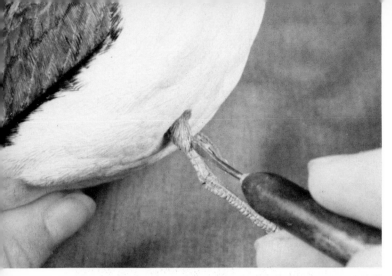

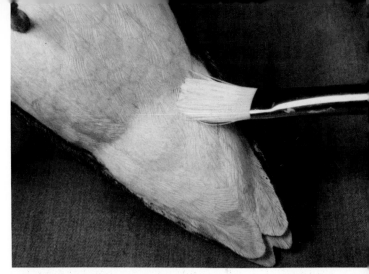

Figure 129. When the glue has hardened, mix a small amount of the ribbon putty and apply a moderate amount around the tibiotarsus to create a leg tuft that will hide the joint. Create interesting feathers and splits on the leg tuft. Blend the edges of the leg tuft into the surrounding stoning.

Figure 132. Using a stiff bristle brush, scrub gesso into the texturing. Use a small amount of gesso with a dry-brush technique. Do not leave any puddles or globs that will obscure the texture. Cover the entire bird including feet. The burned areas may require two coats.

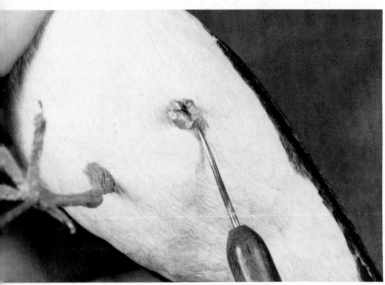

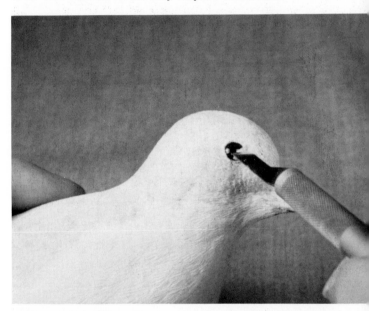

Figure 130. Fill any area necessary around the dangling toes so that there is a tight fit of the feathers up against the toes. Blend the putty into the surrounding stoning.

Figure 131. When the putty has hardened, spray lightly with *Krylon Crystal Clear* to seal the bird.

Figure 133. When the gesso is dry, carefully scrape the eyes with a sharp knife.

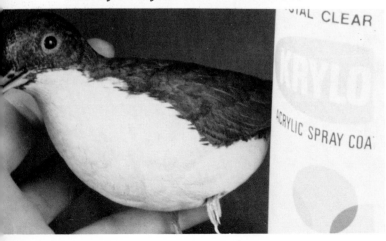

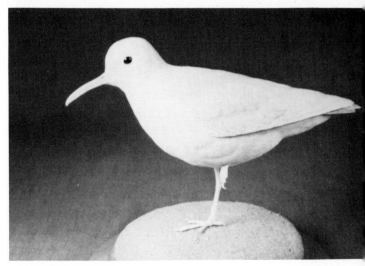

Figure 134. Ready for color!

PAINTING THE DUNLIN
(Breeding Plumage)

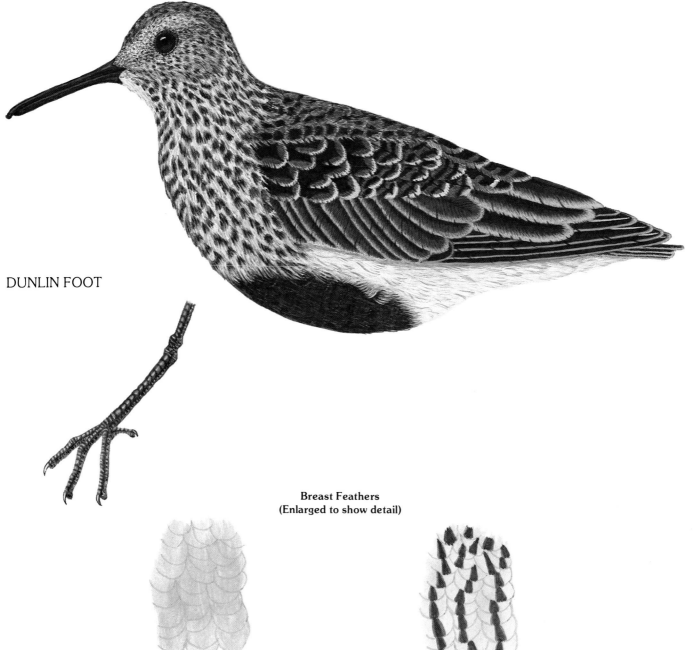

DUNLIN FOOT

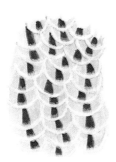

Breast Feathers
(Enlarged to show detail)

1. Base coat is white with small amounts of raw umber and payne's grey.

2. Burnt umber with small amount of payne's grey for dark centers.

3. Highlights on edges are white.

4. Very watery burnt umber wash.

Acrylic Colors needed

 Payne's grey
 Burnt umber
 Raw umber
 Burnt sienna
 Raw sienna
 Yellow ochre
 Black
 White

Top of head, mantle, and scapulars

Raw sienna with small amounts of burnt sienna, burnt umber, and white

Ear coverts, sides of head and the band around the nape of the neck

White with small amounts of burnt umber and payne's grey

Dark areas on head, neck, mantle, and scapulars

Burnt umber and payne's grey

Edgings on head

Raw sienna and white

Washes on scapulars

Burnt sienna, raw sienna and burnt umber

Wings and upper surface of tail

Burnt umber, peyne's grey, and small amount of white

Light edgings on tertials and greater secondary coverts

White and burnt umber

Light grey edgings on tail feathers

White, burnt umber, and payne's grey

Lower tail coverts, flanks, belly, breast, throat, and chin

White with small amounts of raw umber and payne's grey

Dark belly patch

Burnt umber with small amount of black

Feet and beak

Black, burnt umber, and a small amount of white

Dunlin
Feathers on Top of Head
(Enlarged to show detail

1. Burnt umber, payne's grey, and a small amount of white for centers on feathers.

2. Burnt umber wash.

3. Raw sienna with small amounts of burnt umber and white for outer edges.

4. Blend darks into chestnut color. Use raw sienna and white to highlight random edges.

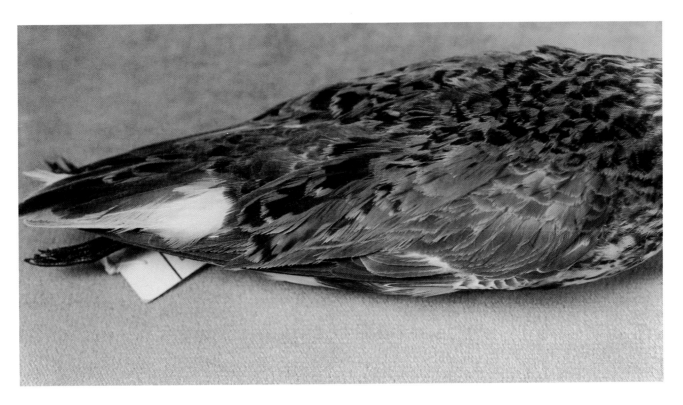

Figure 1. Note the chestnut coloring on the mantle and scapulars of the breeding (summer) plumage of the dunlin.

219

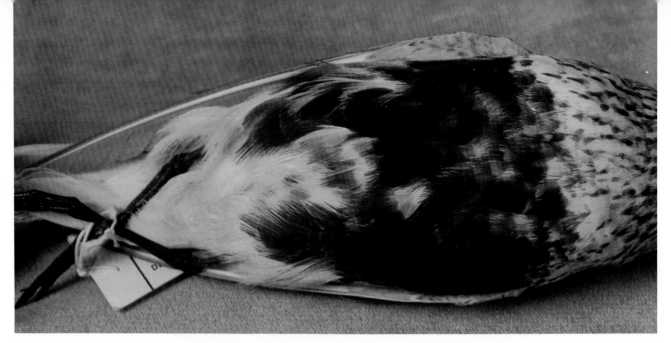

Figure 2. On a live bird in a natural position, the dark belly patch would not have as much white in it.

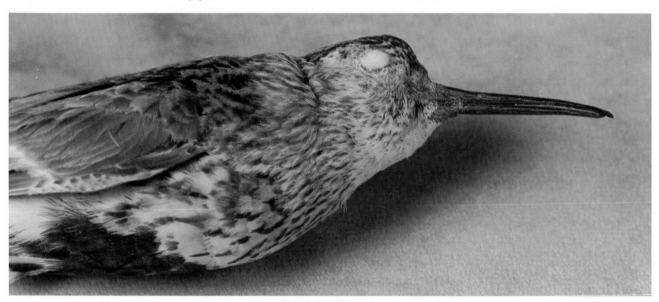

Figure 3. On a live bird, the whitish chin area would be smaller. Remember that study skins sometimes distort the size and shape of some areas.

Figure 4. On the plan view of the study skin, note the lack of chestnut coloring at the base of the neck.

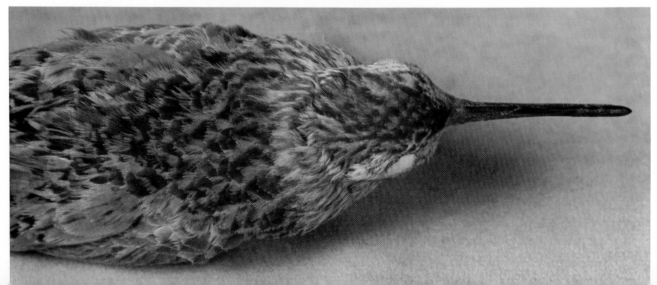

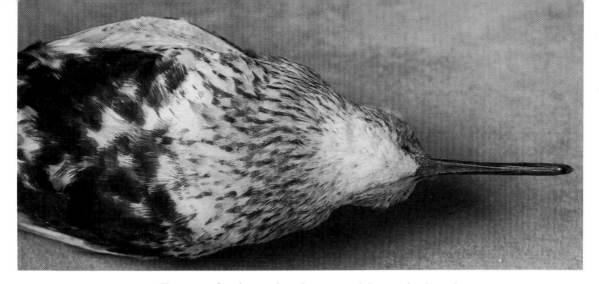

Figure 5. On the under plan view of the study skin, the dark streaks on the breast are the centers of the feathers.

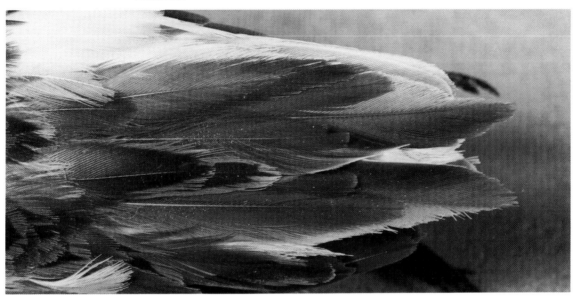

Figure 6. The centers of the tail feathers are a charcoal color.

Figure 7. On the mantle, the chestnut coloring is on the outer edges of the feathers.

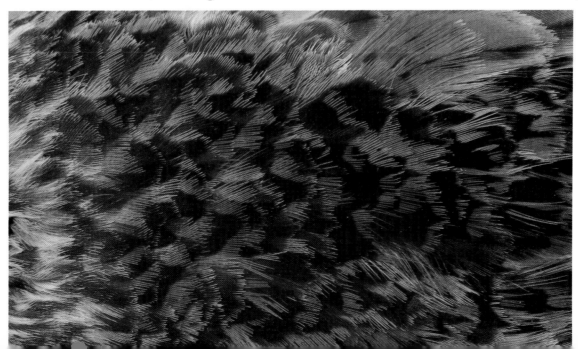

221

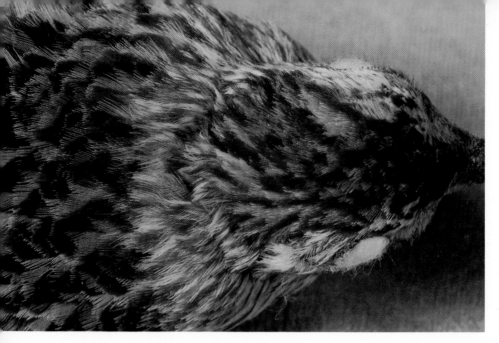

Figure 8. On a live dunlin, the dark streaks, which are the feather centers, are in irregular rows.

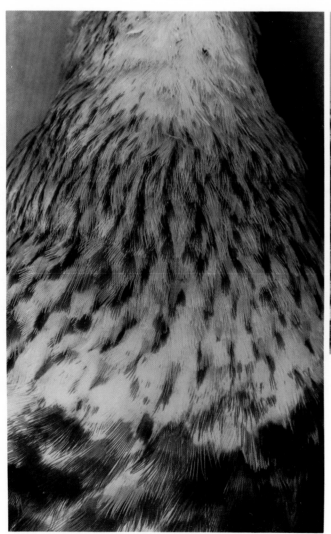

Figure 9. Notice the light colored throat feathers laying over the dark belly patch feathers.

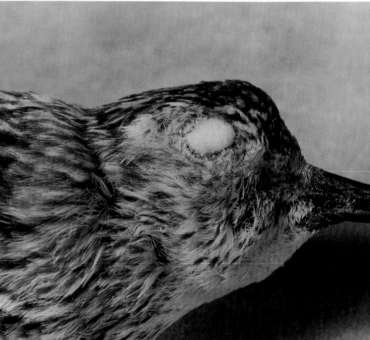

Figure 10. A close-up profile view of the head shows the light chestnut coloring at the back of the ear coverts.

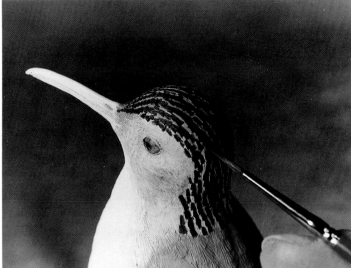

Figure 13. Using a liner brush and a dark mixture composed of burnt umber, payne's grey and a small amount of white, paint the centers of the feathers on the forehead, crown and back of the neck.

Figure 11. Mix raw sienna with small amounts of burnt sienna, burnt umber and white and apply several basecoats to the forehead, crown, mantle and scapulars. Dry-brush a small amount of this color on the back of both ear coverts and lores. When these are dry, apply several very thin washes of burnt sienna to the scapulars.

Figure 12. Mix a light grey with white and small amounts of burnt umber and payne's grey and apply to the sides of the head and the nape of the neck. Blend the edges of the light grey into the chestnut basecoat edges of the mantle, back of the head and ear coverts.

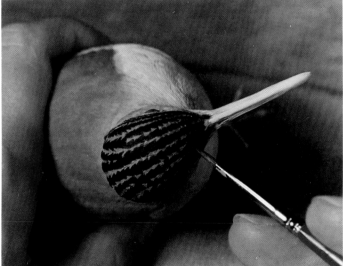

Figure 14. Wash the forehead, crown and back of the neck with a very thin, watery burnt umber wash. Mix up the chestnut basecoat mixture used in Figure 11 and pull into the edges of the dark centers and then pull the dark color into the chestnut color until there is a soft transition. On the back of the neck, pull the light basecoat color used in Figure 12 into the dark centers and the dark color into the light grey. Blend the lights and darks, breaking up the regularity of the pattern. Then, mix white with a small amount of raw sienna and highlight random light edgings.

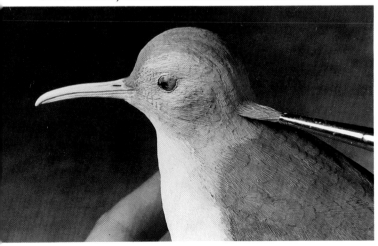

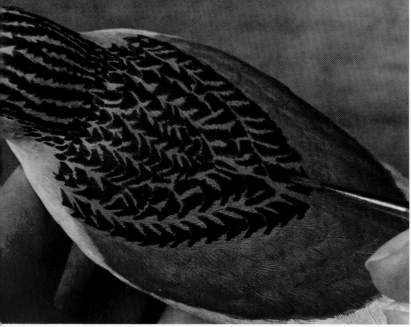

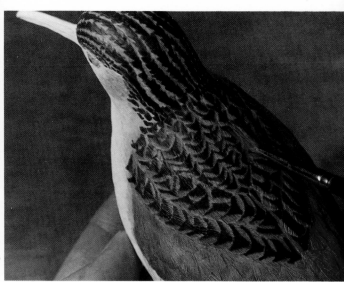

Figure 15. Mix a very dark brown color with burnt umber and payne's grey and paint in the dark centers on the mantle. You will need to reinforce these several times.

Figure 17. Apply a very thin wash with a mixture of burnt umber and burnt sienna.

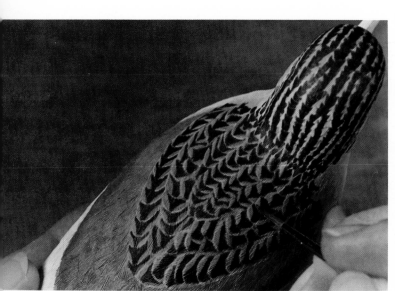

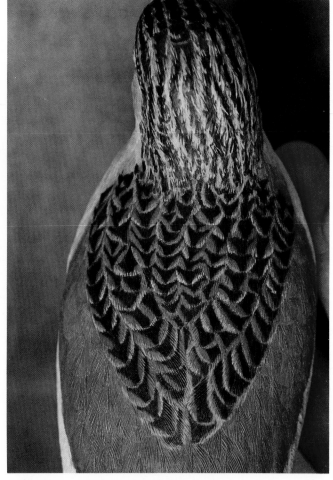

Figure 16. Lightly edge all of the mantle feathers with a very thin mixture of white and yellow ochre.

Figure 18. Apply several thin washes of a mixture of burnt sienna, raw sienna and a small amount of burnt umber.

224

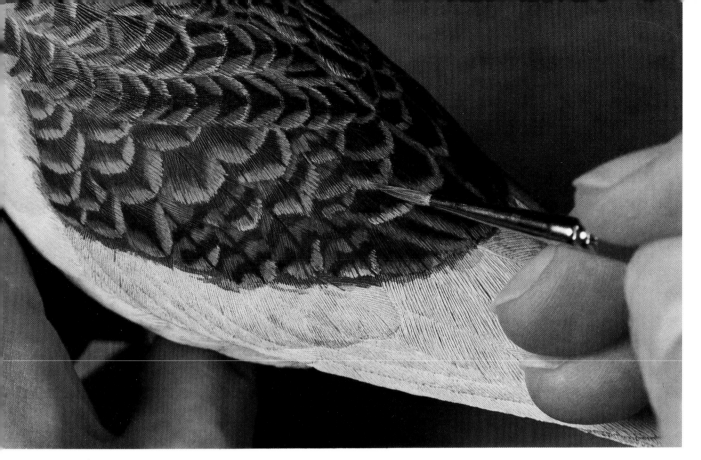

Figure 19. For the dark color on the scapulars make a mixture of burnt umber and payne's grey. For the light tips and edgings, make a mixture of white with small amounts of burnt umber and yellow ochre.

For the forward third of the scapular feathers, the pattern is:

For the middle third of the scapular feathers, the pattern is:

For the rear third of the scapular feathers, the pattern is:

225

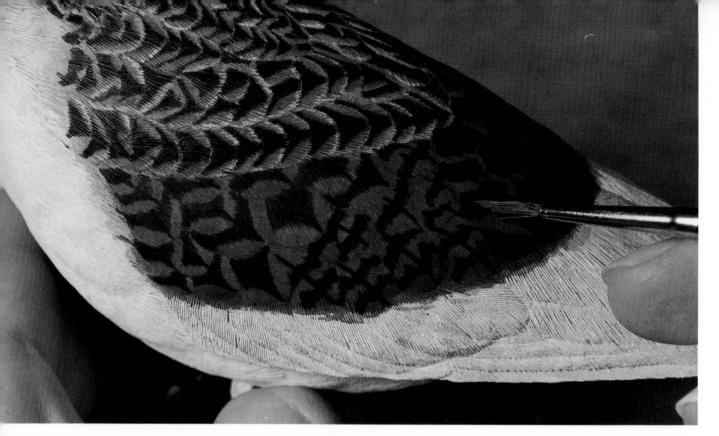

Figure 20. Blend the darks back and forth into the basecoat color (raw sienna, burnt sienna, burnt umber and white). Then lighten the tips of the middle and rear sections feathers.

Figure 21. Using a mixture of burnt umber, payne's grey and white, apply several basecoats to the wings and upper surface of the tail.

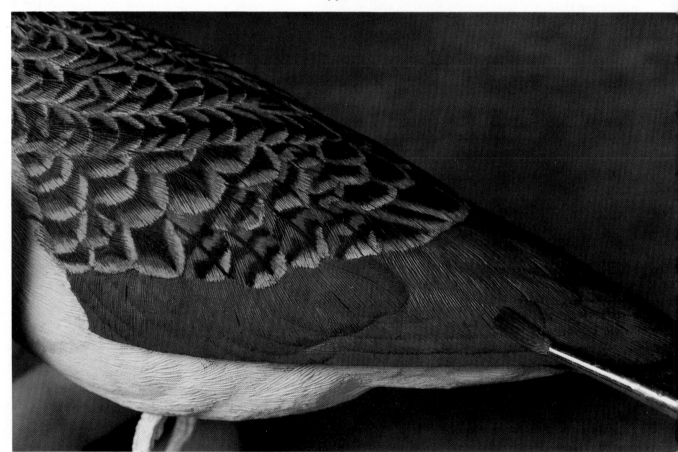

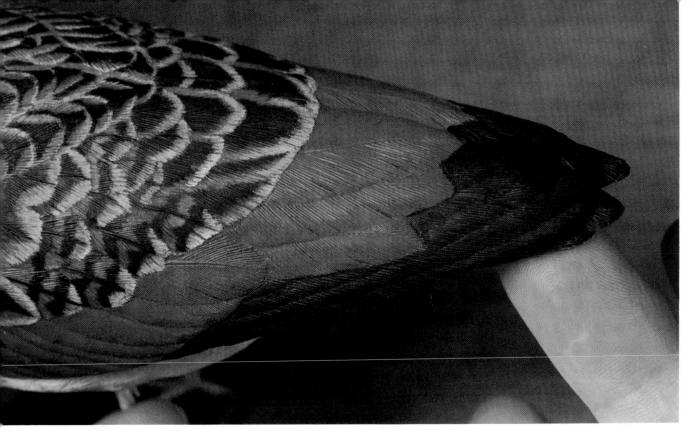

Figure 22. With a thin mixture of burnt umber, payne's grey and a smaller amount of white than in the basecoat mixture, paint the primary coverts, primaries and the upper surface of the tail. Use several thin washes to gradually darken these areas instead of one heavy application that may tend to turn shiny as well as fill up the texture grooves.

Figure 23. Make a light grey mixture of white, burnt umber and payne's grey and lightly dry-brush the edges of the tertials and the greater secondary coverts. Pull a narrow line of edging along the edges of the primary covert and the primaries.

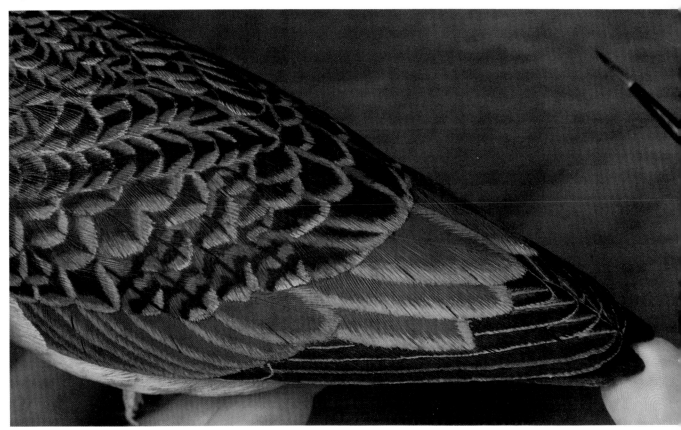

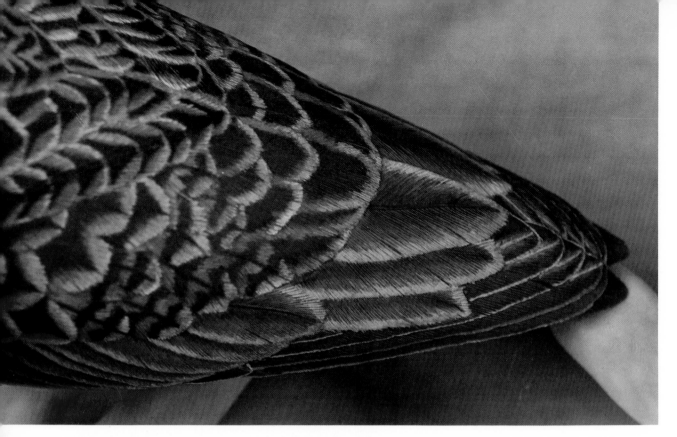

Figure 24. Blend the light grey into the darker basecoat color and the darker color back into the lighter edging until there is a soft blended area on each feather. Also darken the quills and a narrow band on each side of them with a mixture of burnt umber and payne's grey. Paint in a few random splits with the thin burnt umber and payne's grey mixture.

Figure 25. Apply a thin, watery burnt umber wash to the scapulars and wings.

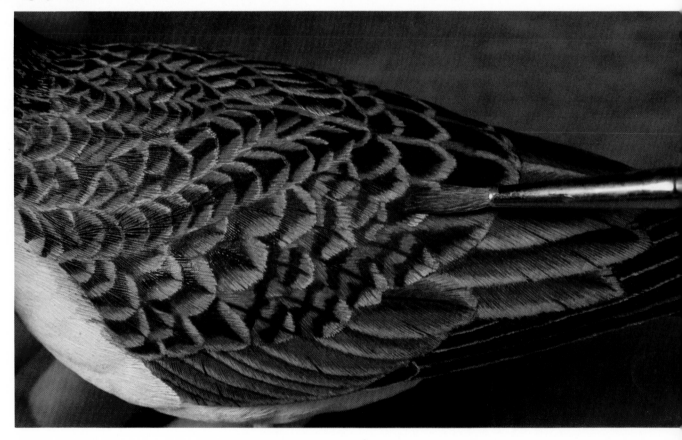

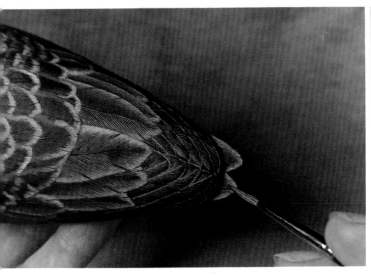

Figure 26. Mix white with small amounts of burnt umber and payne's grey, and lightly dry-brush the tail feather edges, including those on the side. Pull the light color of the edgings into the darker basecoat color to get a soft blend. When this is dry, apply a very thin, watery burnt umber wash.

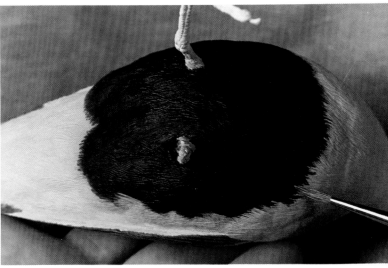

Figure 28. Mixing burnt umber and a small amount of black, paint in the dark belly patch, pulling the dark color into the light grey basecoat color. Then pull the light grey color into the edge of the dark belly patch. Keep working the light and dark together until there is a soft blend line all around the belly patch.

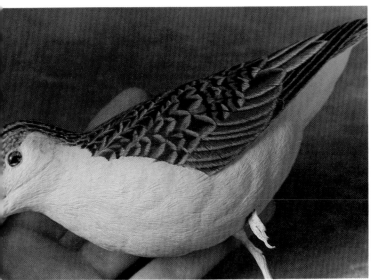

Figure 27. For the basecoats for the lower tail coverts, belly, flanks, leg tuft, breast, throat, sides of neck and chin, mix white with small amounts of raw umber and payne's grey to make a light grey. Several applications of the basecoat color will be necessary. Keep the paint thin so that the texturing is not obliterated. Keeping the edges irregular in shape will make it easier to get a soft blended transition between the light and the dark edges.

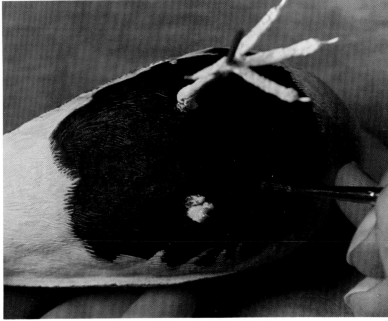

Figure 29. Use straight black to edge the feathers on the belly patch.

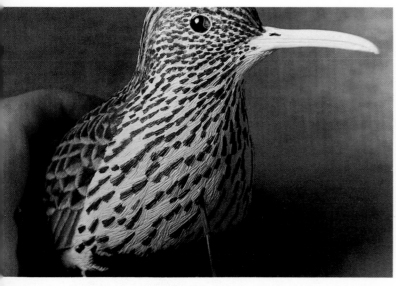

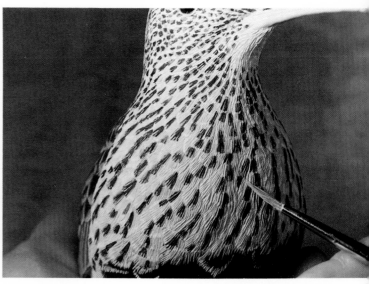

Figure 30. Mixing burnt umber and a small amount of payne's grey, paint in the dark streaked centers of the feathers on the ear coverts, throat (not the chin) and breast. It will take several applications to feather these dark streaks into the light grey areas.

Figure 31. Using straight white, edge the feathers on the lower tail coverts and some light random edges along the edge of the dark belly patch on both flanks.

Figure 32. Use a small brush to dry-brush the light edgings on the breast, throat, ear coverts and this time, the chin.

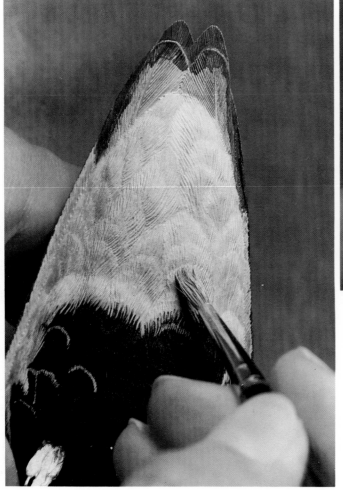

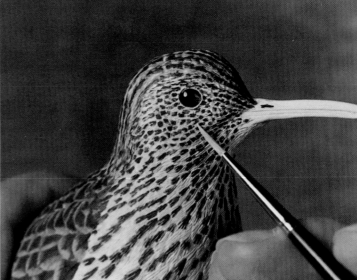

Figure 33. You will need several applications of all three values on the ear coverts and sides of the head: the light grey basecoat, the dark center color and the white for highlights. Alternate these three values until the sides of the head and ear coverts are softly blended streaks of random length and shape.

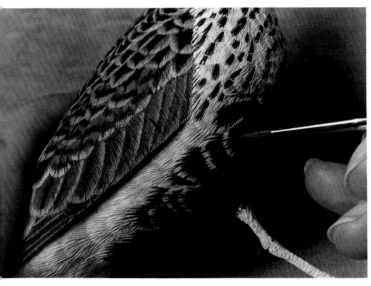

Figure 34. To separate some of the edgings on the flanks, into splits, use a liner brush and a mixture of burnt umber and black. Keep the mixture thin so that it settles into the bottom of the texture grooves.

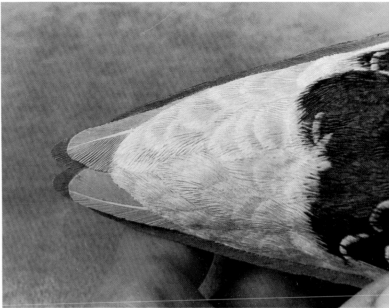

Figure 36. The lighter grey for the shorter feathers on the underside of the tail is made up of white, burnt umber and payne's grey. Make a darker grey mixture using burnt umber, payne's grey and a small amount of white and apply to the underside tips of the longer feathers and to the underside of the lower wing edges. Lighten the quills with a mixture of white and a very small amount of burnt umber and payne's grey. When this is dry, apply a very thin, watery burnt umber wash.

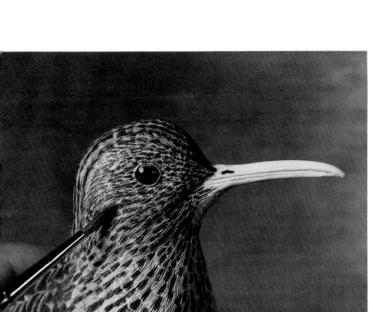

Figure 35. Apply a very thin, watery burnt umber wash to the breast, belly and lower tail coverts. When this is dry, apply a very thin raw sienna wash to the rear area of the ear coverts. Apply a very thin watery raw umber wash to sides of the head and neck. Carefully scrape the eyes.

Figure 37. Mix burnt umber, black and a small amount of white to a dark charcoal color and paint the beak several times.

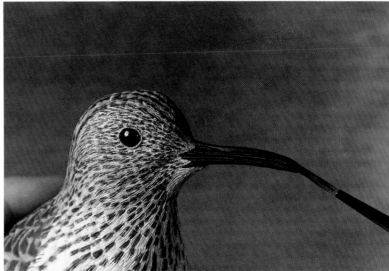

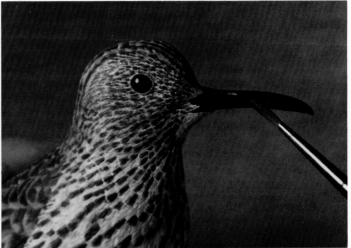

Figure 38. Paint the leg and both feet with a mixture of burnt umber, black and a small amount of white. It will take several thin applications to cover the gesso. When these are dry, apply straight black to the claws. MIx a small amount of gloss medium in a large puddle of water and apply to the support leg and both feet. When this is dry, apply straight gloss to the claws and the quills on the wings and tail.

Figure 39. Make a 50/50 mixture of matte and gloss mediums and apply to the beak.

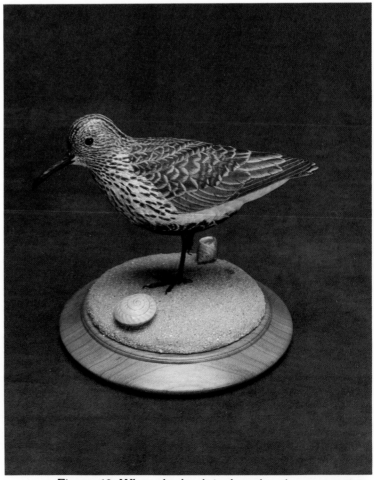

Figure 40. When the beak is dry, glue the supporting leg wire into the habitat. The completed dunlin!

Chapter 7.

Habitat

Creating a Rock
(as used in the plover composition)

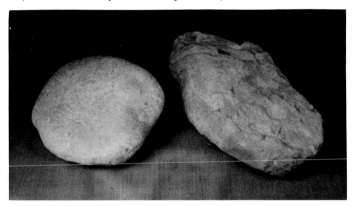

Figure 1. Having a real rock to use as a model is very helpful when creating a rock from wood. When deciding upon the plover's setting, I decided that a fairly smooth textured rock (such as the one on the left) would complement his textured and feathered body. To create motion within the composition, an inclined surface rather than a flat one would help to create movement.

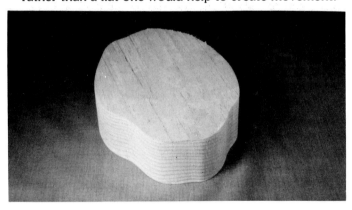

Figure 2. Draw the rock. The wood I used happened to be a scrap piece of pine, but any type of wood would suffice. With a bandsaw or coping saw, cut around the pattern lines.

Figure 3. A bandsaw is very helpful in cutting away excess wood though a large carbide bit would accomplish the task.

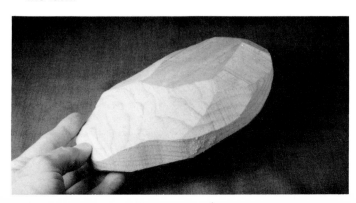

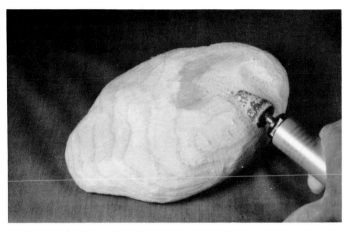

Figure 4. Round and shape the rock using real rocks for models. Create interesting and varied contours.

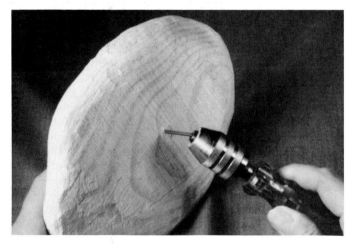

Figure 5. When the rock is shaped, I found it helpful to insert a short piece of brazing rod into the bottom so that I could hold the rock with a pin vise for the remaining procedures.

Figure 6. Mix a small amount of burnt umber acrylic paint into a large amount of modeling paste. Frost the entire rock with the light brown modeling paste.

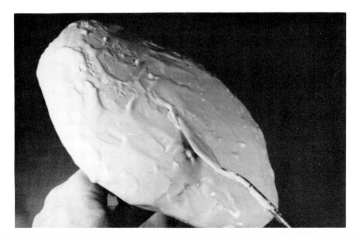

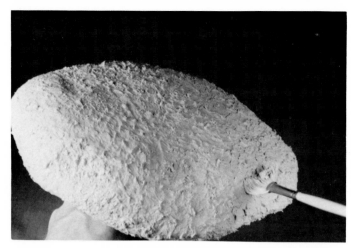

Figure 7. Use a hair dryer to slightly dry the outside of the modeling paste. With a stiff bristle brush, poke and lift the partially dry paste in interesting textures.

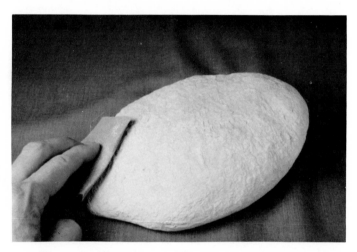

Figure 8. Allow the modeling paste to thoroughly dry. Then, sand off some of the tops of the textures with a piece of fine grit sandpaper. The rock is now ready for painting.

Creating Mud
(for use in the yellowlegs' composition)

Figure 9. Cover the edges of a recessed base with masking tape to prevent damage and spills along the outside edge. Any formed rocks or pieces of driftwood should be glued and/or pinned to the bottom of the base.

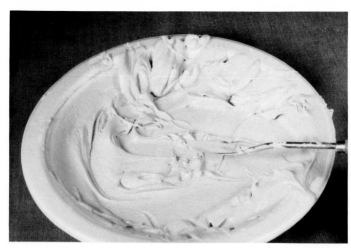

Figure 10. Mix a large amount of auto body patch or Tuf-Carve with the respective hardener according to directions. Mix the hardener and resin thoroughly and quickly.

Figure 11. Apply the mixed resin to the inside of the base and around the driftwood or rocks. Pull and push the resin so that it fills the entire bottom of the base. Swirl the material with a palette knife for interesting effects much like real mud.

Figure 12. When the resin has almost hardened, an interesting effect can be obtained by pressing in the toe print of the bird (in this case, a yellowlegs). I used a casting for pressing in the print. There was no way that I was going to glop up the foot that took days to make! Allow the resin/hardener mixture to harden completely and then apply a coat of gesso for better paint adhesion.

Figure 13. The sandy setting for the sanderling will include creating a bent reed to support the flying bird. Attaching the bent reed in two places (inside and outside the base) will give substantial support for the flying bird.

Figure 14. Pieces of telescoping brass tubing can be bought in most craft and hobby stores specializing in modeling planes or trains. It comes in successive diameters so that several pieces can fit together to gradually lessen the diameter of a reed or branch.

Figure 15. Determine the angle for the reed's insertion into the base. Drill a hole sufficiently deep enough to support the tubing and the weight of the bird. Rather than bend the tubing, I drilled the hole at the angle that I wanted the reed to be positioned.

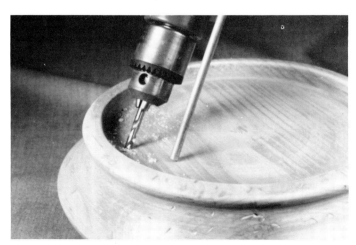

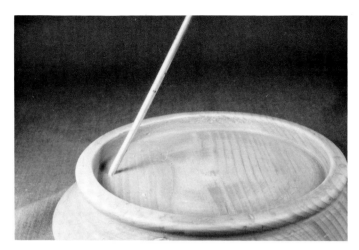

Figure 16. Drilling a hole slightly larger than the diameter of the tubing allows for easier removal and insertion.

Figure 17. To connect the telescoping pieces of tubing, I chose to silver solder the joints for strength. Before soldering, the joint areas (inside and outside of the tubing) must be fine sanded.

Figure 18. Stay-brite is one brand of silver solder and flux that can be used.

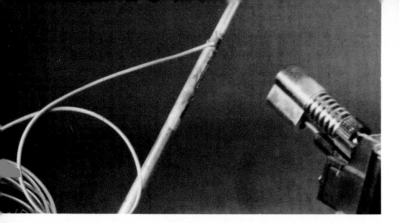

Figure 19. Holding the pieces to be soldered with a vise, vise grip pliers or helping hands (the mechanical kind with alligator clips), flux the joint. Holding a butane torch flame near the joint, heat the area and then touch the end of the piece of solder to the joint. The heated joint will suck up the melting solder.

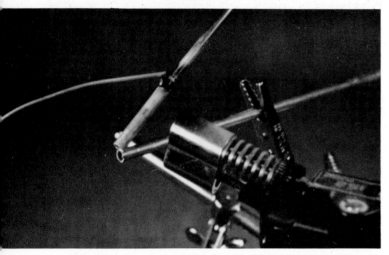

Figure 20. At the top of the bend, cut the tubing partially in two. Bend the tubing into the desired angle and solder the down part of the reed with the next size smaller tubing.

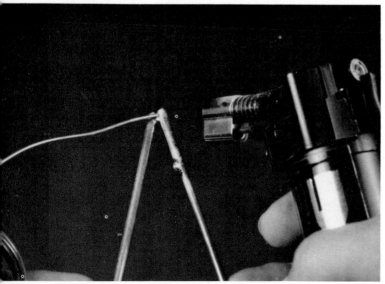

Figure 21. Reinforce the cut and bend point with some silver solder to prevent it from completely breaking apart.

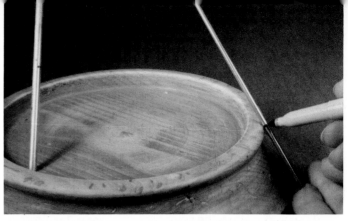

Figure 22. A base does not always have to totally contain a composition. I chose to attach the reed on the outside of the base to free up the composition. Mark the point on the base and the tubing that the angled down reed touches and drill a 5/64" diameter hole about one-half inch deep into the base.

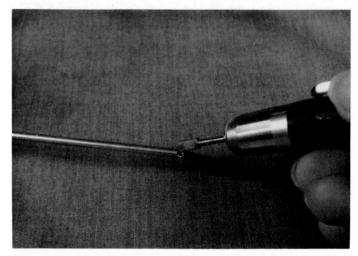

Figure 23. Using a metal cutter or hacksaw, slice a hole in the tubing at the point marked.

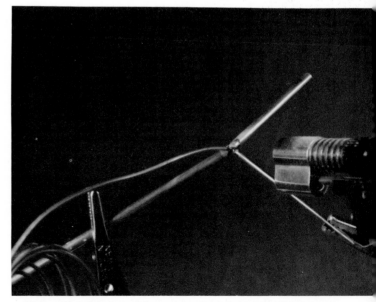

Figure 24. Silver solder a bent piece of 1/16" brazing rod into the hole.

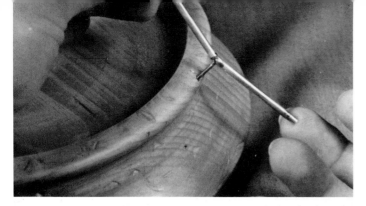

Figure 25. When the solder is cool, check the bend of the brazing rod for insertion into the hole in the base.

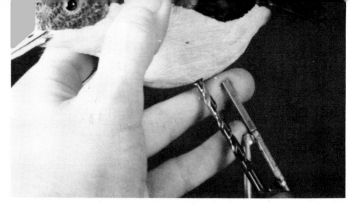

Figure 28. Cut a piece of the larger square tubing the same length as the protruding small one. Determine the position of the bird and the angle needed to maintain that position. Using a drill bit slightly larger in diameter than the larger square tubing, drill at the appropriate angle.

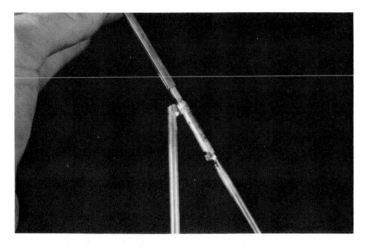

Figure 26. Fit a piece of square tubing inside the round tubing of the reed. Then fit the next larger size of square tubing over the smaller one. Make sure that there is a snug but not tight fit. The larger square will be in the bird's belly and the smaller square soldered into the round reed. Square tubing is used to attach the bird to keep it from twisting on the reed.

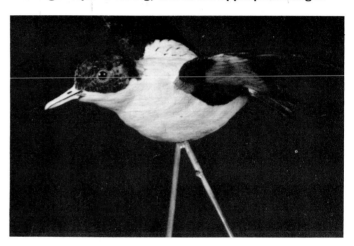

Figure 29. Put masking tape on the end of the large square tubing that is to go into the belly. Mix up a small amount of 5 minute epoxy and put it into the hole in the belly. Insert the taped end of the large square tubing. When the glue has almost hardened (you can check on the glue left over for its amount of hardening), put the bird in place on the reed by carefully sliding the larger square tubing (glued in the bird) onto the smaller tubing soldered in the reed. Allow to completely harden and then remove the bird.

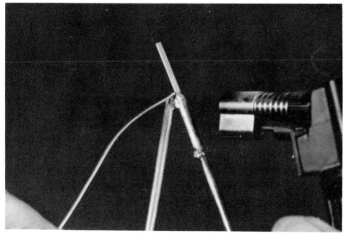

Figure 27. Silver solder a piece of the smaller square tubing into the angled reed. Leave approximately three-quarters of an inch of the square outside of the tubing.

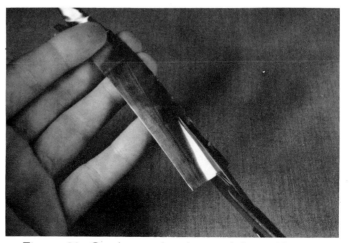

Figure 30. Cut leaves for the reed from 40 gauge copper. Ordinary scissors are sturdy enough to cut the thin copper.

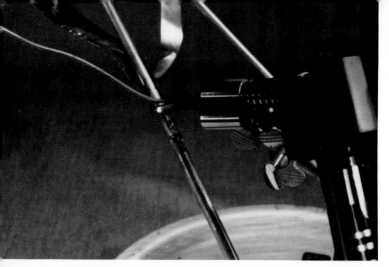

Figure 31. Hold the leaves to the tubing with alligator clips and solder.

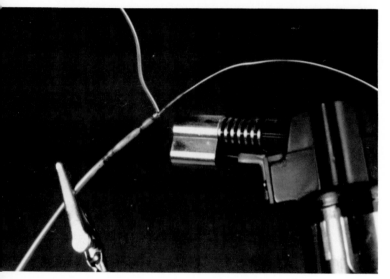

Figure 32. To create a grass stalk, solder a piece of small diameter copper wire into a piece of small brass tubing.

Figure 33. When the solder is cool, cut a two inch piece of stranded picture hanging wire and wrap one-half inch of it around the joint. Apply super-glue to the wrap. When the glue has hardened, wrap the rest of the stranded wire around the copper wire. Begin unraveling it randomly down the piece of copper wire. Cut the strands off so that short ends stick out from the base. Apply super-glue to harden the entire piece of stranded wire.

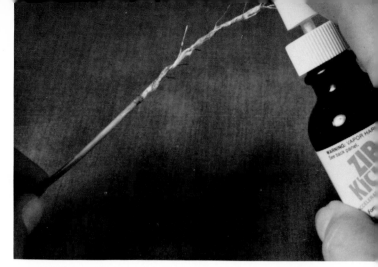

Figure 34. Applying super-glue and Zip Kicker (an accelerator) alternately will build up sufficient diameter of the stalk of the grass stem.

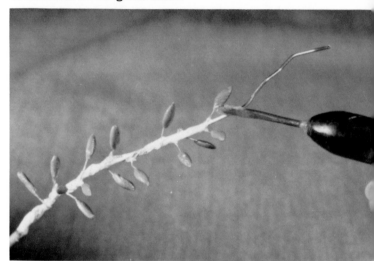

Figure 35. Mix up a small amount of the ribbon putty. Shape small, flattened seeds on the end of each of the protruding wires.

Figure 36. Spray both the grass stalk and the bent reed with spray primer.

Figure 37. Put masking tape around the edge of the base to protect it. Mix a large amount of sand and modeling paste on a styrofoam plate. Put the sand/modeling paste mixture into the bottom of the base. Create interesting contours with a palette or putty knife.

Figure 38. Allow the modeling paste plenty of drying time so that it hardens all the way through and not just on the surface. If there are thick areas of the modeling paste, it may crack as it dries. More modeling paste can be added to fill the cracks or change the contour. Mix a small amount of water in some white glue. Brush the glue onto the hardened modeling paste. Sprinkle with sand and let dry. This glue and sand procedure can be done again if there are any bare spots.

The bent reed is ready for painting.

Figure 39. To create a sand habitat on a flat base, cut a piece of one-quarter inch plywood slightly smaller in diameter than the base. Round over the edges with a large carbide cutter.

Figure 40. Shorten two aluminum nails. I use aluminum nails because they can be cut with linemen's pliers (or a linemen can do it with regular pliers!). Using two nails to pin the plywood will keep it from twisting on the base. Drill two holes slightly wider and longer than the nails.

Figure 41. Put the nails into the holes. Mix up a large amount of 5 minute epoxy and apply around the heads of the nails. Do not let any glue under the heads that might travel down the shank and glue the plywood to the base. Being able to remove the plywood for further steps avoids damaging the fancy base.

Figure 42. Make a mixture of modeling paste and sand.

239

Figure 43. When the glue has hardened, remove the plywood from the base. Frost the plywood with the sand mixture. Shape and contour as desired.

Figure 44. Allow to dry and harden thoroughly. Mix a small amount of water with white glue. Brush the glue onto the modeling paste and sprinkle with sand. Allow to harden. This glue and sand procedure can be done again if there are any bare spots.

Figure 45. Mix up a small amount of 5 minute epoxy on the base. Poke it down into the nail holes. Put the plywood sand base in place and allow to harden.

Creating Water

Figure 46. EnvironTex is a product often used to cover imbedded objects on tables, bar tops, etc., but it is an excellent product to use in making water in habitats.

Figure 47. Read the directions thoroughly. Mix equal amounts of resin and hardener in a square bottomed container for two minutes.

Figure 48. Pour small amounts onto the ready habitat. Breathing heavily over the water's surface will cause bubbles to rise and burst. When there are no more air bubbles visible, put the base aside in a dust-free environment to harden.

Making Grass Blades

Figure 49. Cut strips of thin copper (40 gauge) in the shape of grass blades.

Figure 50. On a firm piece of felt, press the crease in the middle of each blade. A dull awl or wooden clay tool can be used.

Figure 51. Using needle-nose pliers, twist the base end into a tight stalk. Apply gesso or spray primer before painting.

PATTERNS

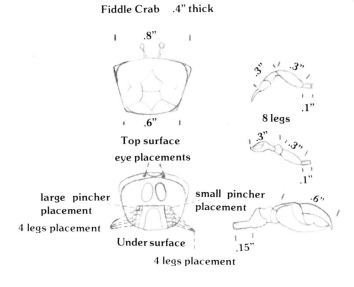

Fiddle Crab .4" thick

.8"

.6"

Top surface
eye placements

large pincher placement

small pincher placement

4 legs placement

Under surface

4 legs placement

.3" .3"

.1"

8 legs

.3" .3"

.1"

.6"

.15"

Shark's Eye Shell .6" thick

Piece of oyster shell .56" thick

Periwinkle shell .56" thick

241

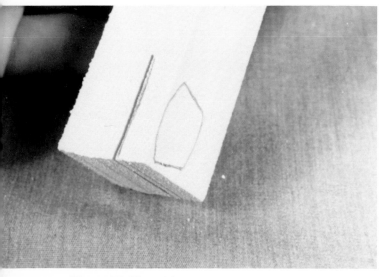

Figure 52. Trace the pattern on a one-inch thick piece of tupelo. Make a bandsaw cut .4 of an inch thick. Then cut out the pattern view.

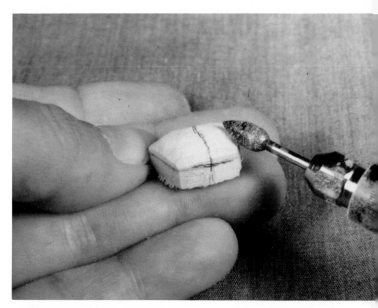

Figure 55. Round the top shell down toward the side edges.

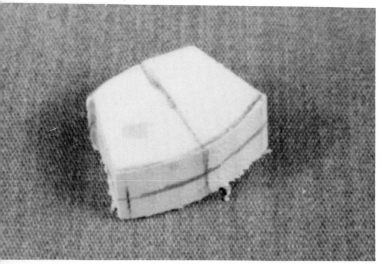

Figure 53. Draw centerlines on the top, bottom and sides.

Figure 54. Note the shape of the upper shell.

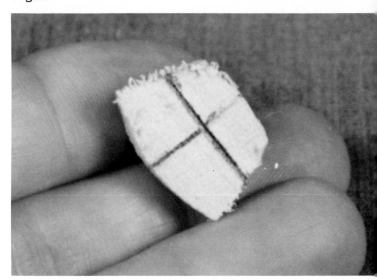

Figure 56. Draw a line .25 of an inch from the back edge on the underside.

Figure 57. Remove the wood from the line to the back edge to make a sharp angle. Round over the wood from the line to the front edge. Drill a hole and super-glue in a piece of wire to be held in a pin vise or vise grip pliers.

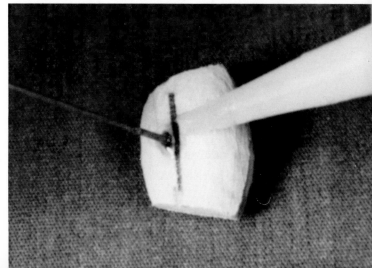

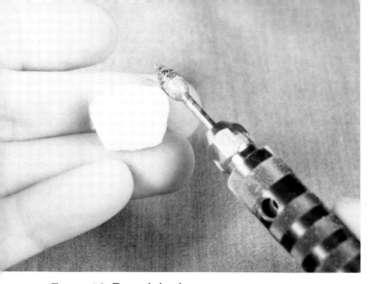

Figure 58. Round the front corners.

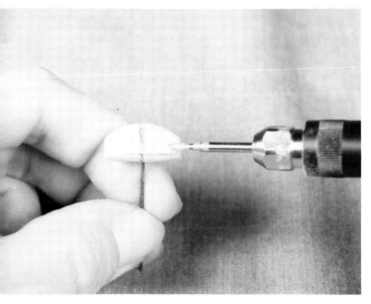

Figure 59. With a small diamond bit, carve a narrow channel between the upper and lower shells along the front edge.

Figure 60. Note the two oval structures on the center of the underside.

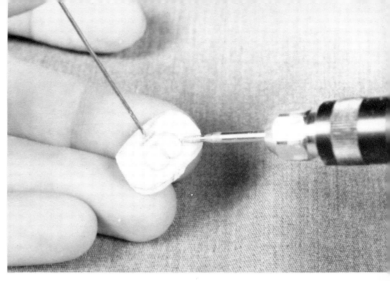

Figure 61. Draw in the two oval structures. With a small pointed diamond bit, channel around the lines, flow the channels out and round over the edges.

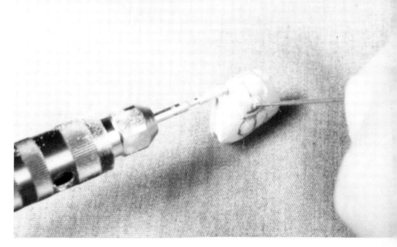

Figure 62. Using a square-edged bit, cut in a shelf .1 of an inch on both sides of the centerline. This will be the attachment point for the legs and claws.

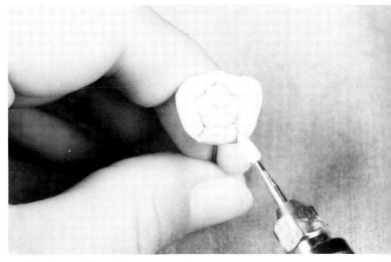

Figure 63. Sand the entire body with fine sandpaper. Draw in the upper shell pattern. With a pointed stone, channel along the pattern lines.

243

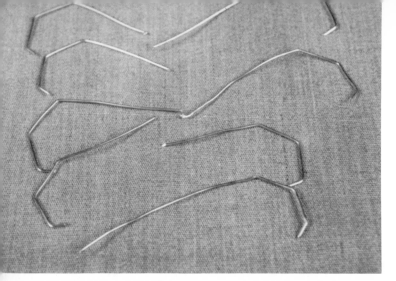

Figure 64. Using #22 gauge copper wire, make the bends in 8 legs. Leave the wire longer than the actual legs so that you have something to hold onto.

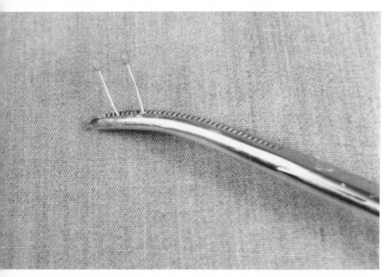

Figure 65. On two shorter pieces of wire, form two round balls for eyes with ribbon epoxy putty.

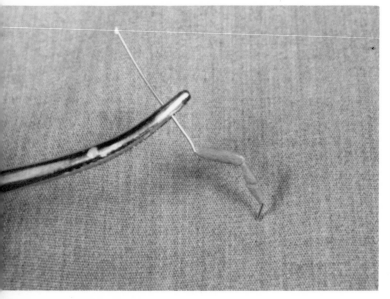

Figure 66. Form the heftier parts of the legs with the putty. Score the middle pad with an angled depression.

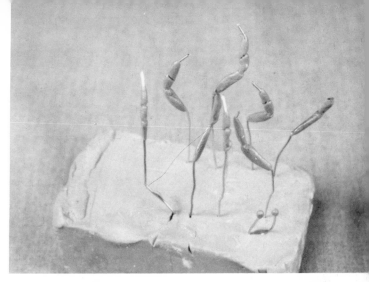

Figure 67. When each leg is completed, stick it in a block of clay until it hardens. Here you see the 8 formed legs and two eyes hardening.

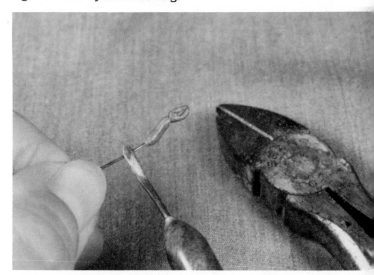

Figure 68. Shape the small pincher on a piece of wire. Wire cutter blades work great for separating the ends of the pincher.

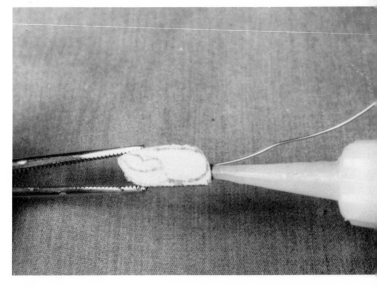

Figure 69. Draw the large pincher on a small piece of tupelo. Glue a wire into the end.

244

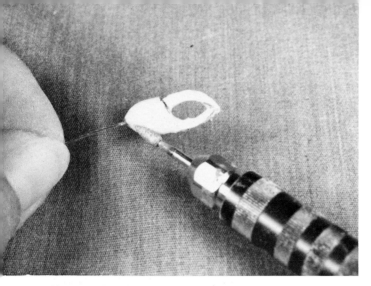

Figure 70. Round the fat end and narrow the tip towards the pinching end.

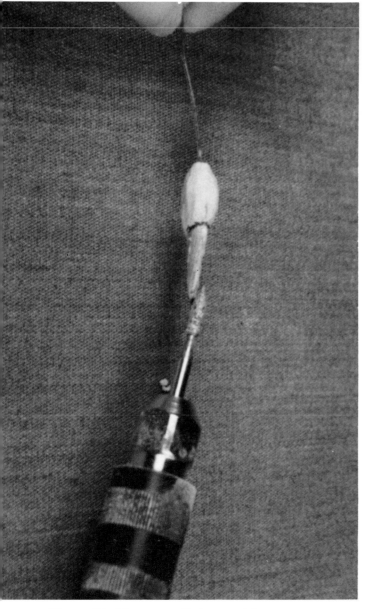

Figure 71. Use a small diamond bit to narrow the pinching end and separate the two parts.

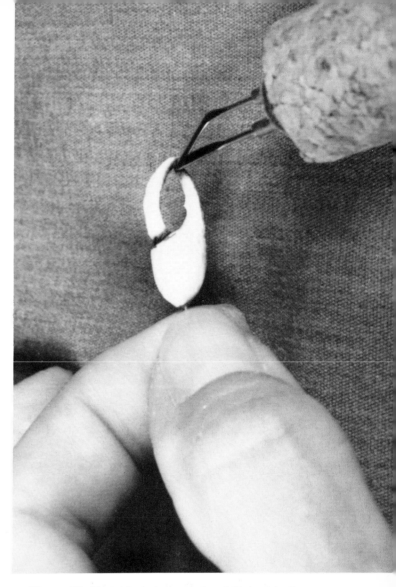

Figure 72. Use a burning pen for delineating the joint and sharpening the joint at the pinching end. Sand with fine sandpaper.

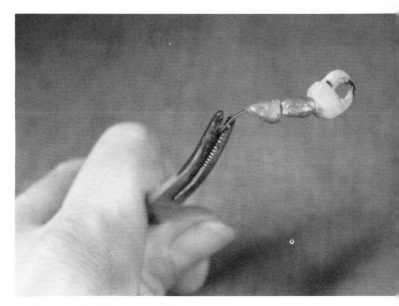

Figure 73. With the ribbon putty, form the angular joints at the base of the large pincher.

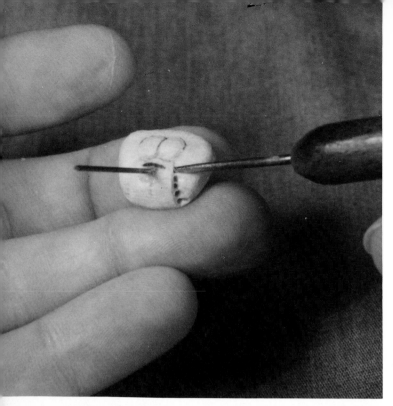

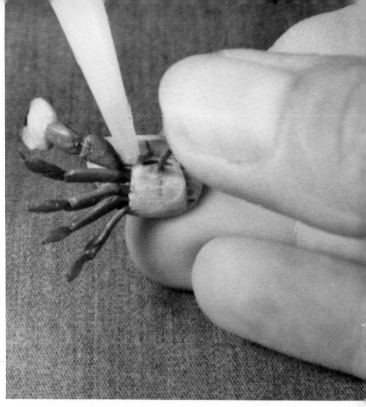

Figure 74. When all the putty parts have hardened, use a pointed clay tool to poke the holes in the shelf for the legs on each side of the under shell.

Figure 76. Clip the excess off the legs and pinchers and glue in place.

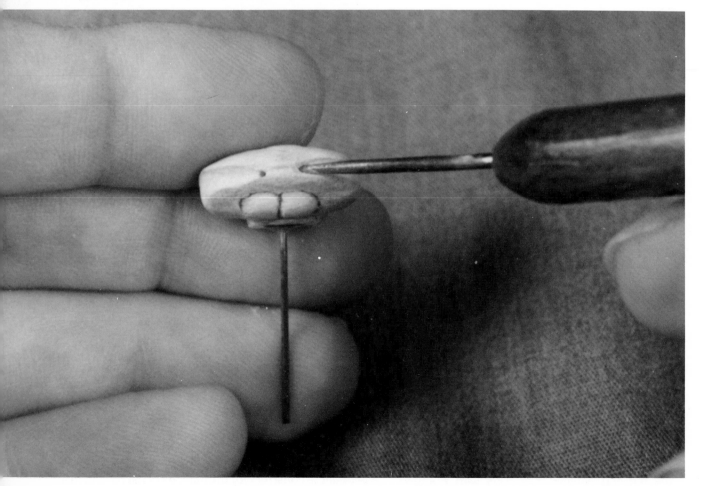

Figure 75. Poke the two holes for the eye wires.

246

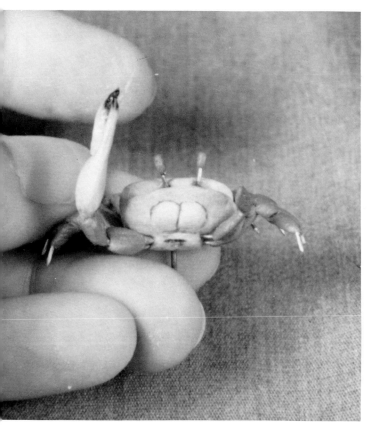

Figure 77. Clip the excess off the eye wires and glue in place.

Figure 78. When the glue has hardened, cover the joints of the leg and pincher insertions with a small amount of the ribbon putty.

Figure 79. When the putty has hardened, spray with *Krylon*. Apply two coats of gesso and allow to dry. The fiddler is ready for color!

Making Shells

Figure 80. Here you see the patterns and the shells that I want to construct for the habitats of the birds in this book.

Figure 81. After I cut the pattern out of a block of wood, I begin shaping and contouring it as I see the real one. Here you see the bottom of the piece of oyster shell.

Carving a shell is just a problem solving situation. I first have to see—I mean, really see the contour. I ask myself questions: "Does the contour go up or down?", "Is it round or angled?", or "Is it depressed and if so, how?" When I see the answers, I go into the piece of wood boldly, hacking off wood here and there until the piece starts looking like the model. After all, it is only a piece of wood, and if I botch it, I have plenty of wood. So I will just start again, and again or whatever is needed to get it right. Come to think of it, that is the way I carve birds and animals. I problem solve and execute until I get in the wood what I see in the model. But it all starts with being able to see!

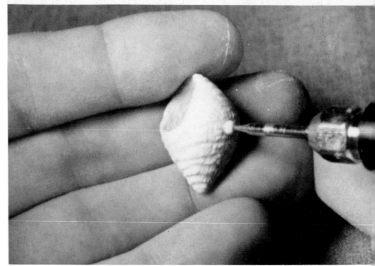

Figure 82. Here you see the carved periwinkle being textured.

Figure 83. Here you see the shark's eye being sanded. When all of the details on the shells are completed, they were sprayed and sealed with *Krylon*. The shells are then ready for color!

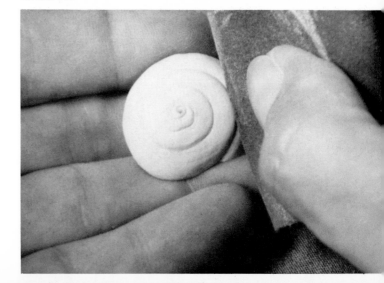

PAINTING THE CONSTRUCTED ROCK

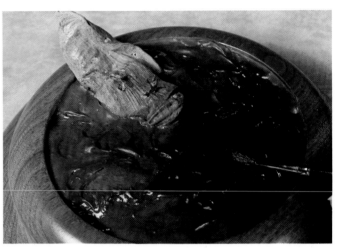

PAINTING MUD

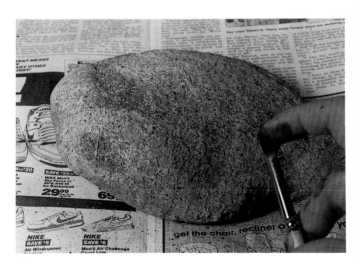

Figure 1. Apply a very thin, watery burnt umber wash. The thin burnt umber will sink to the bottom of the texture, creating shadow and depth and enhancing the three-dimensional quality of the rock. Darken some of the depressions and sunken areas on the rock with thin burnt umber and payne's grey. Use a thin mixture of burnt umber and payne's grey and a liner brush to paint in lines representing cracks.

Figure 3. Blend burnt umber, payne's grey and a small amount of white and apply to the mud surface working carefully around any driftwood or other habitat components already in place. While the basecoat is still wet, work in small amounts of payne's grey into the depressions. It will take several basecoats to cover the gesso sufficiently. If desired, mix and pour the water when the basecoats are dry.

PAINTING REEDS AND GRASSES

Figure 2. When the wash is dry, use an old toothbrush or stiff bristle brush to spatter yellow ochre, burnt sienna, black, white, black and white to a medium grey and iridescent white on the rock. Load a thin mixture of each color separately in the brush and use your index finger to pull back and let go of the bristles. This will sling very small spots or droplets of that particular color onto the surface. If the rock's color starts getting too dark, apply more light spatter or a light wash. If it gets too light, apply more dark spatters or a dark wash.

Figure 4. The basecoat for the dried grasses and reeds is a mixture raw sienna, yellow ochre and white. Apply several coats othe reeds and leaves.

Figure 5. Apply a burnt umber wash to the seed heads.

Figure 7. Lightly spatter the grass blades on one side. When this is dry, flip them over and spatter the other side.

Figure 8. Using an awl, press a hole into the modeling paste and sand mixture. Use an old drill bit to enlarge the hole sufficiently wide enough to hold the grass stems. Fill the hole with super-glue and put in the grass stem ends. Sprinkling with baking soda will cause the super-glue to harden more quickly. When the super-glue and baking soda are hard, apply a mixture of burnt umber, raw sienna and white so that their color blends with the surrounding sand's color.

Figure 6. Using thin burnt umber paint and an old toothbrush or stiff bristle brush, lightly spatter the reeds and leaves.

Figure 9. Here you see the plan view of two slightly different colored fiddler crabs. Fiddler crabs can be purplish or greyish blue with purple, brown, black or grey markings. The claw color can be blue, red-brown or purple.

Figure 11. Blend payne's grey, burnt sienna and a small amount of white to a dark purplish grey and basecoat the top shell, eyes, legs and bottom two joints of the pinchers. It will take several thin coats to cover the gesso. The basecoat color for the underside is a mixture of black, raw sienna and a small amount of white. Also use this second mixture to highlight the leg and pincher joints and the markings on the top shell. Add more white to the second mixture and basecoat the two pinchers.

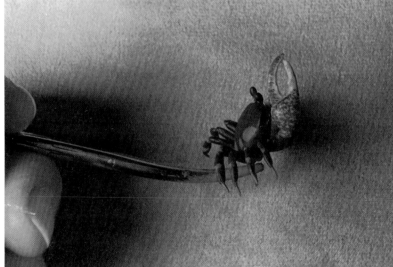

Figure 10. The underside of the two fiddlers.

Figure 12. Blend payne's grey, burnt sienna and white and dot the outside base and the top ridge of the big claw. Add more white to the mixture and dot the same areas again.

251

Figure 15. Here you see the top view of a piece of oyster shell I found along the shores of the Chesapeake Bay.

Figure 13. Paint the tips and joints of the legs and the small pincher with a mixture of raw umber and yellow ochre.

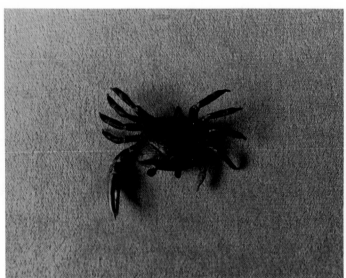

Figure 14. Paint the eyes black. Apply a thin watery wash of a mixture of black and raw umber to the underside of the body. Apply thin yellow ochre and black washes to the top shell and tops of the legs. Mix a small amount of raw sienna and matte medium and paint in highlights at the base of the top shell. Add black to matte medium and paint the thin lined pattern on the top shell. To give a greenish tinge to the top shell, coat the shell with a mixture of raw umber, yellow ochre and matte medium. When this is dry, apply several coats of very watery gloss medium, drying in between applications.

Figure 16. The underside of the oyster shell.

252

Figure 17. The basecoats are a mixture of white with small amounts of burnt umber and payne's grey to a light grey. While each basecoat is still wet, work straight payne's grey and burnt umber into the depressions and darker areas.

Figure 19. Blend iridescent white with a small amount of raw umber. Thin with water and apply several washes to both sides.

Figure 18. Add the darker lines along the layered edges with a thin mixture of burnt umber and a small amount of payne's grey.

Figure 20. Here you see the underside of the completed oyster shell.

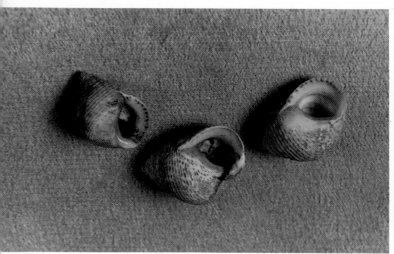

Figure 21. Here you see the opening side of three periwinkles.

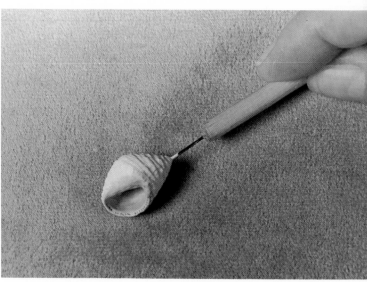

Figure 23. With a mixture of white, yellow ochre and a small amount of black, paint inside the opening several coats. Add more yellow ochre to the mix and paint the band near the edge of the opening. Then, adding more white to the mixture, lighten the very edge.

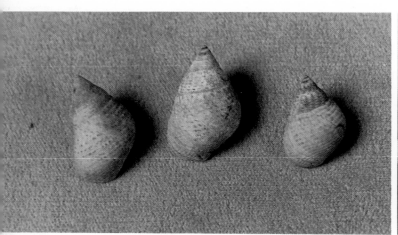

Figure 22. The other side of the periwinkles.

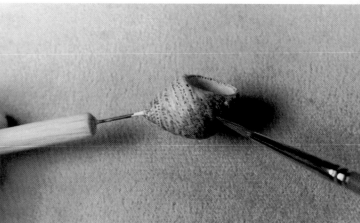

Figure 24. Basecoat the outside of the shell several times with a mixture of white, raw umber and payne's grey. When these are dry, apply a thin burnt umber wash.

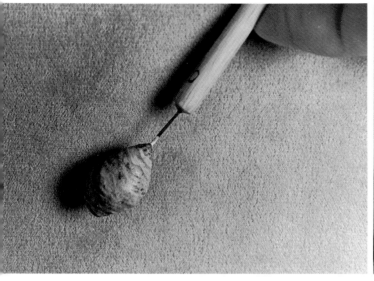

Figure 25. Paint the spirals from the tip to the base of the shell with very thin payne's grey. Dot the tops of the ridges and nubs with thin burnt umber. When these are dry, apply a very thin wash of a mixture of white and yellow ochre.

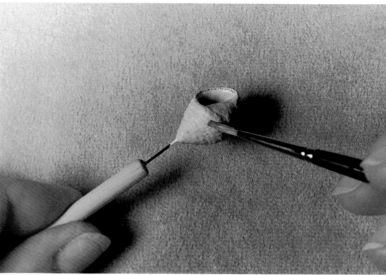

Figure 27. To give the outside shell a mossy appearance, paint small areas with a mixture of ultramarine blue, yellow ochre and a small amount of raw umber. Apply several thin coats of gloss medium inside the shell's opening, but do not put any on the outside.

SHARK'S EYE

Figure 26. With a very thin mixture of raw sienna, burnt sienna and a small amount of white, paint an accent inside the shell's opening.

Figure 28. Here you see the top view of two shark's eyes. Their color can be pink, purple, blue, brown or grey tones.

Figure 29. Note the shiny outer bands on the undersides.

Figure 31. With a thin mixture of payne's grey, burnt umber and a small amount of white, paint in the spiral markings on the whorls.

Figure 30. The basecoat color is a mixture of white, raw umber and a small amount of payne's grey.

Figure 32. Apply several thin washes of a mixture of white and burnt umber. When these are dry, darken the depression of the spiral whorl with very thin raw umber. Apply a thin, watery yellow ochre wash. At the center apex of the swirl, apply a thin wash of burnt sienna. Apply two coats of very watery gloss.